CAR DESIGN EUROPE

Paolo Tumminelli

MYTHS, BRANDS, PEOPLE

teNeues

START

The automobile is omnipresent. People love it. Or, at least, they are aware of it. But what is the automobile actually all about, what does it stand for and why does it look the way it looks?

To me, the history of the automobile starts sometime around the year 1935, when the car was no longer regarded as just a technical appliance, but as a thoroughly designed object. The automobile gained a form of its own and started to transcend its carriage-work origins. Thus it began to obtain a function that exceeded by far the transportation of people and goods. The car was evolving into a social entity with an identity of its own that people aspire to, that they want to interact with and finally use on a daily basis.

Slowly but steadily, the automobile merged with society and the economy, as well as with politics, which caused its architecture, size and style to change continually. Besides the artistic aspect, auto-

Das Automobil ist überall. Man liebt es. Oder man kennt es auch nur. Aber was ist das Automobil wirklich, was bedeutet es und warum sieht es so aus, wie es aussieht?

Für mich beginnt die Geschichte des Automobils um das Jahr 1935, als man anfängt, das Auto nicht mehr nur als technisches Gerät, sondern als Designobjekt zu betrachten. Das Automobil bekommt eine eigene Form, wird zu mehr als bloßem Fahrwerk. Dadurch bekommt es eine Funktion, die weit über das Befördern von Menschen und Gütern hinausgeht. Es wird zum sozialen Wesen mit eigener Identität.

Langsam aber sicher verwächst das Automobil mit Gesellschaft, Wirtschaft und auch der Politik, wodurch sich Architektur, Größe und Stile permanent ändern. Über die Gestaltung hinaus ist Automobildesign auch eine bewegte Geschichte von Mythen, Marken und Menschen.

L'automobile est omniprésente. On l'adore. Ou tout du moins, on sait qui elle est. Mais le sait-on vraiment ? Quelle est sa véritable raison d'être et pourquoi a-t-elle l'aspect qu'on lui connaît ?

L'histoire de l'automobile, je la fais débuter vers 1935, date à laquelle on commence à la considérer comme un objet esthétique et non plus comme une pure prouesse technique. Elle acquiert une forme et devient plus qu'un simple châssis monté sur quatre roues. Elle acquiert une fonction qui transcende son objectif initial de moyen de transport des biens et des personnes. Elle acquiert un caractère social avec une identité propre. Elle devient marque, se transforme en un mythe, en un objet de désir, que l'on utilise. Un objet fait par les hommes, pour les hommes.

Lentement mais sûrement, elle investit la société, l'économie et même la politique, ne manquant pas de provoquer une mutation

motive design stands for a storied tale of myths, brands and people. In *Car Design Europe*, the emphasis is put not on beauty, but on meaning. Stories will be told about small and large, beautiful and ugly and expensive and cheap cars, because each and every car is just as precious as it is innocent. As Pixar put it most succinctly in the motion picture *Cars*: we humans do not own cars—we are cars. Cars reflect ourselves, one mirroring the other, whether we like it or not.

Bei *Car Design Europe* liegt der Schwerpunkt nicht auf Schönheit, sondern auf Bedeutung. Es wird von kleinen und großen, hübschen und hässlichen, teuren und billigen Autos erzählt. Denn jedes Auto ist gleichermaßen wertvoll wie unschuldig. Pixar hat das mit dem Film *Cars* auf den Punkt gebracht: Wir Menschen besitzen Autos nicht – wir sind Autos. Autos entsprechen uns. Eines wie das andere, ob es uns gefällt oder nicht.

continuelle de l'architecture, des tailles et des styles. Le design automobile, plus qu'une histoire des formes, raconte une histoire fascinante de mythes, de marques et d'hommes. Le but de *Car Design Europe* n'est pas uniquement de donner de la beauté à voir, mais de s'intéresser au pourquoi des choses. Il y sera question de voitures, petites ou grandes, belles ou laides, à bas prix ou luxueuses. Toutes les voitures se valent, elles ont toutes ce charme de l'innocence. Pixar résume la chose ainsi dans son film *Cars – Quatre roues* : Les voitures, nous ne les possédons pas, nous sommes des voitures. Les voitures nous correspondent. Il en va ainsi de toutes les voitures, que cela nous plaise ou non.

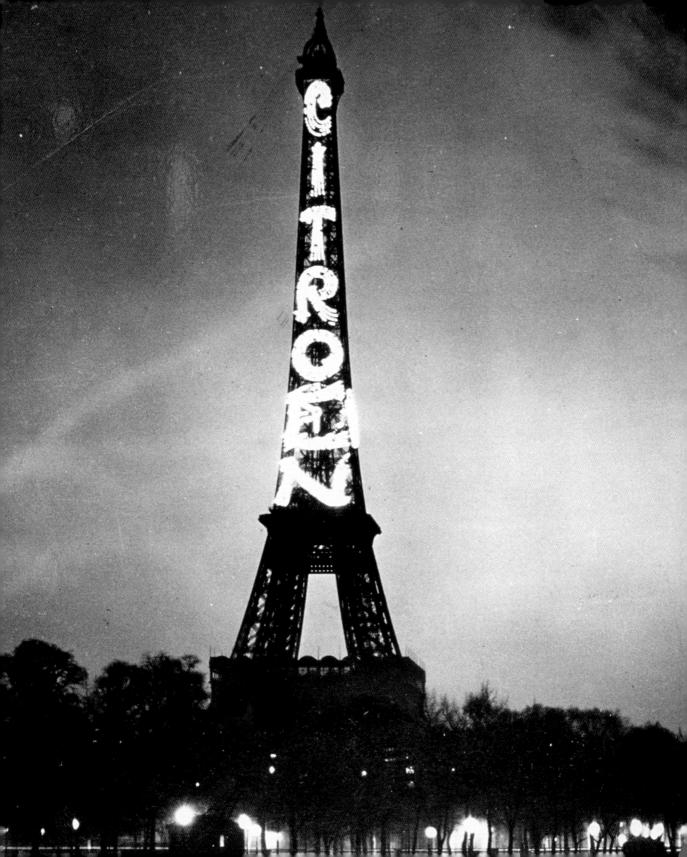

EUROPE

Europe invented the automobile. Or maybe it was the other way around. When Carl Benz patented his motor vehicle in 1886, the German Empire was a patchwork made up of 25 kingdoms, grand duchies, principalities and the like. Meanwhile, the imperialistic nobility from the right and Karl Marx's rebellious labour proletariat from the left were causing mayhem in Europe, with a modern, but bourgeois, middle class caught right in between. The blaze of revolution can be felt everywhere—ignited by a young avant-garde who chose the machine as their symbol. So we have Picabia painting a child in the shape of a carburettor, Léger conducting a mechanical ballet and Le Corbusier creating a living machine, while the futurists were interpreting driving as a form of

Europa hat das Automobil erfunden. Oder auch umgekehrt. Denn das deutsche Kaiserreich des Jahres 1886, als Carl Benz seinen Motorwagen patentiert, ist ein Flickenteppich aus 25 Königreichen, Großherzogtümern, Fürstentümern und dergleichen. Unterdessen sorgen der imperialistische Adel von rechts, Karl Marx' aufstrebendes Arbeiterproletariat von links und ein modernes, aber spießiges Bürgertum mittendrin für Aufruhr. Es brennt an allen Ecken – entzündet von einer Avantgarde, die die Maschine zu ihrem Symbol kürt. So malt Picabia ein Kind in Vergaserform, Léger dirigiert ein mechanisches Ballett und Le Corbusier ersinnt die Wohnmaschine, während die Futuristen das Fahren gar als Geschlechtsverkehr verstehen. Und Gabriele

L'Europe a inventé l'automobile. A moins que ce ne soit l'inverse. En 1886, l'année où Carl Benz dépose son brevet de voiture à moteur, l'Empire allemand n'est en effet qu'une mosaïque de 25 états. Des forces contraires balayent l'Europe, avec à droite, la noblesse impérialiste, à gauche, un prolétariat ouvrier naissant, fruit de la pensée de Karl Marx, et entre les deux une bourgeoisie moderne, certes, mais néanmoins très étriquée. Partout le vent gronde, que fait souffler une jeune avant-garde, qui élève la machine au rang de symbole de son mouvement. Picabia peint un enfant en forme de carburateur, Léger dirige un ballet mécanique et Le Corbusier conçoit la machine à habiter, tandis que les futuristes associent la conduite à l'acte sexuel. Gabriele D'Annunzio,

Paris, 1925

From 1925–36, Europe's landmark advertises Citroën's automobiles.

Von 1925–36 wirbt Europas Wahrzeichen für Citroëns Automobile.

De 1925 à 1936 l'emblème de l'Europe sert de panneau publicitaire géant à la Citroën.

sexual intercourse. And Gabriele D'Annunzio—poet, warrior, playboy—proclaimed: "The automobile is female." It is those intellectuals, together with their rich friends, who created the myth of the automobile, rather than the engineers or the people, who were standing by the side of the road, watching, dreaming of a pair of shoes. This resulted in two world wars and the multiple personality of European automotive design.

A terribly conservative aristocracy was still demanding coach lights on their cars—as Pinin Farina remembered vividly—and would not even consider a sloping windscreen. The avant-garde, on the other hand, were seeking cars with a wild soul and the form of a work of art. The Bugattis, a family of artists, gave them what they wanted. Flamboyant art deco, the first international style and symbol of the Roaring Twenties, lent the automobile an appropriate form for the very first time. Tamara de Lempicka—

D'Annunzio – Dichter, Krieger, Playboy – erklärt: „Das Automobil ist weiblich." Es sind diese Intellektuellen, mitsamt ihrer reichen Freunde, die den Mythos Automobil kreieren. Nicht die Ingenieure und nicht das Volk, das dabei zuschaut und von einem Paar Schuhe träumt. Zwei Weltkriege und die pluralistische Identität des europäischen Automobildesigns sind die Folge.

Die grausam konservative Aristokratie verlangt – so erinnert sich Pinin Farina – nach Kutscherlaternen und will von einer geneigten Windschutzscheibe nichts wissen. Die Avantgarde hingegen sucht Autos mit wilder Seele und der Form eines Kunstwerks. Die Bugattis, eine Künstlerfamilie, geben sie ihnen. Mit dem flamboyanten Art déco, dem internationalen Sinnbild der Roaring Twenties, findet das Automobil erstmals eine angemessene Form. Tamara de Lempicka – Künstlerin und bisexueller Star – wählt Autos passend zum Kleid aus.

poète, combattant et playboy, déclare d'ailleurs: « La voiture est une femme ». Ce sont ces intellectuels là et leurs richissimes amis qui créent le mythe de l'automobile, et non les ingénieurs, ou le peuple, réduit au rang de simple spectateur et tellement démuni qu'il rêve d'une paire de chaussures. Deux guerres mondiales s'en suivront avant la naissance d'un design automobile européen aux multiples facettes.

L'aristocratie, horriblement conservatrice, exige alors, se souvient Pinin Farina, que les voitures soient équipées de lanternes comme sur les calèches et refuse le pare-brise incliné. L'avant-garde quant à elle a envie de voitures racées qui ressemblent à des œuvres d'art. Les Bugatti, issus d'une famille d'artistes, les lui offriront. Avec l'âge d'or de l'art déco, symbole international de ces années folles, de ces « Roaring Twenties », l'automobile acquiert pour la première fois une forme adéquate. Touring dessine alors la

Bugatti 57 SC *Atlantic*, 1937

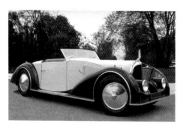

Voisin C27, 1931

artist and bisexual celebrity—chose her Bugattis to match her dresses. Touring designed the Flying Star, a white comet for the road. Saoutchik and Figoni & Falaschi of Paris created a surreal aesthetic of morbidly floating coachwork, yet Le Corbusier preferred creations by aircraft designer, Avions Voisin, for whom he envisioned a new Paris for the year 1925, designed for aircraft and cars, not for people, people who were longing for a simple automobile that is as cheap as it is versatile. But this plea remains unanswered by all the kings and emperors: after all, resources were scarce and expensive.

Great Britain might be the biggest amongst all those small, closed European markets, but that is a relative conclusion: production of the most successful British pre-war car, the Austin Seven, peaked at a modest 17,000 units a year. Over that same period, Ford built a more substantial two million Model-Ts. This enabled the fascist

Touring zeichnet den Flying Star, einen weißen Kometen für die Straße. In Paris kreieren Saoutchik und Figoni & Falaschi eine surrealistische Ästhetik der morbide schwebenden Karosserien. Le Corbusier bevorzugt seinerseits die Kreaturen des Flugzeugbauers Avions Voisin, für die er 1925 ein neues Paris plant – für Flugzeuge und Automobile. Und für ein Volk, das sich nach einem einfachen Automobil sehnt, das wenig kostet und viel kann. Auf diese Bitte reagieren weder Könige noch Kaiser: schließlich sind die Rohstoffe knapp und teuer.

Unter diesen kleinen geschlossenen Märkten Europas ist Großbritannien zwar der größte, doch das ist relativ: vom erfolgreichsten britischen Auto der Vorkriegszeit, dem Austin Seven, werden siebzehntausend Stück pro Jahr gebaut. Ford produziert währenddessen gut zwei Millionen T-Modelle. Das ermöglicht den faschistischen Diktatoren, unter dem Deckmantel eines nationalen

Flying Star, une comète blanche qui défile sur les routes. A Paris, Jacques Saoutchik ainsi que Figoni & Falaschi créent des carrosseries suspendues d'une esthétique surréaliste pleine de débauche. Le Corbusier leur préfère les créations du constructeur aéronautique Avions Voisin, pour lesquelles il dessine en 1925 les plans d'un nouveau Paris, axé sur l'avion et la voiture, un Paris fort éloigné des intérêts du peuple qui lui ne désire alors qu'une chose, posséder une voiture simple, pratique et bon marché. Mais ces désirs, ni les rois, ni les empereurs ne les satisferont ; les matières premières sont chères et rares.

À la même époque Ford produit deux millions de son modèle T. Les deux dictateurs fascistes tirent parti de la situation et propagent, sous couvert de national-socialisme, l'idée d'une voiture populaire et d'une société du tout-automobile. Ils rivalisent d'ardeur pour construire les premières autoroutes, financent l'organisation de

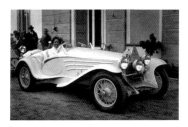

Alfa Romeo 6C 1750
Flying Star Touring, 1931

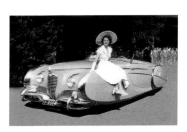

Delahaye 175 S Roadster
Saoutchik, 1949

dictators to propagate their vision of an automobile for the people under the cloak of nationalistic socialism and to promote the 'automobilisation' of society. They tried to best one another with the construction of the first motorways, advocated Grand Prix motor sports, aimed for records and demanded from their own industries a people's car for daily use, based on Ford's template. Thus, Germany and Italy made enormous technological strides, even before 1940. The painful conclusion is, therefore, that the modern European automobile can be regarded a fascist creation, which goes some way to explaining the ongoing political debate concerning the topic.

But before this automotive vision could become a reality, Europe first had to be reduced to rubble by a world war. The ensuing rebuilding process caused an automotive blossoming: 75 manufacturers, as well as a plethora of independent coachbuilders, were

Sozialismus die Vision des Bürgerautomobils zu propagieren und die Automobilisierung der Gesellschaft voranzutreiben. Sie übertreffen sich gegenseitig mit dem Bau der ersten Autobahnen, fördern den Grand-Prix-Rennsport, streben nach Rekorden und verlangen von ihren Industrien ein alltagstaugliches Volksauto nach Fords Vorbild. So gelingen Deutschland und Italien bereits vor 1940 enorme technologische Fortschritte. Und auch wenn die Feststellung schmerzhaft ist: Das moderne europäische Automobil kann durchaus als faschistisches Erzeugnis betrachtet werden – was auch die andauernde politische Debatte um das Thema erklärt.

Bevor die automobile Vision Realität werden kann, muss zunächst ein Weltkrieg Europa in Schutt und Asche legen. Der Wiederaufbau sorgt für ein automobiles Feuerwerk: 75 Hersteller und dazu viele unabhängige Karosseriebauer buhlen um die Gunst

Grands-Prix, sont avides de records et demandent à leurs industriels de construire enfin la voiture de Monsieur Tout-le-monde sur le modèle de Ford. Ainsi dès avant 1940, l'Italie et l'Allemagne ont une longueur d'avance sur le plan technologique. Force est de constater, même si c'est à contrecœur, que la voiture moderne européenne est un pur produit du fascisme, d'où cette éternelle controverse à son égard.

Il faudra néanmoins attendre la fin de cette guerre qui mit l'Europe à feu et à sang avant que ne s'impose progressivement la vision d'une société automobile. La reconstruction entraînera un véritable essor de l'automobile : 75 constructeurs et un grand nombre de carrossiers indépendants briguent les faveurs du public. Les différences culturelles s'accentuent. La Grande-Bretagne, malgré le génie créatif de nombreux de ces constructeurs, s'enlise dans un conservatisme victorien, tan-

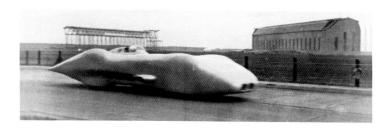

Mercedes-Benz Rekordwagen, 1938

courting the new customers' favour. Cultural differences emerged: Great Britain, for example, persisted in its Victorian conservatism, despite many engineers' daring genius, while France, in a melange of surrealism and radicalism, evoked the automobile's political dimension and effectively banned status symbolism. Italy, on the other hand, concealed its social disparity with stylistic sophistication and thus gave a modish appearance to even the smallest of cars. And Germany, now a divided country, disarmed itself utilising Calvinist dogmatics that put concept and function well ahead of aesthetics. It was only once the Iron Curtain had fallen that Europe was able to rid itself of those burdens of the past. In 1999, Mercedes-Benz finally announced 'design freedom': markets were opened and another blossoming beckoned. The Old Continent still is a chequered empire, as far as automotive design is concerned.

des Publikums. Kulturelle Unterschiede werden deutlich: Großbritannien etwa verharrt, trotz der mutigen Genialität vieler Konstrukteure, im viktorianischen Konservativismus, während Frankreich, mit einer Mischung aus Surrealismus und Radikalität, die politische Dimension des Automobils beschwört und die Statussymbolik verbannt. Italien hingegen kaschiert soziale Ungleichheiten mit stilistischer Raffinesse, so dass selbst das kleinste Auto eine gute Figur abgibt. Und das nun geteilte Deutschland entschärft sich selbst mit Hilfe calvinistischem Dogmatismus, der nicht Ästhetik, sondern Konzept und Funktion in den Vordergrund stellt. Von diesen Altlasten kann sich Europa erst mit dem Fall des Eisernen Vorhangs befreien. 1999 ruft Mercedes-Benz schließlich die Designfreiheit aus: Die Märkte öffnen sich, ein neues Feuerwerk wird gezündet. Für das Automobildesign bleibt der alte Kontinent bis heute ein buntes Kaiserreich.

dis que la France, dans un esprit radical et surréaliste tout à la fois, conjure la dimension politique de l'automobile et lui dénie le symbole de statut social qu'elle représente. L'Italie tente de masquer les inégalités sociales par une recherche esthétique capable de donner fière allure à la plus petite des voitures. Quant à l'Allemagne, désormais divisée, elle se dépassionne à la faveur d'un dogmatisme protestant et privilégie l'aspect fonctionnel et conceptuel au détriment de l'esthétique. L'Europe ne se libèrera du poids de son passé qu'à la chute du rideau de fer. En 1999, Mercedes-Benz proclame la liberté de design : les marchés s'ouvrent, marquant le deuxième coup d'envoi d'un formidable développement. Dans le domaine du design automobile, le vieux continent reste un haut lieu du mélange des genres.

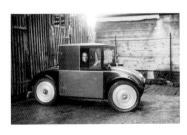

Hanomag 2/10 PS *Kommissbrot*, 1925

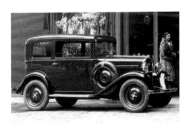

Fiat 508 *Balilla*, 1932

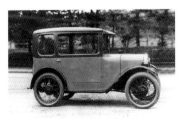

Austin Seven Saloon, 1928

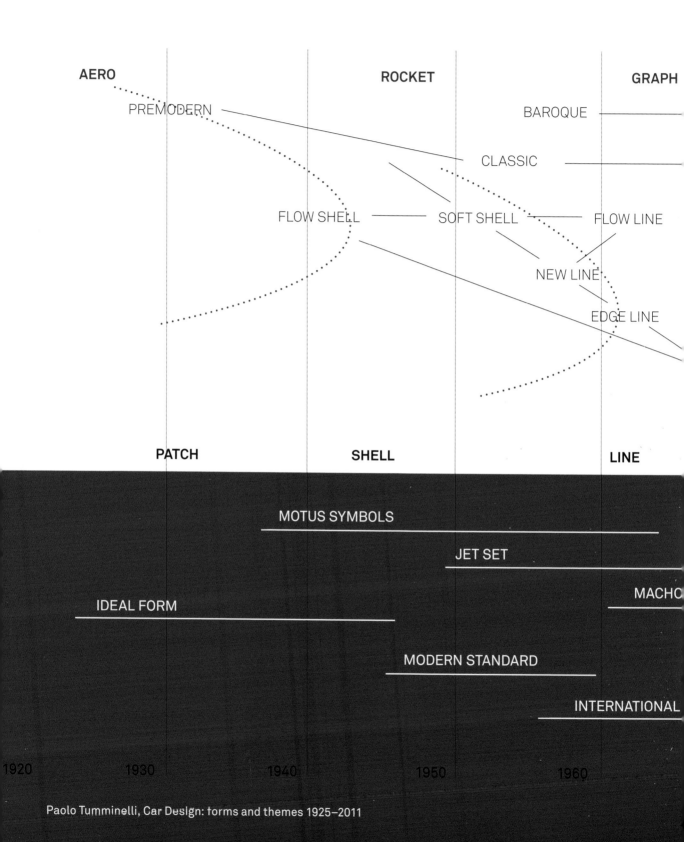

AERO ROCKET GRAPH

PREMODERN
 BAROQUE

 CLASSIC

FLOW SHELL ——— SOFT SHELL ———— FLOW LINE

 NEW LINE

 EDGE LINE

PATCH SHELL LINE

MOTUS SYMBOLS

 JET SET

 MACHO

IDEAL FORM

 MODERN STANDARD

 INTERNATIONAL

1920 1930 1940 1950 1960

Paolo Tumminelli, Car Design: forms and themes 1925–2011

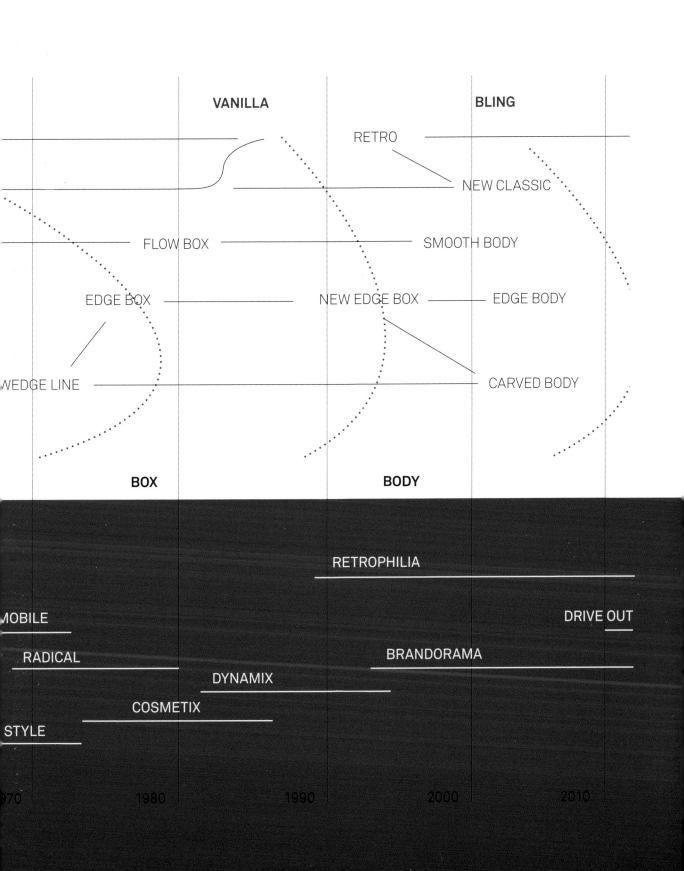

VANILLA

BLING

RETRO

NEW CLASSIC

FLOW BOX ─────────────── SMOOTH BODY

EDGE BOX ────── NEW EDGE BOX ────── EDGE BODY

WEDGE LINE ──────────────── CARVED BODY

BOX

BODY

RETROPHILIA

MOBILE

DRIVE OUT

RADICAL

BRANDORAMA

DYNAMIX

COSMETIX

STYLE

970 1980 1990 2000 2010

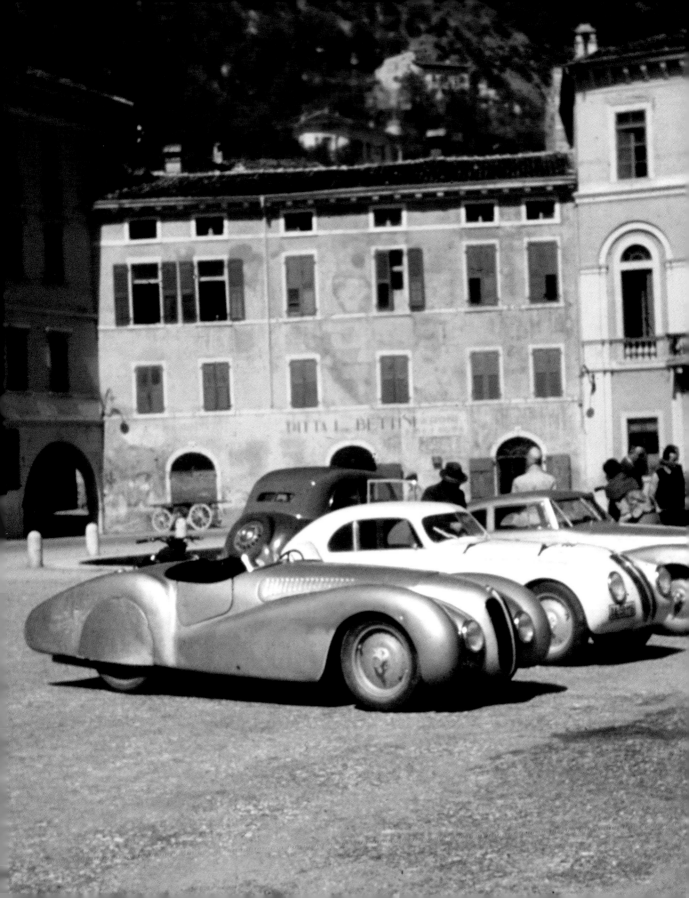

IDEAL FORM

In sharp contrast to *fin de siècle* historicism, which had been made popular through industrial reproduction, the avant-garde developed an entirely original style. Incorporating the arts into the machine by means of craft resulted in an interplay of architecture, design and fashion: a self-contained, animated synthesis of art forms. In 1925, a peak was reached at the Paris Salon des Arts décoratifs: art deco was colourful, extravagant, creative, sophisticated and exotic. Modern and very elitist, these aesthetics complemented the automobile perfectly. But this combination did not work as intended, as art deco was mainly used just as brute ornamentation. The ensuing modernity was an era defined by engineers and capitalists devoting themselves to the principle of

Als Kontrast zum altbackenen Historismus entwickelt die Avant-garde einen gänzlich neuen Stil. Das Zusammenspiel von Architektur, Design und Mode ergibt ein lebendiges Gesamtkunstwerk, dessen Höhepunkt der Pariser Salon des Arts décoratifs im Jahre 1925 ist. Der Art déco ist bunt, extravagant, kreativ, raffiniert, exotisch. Modern und daher elitär. Seine Ästhetik scheint für das Automobil wie geschaffen zu sein. Doch die Verwendung des Art déco geht kaum über bloße Dekoration hinaus. Die Moderne ist dann die Epoche der Ingenieure und Kapitalisten, die sich ganz dem Prinzip „Ergebnis durch Leistung" verschrieben haben. Dank der Erfahrung mit dem Design von Schiffen und Flugzeugen begreifen sie, dass das Automobil nicht wie eine bessere

En rupture totale avec le style classique suranné et désormais accessible à un plus grand nombre grâce aux procédés de fabrication industriels, l'avant-garde développe un style entièrement nouveau. Surgi des interactions entre l'architecture, le design et la mode, il s'agit d'un art à part entière et vivant dont la consécration est célébrée en 1925 au Salon des Arts décoratifs de Paris. Mélange d'influences, l'art déco est à la fois excentrique, créatif, raffiné et exotique. Élitaire car à la pointe de la modernité, il est doté d'une esthétique qui semble faite pour l'automobile, dont il se tient pourtant à distance, restant confiné au monde de la décoration. Les temps modernes sont alors dominés par des ingénieurs et des capitalistes, adeptes du principe de « résultat par la performance ».

Lago di Garda, 1940

Streamlined BMWs on their way to a victorious Mille Miglia.

Stromlinien-BMWs auf dem siegreichen Weg zur Mille Miglia.

Les BMW aérodynamiques en route vers la victoire aux Mille Miglia.

performance through effort. Thanks to their experience designing ships and aircraft, they realised that the automobile did not need to look like a horse-drawn carriage. At the same time, they disapproved of art deco's superficial excess, simply because it was too costly. What they wanted was to provide the automobile with an ideal, easily manufacturable form.

THE IDEAL FORM

The original draughtsmen looked upon the automobile as yet another technical construction challenge. They built a rolling chassis, whose coachwork was constructed separately. Anything exceeding four wings, three side panels, two headlights and a windscreen was a rare occurrence, indeed. Most cars up to the 1920s featured simple, open bodywork like the Torpedo. The bonnet was merged with the side panels, the side line raised and the whole body subtly rounded off. The Torpedo looked

Kutsche auszusehen hat. Gleichzeitig lehnen sie die oberflächlichen Exzesse des Art déco ab. Sie suchen für das Automobil eine ideale, einfach zu produzierende Form.

DIE IDEALE FORM

Die Konstrukteure der ersten Stunde betrachten das Automobil lediglich als technisches Konstrukt. Sie bauen rollende Chassis, für die der Kunde selbst eine Karosserie – ganz nach seinem Geschmack und seinen Bedürfnissen – fertigen lassen muss. Mehr als vier Kotflügeln, drei Seitenbleche, zwei Scheinwerfer und eine Windschutzscheibe kommt meist nicht in Frage. Bis in die 1920er Jahre tragen die meisten Autos eine simple, offene Karosserie. Sie sind Sportgerät und Spielzeug. So wie der Torpedo, dessen Idee aus der Marine kommt – zu Beginn des zwanzigsten Jahrhunderts Auslöser eines regelrechten Modetrends. Die Motorhaube wird mit den Seitenblechen zusam-

Les ingénieurs réalisent qu'une automobile peut être bien plus qu'une simple calèche améliorée. Avant-gardistes certes, ils rejettent cependant les excentricités frivoles des arts déco en raison de leurs coûts excessifs. Bref, ils recherchent la forme idéale et simple à produire.

LA FORME IDÉALE

Les constructeurs de la première heure considèrent la voiture comme un simple produit technique. On entend alors généralement par carrosserie, quatre ailes, trois panneaux latéraux, deux phares et un pare-brise. Jusque dans les années 20, la plupart des voitures, n'ont d'ailleurs qu'une carrosserie ouverte, et ce pour des raisons financières essentiellement. Ainsi en va-t-il du modèle Torpedo, issu du monde de la marine et qui est à l'origine d'un véritable engouement au début du 20ème siècle. Le capot est assemblé aux panneaux latéraux, les lignes transversales rehaussées et le tout est légère-

Citroën B2 Caddy, 1922

Rumpler Tropfenwagen, 1921

like an upended bath tub and suggested the speed of a rocket. The main influence on design was the Zeppelin airship's teardrop shape, which was suited for flying, but not for driving. On this basis, the engineer Paul Jaray developed an 'ideal streamlined body close to the ground' and, in 1925, filed a patent for an ideal streamlined shape. Castagna and Rumpler had already looked into this idea, but Jaray's execution was decisively more advanced. His flat teardrop enclosed the entire chassis, thus creating an integrated structure. The result was an example of pure design. Jaray's concept was in keeping with the times, as its shape was not just essential for faster driving, but was also very effective advertising in and of itself and at the same time simple enough to advance the industrial production of a standardised automobile. Jaray's automotive design concept set an example for others to follow. From airship via locomotive to automobile: indeed, the aerodynamic

mengefügt, die Seitenlinie erhöht und alles sanft abgerundet. Der Torpedo sieht wie eine Badewanne aus, suggeriert aber die Schnelligkeit einer Rakete. Die entscheidende Design-Inspiration stellt das Luftschiff mit seiner Tropfenform dar. Der Zeppelin-Ingenieur Paul Jaray entwickelt einen „idealen Stromlinienkörper in Bodennähe" und patentiert 1925 die Form des modernen Automobils. Mit der Idee hatten sich zwar bereits Pioniere wie Castagna und Rumpler auseinandergesetzt, doch die Umsetzung Jarays ist entscheidend besser. Sein plattgedrückter Tropfen integriert das gesamte Fahrwerk in einer ganzheitlichen Konstruktion; das daraus resultierende Design ist Konstruktion, nicht Dekoration. Jarays Konzept kommt zur rechten Zeit, denn die Stromlinie ist nicht nur essentiell um schneller fahren zu können, sondern auch äußerst werbewirksam. Gleichzeitig ist sie schlicht genug, um die industrielle Produktion eines standardisierten Automobils vo-

ment arrondi. Le Torpedo ressemble à une baignoire et suggère déjà la vitesse de la fusée. Il reprend la forme ovoïde de l'aéronef Zeppelin, dont il s'est largement inspiré pour le design. Mais cette forme « goutte d'eau », si elle convient parfaitement aux véhicules aériens, n'est pas adaptée à la route. L'ingénieur Paul Jaray en reprend l'idée pour concevoir « un corps aérodynamique proche du sol » ; en 1925, il fait breveter cette forme aérodynamique, que toutes les voitures modernes adopteront. Avant lui, les concepteurs Castagna et Rumpler en avaient également eu l'idée mais sans jamais réussir à l'égaler sur le plan pratique. En forme de goutte d'eau aplatie, la carrosserie englobe désormais le châssis avec lequel elle forme un tout ; le design qui en résulte relève de la prouesse technique et non du simple élément de décoration. La forme aérodynamique arrive à un moment opportun ; elle permet d'augmenter la vitesse des véhicules, possède un large impact

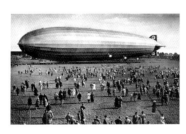

Zeppelin LZ 127 *Graf Zeppelin*, 1928

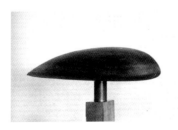

Paul Jaray, *ideal streamlined body close to the ground,* 1920

pushchair seemed only a step away, as the whole world lusted after the new streamlining.

THE PEOPLE'S CAR

The wave of modernisation forced social change. Europe became acquainted with the Ford phenomenon. But gigantic investments were necessary in order to duplicate Ford's example, and with markets too small to warrant such expenditure, nobody dared to even try. It would take the political will of two dictators to create the framework required for the mass mobilisation project: Mussolini and Hitler knew how to bask in the glow of the automobile and present themselves as its ambassadors through the media, and a hopeful public welcomed the fascists' confident, progressive image. Their leaders demanded a 'people's car' project from their respective industries. In 1936, Fiat presents the minimalist 500, lovingly referred to as 'little mouse': small, yet featuring a

ranzutreiben. Jarays Automobildesignkonzept wird zum Vorbild. Vom Flugschiff über die Lokomotive bis zum Automobil; von dort ist es zum aerodynamischen Kinderwagen nur noch ein kleiner Schritt. Um 1930 ergötzt sich die Welt an der Stromlinie.

DAS VOLKSAUTO

Die Modernisierungswelle treibt soziale Veränderungen an. In Europa lernt man das Phänomen Ford kennen. Doch um Fords Beispiel zu kopieren sind gewaltige Investitionen notwendig, wofür die Märkte zu klein sind, weshalb sich niemand daran wagt. Die „Führer" verlangen von der Industrie ein Volksmobil-Projekt. Ein hoffnungsvolles Volk begrüßt das progressiv-souveräne Bild der Faschisten. Im Dienste des „Automobils für jedermann" werden Straßen und Autobahnen gebaut, alte Städte entkernt und modernisiert: ein Jahrhundertprojekt. 1936 präsentiert Fiat seinen Volks-Wagen: den minimalisti-

publicitaire et reste suffisamment simple pour booster la production en série. Le concept mis au point par Jaray s'établit très vite comme une référence. Tout devient aérodynamique, des bateaux aux voitures en passant par les locomotives et en allant jusqu'aux poussettes.

LA VOITURE DU PEUPLE

En déferlant sur la société, la modernité entraîne de nombreuses mutations. L'Europe découvre le phénomène Ford qu'elle voudrait imiter ; mais, cela nécessite de lourds investissements auxquels personne ne se risque vu l'étroitesse des marchés locaux. Le peuple, gorgé d'espoirs et d'attentes, salue l'arrivée des fascistes à l'allure à la fois progressiste et toute puissante. Les dictateurs, allemand et italien, exigent de leur industrie respective de leur livrer un projet de mobilité populaire. Pour servir l'idée d'une « voiture pour tous », on construit alors des routes et des autoroutes, on dé-

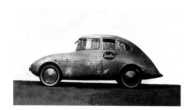

Audi Typ K, 1923

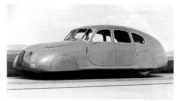

BMW K1, 1939

BMW K1, 1939

fashionably streamlined nose. It would take two more years before Germany got its long-awaited *Kraft-durch-Freude-Wagen* ('Strength through joy car'), as ordered by Hitler. It was a contemporary design, but one whose Jaray-inspired shape was augmented with frivolous art deco elements. But, just as the construction of the giant *Volkswagenwerk* (Volkswagen factory) was about to commence, the Second World War broke out. Once it had come to an end, the markets were demanding a cheap automobile, but one that was, this time, stripped of any political ideology. Thus, Citroën further developed their *toute petite voiture* ('really small car'). Morris brought the 1948 Minor MM to the market. 'Dolly', 'Little Mouse', 'Beetle', 'Mosquito': the urge to bestow anthropomorphising nicknames upon the people's cars attested to their recognition as members of the collective. The automobile was no longer a technical appliance, but a design object.

schen 500, liebevoll „Mäuschen" getauft. Klein, aber mit modischer Stromliniennase. Zwei Jahre später bekommt Deutschland den von Hitler georderten, lang ersehnten Kraft-durch-Freude-Wagen. Ein Design auf der Höhe der Zeit: Jaray-Form mit frivolen Art-déco-Elementen. Mit dem Bau des großen Volkswagenwerks beginnt der Weltkrieg. Nach dessen Ende ist ein günstiges Automobil genau das, wonach der Markt verlangt – nur dieses Mal befreit von politischer Ideologie. Citroën entwickelt seine Tout-Petite-Voiture weiter, daraus wird der 2CV. Morris bringt den Minor MM auf den Markt. Ente, Mäuschen, Käfer, Moskito: Das Bedürfnis, den Volksautos einen vermenschlichenden Spitznamen zu geben, bezeugt ihre Anerkennung als Mitglieder der Kollektivität. Das Automobil ist kein technisches Erzeugnis mehr, sondern Designobjekt.

truit ou modernise les vieux quartiers des villes : le projet du siècle est lancé. En 1936, Fiat présente sa « voiture du peuple », la 500, baptisée la « souris » par les Italiens, une voiture à la conception minimaliste et dotée d'une partie avant moderne aux lignes aérodynamiques. Hitler doit encore patienter deux ans avant d'offrir à l'Allemagne la voiture qu'il a commandée à ses ingénieurs, la fameuse « Kraft durch Freude » (Force par la joie). Au déclenchement de la guerre, l'Allemagne commence à cons-truire des usines Volkswagen. Citroën perfectionne la Toute Petite Voiture. Morris lance la Minor MM. « Pot de yaourt », « Souris », « Coccinelle », « Deudeuche », autant de sobriquets qui dénotent une volonté de considérer la voiture comme faisant partie intégrante de la vie. D'abord pur produit technique, la voiture a évolué pour devenir un objet qui retient toute l'attention des designers.

Fiat 500 B *Topolino* Giardinera, 1949

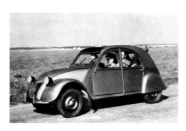

Citroën 2CV, 1949

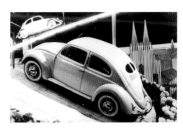

Volkswagen Typ 11 Export *Brezelkäfer*, 1951

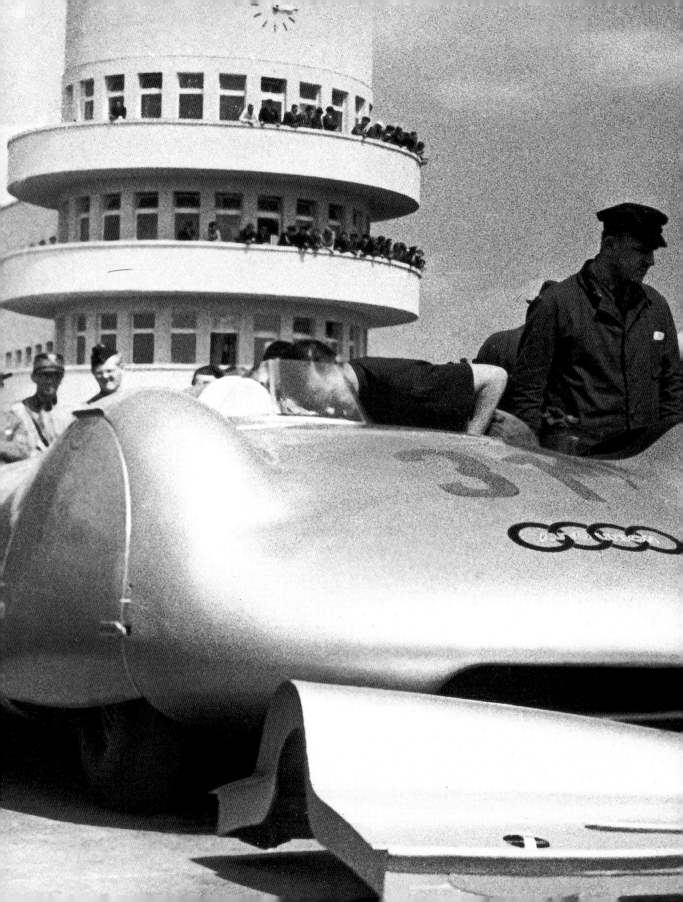

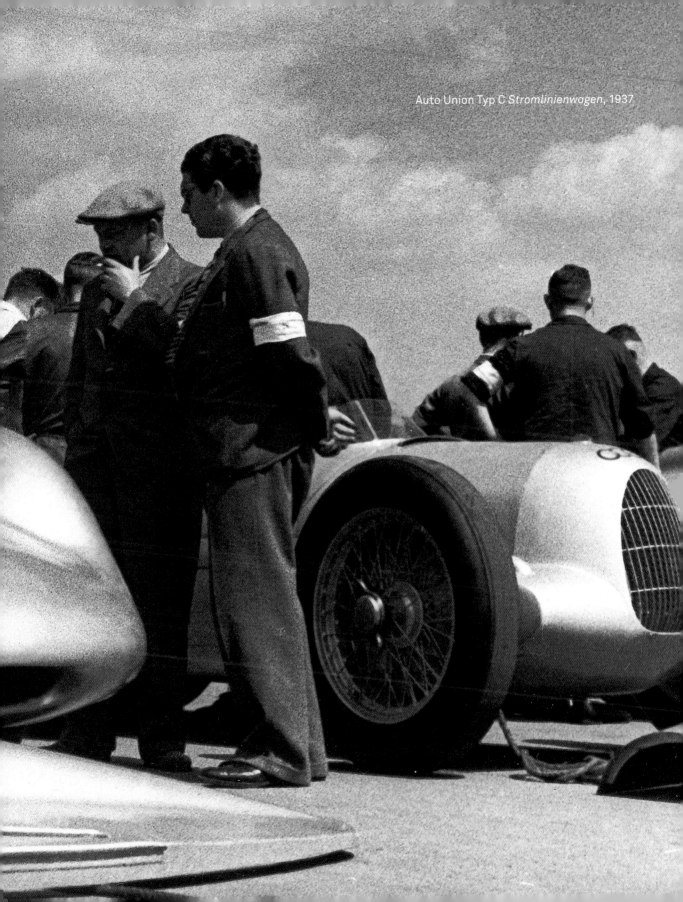
Auto Union Typ C *Stromlinienwagen*, 1937

AUTOBAHN

The first public motorway, connecting Milan and lake Maggiore, was built in 1924. Mussolini loved driving fast, one of the reasons why he left behind about 2,500 miles of Autostrada. The Avus in Berlin was considered the archetypal modern motorway. The racetrack was open for public use as a dual carriageway during the week. Hitler was intent on further accelerating the *Reichsautobahnen* project, thus enabling everybody to experience the pleasures of motoring firsthand. For this purpose, a new type of automobile was created: the *Autobahnkurier*.

Zwischen Mailand und dem Lago Maggiore entsteht 1924 die erste öffentliche Schnellstraße. Mussolini liebt schnelle Autofahrten; auch deshalb hinterlässt er Italien gut 4000 Autostraßenkilometer. Als Prototyp der modernen Autobahn gilt die Berliner Avus. Die Rennstrecke wird unter der Woche doppelspurig dem Privatverkehr freigegeben. Hitler will das Projekt Reichsautobahnen weiter beschleunigen und den Mythos Geschwindigkeit für Jedermann erfahrbar machen. Dafür wird ein neuer Automobiltypus erfunden: der Autobahnkurier.

La première voie expresse publique construite en 1924 rattache Milan au lac Majeur. L'Italie de Mussolini qui raffole de voyages rapides en automobile construit près de 4000 km de routes. L'autoroute moderne, dont le prototype est l'AVUS, voit le jour à Berlin. Ce circuit automobile se transforme les jours de semaine en piste à deux voies, ouverte à la circulation. Hitler accélère le processus de réalisation du projet d'autoroutes mis en place pendant le troisième Reich. Il veut, en effet, permettre à tous de vivre le mythe de la vitesse. Dans cette optique également, un

The regime uses speed records as an instrument of propaganda. On January 28th 1938, Rudolf Caracciola, piloting a Mercedes-Benz W125, reaches a top speed of 268.9 mph. Next up is Bernd Rosemeyer, at the wheel of an Auto Union Typ R. He gets caught by a gust of wind and careens off to his death, his speed exceeding 250 mph. The people remain intoxicated by heroic deeds: even Porsche's *Berlin-Rom* car, with its tiny Beetle engine, manages a top speed of 120 mph.

Autobahn-Geschwindigkeitsrekorde werden zum Propaganda-Instrument für das Regime. Am 28. Januar 1938 fährt Rudolf Caracciola auf Mercedes-Benz W125 432,7 km/h schnell. Ihm folgt Bernd Rosemeyer auf Auto Union Typ R. Von einer Windböe erfasst, fliegt er mit über 400 km/h in den Tod. Das Volk berauscht sich weiter an Heldentaten: Porsches Berlin-Rom-Fahrzeug mit winzigem Käfer-Motor soll gut für Tempo 190 sein.

nouveau type de voiture, l'Autobahnkurier, est développé. Les records de vitesse sur route deviennent l'instrument de propagande privilégié du régime. Le 28 janvier 1938, Rudolf Caracciola atteint sur une Mercedes-Benz W125 la marque de 432,7 km/h. Il sera suivi de Bernd Rosemeyer sur une Auto Union Typ R qui trouvera la mort, à plus de 400 km/h, emporté par une bourrasque. Le peuple s'enivre d'actes héroïques ; la Porsche Berlin-Rom équipée d'un petit moteur de coccinelle atteint 190 km/h.

Mercedes-Benz 540K *Autobahn-Kurierwagen*, 1936

JARAY VS. KAMM

The automobile à la Paul Jaray was a rolling airship. In 1922, its aerodynamic shape seemed exotic and therefore ideal for competition purposes. Jaray's perfect design was not only faster and more efficient: the cabin's ventilation and acoustic comfort was also superior. Active safety measures ranged from high stability to optimal safety for pedestrians. All components interacted harmoniously with each other: it was the birth of modern automotive design, but this was only really understood a dozen years later. Audi, Fiat, Maybach and Mercedes-Benz experimented with it, Adler, Chrysler and Volkswagen imitated it, but only Tatra had the

Das Automobil à la Paul Jaray ist ein rollendes Luftschiff. Dessen aerodynamische Form wirkt 1922 exotisch und somit für Wettbewerbszwecke ideal. Die perfekte Jaray-Konstruktion ist nicht nur schneller und verbrauchsgünstiger; auch Belüftung des Innenraums und akustischer Komfort sind überlegen. Die aktive Sicherheit reicht von hoher Stabilität bis zu optimalem Fußgängerschutz. Alles greift ineinander über – es ist die Geburt des modernen Automobildesigns. Doch das wird erst ein Dutzend Jahre später begriffen. Audi, Fiat, Maybach, Mercedes-Benz experimentieren damit, Adler, Chrysler und Volkswagen imitieren sie, nur

La voiture selon la vision de Paul Jaray est un aéronef sur roues. Très exotiques en 1922, ses formes aérodynamiques la rendent idéale pour la compétition. Plus rapide, elle consomme largement moins et se caractérise par une meilleure circulation de l'air intérieur ainsi qu'un confort acoustique accru. Ces éléments qui s'enchaînent à merveille marquent la naissance du design automobile moderne. Mais cela, on ne le comprendra que douze ans plus tard. Audi, Fiat, Maybach, Mercedes-Benz s'essayent au concept aérodynamique. Adler, Chrysler et Volkswagen les imiteront, mais c'est Tatra qui en 1934 aura le courage d'appliquer le

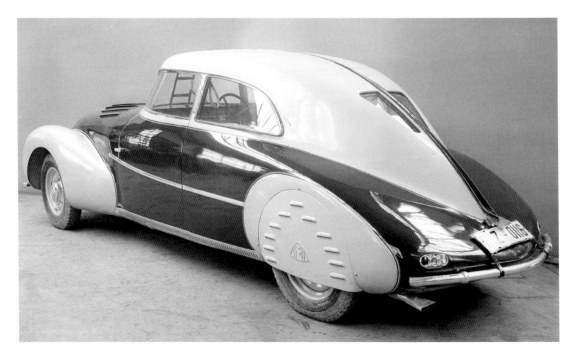

Maybach Typ SW 35, 1935

courage to bring a genuine Jaray body shape to the market in 1934. Simultaneously, Wunibald Kamm and Reinhard Koenig-Fachsenfeld continued with the further development of the Jaray form. Almost by accident, they discovered that by abruptly cutting off the drop they greatly improved its aerodynamics. Prototypes featuring the 'K' rear were more compact, with more spacious interiors. There was only one drawback: they looked rather ungainly. Rediscovered in the sixties, hyped since the seventies and later on completely reinterpreted, the 'K' body shape can be considered to be the template for current automotive design.

Tatra hat 1934 den Mut, eine echte Jaray-Form in Serie zu fertigen. Parallel entwickeln Wunibald Kamm und Reinhard Koenig-Fachsenfeld Jarays Form weiter. Fast per Zufall entdecken sie, dass sich die Aerodynamik verbessert, wenn man dem Tropfen das Heck abrupt abschneidet. Prototypen mit K-Heck sind kompakter, ihr Innenraum geräumiger. Es gibt nur einen Nachteil: sie sehen eher hässlich aus. In den Sechzigern wiederentdeckt, ab den Siebzigern gehypt und später völlig neu interpretiert - die K-Form gilt als Vorlage des gegenwärtigen Automobildesigns.

concept Jaray à une voiture de série. Parallèlement, Wunibald Kamm et Reinhard Koenig-Fachsenfeld poursuivent le travail de Jaray. C'est presque par hasard qu'ils découvrent qu'une poupe tronquée permet une nette amélioration des performances aérodynamiques. Leurs prototypes sont plus compacts et plus spacieux à l'intérieur mais ils sont aussi très laids. La forme tronquée, redécouverte dans les années 60, adulée dans les années 70 et complètement réinterprétée plus tard peut être considérée comme la base du design automobile contemporain.

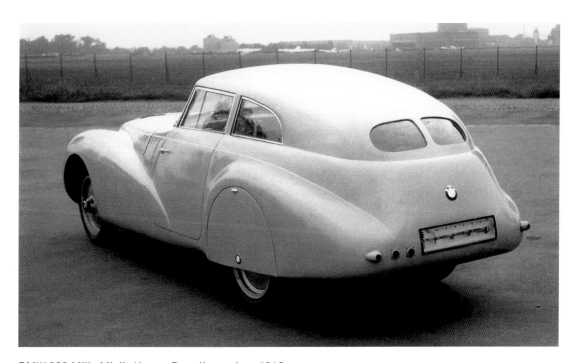

BMW 328 *Mille Miglia* Kamm Rennlimousine, 1940

CITROËN

When André Citroën entered the automotive sector in 1924, he was intent on doing many things differently from the competition. Thus he brought the first car built completely from steel to the market and was the first to implement mass production in Europe. At the same time, Citroën also illuminated the Eiffel Tower with his name and printed the company's logo on road signs (which he donated to the French state) for promotional purposes. The man was, to use the vernacular, a bit of a 'chancer'. In 1934, Citroën was forced to sell his company to Michelin, shortly before the *Traction Avant* with front-wheel drive and monocoque body became a smash hit. Thank-

Als André Citroën 1924 in die Automobilbranche einsteigt, möchte er vieles anders machen als die Konkurrenz. So bringt er das erste Auto in kompletter Stahlbauweise auf den Markt und führt als erster in Europa die Massenproduktion ein. Daneben lässt Citroën noch als Werbemaßnahmen den Eiffelturm mit seinem Namen erleuchten und das Firmenlogo auf Straßenschilder (die er dem französischen Staat spendiert) drucken. Der Mann pokert hoch. Schon 1934 muss Citroën an Michelin verkaufen, kurz bevor der Traction Avant mit Frontantrieb und selbsttragender Karosserie zum Verkaufsschlager wird. Glücklicherweise hat der neue Herr im Hause, Pierre-Jules

Dès ses débuts dans le milieu automobile en 1924, André Citroën cherche à se démarquer de la concurrence. Le premier à commercialiser la voiture à carrosserie tout acier, il est également pionnier de la production de série en Europe. Inventif en marketing, il utilise la Tour Eiffel comme panneau publicitaire et fait imprimer son logo sur des plaques de rue dont il fait cadeaux à l'état. Mais Citroën prend des risques. Trop : en 1934 il se voit contraint de vendre à Michelin, juste avant que la Traction Avant à carrosserie autoporteuse ne remporte un vif succès commercial. Heureusement, Pierre-Jules Boulanger, le nouveau responsable chez Citroën, partage

Citroën, *Internationale Automobil-Ausstellung*, 1960

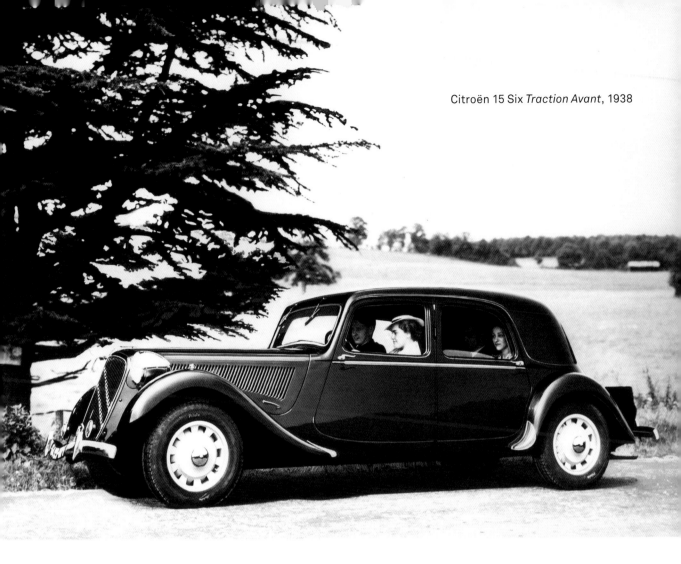

Citroën 15 Six *Traction Avant*, 1938

fully, the new master of the house, Pierre-Jules Boulanger, was entertaining ambitions similar to those of the company founder and kept on advocating the brand's creative spirit, thus enabling Citroën to continue revolutionising automotive design after the Second World War with radical offerings such as the 2CV and the DS. Extravagant, anti-conformist and provocative: Citroën was incorporating the subtle irony of French surrealism in its automobiles.

Boulanger, ähnliche Ambitionen wie der Firmengründer und fördert den kreativen Geist der Marke weiter, weshalb Citroën auch nach dem Zweiten Weltkrieg mit radikalen Konstruktionen wie der 2CV oder der DS den Autobau revolutioniert. Extravagant, antikonformistisch, provokant: Citroën baut Automobile mit der subtilen Ironie des französischen Surrealismus.

les ambitions de son fondateur et développe la marque dans ce même esprit novateur. Après la 2ème guerre mondiale, Citroën produit toujours des modèles d'un radicalisme total, comme la 2CV ou la DS, qui révolutionneront la construction automobile. Imprégnées de cette ironie subtile propre au surréalisme français, les Citroën sont extravagantes, anticonformistes et provocatrices.

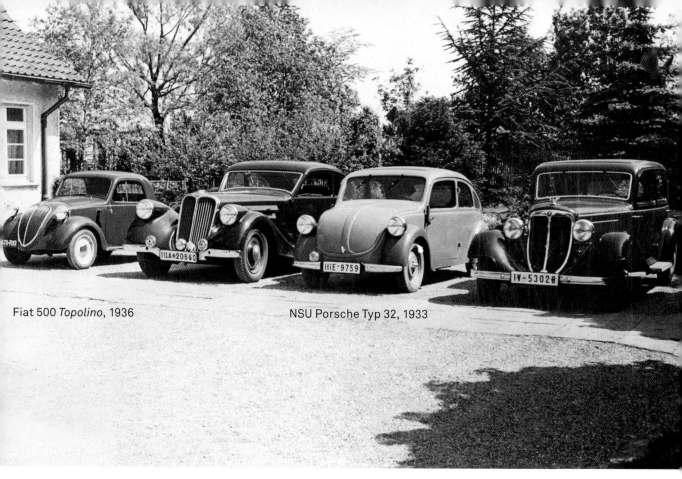

Fiat 500 *Topolino*, 1936

NSU Porsche Typ 32, 1933

Villa Porsche, Stuttgart, 1937

FERDINAND PORSCHE

Born in Bohemia, the engineer is surely associated with one vehicle above any other: the *Kraft-durch-Freude-Wagen* (the 'strength through joy car'), which became a worldwide success under the VW Beetle moniker. Porsche was a gifted designer, who quickly became a thorn in the side of any employer, thus forcing him to work as a freelancer in Stuttgart from 1931 onwards. He directed a team of similarly talented engineers. Thanks to the famous *Exposé concerning the construction of a German people's car* he managed to convince

Der in Böhmen geborene Ingenieur muss vor allem mit einem Fahrzeug in Verbindung gebracht werden: dem Kraft-durch-Freude-Wagen, der als VW Käfer zum Welterfolg wird. Porsche ist ein begabter Konstrukteur, der jedem Arbeitgeber bald unbequem wird, weshalb er sich 1931 in Stuttgart selbstständig macht. Er dirigiert ein Team nicht minder begabter Entwickler, mit denen er die Rennwagen der Auto Union entwickelt. Mit dem *Exposé betreffend den Bau eines deutschen Volkswagens* gelingt es ihm, Adolf Hitler zu begeistern. Als Porsche

La voiture la plus connue de cet ingénieur né en Bohême est la Volkswagen « Kraft durch Freude », surnommée la coccinelle. Elle obtiendra un succès mondial. Porsche, dont le talent est immense, est un employé incommode. C'est tout logiquement, qu'il créera donc en 1931 sa propre firme à Stuttgart rassemblant autour de lui une équipe d'ingénieurs non moins talentueux. À sa tête, il développera, entre autres, les voitures de course d'Auto Union. Son fameux *Exposé sur la construction d'une voiture du peuple allemand* lui vaut l'admiration d'Adolf Hitler. En

Adolf Hitler of the vehicle's merits. When Porsche won the contract to construct his Volkswagen in 1934, he had already tried to promote the concept with Mercedes-Benz, NSU and Zündapp. His new project demanded a high degree of political sensitivity. He contracted the best know-how and personnel from the US, in order to build the *Volkswagenwerk* (Volkswagen factory) to the most modern standards. Development was finished in 1939, but the war was already raging, and coming off the lines in Wolfsburg were military vehicles. Only after his death did regular production resume. His Beetle would outlive him by half a century.

1934 den Zuschlag erhält, den Volkswagen zu realisieren, hat er bereits versucht, sein Konzept bei Mercedes-Benz, NSU und Zündapp unterzubringen. Dieses Vorhaben erfordert nun hohe politische Sensibilität. Für die Umsetzung holt er sich Know-How und Personal aus den USA, um das Volkswagenwerk nach modernsten Standards zu errichten. 1939 ist die Entwicklung abgeschlossen, doch es herrscht Krieg, in Wolfsburg laufen Militärfahrzeuge vom Band. Erst mit Porsches Tod wird die reguläre Produktion wiederaufgenommen. Eine Lebensaufgabe, der Käfer wird ihn um ein halbes Jahrhundert überleben.

1934, après avoir essuyé refus sur refus chez Mercedes-Benz, NSU et Zündapp, son concept remporte enfin l'approbation. Mais pour le mener à bien, il devra faire preuve d'un sens aigu de la politique. En outre, il ira jusqu'aux Etats-Unis pour chercher savoir-faire et personnel à même de construire la voiture d'après les standards les plus modernes du moment. En 1939, le projet est achevé, mais la guerre éclate et ce sont des véhicules militaires qui sortent des unités de production de Wolfsburg. La production civile ne redémarrera qu'après la mort de Porsche. Son chef d'œuvre, la coccinelle, lui survivra pendant près d'un demi-siècle.

Ferdinand Porsche, VW 38
Versuchswagen, 1938

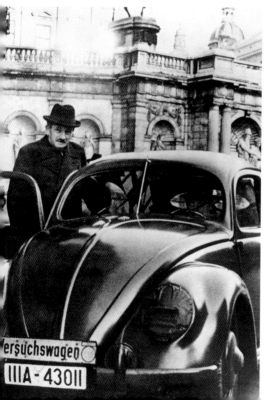

Mercedes-Benz Typ 170 H
Cabrio-Limousine, 1936

Volkswagen Typ 60 K 10
Berlin-Rom-Wagen, 1939

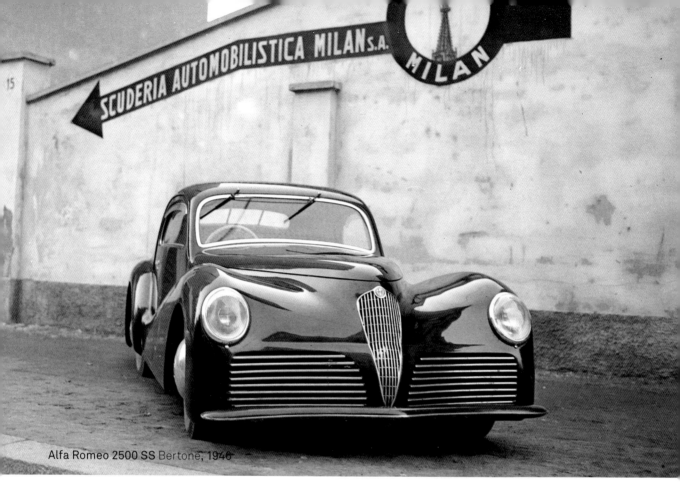

Alfa Romeo 2500 SS Bertone, 1946

MARIO REVELLI DI BEAUMONT

Noblesse oblige. During the twenties, Revelli designed high-class coachwork for luxury cars. He earned the respect of Senator Agnelli and worked at Fiat's Special Car Bodies department. He was chief designer of the 1935 Fiat 1500, which featured a streamline body, while at the same time he conceived of city cars with electric drive and of family vans. His style is flamboyant, subtle and substantial all at once. He embodied the very qualities of Italian design: the art of creating marvels out of nothing, using only limited resources, leading to results like this unique Alfa Romeo.

Adel verpflichtet. In den Zwanzigern entwirft Revelli Karosserien für Luxusautos. Er genießt den Respekt des Senators Agnelli und ist in der Abteilung Sonderkarosserie von Fiat zuhause. Von ihm stammt der Fiat 1500 von 1935 mit Stromlinienform. Gleichzeitig ersinnt er Stadtautos mit Elektroantrieb und Großraumfahrzeuge. Sein Stil ist sehr flamboyant, subtil und fundiert zugleich. Er begründet die Qualität italienischen Designs: Aus dem Nichts, anhand weniger Mittel, entstehen Wunderwerke – so wie dieser einmalige Alfa Romeo.

Noblesse oblige. Dans les années 20, Revelli dessine des carrosseries de voiture de luxe. Il bénéficie de la haute estime du sénateur Agnelli et il se sent très à son aise dans le département « carrosseries spéciales » de Fiat. On lui doit la Fiat 1500 de 1935 à la forme aérodynamique. Visionnaire, il imagine déjà des citadines à moteur électrique et des monospaces. Son style est flamboyant, subtile et érudit. Il contribuera largement à établir le design italien, un design de qualité capable de produire, à partir de rien et avec peu de moyens, des chefs-d'œuvre du type de cette unique Alfa Romeo.

TATRA

Quieter than Citroën, but hardly any less creative was the Czechoslovakian manufacturer Tatra, whose chief engineer Hans Ledwinka was a stern advocate of air-cooled boxer engines and streamlined, aerodynamic bodies. Paul Jaray himself was his mentor during development. The executive class 77 and 87 saloons consequently made a real impression with their advanced technology. These were Europe's most modern cars of the mid-1930s and created a tantalising promise of the dream of speed.

Stiller als Citroën, aber kaum weniger kreativ gibt sich der tschechoslowakische Hersteller Tatra, dessen Chefentwickler Hans Ledwinka konsequent auf luftgekühlte Boxermotoren und stromlinienförmige Karosserien setzt. Paul Jaray persönlich hilft ihm bei der Entwicklung. Entsprechend fortschrittlich wirken die Tatra-Oberklasselimousinen 77 und 87. Mitte der 1930er sind sie die modernsten Autos Europas und verleihen dem Traum von Geschwindigkeit eine atemberaubende Form.

Non moins créatif, le constructeur tchécoslovaque Tatra se fait plus discret que Citroën. Son designer en chef, Hans Ledwinka, mise sur le moteur boxer à refroidissement à air et sur les carrosseries aérodynamiques. Paul Jaray, en personne, lui apporte son soutien. De leur coopération résultent les Tatra 77 et 87, des limousines de luxe décidément progressistes, les plus modernes du milieu des années 30. Voici le rêve devenu réalité, la vitesse qui prend corps dans une forme époustouflante.

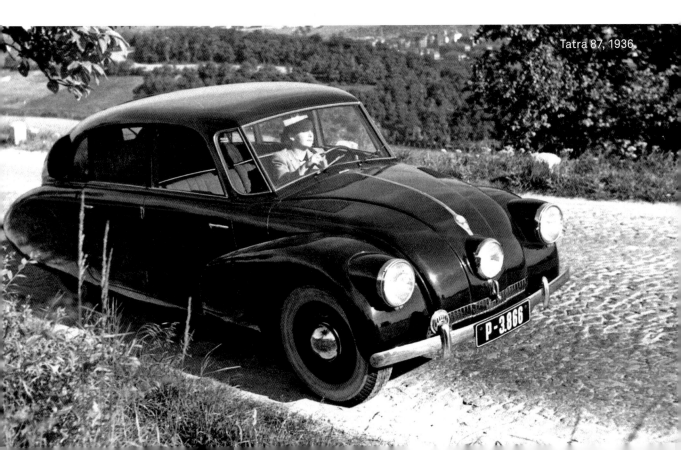

Tatra 87, 1936

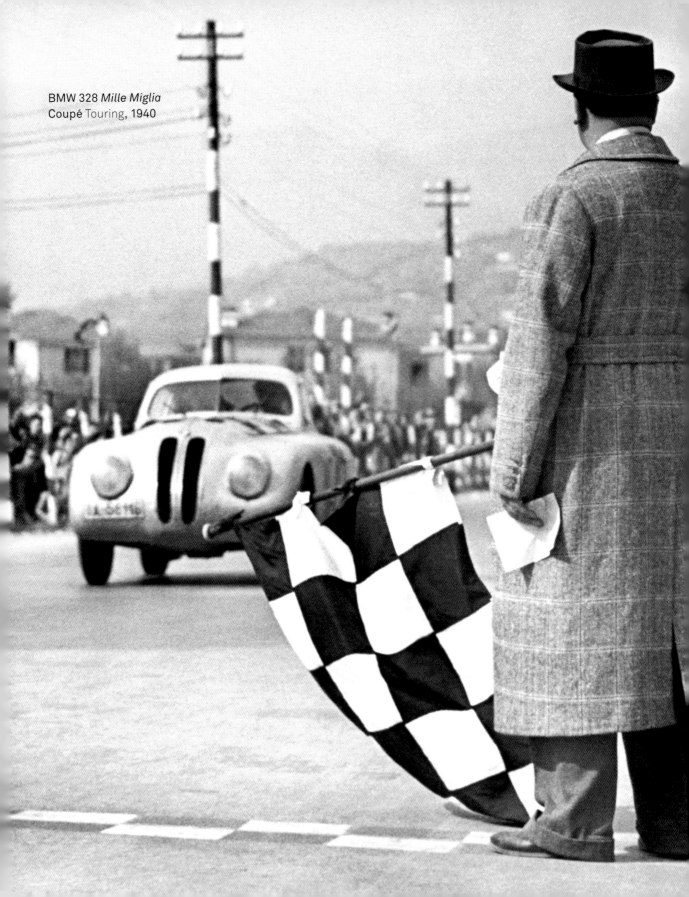

BMW 328 *Mille Miglia*
Coupé Touring, 1940

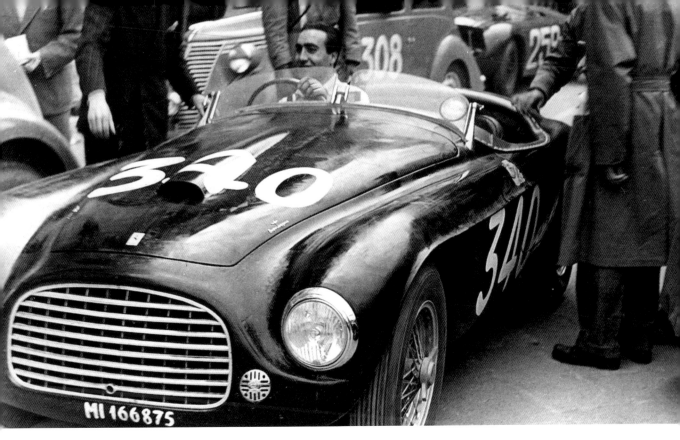

Ferrari 166 MM *Barchetta* Touring, 1948

TOURING SUPERLEGGERA

The Touring Superleggera system allowed the fabrication of feather-light bodies, whose aluminium skin afforded the designer great creative freedom. In 1940, BMW challenged the Milanese: Touring was asked to build a 328 for the Mille Miglia. Touring's entry, the Berlinetta, with its simple profile, called *ala spessa* ('fat wing'), ended up the overall winner. Despite their sporting focus, Touring's race cars posses a poetic quality, like, for example, the Ferrari Barchetta and the Alfa Romeo Disco Volante. More opulent, but no less sophisticated, were the high-end road cars, which were often dressed in Superleggera clothing until 1966.

Mit dem System Touring-Super-leggera lassen sich superleichte Karosserien realisieren, deren Aluminiumhaut dem Designer große Freiheiten erlaubt. 1940 fordert BMW die Mailänder heraus: Touring soll einen 328 für die Mille Miglia bauen. Die Berlinetta mit dem schlichten Profil, von Touring „Ala Spessa" – dicker Flügel – genannt, wird Gesamtsieger. Trotz sportlicher Ausrichtung sind Tourings Rennwagen poetische Kreaturen, wie etwa die Barchetta für Ferrari und der Disco Volante für Alfa Romeo. Opulenter, aber nicht minder raffiniert sind die feinsten Straßenautomobile, die gerne bis 1966 ein Superleggera-Kleid tragen.

La technique Touring dite « Superleggera » permet la construction de carrosseries superlégères dont la surface en aluminium offre une grande liberté au designer. En 1940, BMW commande à Touring une 328 destinée aux Mille Miglia. Touring relève le défi. La berlinette à l'élégante simplicité, nommée « ala spessa » (grande aile) par Touring, remportera la course. Sportives, les voitures de course Touring sont aussi empreintes de poésie. La Barchetta construite pour Ferrari ou la Disco Volante pour Alfa Romeo en livrent de beaux exemples. Touring créera également de très belles routières à l'opulence raffinée, habillée pour la plupart jusqu'en 1966 de la robe superlégère.

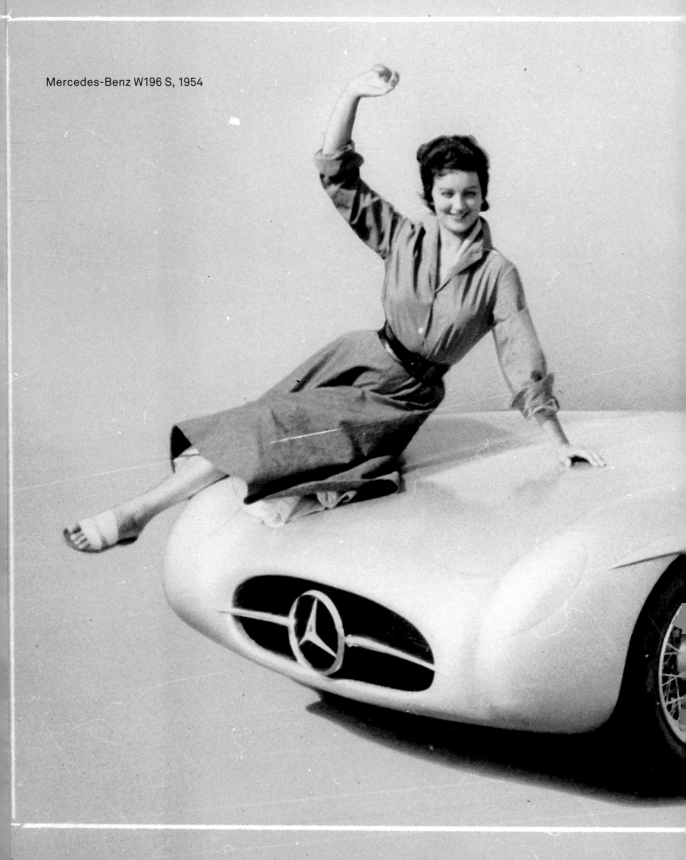

Mercedes-Benz W196 S, 1954

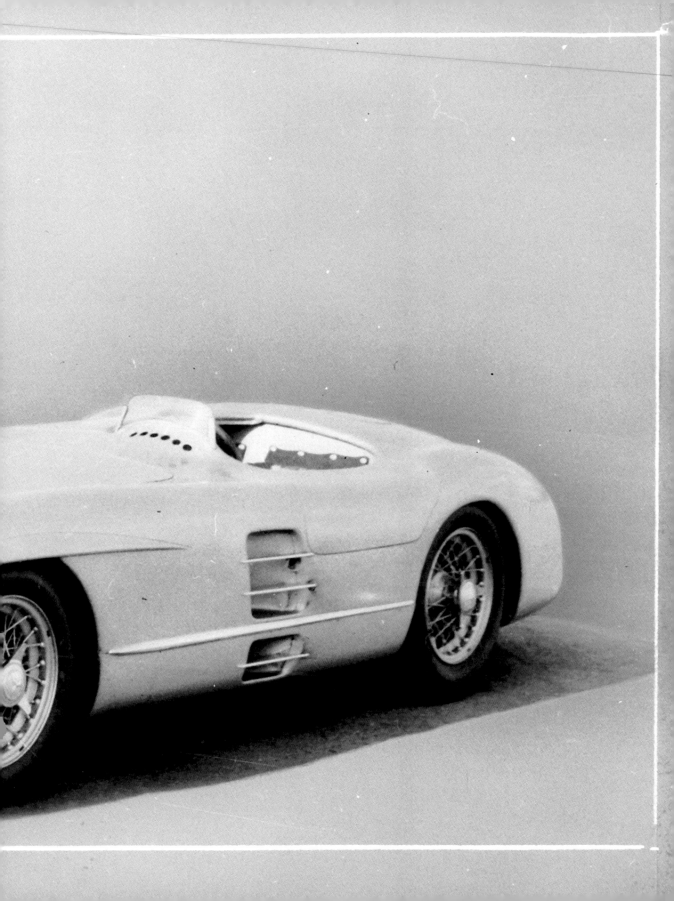

MODERN STANDARD

After the war, Europe was wanting for almost anything, except for the desire to create something new. This desire brought about societal change. Italy and Germany were re-established along a republican model. People were granted more rights. The newly responsible citizens were now working less and were allowed to own and consume more. The automobile played an important part in this new lifestyle: as an outward expression of the family's dignity, it was supposed to demonstrate success. Meanwhile, the industry put the know-how it had gained during the war to good use, establishing quick and cheap production. The European manufacturers quickly recognised the advantages of unibody designs for mass production. This meant that the body shape of the cars for the middle classes needed to be stand-

Nach dem Krieg fehlt es in Europa an allem – außer der Lust, Neues zu schaffen. Italien und Deutschland erfinden sich als Republiken neu. Überall werden dem Volk mehr Rechte zuerkannt. Mündige Bürger müssen weniger arbeiten, dürfen mehr besitzen, können endlich konsumieren. In diesem neuen Lebensentwurf spielt das Automobil eine wichtige Rolle: als Banner der Familienwürde demonstriert es, dass man es zu etwas gebracht hat. Die Industrie setzt ihr während des Krieges erlerntes Wissen ein, um schnell und günstig zu produzieren. Die europäischen Hersteller erkennen die Vorteile der selbsttragenden Karosserie für die Massenproduktion. Die Form des bürgerlichen Automobils muss standardisiert werden. Doch zuvor gilt es, diese Form erst neu zu erfinden.

Après la guerre, les populations manquent de tout, sauf de l'envie de bâtir un monde nouveau. On assiste alors à une transformation de la société. L'Italie et l'Allemagne deviennent des républiques. Partout les sociétés se démocratisent et accordent plus de droits à leurs populations. Emancipés, les citoyens travaillent moins, possèdent davantage et consomment plus. La voiture joue un rôle important dans ce nouveau mode de vie. Porte-étendard de l'honneur familial, elle sert à démontrer sa réussite aux autres. Pendant ce temps, l'industrie met à profit tout le savoir acquis pendant la guerre pour produire plus vite et à moindre coût. Les européens comprennent avant les américains l'intérêt de la carrosserie autoportante pour la production de masse. La nécessité de standardiser la forme de la voiture bourgeoise s'impose

Mercedes-Benz 180 *Ponton*, 1953

Freehold apartments and saloon cars were every family's dream.

Eigentumswohnung und Limousine sind der Traum einer jeden Familie.

Accéder à la propriété et posséder une voiture représentent le rêve de toute famille.

ardised. But before that could happen, the very shape itself had to first be invented.

SPORTS EFFICIENCY

Traditionally, the history of modern automotive design began with the Cisitalia 202. The small sports car was unveiled at the 1946 *concours d'élégance* at Villa d'Este and immediately won the gold medal. In 1951, it joined the MoMA design collection. Pinin Farina used Giovanni Savonuzzi's aerodynamic bodywork for the Cisitalia race car, with its rear defined by characteristic fins, as a starting point. Thanks to a combination of classical lines and new proportions—smooth, flowing, horizontal—the Cisitalia appeared to be one seamless shape. And yet the design's largely undisputed beauty was not the point: its slim form was. As Arthur Drexler, curator of the New York museum's department of architecture, concisely put it: "...the Cisitalia's body is slipped over its chassis like a

SPORTLICHE EFFIZIENZ

Traditionell beginnt die Geschichte des modernen Automobildesigns mit dem Cisitalia 202. Der kleine Sportwagen wird 1946 beim Concours in Villa d'Este präsentiert und gewinnt prompt die Goldmedaille. 1951 wird er in die Designsammlung des MoMA aufgenommen. Pinin Farina dient die Karosserie des aerodynamischen Cisitalia-Rennwagens von Giovanni Savonuzzi – mit dem von markanten Flossen charakterisierten Heck – als Ausgangsbasis. Dank einer Kombination aus klassischen Linien und neuen Proportionen – flach, fließend, horizontal – überzeugt der Cisitalia die Kritiker. Nicht die weitgehend unstrittige Schönheit des Entwurfs ist entscheidend, sondern dessen Schnitt. Arthur Drexler, Architekturkurator des New Yorker Museums, bringt es auf den Punkt: „The Cisitalia's body is slipped over its chassis like a dust jacket over a book". Aus dem Prinzip Knappheit resultiert

progressivement. Quant à la forme, elle reste à définir.

LES SPORTIVES

L'histoire du design automobile moderne commence traditionnellement avec la Cisitalia 202. Présentée en 1946 au Concours de la Villa d'Este, cette petite voiture sportive remporte d'emblée la médaille d'or. En 1951, elle entre dans la collection design du MoMA. Son designer, Pinin Farina, s'est inspirée de la carrosserie aérodynamique de la version course de la Cisitalia à la poupe flanquée d'ailerons caractéristiques conçue par Giovanni Savonuzzi. De par ses lignes basses, fluides et horizontales qui allient tradition et sens moderne des proportions, la Cisitalia donne l'impression d'avoir été réalisée d'une seule pièce. Pourtant ce qui est décisif, ce n'est pas l'incontestable beauté du dessin, c'est sa coupe. Arthur Drexler, commissaire du département architecture du célèbre musée New-yorkais en

Cisitalia 202 Pininfarina, 1946

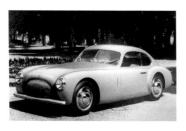

Cisitalia 202 Pininfarina, 1947

dust jacket over a book…" The principle of tautness results in an entirely new design quality. The Cisitalia needed to make up for its humble Fiat engine with compact dimensions and minimised metal components. As chrome was a scarce commodity, ornamentation is limited: the interplay of light and metal had to suffice. Nevertheless, the 202 was an expensive toy in those austere postwar times—when fuel and tyres were still rationed—whose shape ought to inspire: long, imposing and aristocratic. At the same time, it needs to be unreservedly suitable for daily use, so Pinin Farina removed the fins, extended the roof and elongated the side windows rearwards. This creates more visual space, similar to a Berlina. Hence, the Cisitalia becomes a Berlinetta: a small saloon, the prototype of the modern European sports car. Compact, light, comfortable, fast: in other words, sexy. Cisitalia boss Piero Dusio insists on a wide chrome grille with a 'dollar grin' like his

eine neue Designqualität. Wegen der bescheidenen Fiat-Motorisierung muss der Cisitalia mit Kompaktheit und einem möglichst knappen Gewicht punkten. Da Chrom Mangelware ist, spart man an der Dekoration – das Zusammenspiel von Licht und Blech muss ausreichen. Trotzdem ist der 202 in der zertrümmerten Nachkriegszeit – als Benzin und Reifen noch rationiert werden – ein teures Objekt, dessen Form anregen soll: lang, imposant und wertvoll. Gleichzeitig muss er uneingeschränkt alltagstauglich sein. Pinin Farina entfernt die Flossen, verlängert das Dach und dehnt die Seitenfenster nach hinten aus. Kompakt, leicht, schnell, der Cisitalia wird zur Berlinetta: einem Sportwagen mit dem Komfort einer Limousine. Cisitalia-Boss Piero Dusio insistiert auf einem breiten Chromgrill mit dem „Dollar Grin" seines Buick. Pinin Farina gestaltet den Grill breiter und die Motorhaube flacher: Es ist das Gesicht des modernen Automobils. Vom Cisitalia zum Porsche

formule l'essence en ces termes : « La carrosserie de la Cisitalia épouse parfaitement la forme du châssis ». La pénurie élevée au rang de principe fait naître un design d'une qualité entièrement nouvelle. Equipée d'un moteur Fiat peu puissant, la Cisitalia doit séduire par son aspect compact et par une utilisation parcimonieuse de l'acier. Face au manque de matières premières, on limite également les décorations en chrome, en se disant que les effets de lumière sur la carrosserie suffiront amplement. Dans les villes en ruine de l'après-guerre où l'essence et les pneus sont encore rationnés, la 202 fait figure de « joujou » de luxe, dont les lignes élancées, nobles et prestigieuses doivent donner matière à rêver. Soucieux de lui donner un côté pratique, Pinin Farina supprime les ailerons, allonge le toit et étire les vitres latérales vers l'arrière. L'espace en paraît agrandi, comme sur une Berlina. La Cisitalia se mue en Berlinetta, annonciatrice de la voiture de

Buick's. Pinin Farina then designed an even wider and shallower grille, thus inventing the face of the modern automobile. The leap from Cisitalia to Porsche was a small one indeed, since a team of engineers, headed by Ferry Porsche, built a Grand Prix race car on behalf of Piero Dusio. Two years later, the son of the Volkswagen designer created the Porsche 356. Yet art in metal à la Pinin Farina was not Porsche's forte. Hence the straightened flanks and softly integrated wings that cause the body, despite a shorter wheelbase, to protrude over the chassis like a shell. The 356 is bigger, wider and flatter, yet it appears to be smaller and chubbier than the Cisitalia.

This is what made the Porsche unique, since the Cisitalia's lines were being adapted by almost everyone: the Lancia Aurelia B20, Aston Martin DB2, Alfa Romeo Giulietta Sprint and numerous models by Ferrari and Maserati are vivid proof of this. The sporty

ist es ein kleiner Schritt. Dusios Idee, mit Bauteilen aus der Groß-serie einen populären Sportwagen zu bauen, lässt den Sohn des Volkswagen-Erfinders, dessen Team für Cisitalia einen Grand-Prix-Wagen baut, nicht los. Binnen zwei Jahren kommt Porsches Modell 356. Man hofft zunächst, 500 Stück davon zu verkaufen. Der Sportwagen auf Käfer-Basis hat selbstverständlich einen Heck-motor. Erwin Komenda kann vorne noch flacher bauen und auf den Grill verzichten. Blechkunst à la Pinin Farina ist jedoch nicht Porsches Sache. Die Seitenflanken werden geradegezogen und die Kotflügel sanft integriert. Das pummelige Kleid ragt weit über das Fahrwerk hinaus – es sieht wie eine Muschel aus. Gerade das macht den Porsche einmalig.

Die Cisitalia-Linie macht Schule. Ihr folgen Lancia Aurelia B20, Aston Martin DB2, Alfa Romeo Giulietta Sprint, sowie etliche Modelle von Ferrari und Maserati. Die sportliche Berlinetta, mit der

sport moderne. Compacte, légère, confortable et rapide. Quant à la grille de calandre, Piero Dusio, le patron de Cisitalia, la veut large, chromée et avec les mêmes dents que sur sa Buick. Le résultat concocté par Pinin Farina dépasse ses attentes ; la calandre est non seulement plus large mais aussi plus plate. Quelques coups de crayon auront suffi à donner forme à ce qui préfigure déjà la voiture moderne. De la Cisitalia à la Porsche, il n'y a qu'un pas, d'autant plus facile à franchir que l'équipe d'ingénieurs qui entoure Ferry Porsche construit une voiture de grand prix pour Piero Dusio. Reprenant l'idée de Piero Dusio de construire une voiture de sport populaire avec des pièces destinées à la production de masse, le fils de l'inventeur de la Volkswagen, créé la Porsche 356, dont les ventes ne seront d'abord estimées qu'à 500 exemplaires. Voiture de sport à moteur arrière inspirée de la Coccinelle mais proche dans l'esprit d'une Cisitalia, elle s'en distingue sur le plan es-

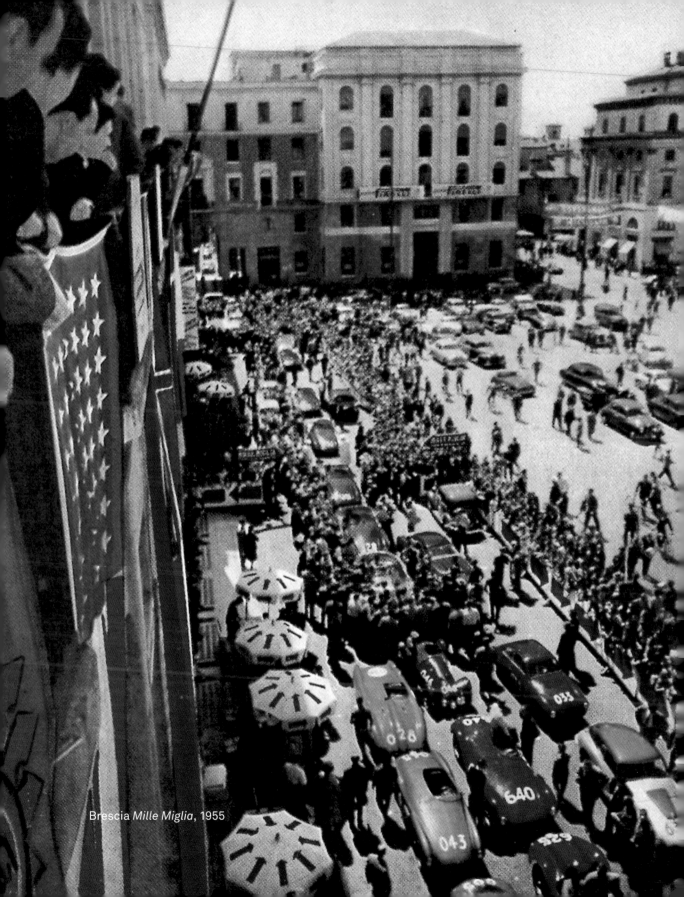

Brescia *Mille Miglia*, 1955

Berlinetta, used by the gentleman driver to commute during the week and race on Saturdays, became the symbol of a lifestyle that was getting closer to reality than dream.

A MODERN SHAPE

At the end of the 1940s, there were more important things to do in Europe besides racing. Cities, factories and infrastructure needed to be rebuilt. People left the countryside, following their hopes for work and elevation to the middle class. This modern family wanted to be 'designed'. A flat with heating and a bathroom with running water would form the basis. Fridge, washing machine, television set and automobile, each were symbols of yet another step having been taken towards the middle class. But the middle class leaves a schizophrenic impression: torn equally between the alien 'American Way of Life' and the familiar glamour of pre-war aristocracy. Both were being ide-

ein Gentleman-Driver unter der Woche ins Büro, am Samstag Rennen und einmal im Jahr die Mille Miglia fährt, wird zum Sinnbild eines Lebensstils, der der Realität näher als dem Traum ist. Modern, effizient, leistungsfähig, sie ist die Mutter der modernen Automobilform.

DIE MODERNE FORM

Ende der 1940er Jahre gibt es in Europa Wichtigeres zu tun als Rennen zu fahren. Städte, Fabriken und Infrastrukturen müssen wiederaufgebaut werden. Die Menschen verlassen das Land und folgen dem Wunsch nach Arbeit und Aufstieg ins Bürgertum. Die moderne Familie will designt werden. Eine Wohnung mit Heizung und ein Badezimmer mit fließend Wasser sind die Basis. Kühlschrank, Fernsehgerät und Automobil sind jeweils Symbole eines vollzogenen Schritts in Richtung Bürgertum. Doch das Bürgertum gibt ein schizophrenes Bild ab: Man ist zwischen dem

thétique avec une proue plus plate – dessinée par Erwin Komenda – et par l'absence de calandre. Porsche, loin de maîtriser l'art de la carrosserie comme un Pinin Farina, étire les flancs latéraux et y intègre les ailes en douceur. Du coup, malgré un empattement beaucoup plus court, la robe déborde largement du châssis, pareille à la coquille d'un mollusque. Pourtant plus grande, plus large et plus plate que la Cisitalia, la 356 paraît nettement plus petite et plus ronde.

C'est ce qui fait que la Porsche est unique et le restera, tandis que les lignes de la Cisitalia s'effaceront avec les modèles qu'elle inspire, comme la Lancia Aurelia B20, l'Aston Martin DB2, l'Alfa Romeo Giulietta Sprint et ceux de Ferrari et de Maserati. La Berlinetta sportive, au volant de laquelle le *gentleman driver* se rend en semaine à son bureau et le samedi sur les circuits, devient le symbole d'un mode de vie qui se veut plus proche des réalités que du rêve.

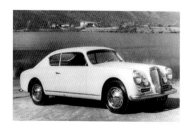

Lancia Aurelia GT B20, 1951

alised and abused. So even though the colourful American kitchenette may have found its way into the flat, the kitchen very much remained the housewife's fiefdom. And the sought-after apartment suite, albeit inevitably located inside a modernist, lift-equipped high rise, had to be kept in faux-classical style.

For decades, this kind of ambivalence was also present in automotive design, simply because the industry needs to offer an equivalent of that very flat for the road. This new kind of automobile needs to be simple to produce, to be as long lasting as possible and should, ideally, find favour with everybody. So the designers decided to do without the exclusive coachbuilders' services and turned instead to an American role model: the 1947 Studebaker Champion. Its designer, Raymond Loewy, had taken a brilliant approach: he understood that, after the war, the American family would wish to undertake

fremden American Way of Life und dem vertrauten Glamour des Vorkriegsadels hin- und hergerissen. Die bunte amerikanische Küchenzeile aus Laminat kommt zwar in die Wohnung, die Küche bleibt aber das verschlossene Reich der Hausfrau. Und auch wenn die ersehnte Eigentumswohnung im modernistischen Hochhaus mit Aufzug gelegen sein muss, soll deren spießige Einrichtung im klassischen Stil-Imitat gehalten sein.

Diese Ambivalenz findet sich jahrzehntelang auch im Automobildesign. Denn die Industrie soll eben ein rollendes Pendant zu jener Eigentumswohnung anbieten: simpel zu bauen sein, möglichst lange halten und möglichst allen gefallen. Die Konstrukteure bedienen sich dafür eines amerikanischen Vorbilds: dem Studebaker Champion von 1947. Dessen Designer, Raymond Loewy, begreift, dass es die amerikanische Familie nach den Kriegsjahren zu gemeinsamen Freizeitak-

LA FORME MODERNE

Dans l'Europe de la fin des années 40, on se préoccupe peu de compétitions automobiles. Il y a alors tellement à faire : reconstruire les villes, les usines, les infrastructures. En quête de travail et d'ascension sociale, les populations quittent les campagnes. La famille moderne change d'image et se fait produit de design. Appartement avec chauffage et salle de bain avec eau courante sont les premiers signes du changement. Puis viennent, dans l'ordre, le réfrigérateur, la machine à laver, le téléviseur et la voiture, des éléments emblématiques qui marquent à chaque acquisition l'amenuisement des distances entre le petit peuple et la bourgeoisie. Pourtant les choses ne sont pas si simples ; la société bourgeoise est partagée entre l'attrait de ce très exotique « American Way of Life » et le côté glamour de la noblesse d'avant guerre. On idéalise les deux courants et on les bafoue en même temps. D'un côté, on adop-

Aston Martin DB2/4, 1953

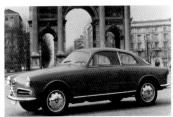

Alfa Romeo Giulietta Sprint, 1954

joint leisure activities. Consequently, the road trip to the National Parks and, later on, to Disneyland, was established. A long journey and a lot of baggage: with these considerations in mind, Loewy decided to stretch the rear as long as the bonnet, in order to provide a generous boot. Thus, the notchback saloon was born. In the beginning, the car, equally stretched in both directions, is the target of much ridicule, and prompts questions such as: "which way is it going?"

But, precisely because of its ambivalent statement, the idea is spot-on: as far as the rear door, the family saloon feels like a noble limousine. Behind it is the separate boot, only accessible from outside the car. The boot is deliberately ignored: after all, travelling inside the same space as the luggage would have been unacceptable to the modern citizen with rural roots. The reason why designers did not originally pay any attention to it is that the boot's

tivitäten drängen würde. So entwickelt sich die Autoreise zu den National Parks, später dann nach Disneyland, zur Institution. Langer Weg, viel Gepäck – das bringt Loewy auf die Idee, das Heck so lang wie die Motorhaube zu dehnen, um darin einen üppigen Kofferraum unterzubringen. So wird die Stufenhecklimousine geboren. Zu Beginn scherzt man noch über den in beide Richtungen gleichermaßen gestreckten Wagen und fragt: „Which way is it going?"

Doch die Idee ist goldrichtig, dank ihrer ambivalenten Botschaft: Bis zur hinteren Tür fühlt sich die Familienlimousine wie eine edle Karosse an. Der abgetrennte, von außen zugängliche Gepäckraum wird geflissentlich ignoriert. Reisen im selben Raum mit dem Gepäck, wie auf der Bauernkutsche, das ist für den modernen Bürger mit ländlichen Wurzeln inakzeptabel. Daher schenken die Designer dem Heck zunächst keine Beachtung: es soll

te la cuisine toute équipée en laminé aux couleurs gaies, de l'autre on continue à la considérer comme le territoire exclusif de la femme. D'un côté, l'appartement que l'on rêve d'acquérir est forcément situé en haut d'une tour avec ascenseur, de l'autre, son ameublement doit imiter le style classique.

Pendant des années, le design automobile sera lui aussi marqué par cette ambivalence. L'industrie n'a d'autre alternative que de proposer une voiture qui fasse pendant à l'appartement acheté. La nouvelle voiture doit donc être simple à fabriquer, pouvoir se garder longtemps et plaire au plus grand nombre. Les constructeurs, bien obligés de se passer des services des maîtres carrossiers, s'inspirent désormais d'un modèle américain, la Studebaker Champion, sortie en 1947. Son concepteur, Raymond Loewy, propose un concept génial né d'une analyse simple. Le mode de vie des familles américaines a évolué.

Studebaker Champion, 1947

45

main aim was to not attract any attention at all. Production-related requirements shaped the cars' aesthetic: as the body supported itself it needed to be solid, with small openings, flat panels and creamy curves. It was the Porsche 'shell design', just translated into a more mundane shape. At the front, sausage-shape wings ended in round headlights, with the bonnet flowing deeply around the engine.

It is difficult to spot any differences between any models launched from 1949 until 1953: they mirrored the undifferentiated aesthetics of the new tenement blocks, in front of which they had their photo endlessly taken. The radiator grille was about the last remaining piece of adornment and originality that the manufacturers afforded themselves: Alfa kept its *Scudetto* and Rover, Mercedes-Benz and Lancia stuck to their traditional radiator mock-ups. A globe lent Ford an air of jet dynamics, while

bloß nicht auffallen. Produktionstechnische Bedingungen prägen die Ästhetik: Da die Karosserie sich von alleine trägt, muss sie solide sein, mit kleinen Öffnungen, flachen Blechen und sahnigen Kurven. Es ist Porsches simple Muschel-Formensprache, nur auf eine langweiligere Form übertragen. Vorne enden Kotflügel-Würste in runden Scheinwerfern, die Haube fließt tief um den Motor herum.

Bei allen Modellen, die zwischen 1949 und 1953 auf den Markt kommen, erkennt man kaum Formunterschiede: sie spiegeln die undifferenzierte Ästhetik der neuen Wohnblöcke wider, vor denen sie so gerne fotografiert werden. Höchstens mit dem Kühlergrill leisten sich die Firmen etwas Schmuck und Eigenständigkeit: Alfa mit seinem Scudetto; Rover, Mercedes-Benz und Lancia mit ihren traditionellen Kühlerattrappen. Eine Weltkugel bringt bei Ford Jet-Dynamik ins Spiel, während Fiat und Opel eine laute,

Elles adhèrent en masse au principe des loisirs en famille avec notamment les traditionnelles sorties en voiture dans les parcs nationaux, puis dans les Disneyland devenus de véritables institutions. Longs trajets et moult bagages. Raymond Loewy a l'idée d'allonger l'arrière de la voiture de façon à pouvoir y loger un coffre spacieux. C'est la naissance de la berline moderne à coffre. L'esthétique est influencée par les contraintes de production. Autoportante, la carrosserie doit être volumineuse, les ouvertures petites, les surfaces en tôle plates et les courbes généreuses. Le langage esthétique du coquillage conçu par Porsche se généralise, transposé cependant sur des lignes nettement plus fades. À l'avant, des ailes dodues aboutissent sur des phares ronds, le capot englobe bien le moteur. Les modèles sortis entre 1949 et 1953 se distinguent à peine les uns des autres. Ils semblent refléter une esthétique de l'indifférenciation, celle des nouveaux immeubles

Rover 75, 1949

Alfa Romeo 1900, 1950

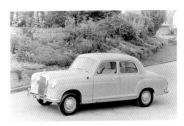

Mercedes 180 *Ponton*, 1953

Fiat and Opel were celebrating a loud, American orgy in chrome. That was all it took to make people happy.

THE UNIVERSAL CAR

Whoever ordered a saloon car in the 1950s was already member of the upper class, who had been used to driving cars before the war. But the manufacturers' main aim was to finally mobilise the masses. In order to achieve that, the search for the ideal people's car was on, with every country having clear ideas of its own. The Morris Minor was a typically British, conservative creation, whose design can be considered a miniature of a full-size car's form. In Italy, Fiat interpreted the people's car in the size of the tiny 600 and 500 models, with modern lines but a less modern rear engine. As Porsche's Volkswagen was, by now, already a dozen years old, the British government failed to identify the engaging vehicle, with its rounded mud-

amerikanische Chromorgie veranstalten. Das reicht aus, um die Menschen glücklich zu machen.

UNIVERSALMODELLE

Wer in den 1950er Jahren eine Limousine bestellt, gehört schon zur gehobenen Gesellschaft, die bereits vor dem Krieg Auto gefahren ist. Das erklärte Ziel der Hersteller ist aber, endlich die Massen zu mobilisieren – dazu wird ein Super-Volks-Wagen gesucht, von dem jedes Land seine eigenen Vorstellungen hat. Der Morris Minor gibt sich britisch konservativ und entspricht einem vollwertigen Auto, nur eben in Miniatur. In Italien interpretiert Fiat mit 600 und 500 den Volks-Wagen in klein: mit moderner Linie und weniger modernem Heckmotor. Da Porsches Käfer mittlerweile ein Dutzend Jahre alt ist, sieht die britische Regierung im niedlichen Fahrzeug mit aufgesetzten Kotflügeln und altmodischer Rahmenkonstruktion dummerweise keine Konkurrenz

devant lesquels on les photographie volontiers. La calandre est le seul élément qui permette aux constructeurs d'afficher un brin de fantaisie et de personnalité : Alfa avec son Scudetto, Rover, Mercedes-Benz et Lancia avec leurs traditionnelles calandres en trompe-l'œil. Ford opte pour la mappemonde à cause de son côté dynamique, tandis que Fiat et Opel donnent dans la débauche de chromes criards, façon américaine. Et cela suffit à rendre les gens heureux.

LA VOITURE UNIVERSELLE

Dans les années 1950, la voiture est réservée à la haute société, seule à pouvoir se l'offrir comme c'était déjà le cas avant la guerre. Les constructeurs se donnent quant à eux pour objectif de rendre la voiture accessible aux masses et veulent tous créer leur voiture du peuple adaptée aux goûts nationaux. La Morris Minor aux accents conservateurs très britan-

Opel Kapitän, 1954

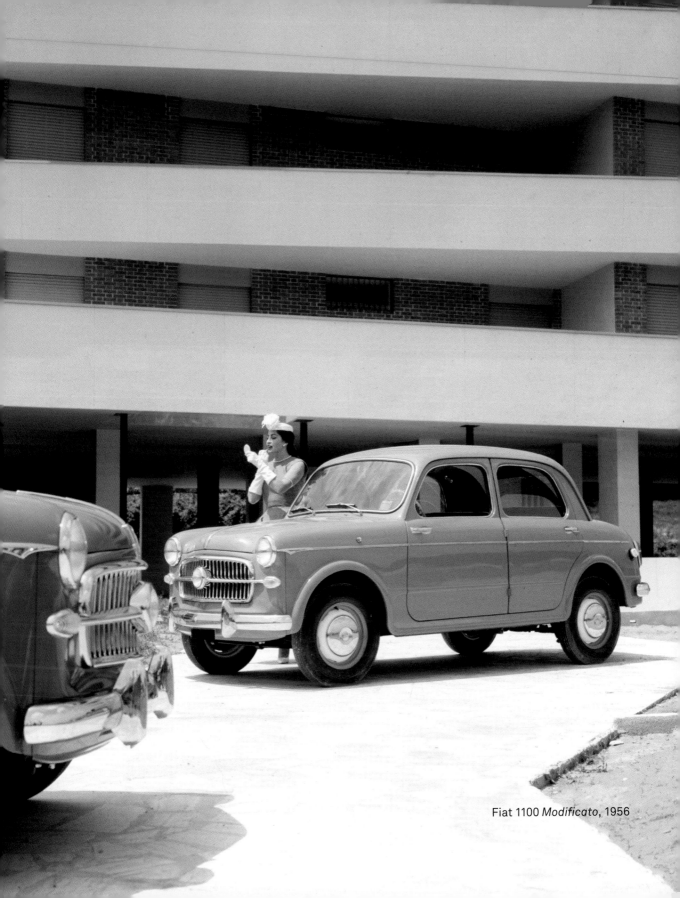

Fiat 1100 *Modificato*, 1956

guards, air-cooled rear engine and old-fashioned body-on-frame construction, as a possible rival to the rest of the European industry. While the British gave the go-ahead for the resumption of production, Renault launched the 4CV. Quite obviously, the Beetle had been a source of inspiration: the 4CV also had a rear engine, but four doors and a 'face' that pretended to be attached to a proper car. The French call it the 'lump of butter', and there is no better way of describing car design in the early fifties.

France's second people's car was the resurrected Citroën 2CV, featuring headlights arched toward the sky, corrugated iron bonnet and a ragtop. 'Dolly' drove like a camel, and looked a bit like one, too. But it can do anything and demands almost nothing in return. Ultimately, people did not give a fig about the engineers' striving for the perfect technical solution, because millions of people were experiencing an unfor-

für die übrige europäische Industrie. Während die Briten grünes Licht für die Wiederaufnahme der Produktion geben, präsentiert Renault im selben Jahr einen eigenen Volks-Wagen: den 4CV. Der Käfer als Inspirationsquelle ist unübersehbar: Auch der 4CV hat einen Heckmotor, dafür allerdings vier Türen und ein Gesicht, das vorgibt, an einem richtigen Automobil angebracht zu sein. Die Franzosen nennen ihn „Butterklumpen" – besser kann man den Wagen sowie seine Zeitgenossen auch nicht beschreiben.

Frankreichs zweiter Volks-Wagen ist die wiederauferstandene Citroën 2CV: mitsamt in den Himmel gereckten Scheinwerfern, Wellblech-Motorhaube und Rolldach. Die Ente fährt sich wie ein Kamel und sieht auch so aus. Doch sie kann alles und verlangt nichts. Der Wettstreit der Ingenieure um die perfekte technische Lösung ist dem Volk letztendlich egal. Millionen von Menschen

nique a tout d'une vraie voiture, mais en miniature. En Italie, Fiat choisit de réinterpréter la voiture du peuple en plus petit et propose les modèles 600 et 500. Les lignes sont résolument modernes, le moteur arrière l'est moins. La Volkswagen de Porsche ayant déjà une bonne dizaine d'années d'âge, les britanniques estiment – à tort – que cette jolie Coccinelle aux ailes gonflées, au moteur arrière à refroidissement à air et au cadre démodé ne risque plus de concurrencer le reste de l'industrie européenne. Aussi donnent-t-ils le feu vert à la reprise de la production de leur nouveau modèle, l'année même où Renault sort lui aussi sa voiture du peuple, la 4 CV. Indéniablement inspirée de la Coccinelle avec son moteur arrière, elle dispose en revanche de quatre portes et se caractérise par une face avant qui lui donne des airs de vraie voiture. On la surnomme très vite la « quatre pattes » ou encore la « motte de beurre », des surnoms qui en disent long.

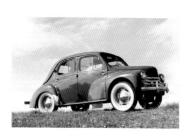

Renault 4CV, 1946

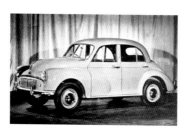

Morris Minor, 1952

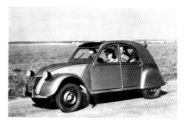

Citroën 2CV, 1949

gettable moment: they were driving their very first car, which they had longed for, taken care of and which they loved dearly and which they drove, drove, drove. These ubiquitous people mobiles now formed the backbone of mobility and were a figurehead of their home countries. They might be standard products, but they were converted into a plethora of variants for all purposes. They were less design icons then they were universal works of art.

Fiat, for example, transformed the 600 into the Multipla taxi mini-van and the 500 into a mini estate. The independent coach-builders, on the other hand, were offering any variant imaginable, from beach buggy to saloon. The Volkswagen spawned a convertible, a chic coupé, a saloon, as well as a number of estate and utility models. But although the idea persisted, prosperity actually spelt the end for the ideology of the people's car, the only exception being the German Demo-

erleben einen unvergesslichen Moment: Sie besitzen ihr allererstes Auto, das sie begehren, pflegen und lieben. Und vor allem fahren, fahren, fahren. Die allgegenwärtigen Volksmobile sind Rückgrat der Mobilität und Aushängeschild ihrer Heimatländer. In etlichen Varianten und für jeden Zweck umgebaut, sie sind weniger Design-ikonen denn Universalkunstwerk.

Fiat etwa transformiert den 600 in die Taxi-Großraumlimousine Multipla und den 500 in einen Mini-Kombi. Die freien Karossiers bieten ihrerseits vom Strandwagen bis zur Limousine jede denkbare Variante an. Vom Volkswagen gibt es ein Cabriolet, den schicken Ghia-Sportwagen, eine Limousine, diverse Kombinations-Modelle und sogar ein Jagdfahrzeug. Mit dem Wohlstand endet allmählich die Ideologie des Volks-Wagens. Einzige Ausnahme ist der Trabant der Deutschen Demokratischen Republik. Als Geniestreich entpuppt sich hingegen der Mini, der 1959

La 2 CV de Citroën, avec ses phares qui regardent le ciel, son capot en tôle ondulée et son toit en toile, est une voiture à part, une voiture à l'allure inqualifiable, mais capable de tout et si peu exigeante. Techniquement, c'est une pure merveille, fruit de la compétition à laquelle se livrent les ingénieurs pour trouver la solution parfaite. Mais pour des millions de personnes, ce qui compte, c'est ce moment magique où ils tiennent entre leurs mains le volant de leur toute première automobile, tant désirée, choyée et adulée et pouvoir enfin prendre la route et partir… n'importe où. Omniprésentes, ces voitures populaires sont la clé de la mobilité et le porte-drapeau de leur pays respectif. Produits standard, déclinées sous différentes formes et pour des usages très divers, elles représentent davantage des œuvres d'art universelles que des icônes du design. Fiat reprend la 600 pour créer la Multipla, un taxi version « minibus » et sort la 500 en version mini-break. Les carrossiers indé-

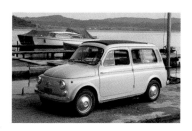

Fiat 500 Giardiniera, 1960

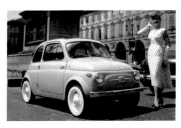

Fiat Nuova 500, 1957

cratic Republic's Trabant. In sharp contrast, the Mini, which in 1959 revolutionised the image of the small car, turned out to be a stroke of genius. Its body was short, wide and ultra-compact, the wheels were as small as possible and the front engine was transversely mounted. Those basic designs decisions were a consequence of the very first oil crisis, the Suez conflict.

The Mini was aimed at replacing the old, inefficient people's cars, which is why it was also offered as an estate, a pick-up, a delivery van and even as a jeep. But this concept was too innovative for the public, its design too fundamental. Finally a friend had to come to engineer Alec Issigonis' rescue: in 1960, Antony Armstrong-Jones married Princess Margaret, and London's coolest couple drove a Mini. As the perfect complement to Mary Quant's mini skirt, the Mini turned into a fashion craze, attracting endless new customers. Thanks to the Mini, the people's

das Image des Kleinwagens revolutioniert. Seine Karosserie ist kurz, breit und ultrakompakt, die Räder sind maximal winzig, der Motor liegt vorne quer. Das ökonomische Mobilitätsminimum ist eine Konsequenz des Suez-Konflikts, der allerersten Ölkrise.

Der Mini soll die alten, unwirtschaftlichen Volksmobile ersetzen – weshalb es ihn auch als Traveller-Kombi, Pickup, Lieferwagen und sogar Jeep gibt. Dem Volk ist das Konzept aber zu innovativ, das Design zu fundamental. Schließlich kommt ein Freund dem Entwickler Alec Issigonis zur Hilfe. Fotograf Antony Armstrong-Jones heiratet 1960 Princess Margaret – Londons coolstes Paar fährt Mini. Als perfektes Pendant zu Mary Quants Minirock wird der Mini zur Modeerscheinung, die neues Publikum anlockt. Mit dem Mini mutiert der Volks-Wagen zum pfiffigen Stadtwagen. Für die Familie eine Notlösung, als Zweitwagen jedoch ideal. Etwas weiter oben angesiedelt etabliert der Fiat

pendants proposent quant à eux tous les modèles possibles et imaginables, de la voiture de plage à la berline. La Coccinelle existe en plusieurs versions : cabriolet, coupé très distingué, berline, modèles mixtes et même un modèle de chasse. Si l'idée de voiture du peuple fait son chemin, le concept idéologique disparaît avec la prospérité. Seule exception, la Trabant de la République démocratique allemande, qui fait vieux malgré une arrivée tardive sur le marché. La Mini, en revanche, a tout du véritable coup de génie. Sortie en 1959, elle révolutionne l'image de la petite voiture. Une carrosserie courte, large et ultra-compacte, des roues minuscules et un moteur avant transversal. Rivalisant de minimalisme et de performance économique, le véhicule est le résultat de la crise de Suez, la première crise du pétrole. Créée pour remplacer les voitures du peuple, devenues trop vieilles et trop chères à produire, la Mini se décline en break, en pickup, en voiture de livraison et

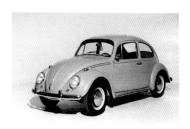

Volkswagen 1200 Export, 1961

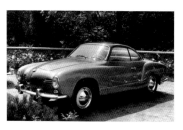

Volkswagen Karmann-Ghia, 1954

car was transformed into a dapper city car, a less then ideal solution for families, but perfect as a second car. A few steps up the automotive ladder, the Fiat 124 established a new class of automobile. Its engine was roughly the size of the Beetle's, but the four-door saloon was a fully-fledged, powerful and versatile family car and also a global success, whose production, from 1971 on, continued as the Lada Schiguli, experiencing an Indian summer as the Soviet people's car. Both the 124 and the Mini were tailor made for the booming decade of the Swinging Sixties.

124 eine neue Fahrzeugklasse. Sein Motor ist zwar nur so groß wie der des Käfers, doch die viertürige Limousine ist ein vollwertiges, leistungsfähiges und vielseitiges Familienauto. Und ein Welterfolg, der ab 1971 als Lada Schiguli einen zweiten Frühling als sowjetisches Volksmobil erlebt. Beide, 124 und Mini, sind perfekt für die boomenden 1960er Jahre, die Swinging Sixties.

même en jeep. Véritable phénomène de mode, à l'instar de la mini-jupe de Mary Quant, la Mini attire un public d'un style nouveau. Avec la Mini, la voiture du peuple s'est muée en une citadine fringante, un choix idéal s'il s'agit d'une deuxième voiture. Dans le plus haut de gamme, on trouve enfin la Fiat 124 qui marque l'arrivée d'une nouvelle catégorie de voiture. Son moteur n'est peut-être pas plus puissant que celui de la Coccinelle mais c'est une berline à quatre portes, une familiale à part entière, performante et polyvalente. Un succès mondial, qui se perpétuera avec la Lada Schiguli qui lui succède en 1971 et qui lui vaudra un second printemps lorsque l'union soviétique entière l'adopte. Les deux modèles, la 124 de Fiat et la Mini sont les voitures idéales pour accompagner la croissance économique de ces années 60, les « swinging sixties ».

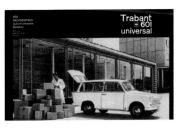

Trabant 601 Universal, 1965

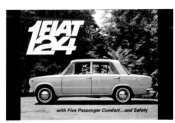

Fiat 124, 1965

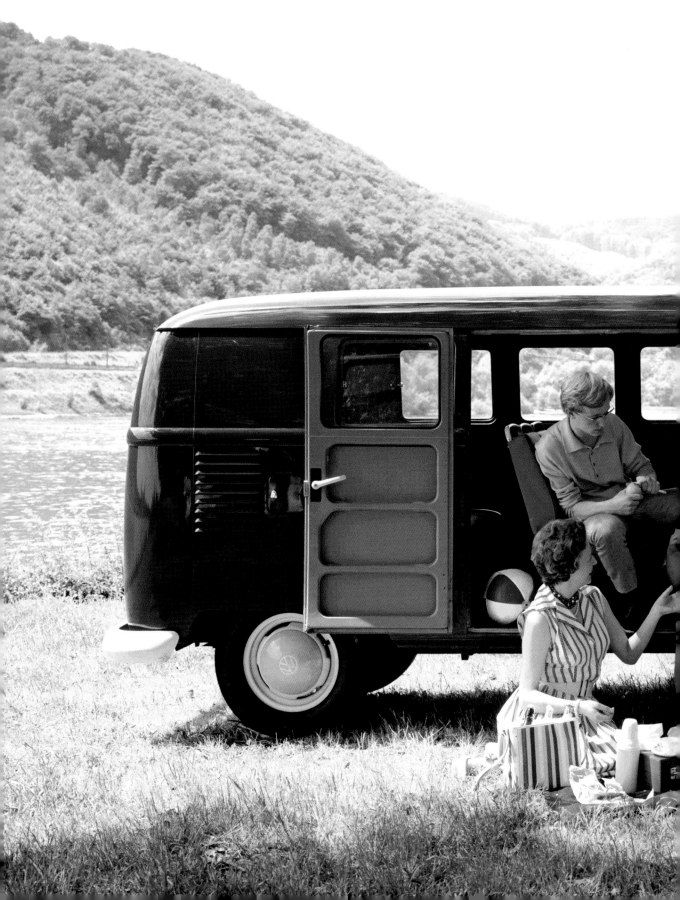

Volkswagen Transporter, 1960

FORD

Henry Ford's name became a legend in Europe, too. Dearborn was turned into a place of pilgrimage, where the art and science of automobile production could be studied. Ford himself established production facilities in the UK, France and Germany. But he quickly learnt that American cars did not stand a chance in Europe. Ford's Euro subsidiaries therefore started off by offering stand-alone products for each market, all of which exuded a certain American flair. An astonishing product variety blossomed after the Second World War: French Ford customers of the 1950s were driving through Paris in their opulent Vendôme or Comète models, while German Ford drivers were experiencing the *Wirtschaftswunder* ('economic

Henry Fords Name ist auch in Europa Legende. Man pilgert nach Dearborn, um zu lernen, wie man Autos baut. Ford selbst wiederum gründet in Großbritannien, Frankreich und Deutschland Niederlassungen. Doch er muss schnell lernen, dass die amerikanischen Autos in Europa keine Chance haben. Die Euro-Töchter beginnen daher, eigenständige Produkte für die jeweiligen Märkte anzubieten, wobei ein gewisses amerikanisches Flair nicht fehlen darf. Nach dem Zweiten Weltkrieg entwickelt sich dann eine erstaunliche Vielfalt: Französische Ford-Kunden fahren in den 1950er Jahren in opulenten Vendôme- oder Comète-Modellen durch Paris, während deutsche Ford-Fahrer das Wirtschaftswunder hinter dem Steuer des Weltku-

Le nom d'Henry Ford relève du mythe, même en Europe. Ford ouvre des filiales en Grande-Bretagne, en France et en Allemagne. Pourtant, très vite, il réalise que les voitures américaines n'ont aucune chance sur le marché européen. Les filiales européennes commencent donc à produire des modèles adaptés, sans pourtant leur enlever totalement leur petit air américain. Après la deuxième guerre mondiale, la diversité des modèles Ford à travers l'Europe est stupéfiante : en France, dans les années cinquante le client Ford traverse Paris à bord d'opulents modèles Vendôme ou Comète, alors que son homologue allemand vit les années du miracle économique au volant de sa Ford Taunus 12 M, et que les anglais eux peuvent satisfaire leurs élans

Ford Anglia
105E, 1959

Ford Taunus 12M *Weltkugel*, 1952

miracle') from behind the steering wheels of their Taunus models and the British were able to make a conveniently patriotic statement simply through the purchase of a Ford Anglia. Ford kept on falling back on American design inspirations right up until the seventies, which lent the marque with the Blue Oval a fascinating additional cachet compared to the *milquetoast* Europeans.

geltaunus erleben und Briten mit dem Kauf eines Ford Anglia bequemerweise auch ein Bekenntnis zum Patriotismus abliefern können. Bis in die Siebziger greift Ford auf amerikanische Design-Inspirationen zurück, was der Marke mit dem blauen Oval einen faszinierenden Mehrwert gegenüber den schmächtigen Europäern verleiht.

patriotiques en achetant une Ford Anglia. Jusque dans les années 70, Ford utilisera la voiture américaine comme référence stylistique qui se révèlera pour la marque au logo ovale bleu comme un atout commercial fort efficace par rapport à ses maigrichonnes concurrentes européennes.

RUDOLF UHLENHAUT

Both before and after the Second World War, the Mercedes Silver Arrow race cars, and in particular the 300 SL with its tubular chassis and characteristic gull wing doors, were the brainchildren of Rudolf Uhlenhaut. Uhlenhaut's overriding strength was that he was not just a world-class engineer, but also a driver of similar renown. He did not own a private car: when Daimler-Benz cancelled its racing programme in 1955, he had a 180 mph Mille Miglia racer converted into a coupé and used this fastest of company cars to tear around all over Europe. After all, class does not age, it matures.

Die Mercedes-Silberpfeil-Rennwagen vor und nach dem Zweiten Weltkrieg und erst recht der 300 SL mit Gitterrohrrahmen und den charakteristischen Flügeltüren sind seine Kinder. Rudolf Uhlenhauts herausragende Stärke ist dabei, dass er nicht nur Ingenieur, sondern auch Fahrer auf Weltmeister-Niveau ist. Ein eigenes Auto besitzt er nicht: Als Daimler-Benz sich 1955 aus dem Rennsport zurückzieht, baut er einen 290 km/h-Mille-Miglia-Boliden zum Coupé um und rast, auch im fortgeschrittenen Alter, mit dem schnellsten aller Dienstwagen durch ganz Europa. Klasse altert eben nicht, sie reift.

Il est le père des « flèches d'argent », ces voitures de course construites par Mercedes avant et après la 2ème guerre mondiale, et surtout de la 300 SL avec châssis en acier tubulaire et portes papillon. Ingénieur mais aussi pilote de course de haut rang mondial, Rudolf Uhlenhaut tire profit de cette double expérience. En 1955, lorsque Daimler-Benz se retire de la course automobile, ne possédant pas de voiture, il transforme un bolide des Mille Miglia en coupé de 290 km/h au volant duquel il parcourra toute l'Europe jusqu'à un âge avancé. Et oui, la classe et le style n'ont pas d'âge, seulement un millésime.

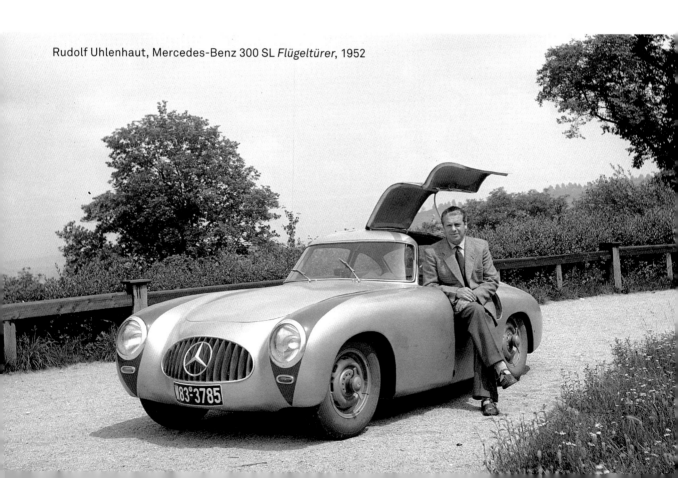

Rudolf Uhlenhaut, Mercedes-Benz 300 SL *Flügeltürer*, 1952

Mercedes-Benz 300 SE *Heckflosse*, 1961

BÉLA BARÉNYI

Innovations such as the passenger safety compartment, side impact protection, roll bars, the safety steering wheel and padded steering boss played a decisive role in the success of Mercedes-Benz. The eccentric genius behind all these lifesavers had a name that gave him the air of a circus ringmaster: Béla Barényi. In 1952, his patented 'crumple zones' defined the notchback saloon as the basic body shape of the Mercedes brand, which, following the Ponton Benz, was the very definition of solidity and safety worldwide or, more romantically, "Your good star on all roads".

Innovationen wie Sicherheitsfahrgastzelle, Seitenaufprallschutz, Überrollbügel, Sicherheitslenkrad und Pralltopf tragen entscheidend zum Erfolg der Marke Mercedes-Benz bei. Hinter all diesen Lebensrettern steht ein exzentrisches Genie mit dem Namen eines Zirkusdirektors: der Österreicher Béla Barényi. Sein Patent der Knautschzonen definiert 1952 die Stufenhecklimousine als Grundform der Marke mit dem Stern, die seit dem Ponton-Benz weltweit als Inbegriff der Solidität und Sicherheit gilt – eben als „Ihr guter Stern auf allen Straßen".

Le succès de la marque Mercedes-Benz doit beaucoup à des innovations comme la cellule passagers indéformable, les barres de protection latérale, l'arceau de sécurité, et le volant de sécurité. Ces éléments qui sauveront de nombreuses vies sont l'œuvre d'un génie, l'autrichien Béla Barényi. « Votre bonne étoile sur toutes les routes » ! C'est dans ces termes que Barényi décrit en 1952, dans son brevet portant sur les zones de déformation, la berline tri-corps de la marque à l'étoile qui dans sa forme originale, depuis la Ponton, est synonyme de solidité et de sécurité à travers le monde.

FIAT

During the post-war years, the Turin automobile factory grew to become Europe's biggest car manufacturer, thanks to a model range that was second to none. Fiat pursued a wise design strategy: base models were developed in-house, with one eye on America and the other eye focused on economical styling. The resulting cars radiate both charm and modesty. Fiat's bestsellers are, to use the title of a 1956 motion picture, *Poveri ma belli*: poor, yet beautiful, in stark contrast

Mit einer Modellpalette, die ihresgleichen sucht, steigt die Turiner Automobilfabrik in der Nachkriegszeit zum größten Automobilhersteller Europas auf. Fiat betreibt eine kluge Marken- und Designstrategie. Die Basismodelle werden mit einem Auge auf Amerika und dem anderen auf gestalterische Ökonomie gerichtet im Hause entwickelt. Daraus resultieren Fahrzeuge mit dem Charme der Bescheidenheit. Fiats Konstruktionen sind, um es mit dem Titel eines

Grâce à la diversité inégalée de sa gamme de modèles, l'entreprise turinoise devient le plus grand constructeur automobile européen d'après-guerre. Fiat déploie une stratégie de marketing et de design intelligente. Les modèles de base, développés en interne, tiennent compte des trends américains et d'un design économe. Il en résulte des véhicules au charme sobre. Les Fiat, pour reprendre les termes du film *Poveri ma belli* sorti en 1956, sont pauvres mais belles,

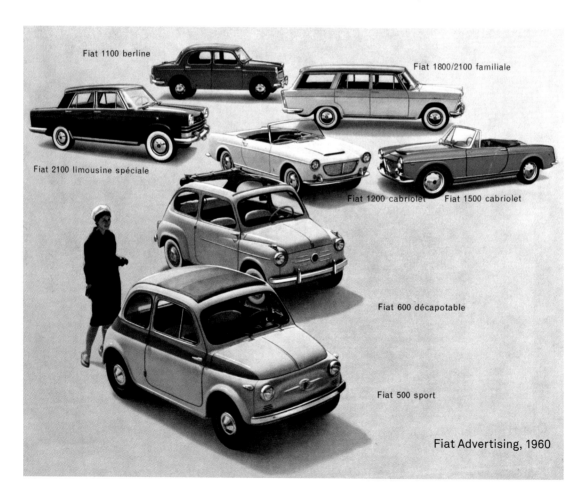

Fiat 1100 berline

Fiat 1800/2100 familiale

Fiat 2100 limousine spéciale

Fiat 1200 cabriolet Fiat 1500 cabriolet

Fiat 600 décapotable

Fiat 500 sport

Fiat Advertising, 1960

to the special models, which are created either at the *carrozzerie speciali* department or at the Turin coachbuilders. Thus, standard models are transformed into elegant *Gran Luce* versions. Spider and Coupé models were adorned with the logos of Pininfarina, Ghia and, later on, Bertone and consequently caught up with Alfa Romeo and Lancia. Carlo Abarth is in charge of the sporting derivatives: a modified 600 becomes a 750, now with twice as much horsepower and

Films von 1956 zu sagen, *Poveri ma belli*: arm, aber schön. Ganz anders die Sondermodelle, die entweder in der Abteilung Carrozzerie Speciali oder bei den Turiner Karossiers realisiert werden. Spider und Coupés schmücken sich mit dem Logo von Pininfarina, Ghia, Bertone, und schließen so zu Alfa Romeo und Lancia auf. Den sportlichen Ablegern widmet sich Carlo Abarth: Ein zum 750 getunter 600 hat nun doppelt so viel PS und schlägt damit weit größere Autos. Unter der

à l'exception cependant des modèles spéciaux réalisés dans le département carrozzerie speciali et chez les carrossiers turinois de renom. Avec des spiders et des coupés qui arborent les sigles de Pininfarina, Ghia et Bertone, Fiat comble le fossé avec Alfa Romeo et Lancia. Les versions sportives sont le domaine de Carlo Abarth. La 600 transformée en 750, par doublement de ch, peut se mesurer avec des voitures bien plus grosses. La Bianchina, une petite 500,

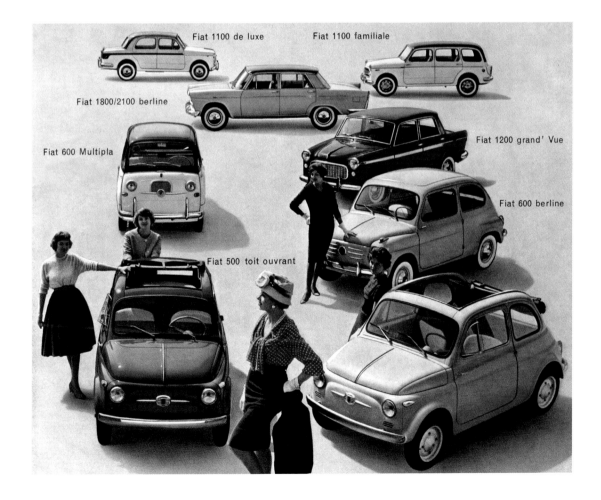

Autobianchi Bianchina Trasformabile Special, 1960

the ability to see off considerably bigger cars. Under the Autobianchi banner, the small 500 was allowed to become more expensive and better looking: in its Bianchina derivative it was the perfect car for the lady. Fiat technology was now available to everyone, enabling the creation of the Jolly beach buggy by Ghia or the elegant one-offs with six cylinder engines. This is the true miracle of Turin's industry.

Marke Autobianchi darf der kleine 500 teurer und schmucker werden: Als Bianchina ist er der perfekte Wagen für die Dame. Fiat-Technik ist für alle verfügbar, weshalb auf einmal der Strandwagen Jolly von Ghia oder edle Einzelexemplare mit Sechszylinder-Motoren entstehen. Das ist das Wunder von Turin.

améliorée et commercialisée sous la marque Autobianchi pour en augmenter le prix de vente, est la voiture rêvée de toutes ces dames au style metropolitain. Flexible, la technologie Fiat permet de produire aussi bien des modèles de plage comme la Jolly de Ghia que des modèles uniques à six-cylindres. C'est ça le miracle de Turin.

Fiat 2100 Familiare, 1959

Fiat 600 Coupé Moretti, 1957

Fiat 600 Coupé Speciale Pininfarina, 1955

Fiat 600 Cabriolet Lombardi, 1959

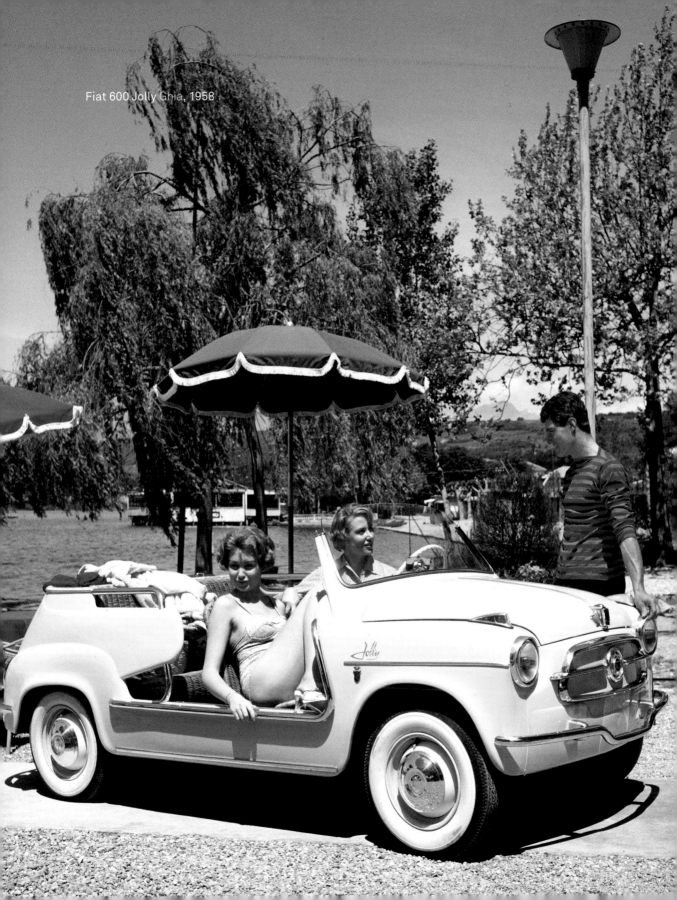

Fiat 600 Jolly Ghia, 1958

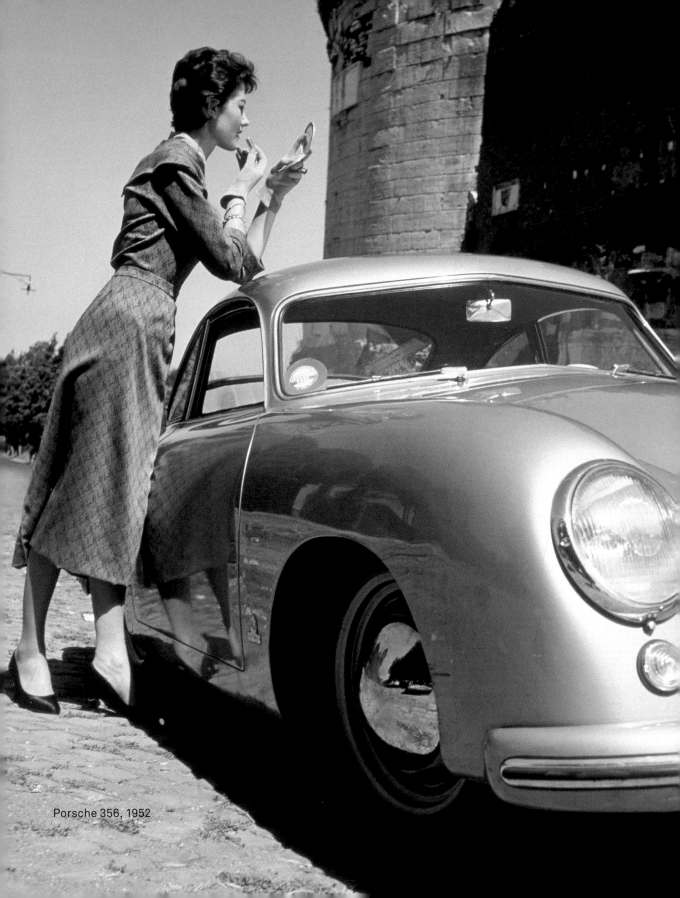

Porsche 356, 1952

ERWIN KOMENDA

The VW Beetle and Porsche 356 owe their characteristic body shape to Erwin Komenda. The Austrian designer was employed both by Ferdinand Porsche and by his son, Ferry. In the Beetle, he combined Jaray's aerodynamics with ornamental decoration somewhere between art deco and Vienna Secession and, hence, got very close indeed to the aesthetic ideal of the people. He styled the first Porsche without any fripperies. It really was something special: podgy yet sporty, cool yet friendly. An iconic shape, which—albeit leaner and more stringent—lives on in the 911, almost unchanged to this day.

Ihre charakteristische Form verdanken VW Käfer und Porsche 356 Erwin Komenda. Der österreichische Designer ist zuerst für Ferdinand Porsche und dann für dessen Sohn Ferry tätig. Im Käfer vereint er Jarays Aerodynamik mit ornamentalem Schmuck zwischen Art déco und Wiener Secession – und kommt dem ästhetischen Volksideal sehr nah. Den ersten Porsche gestaltet er ohne jeden Firlefanz. Er ist etwas Besonderes: dicklich und trotzdem sportlich, kühl aber sympathisch. Eine ikonische Form, die zwar schlanker und stringenter, dennoch praktisch unverändert – und somit bis heute – weiterlebt.

C'est à Erwin Komenda que la coccinelle de VW et la Porsche 356 doivent leur forme si caractéristique. Ce designer autrichien travaille d'abord pour Ferdinand Porsche puis pour son fils Ferry. Il donne à la coccinelle une forme aérodynamique à la Jaray et la dote d'une ornementation entre art déco et sécession viennoise proche de l'idéal esthétique populaire. La première Porsche, par contre, est sans fioriture : très particulière, un peu ronde et pourtant sportive, froide mais sympathique. Légèrement affinée et plus claire, cette forme quasiment inchangée depuis la 911 est devenue une icône qui survit jusqu'à aujourd'hui.

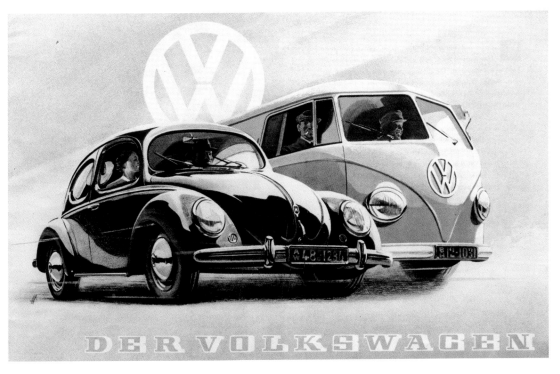

Volkswagen Advertising, 1950

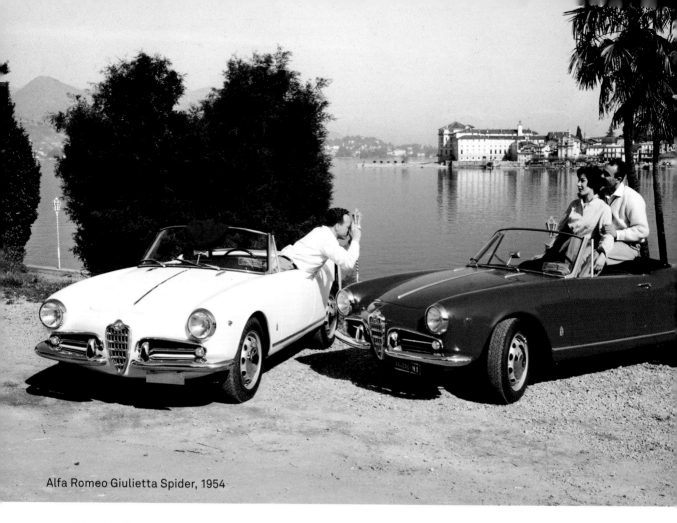

Alfa Romeo Giulietta Spider, 1954

ALFA ROMEO

After the war, Alfa Romeo had the daring to completely reposition itself. This noble marque, which had gone head-to-head with Bugatti before the war, began a second life in the cradle of the middle classes. The switch worked out brilliantly. The 1900 and Giulietta volume-production models were aesthetically in keeping with the mass production canon: their 'shell' shape only received 'make-up' and character at the front end. Below the bonnet ran Alfa's finest Bialbero engine. Noone else was able to offer this kind of performance in mass production. It was

Nach dem Krieg wagt Alfa Romeo eine völlig neue Positionierung. Die adelige Marke, die vor dem Krieg Seite an Seite mit Bugatti stand, beginnt ein zweites Leben im Schoße des Bürgertums. Der Umstieg gelingt blendend. Die Volumenmodelle 1900 und Giulietta folgen ästhetisch dem Kanon der Massenproduktion: muschelartige Form, die erst mit dem Gesicht Schminke und Charakter erhält. Doch unter der Haube arbeitet Alfas feinste Bialbero-Maschine, ab 1954 komplett aus Leichtmetall gefertigt. Vergleichbare Leistung kann in der bürgerlichen Klasse sonst niemand

Après la guerre Alfa Romeo tente un repositionnement total. La marque qui avec Bugatti représentait la noblesse d'avant-guerre, commence sa deuxième vie dans le giron de la bourgeoisie. Les modèles de volume 1900 et Giulietta suivent les canons esthétiques imposés par la production de série et adoptent des formes en coquillage dont le caractère se révèle à l'avant. Sous le capot vrombit le Bialbero, un fin moteur fabriqué entièrement en alliage léger. Alfa est alors la seule marque de voitures bourgeoises à offrir de telles performances motrices sur des modèles de série. De nombreu-

always going to be the fate of the Alfa to feature as a sports car. The thoroughbred 1900 versions by Pininfarina and Zagato were beautiful, expensive and coveted. In 1954 Giulietta, whose name sounds like a declaration of love, did much to popularise Alfa's concept. The marketing strategy was clever: the sporty Sprint versions by Bertone, were offered first, followed by the gorgeous Spider by Pininfarina. By this point, the customer was indulging in the wildest fantasies. When the series' saloon variant was presented it was an instant hit. On this basis, Bertone and Zagato built an SS and SZ racing variant respectively. The small ones' success cannot be topped, even by the bigger 2000 and 2600. From now on, Alfa will remain a marque of the bourgeoisie and, to many, the most beautiful of them all.

bieten: das prädestiniert den Alfa zur Grundlage für Sportwagen-Varianten. Die reinrassigen 1900 von Pininfarina und Zagato sind schön, teuer und begehrt. Durch die Giulietta, mitsamt ihres nach einer Liebeserklärung klingenden Namens, wird Alfas Konzept 1954 populär. Die Vermarktungsstrategie ist raffiniert: zunächst wird die sportliche Sprint-Version von Bertone, einer der schönsten Sportwagen der Nachkriegszeit, angeboten. Dann der bildhübsche Spider von Pininfarina. Erst jetzt wird die Serienlimousine vorgestellt – und auf Anhieb geliebt. Danach bauen Bertone eine SS- und Zagato eine SZ-Rennversion. Den Erfolg der Kleinen können nicht mal die größeren 2000 und 2600 übertreffen. Alfa Romeo bleibt von da an Bürgermarke – und für viele die Schönste.

ses versions sportives en seront donc dérivées, comme les 1900 de Pininfarina et Zagato. En 1954, le concept Alfa gagne en popularité avec la sortie de la Giulietta dont le nom, à lui seul, est une déclaration d'amour. La stratégie de commercialisation est raffinée : Alfa présente la version sprint sportive de Bertone, une des plus jolies voitures de sport d'après-guerre, avant de lancer le beau Spider de Pininfarina, puis la berline de série immédiatement appréciée. Bertone et Zagato construisent ensuite une version de course, respectivement la SS et la SZ. La série 1900 rencontrera un succès inédit que les plus grandes séries (2000 et 2600) n'égaleront jamais. Alfa Romeo fait désormais partie des marques bourgeoises, certains diront qu'elle y occupe même une place privilégiée.

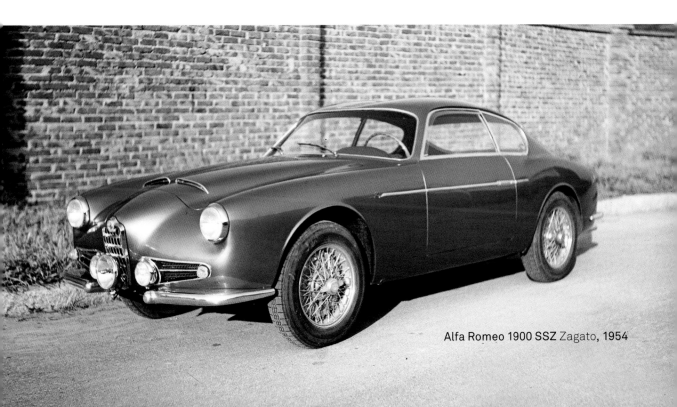

Alfa Romeo 1900 SSZ Zagato, 1954

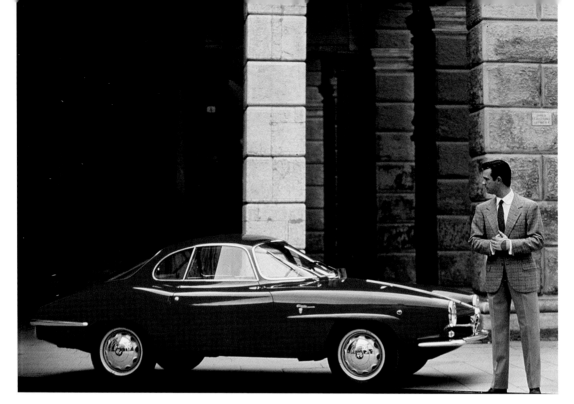

Alfa Romeo Giulietta SS
Bertone, 1957

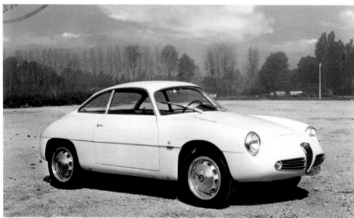

Alfa Romeo Giulietta SZ
Zagato, 1960

SS & SZ

Style and function in sports car design: Bertone's aerodynamic SS was faster on the track, yet Zagato's compact 'bread roll' is unbeatable on mountain roads.

Stil und Funktionalität im Sportwagendesign: Bertones aerodynamische SS ist auf der Strecke schneller, Zagatos kompaktes Brötchen hingegen auf Bergstraßen unschlagbar.

Style et fonctionnalité dans le design des voitures de sport : la SS de Bertone aux accents aérodynamiques est la plus rapide sur circuit. Compacte, la voiture de Zagato est imbattable sur les routes de montagne.

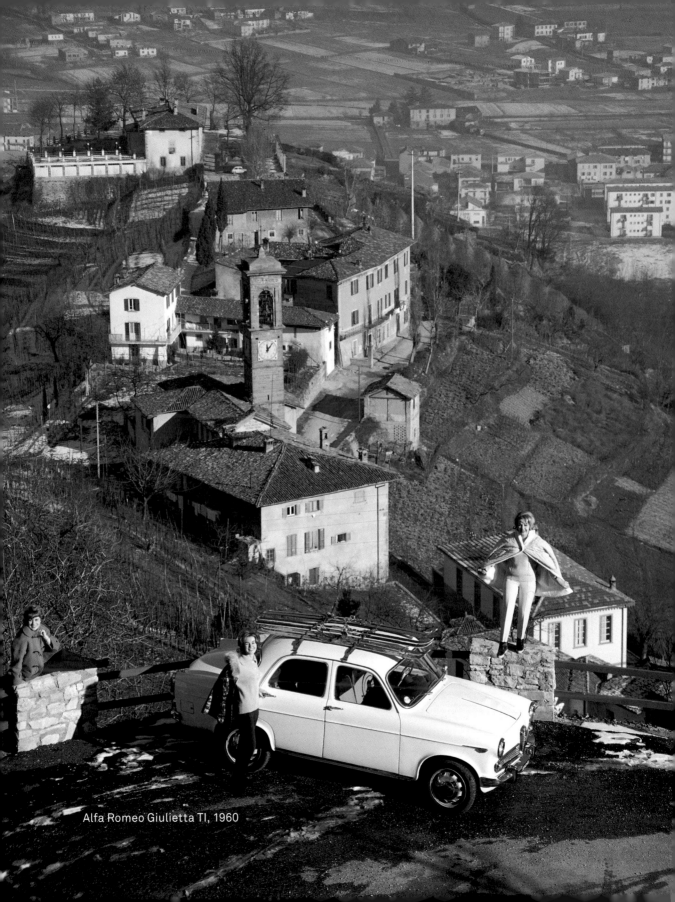

Alfa Romeo Giulietta TI, 1960

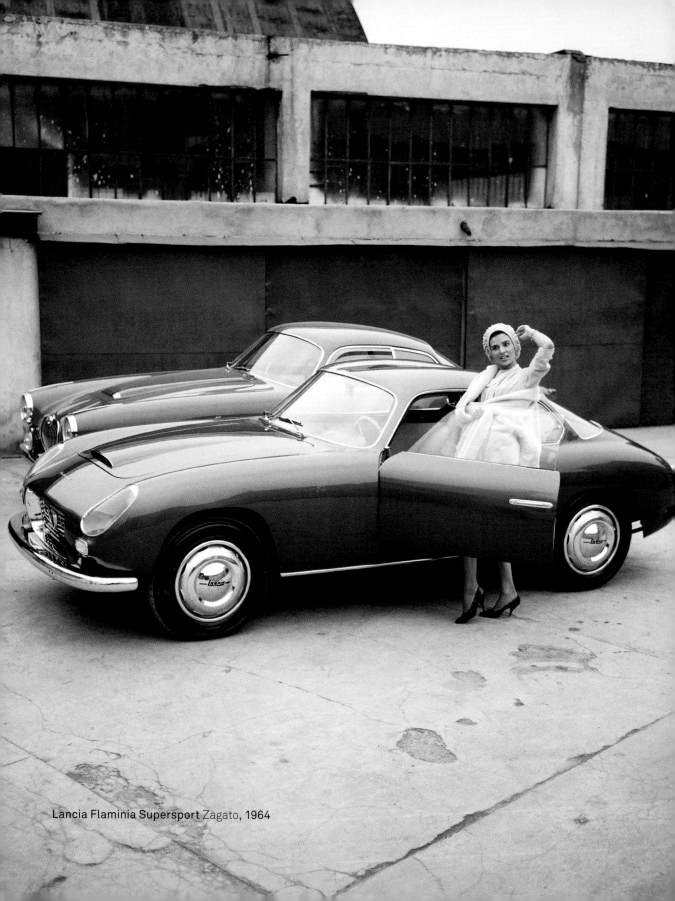

Lancia Flaminia Supersport Zagato, 1964

Fiat Abarth 750 GT Zagato, 1956

ZAGATO

The Zagato Brothers packaged aerodynamics and light weight in exemplary compact shapes. Style is not a dogma at the Milanese house. Being racing drivers, the brothers know all the tricks that improve cars for race use. Good visibility is a necessity, hence the 'panoramica' glazing, as is headroom when wearing a helmet, resulting in the roof's 'double bubble'. Any unnecessary components are noticeable by their absence. Starting in 1960, under design chief Ercole Spada, Zagato's creations took on an experimental character, with an idiosyncratic style that made no attempt whatsoever to be 'all things to all people'.

Die Gebrüder Zagato verpacken Aerodynamik und Leichtgewicht in vorbildlich schlanke Formen. Stil ist im Mailänder Hause kein Dogma. Als Rennfahrer kennen die Zagatos alle Tricks, um die Autos im Einsatz besser zu machen. Da man gute Sicht nach draußen braucht, gibt es die Panoramica-Verglasung, und für ausreichend Kopffreiheit mit Helm erhält das Dach eine Double Bubble. Was man nicht braucht, gibt es nicht. Unter Chefdesigner Ercole Spada erhalten Zagatos Kreaturen ab 1960 einen eigenwilligen Charakter mit sehr persönlichem und stets experimentellem Stil, der gar nicht erst jedermanns Sache sein will.

Les voitures des frères Zagato sont aérodynamiques et ultralégères, leur forme élancée est exemplaire. En matière de style, cette maison milanaise n'est pas dogmatique. Les combines pour améliorer les performances sur route des voitures, les Zagatos, anciens pilotes, les connaissent toutes. Ils emploient la vitre « panoramica » pour ses qualités de visibilité. Le toit profilé en « double bubble » donne de l'aisance au conducteur casqué. Tout le superflu est supprimé. À partir de 1960, le chef designer, Ercole Spada, expérimente beaucoup et crée des véhicules très individuels qui, de toute évidence, ne sont pas destinés à plaire à tous.

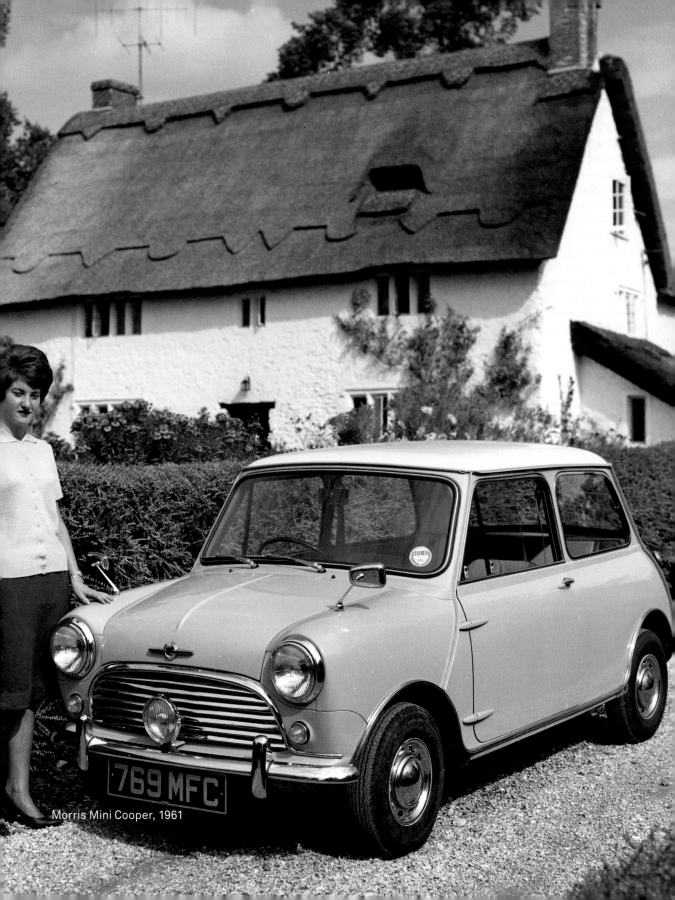

Morris Mini Cooper, 1961

769 MFC

ALEC ISSIGONIS

It is an irony of fate that the creator of the British people's favourite cars was, of all things, an Anglo-Greek, who proudly described himself as a royalist and as 'Arro-gonis'. He cared as much for style as he did for car radios: if necessary, he would happily leave it to Pininfarina to take care of this nuisance. A case in point is the Mini's big brother, the Morris 1800. He constantly challenged himself, addressing any design issues with extravagance. His ideas were brilliant, but rarely correctly understood. He reacted with typical British humour when criticised: so the Mini is supposed to be uncomfortable? That way you don't nod off. There are no wind-down windows? Instead, you can carry 27 bottles of gin and a bottle of vermouth in the door pocket compartments. Issigonis is Mini is Martini. Genius à gogo.

Es mutet wie eine Ironie des Schicksals an, dass ausgerech-net der Anglo-Grieche Issigonis, der sich selbst als Royalist und „Arro-gonis" bezeichnet, für die britischen Volks-Wagen verant-wortlich zeichnet. Stil ist ihm so wichtig wie ein Autoradio – zur Not überlässt er es Pininfarina, sich dieser Belästigung zu widmen. So zum Beispiel für den großen Bruder des Mini, den Morris 1800. Sich selbst fordert er permanent heraus, löst Konstruktionsfragen mit Extravaganz. Seine Ideen sind genial, werden aber selten richtig verstanden. Kritik nimmt er mit britischem Humor entgegen: Der Mini ist unbequem? So schläft man am Steuer nicht ein! Es gibt keine Kurbelfenster? Dafür ist in den Türablagen Platz für 27 Flaschen Gin und eine Flasche Vermouth. Issigonis ist Mini ist Martini. Genie à gogo.

L'ironie du destin veut que ce soit Issigonis, un designer anglais d'ori-gine grecque qui se dit royaliste et se donne le sobriquet d'« Arro-go-nis », qui signera la voiture du peu-ple anglais. Le style est le dernier de ses soucis. Que Pininfarina s'oc-cupe donc de ces détails ! Ce que ce dernier fera d'ailleurs pour le grand frère de la Mini, le modèle Morris 1800. Ses idées, bien que géniales, restent souvent incomprises. Mais il fait face aux critiques avec un humour très british : « la mini est inconfortable », se plaint-on : tant mieux le conducteur au moins ne risque pas de s'endormir au volant ! « Elle est dépourvue de lève-vitre à manivelle », certes, mais les rangements bas de portes peuvent accueillir 27 bouteilles de gin plus une de vermouth. Pas de doute, Issigonis, sa Mini et son Martini forment une triade de génie !

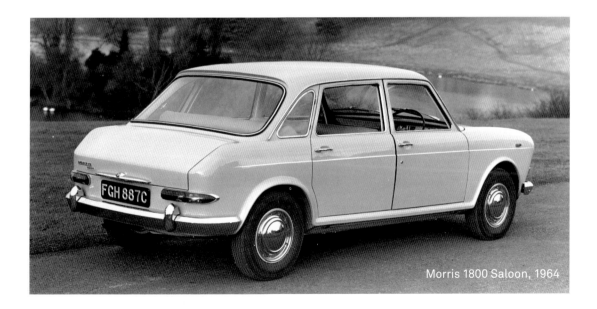

Morris 1800 Saloon, 1964

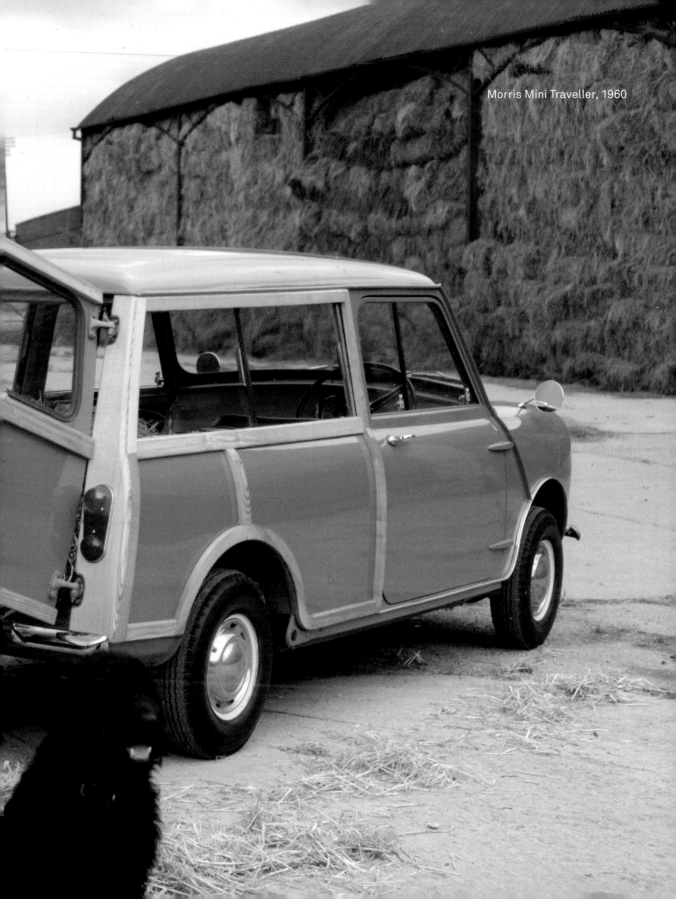

Morris Mini Traveller, 1960

JET SET

Despite the rise of democracy and communism, after the war, the aristocracy actually found itself in splendid shape. Entrepreneurs were licking their lips as their products experienced an incredible increase in demand. Television and the movie industry were producing new idols for the people. Athletes changed from being symbols of nationalist propaganda to being popular heroes. The gutter press documented the lifestyles of the rich and famous: haute couture, villas, yachts, parties, jewellery and, of course, automobiles. The era of the *concours d'élégance*—elitist celebrations of vanity, fashion and the automobile—came to an end in the 1950s. Paparazzi recorded the *dolce vita* of a smiling, glamorous, eternal in-crowd and chased the

Trotz des bürgerlichen Vormarschs steht der Adel nach dem Krieg blendend da. Angesichts unglaublicher Steigerung der Nachfrage lecken sich die Industriellen die Finger. Fernsehen und Filmindustrie produzieren neue Volksidole. Sportler mutieren von nationalistischen Propagandasymbolen zu Publikumshelden. Die Epoche der Concours d'Elegance, elitärer Feste der Eitelkeit um Mode und Automobil, neigt sich in den 1950ern dem Ende entgegen. Nun verfolgen Paparazzi das „Süße Leben" des glamourösen Jetset zwischen London und New York, Paris und Rom, Capri und Monte Carlo, Portofino und St. Tropez. Die Regenbogenpresse dokumentiert den Lebensstil der Prominenz: Haute Couture, Villen, Yachten,

À la fin de la guerre, si la bourgeoisie gagne du terrain, l'aristocratie se porte toujours à merveille. L'augmentation phénoménale de la demande en biens de consommation profite largement aux industriels. La télévision et l'industrie du film fabriquent de nouvelles idoles populaires, tels les sportifs qui ne servent plus les intérêts de la propagande nationale. La presse people relaie le mode de vie de cette nouvelle jet-set, avec ses villas, ses yachts, ses modèles haute-couture, ses soirées, et bien entendu ses voitures. Les années 50 marquent la fin des concours d'élégance, événement célébrant en grande pompe la mode et l'automobile. Les paparazzis photographient la vie insouciante de cette société mondaine, souriante et glamoureuse,

Mastroianni, Loren, Rolls, 1963

To see and be seen: the automobile radiates beauty.

Sehen und gesehen werden: das Automobil macht schön.

Voir et être vu : la voiture donne de la classe.

jet set from London to New York, Paris to Rome, Capri to Monte Carlo, Portofino to St. Tropez. The lady is wearing Paris' 'New Look', the gentleman has just ordered a bespoke car from Turin.

ONE-OFFS

In order to stand out from the crowd, the discerning driver at least needed a *fuoriserie*: limited edition custom coachwork, based on mass-production technology. The coachbuilders would introduce a new style, take orders and then start production of the desired specification. The jet set, on the other hand, preferred the *esemplare unico* made in Italy. Illustrious names made up the customer list of Pininfarina, automotive *couturier* to the stars: King Faruk of Egypt, Roberto Rossellini, Giovanni Agnelli, King Leopold of Belgium, Prince Bernhard of The Netherlands, Princess Liliane de Réthy; all were regular customers. The influence of the *fuoriserie* phenomenon on the development

Partys, Schmuck und selbstverständlich Automobile. Wie die Dame ein Kleid in Paris, lässt sich der Herr in Turin ein Auto nach Maß schneiden.

FUORISERIE

Um sich von der Masse abzuheben braucht man wenigstens eine „Fuoriserie": Sonderkarosserien in limitierter Auflage. Die Karossiers präsentieren mit jeder Saison eine neue Linie, nehmen Bestellungen auf und fertigen dann in der gewünschten Ausstattung. Der Jetset bevorzugt jedoch das „Esemplare Unico", das Unikat. Die Namen der Stammkunden von Pininfarina, dem Automobilcouturier der Sterne, sind illuster: König Faruk von Ägypten, Filmproduzent Jack Warner, Regisseur Roberto Rossellini, Millionär Giovanni Agnelli, König Leopold von Belgien, Prinz Bernhard der Niederlande, Prinzessin Liliane de Réthy. Der Einfluss des Phänomens „Fuoriserie" auf die Entwicklung des Automobildesigns

celle de la « dolce vita », et la suivent partout de Londres à New-York, Paris, Rome, Capri, Monte-Carlo, Portofino et St-Tropez. Les femmes élégantes s'offrent le New Look de Christian Dior et les hommes une voiture dessinée sur mesure de Turin.

HORS SÉRIE

Les carrosseries « fuoriserie », ces carrosseries fabriquées en série limitée et montées sur des châssis de voiture de série, sont l'accessoire idéal de l'homme qui veut se démarquer de la masse. Chaque saison, les carrossiers en présentent une nouvelle ligne qu'ils réalisent sur commande pour leurs clients avec les équipements demandés. La jet-set, leur préfère néanmoins les modèles uniques proposés par les célèbres carrossiers de Turin à l'instar des robes de balle dessinées par les grands couturiers parisiens. L'influence du phénomène « fuoriserie » sur l'évolution du design automobile a longtemps été igno-

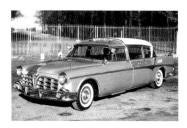

Imperial Crown Ghia, 1956

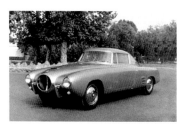

Lancia Aurelia B52 Coupé PF200 Pininfarina, 1952

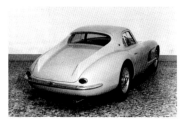

Ferrari 375 MM Berlinetta Speciale Pininfarina, 1954

of automotive design has often been underestimated. The customers' tastes and styles were beyond reproach, as these people were, after all, at home not just all over the globe, but also in the arts, architecture and fashion. They were eccentric, as well as adventurous. They commissioned the world's leading coachbuilders, but wanted also to play designer themselves. They took on the role of the classical patron, thus advocating a modern kind of art. These cars were handmade, their metal being shaped and primed in the workshop. Every detail was created to order. That just a dozen people, using only limited resources, were able to produce such a fabulous object within a few weeks seems hard to fathom. But that is exactly what constitutes the fascination of the jet set manner of coachbuilding. And yet, although the *carrozziere's* handwriting remains evident, the finished cars are as unique as the customer ordering them. While one of them may demand an eye-

wird häufig übersehen. Geschmack und Stil der Kunden sind über jeden Zweifel erhaben, schließlich sind diese Menschen auf der ganzen Welt genauso zuhause wie in der Kunst, Architektur und Mode. Sie sind exzentrisch und experimentierfreudig. Sie beauftragen die besten Karosseriebauer der Welt, spielen aber selbst Designer. Als Mäzene fördern sie eine moderne Form der Kunst. Ihre Wagen entstehen in Handarbeit, das Blech wird im Atelier modelliert, gespachtelt, lackiert. Details werden ad hoc gefertigt. Darin liegt die Faszination des Automobilbaus nach der Façon des Jetsets. Denn obwohl die Handschrift der Karossiers erkennbar bleibt, sind diese Autos so eigen wie ihre Auftraggeber. Der eine verlangt nach einer auffälligen Rakete, der andere bevorzugt klassische Eleganz. Davon angespornt, fordern sich die Autoschneider mit brillanten Ausstellungs- und Konzeptfahrzeugen gegenseitig heraus. Egal ob Paris, Genf oder Turin: bei allen

rée. Ces clients illustres, cosmopolites et fins amateurs d'art, de mode et d'architecture ont le goût sûr et un style affirmé. Cultivés, excentriques et friands d'innovation, ils font appel aux designers automobiles les plus renommés et n'hésitent pas à passer derrière les planches à dessin. Véritables mécènes au sens classique du terme, ils soutiennent le développement d'une forme moderne de l'art. Les châssis sont habillés en atelier ; le travail est artisanal, du façonnage des tôles à la finition personnalisée, en passant par les soudures et l'enduction. Chaque voiture porte certes la signature du carrossier qui en a dessiné les lignes, mais n'en reste pas moins une création aussi unique que son propriétaire, adoptant tantôt des formes aérodynamiques modernes, tantôt des lignes d'une élégance classique. Stimulés par l'enthousiasme créatif de leurs clients, les designers se lancent des défis permanents et réalisent des prototypes et des modèles d'exposition toujours plus innovants. À

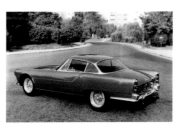

Ferrari 250 GT Speciale Boano, 1957

catching rocket, the other might prefer classical elegance. This spurred on the car *couturiers* to challenge each other with brilliant show and concept cars. No matter whether in Paris, Geneva or Turin: the Italian experiments would catch everybody's attention at any *salon*. Thus, a huge number of stylistic ideas could be tested before they were brought to the market, in a very special kind of market research. Companies like Pininfarina, Bertone, Ghia, Frua, Vignale or Zagato—similar in status to fashion designers—continued to shape the appearance of the automobile up to the 1970s. The gorgeous emblem distinguishing their creations becomes a subtle sign of distinction: a myth in and of itself.

A PLACE IN THE SUN

The roadster phenomenon was founded equally on irrationality and *joie de vivre*. The open-top sports car is a domesticated version of the Grand Prix race car:

Salons ziehen die italienischen Experimente die Aufmerksamkeit aller auf sich. Wie bei einer Art Marktforschung kann so eine Unmenge gestalterischer Ideen erprobt werden, bevor diese ihren Weg in die Serie finden. Dem Status eines Modeschöpfers vergleichbar, prägen Firmen wie Pininfarina, Bertone, Ghia, Frua, Vignale oder Zagato bis in die 1970er Jahre die Linie des Automobils. Das schmucke Wappen, das ihre Kreationen kennzeichnet, wird zum kleinen, feinen Unterschied: einem Mythos für sich.

EIN PLATZ IN DER SONNE

Dem Phänomen Roadster liegen zu gleichen Teilen Irrationalität und Lebensfreude zugrunde. Der offene Sportwagen ist die domestizierte Version des Grand-Prix-Fahrzeugs: ein Auto für Helden. Wie James Dean, der, auf dem Weg zu einem Rennen, 1955 mit seinem Porsche Spyder gegen einen Ford Custom prallt. Der

Paris, Genève ou Turin, partout les créations italiennes retiennent l'attention. Les salons automobiles servent de laboratoire test d'idées dont les meilleures seront retenues pour la production en série. À l'instar des grands couturiers, les ateliers Pininfarina, Bertone, Ghia, Frua, Vignale et Zagato marquent les lignes de l'automobile de leur empreinte jusque dans les années 70. Les plaques, ces petits bijoux appliqués par les carrossiers sur leur création, sont les marques discrètes qui font toute la différence et créent le mythe.

UNE PLACE AU SOLEIL

Le phénomène roadster relève autant de l'irrationnel qu'il est synonyme de joie de vivre. Ce cabriolet sport est la version domestiquée de la voiture de grands prix, c'est la voiture des héros. Celle d'un James Dean en route pour une compétition automobile et dont la Porsche Spyder percute une Ford Custom. Des deux conducteurs, l'un, le jeune

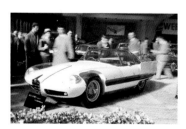

Alfa Romeo 6C 3500 Super Flow Pininfarina, 1956

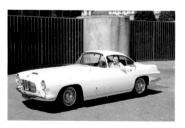

Jaguar XK 140 Coupé Ghia, 1955

an automobile for heroes, like James Dean, who died in 1955, crashing his Porsche Spyder into a Ford Custom while on his way to a race. The law abiding citizen survives, the rebel dies, and becomes a legend. In a roadster, the driver can flaunt himself like a *nouveau* Dean and bask in the admiration of others. At the same time, he can relish the panorama and the notes produced by the engine. As with the horse, the roadster is a wild means of transport for the individualist, whose stature and potency are both heightened.

There is also an erotic motivation behind the roadster's two-seat nature: it doesn't transport the family, but instead conquers the opposite sex, which is the reason why not just men, but women as well will use it with delight. The roadster is not for the faint-hearted. It is not very practical at all, its fabric roof is delicate and the whole car is overpriced. Yet, at the same time, the topless car is

brave Bürger überlebt, der Rebell stirbt – und wird zur Legende. Im Roadster kann man sich wie ein Nouveau-Dean zur Schau stellen. Gleichzeitig genießt man das Panorama und erfreut sich am Fahrspaß. Wie ehedem das Pferd ist der Roadster ein wildes Fortbewegungsmittel für Individualisten, das Statur wie Potenz seines Besitzers verstärkt.

Die Zweisitzer-Natur des Roadsters ist auch erotisch motiviert: Er befördert keine Familien, sondern erobert das andere Geschlecht. Weswegen nicht nur Männer, sondern auch Frauen gerne mit ihm unterwegs sind. Doch der Roadster ist nichts für zarte Gemüter. Er ist alles andere als praktisch, sein Stoffverdeck ist empfindlich und er ist überteuert. Dafür ist der Oben-ohne-Wagen leichter und sein Schwerpunkt niedriger, was ihn für den Einsatz als Wochenendrennwagen prädestiniert. 1948 zeigen gleich drei Fahrzeuge, wie unterschiedlich das Konzept ausgelegt werden

homme de bonne famille, survit, l'autre, le héros rebelle, meurt et devient une légende. Rouler en roadster, c'est incarner un nouveau James Dean, se donner aux regards et les savourer tout autant que le paysage et le bruit du moteur. Le roadster est le moyen de locomotion moderne des individualistes. Suggérant la liberté, tel le cheval, il exalte la stature et la puissance de son propriétaire.

Ce deux places a une composante érotique évidente : son conducteur ne véhicule pas une famille, il part à la conquête de l'autre sexe et c'est bien là l'argument majeur du roadster qui convainc homme et femme. Le roadster n'est pas non plus destiné aux âmes sensibles. Il est loin d'être pratique ; sa capote en toile est très fragile et son prix est exagérément élevé. En revanche, son faible poids et son centre de gravité abaissé en font la voiture idéale pour disputer les courses automobiles du week-end. Trois modèles sortis en 1948 illustrent les différentes dé-

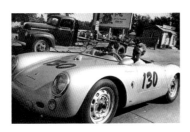

James Dean, Porsche 550 Spyder, 1955

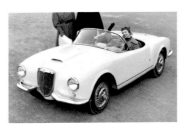

Lancia Aurelia B24 S Spider *America*, 1954

lighter and its centre of gravity lower, which makes it ideal for use as a weekend race car. In 1948, three cars simultaneously showed how differently the concept could be interpreted. England introduced the Jaguar XK120: metal and machine merging into an extremely sensuous composition of classic and modernity, taste and sex. In Italy, Touring presented the Ferrari 166 Barchetta: a body that was as athletic as can be, with its tense, pulsating 'biceps'. From Gmünd in Austria came the Porsche 356 *Nr. 1*: an ethereal, synthetic, yet still very emotional shape.

These three designs encompassed the European roadster's character: elegant, dynamic, efficient. But not elitist: the roadster is a classless genre of automobile, at whose lower end cars like the Bond Minicar Mark C or a Fiat 500, that had been converted using a few simple cuts, can be found. MG, Alfa and Triumph covered the middle section of the

kann. Aus England kommt der Jaguar XK 120. Blech und Maschine fusionieren zu einer extrem sinnlichen Mischung aus Klassik und Moderne, Aplomb und Sexappeal. In Italien stellt Touring den Ferrari Barchetta vor: eine Karosserie, wie sie athletischer nicht sein kann. Ein angespannter, pulsierender Bizeps. Aus Gmünd in Kärnten kommt Porsche 356 Nr.1: eine ätherische, synthetische und doch emotionale Linie.

Die drei Designs fassen den Charakter des europäischen Roadsters zusammen: elegant, dynamisch, effizient. Aber nicht elitär – der Roadster ist eine klassenlose Fahrzeuggattung, an deren unterem Ende Spielzeuge wie das Bond Minicar Mark C oder ein mit wenigen Schnitten umgebauter Fiat 500 stehen. MG, Alfa, Triumph, besetzen die Mitte. Ferrari & Co. sowie der mythische SL bilden die absolute Spitze. Ende der 1950er machen Hollywood und Cinecittà den Roadster

clinaisons possibles du concept de décapotable. La Jaguar XK 120 de Grande-Bretagne réussit une fusion sensuelle de la tôle et de la machine alliant modernité et classicisme, aplomb et sex-appeal. En Italie, Touring présente la Ferrari Barchetta à la carrosserie à la fois forte et athlétique, tel un muscle tendu. Et à Gmünd en Carinthie, Porsche crée la 356, son premier roadster, une voiture à la ligne éthérée, une synthèse d'émotions pures tout en retenue. Ces trois interprétations représentent parfaitement le roadster européen : élégant, dynamique et efficace sans être élitaire. Le roadster est une voiture pour tous, avec en bas de l'échelle des petits joujoux comme la Bond Minicar Mark C ou la fameuse Fiat 500 retravaillée en roadster par ajout de quelques lignes de découpe, au milieu les MG, Alfa et Triumph et tout en haut les Ferrari et consorts ainsi que la mythique SL. À la fin des années 50, Hollywood et Cinecittà font du roadster un accessoire du life-style

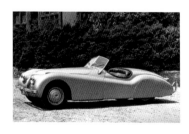

Jaguar XK 120, 1948

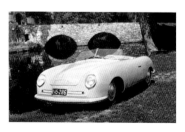

Porsche 356 *Nr. 1*
Roadster, 1948

market. Ferrari & Co. and the mythical SL form the absolute pinnacle. At the end of the 1950s, Hollywood and Cinecittà turn the roadster into a lifestyle accessory. The colourful cars are almost as good-looking on film as the actors. From 1955, Hitchcock's *To Catch a Thief* embodied the essence of the roadster lifestyle: French Riviera, beach, money and Grace Kelly behind the wheel of a Sunbeam Alpine Sports. A year later, in 1956, Roger Vadim's *And God Created Woman* portrayed a similar world, but this time supplemented with alcohol, sex, a morbid Brigitte Bardot and a Lancia Aurelia B24 Spider. Driving the same car, Vittorio Gassman lived *The Easy Life* in tragicomical style. With time, the boundaries between fiction and reality became blurred. In 1957, the infamous murder of German callgirl, Rosemarie Nitribitt, also tainted the image of her work car: a Mercedes-Benz 190 SL. And yet it is exactly this existence beyond good and evil that gives the road-

zum Lifestyle-Accessoire. Die bunten Autos machen sich beinahe so gut auf Zelluloid wie die Schauspieler. Hitchcocks *Über den Dächern von Nizza* von 1955 stellt die Essenz des Lebensstils dar: Côte d'Azur, Strand, Geld und Grace Kelly im hellblauen Sunbeam Alpine Sports. 1956 zeigt Roger Vadim in *... und immer lockt das Weib* eine ähnliche Welt, ergänzt um Alkohol, Sex – und eine morbide Brigitte Bardot mitsamt Lancia Aurelia B24 Spider. Vittorio Gassman stimmt in *Verliebt in scharfe Kurven* mit demselben Wagen tragikomische Töne an. Allmählich beginnen Fiktion und Realität sich zu vermischen. Der Skandalmord am Callgirl Rosemarie Nitribitt befleckt 1957 auch das Image ihres Dienstwagens: eines Mercedes-Benz 190 SL. Diese Existenz jenseits von Gut und Böse macht den Roadster unwiderstehlich. Egal ob Dustin Hoffman im roten Alfa in *Die Reifeprüfung* oder Ryan O'Neal mitsamt MG TC im Melodrama *Love Story*: es sind Roadsterfahrer,

moderne. Ces voitures colorées font aussi bonne figure que les acteurs sur les pellicules celluloïd. En 1955, dans son film *La Main au collet*, Hitchcock met en scène tous les attributs de ce mode de vie roadster : la Côte d'Azur, les plages, l'argent et une fabuleuse Grace Kelly dans une superbe Sunbeam Alpine Sports bleue clair. En 1956 Roger Vadim, à son tour, évoque dans *Et Dieu ... créa la femme* un monde similaire auquel il y ajoute quelques ingrédients : l'alcool, le sexe et une Brigitte Bardot quelque peu fatale dans son spider Lancia Aurelia B24. Grâce à Fellini et son film *Les Vitelloni*, le petit provincial prend lui-aussi des allures de vedette au volant de son roadster. Enfin, *Le Fanfaron*, joué par Vittorio Gassman, aux accents tragicomiques, semble annoncer déjà ces événements où se mêlent réalité et fiction. En 1957, le meurtre de la callgirl Rosemarie Nitribitt salit quelque peu l'image de son « véhicule de fonction », une superbe Mercedes-Benz 190 SL

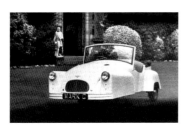

Bond Minicar Mark C, 1953

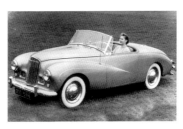

Sunbeam *Talbot* Alpine
Roadster, 1953

ster its irresistible charisma. No matter if it is Dustin Hoffman at the wheel of a red Alfa as *The Graduate* or Ryan O'Neal in an MG TC in the melodrama *Love Story*: it is always the roadster drivers who stand up against the establishment. When the spoiled Audrey Hepburn (driving a 'pagoda roof' SL in *Two For The Road*) took a melancholic look back at a youth spent in an MG, the roadster era was already nearing its end. In his bestseller, *Unsafe at Any Speed*, Ralph Nader denounces the dangerousness of American cars, particularly in the event of a rollover accident.

The European roadsters, bestsellers in the US, fall victim to this attack. Manufacturers were fearful of a general ban on convertibles and pulled the plug on any further development in this sector. But Pininfarina had got way ahead of Nader and, in 1963, he came up with a stylised rollover bar for road and race cars. Its inclusion on the Ferrari 250 P

die gegen das Spießertum aufbegehren. Dann das Ende. Im Bestseller *Unsafe at Any Speed* prangert Ralph Nader die Gefährlichkeit amerikanischer Autos an – vor allem beim Überschlag.

Auch die europäischen Roadster, Bestseller in den Staaten, fallen diesem Rundumschlag zum Opfer. Man fürchtet ein generelles Verkaufsverbots für offene Autos, weshalb Entwicklungen in diesem Bereich gestoppt werden. Nader weit voraus, erfindet Pininfarina 1963 einen stilisierten Überrollbügel für Straßen- und Rennfahrzeuge: das Rollbar-Dach. Rennwagen machen ihn zur kurzlebigen Mode. Wagemutige Linien wie die eines Porsche 914 oder die Keilform des Fiat X1/9 stehen dem Targadach gut. Doch wilder Roadster und Kopfschutz passen zusammen wie James Dean und Kondom. Zu Sex, Drugs and Rock'n'Roll-Zeiten eine ziemlich unattraktive Kombination. Ende der 1970er Jahre kann man die klassischen Modelle aus Italien

noire. Son côté obscure et son côté lumineux, voilà ce qui fascine dans le roadster ; à la fois voiture de brigand et voiture de héros en lutte contre l'establishment, tel Dustin Hoffman au volant de son Alfa rouge dans *Le Lauréat*, ou Ryan O'Neal et sa MG TC dans le mélodrame *Love Story*. Tandis qu'avec Audrey Hepburn (en Mercedes SL « Pagode ») qui se rappelle, un brin mélancolique, sa jeunesse dorée en MG dans *Voyage à deux*, l'ère du roadster touche à sa fin. Pire encore, Ralph Nader dans son bestseller *Ces voitures qui tuent* dénonce le manque de sécurité des voitures américaines en particulier en cas de tonneau.

Les roadsters européens alors très vendeurs aux Etats-Unis font très vite les frais de cette critique. Par crainte d'une interdiction générale des découvrables, leur développement est abandonné. Par contre, dès 1963 bien avant Nader, Pininfarina a trouvé la solution au problème de sécurité en

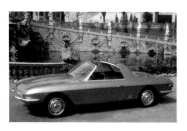

Fiat 2300 Cabriolet
Speciale Pininfarina, 1963

Ferrari 250 P, 1963

made it fashionable. Daring lines like the Porsche 914's or the wedge of a Fiat X1/9 suited the targa roof perfectly. But the wild roadster and head protection go together like James Dean and a condom: a most unattractive combination at the time of sex & drugs & rock'n'roll. At the end of the 1970s, it was still possible to purchase the classic models from Italy and England. Mercedes-Benz was even offering an astonishingly solid and safe SL. But Europe was increasingly finding itself in the clutch of oil crises and terrorism. People preferred to keep a low profile. Driving around in a roadster? No, thanks.

und England zwar noch kaufen. Mercedes-Benz bietet sogar einen bestechend soliden und sicheren SL an. Doch Ölkrise und Terrorismus beherrschen Europa. Man hält sich also lieber bedeckt. Roadsterfahren? Nein, Danke.

développant le toit Targa avec son arceau de sécurité stylisé. D'abord mis à la mode sur les voitures de course, il sera finalement adopté par les voitures conventionnelles. L'arceau épouse parfaitement les lignes audacieuses de la Porsche 914 ou celles, cylindriques, de la Fiat X1/9. Pourtant le roadster, animal sauvage, souffre de cet ajout qui lui convient aussi peu que la capote anglaise ne sied à l'attitude « sex, drugs and rock'n roll » des James Dean de l'époque. À la fin des années 70, les modèles classiques d'Italie et de Grande-Bretagne sont certes toujours disponibles sur le marché et Mercedes-Benz sort même un SL, modèle en son genre de solidité et de sécurité. Pourtant la crise du pétrole et le terrorisme qui dominent alors l'Europe ne tardent pas à sonner le glas de la conduite en roadster.

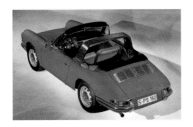

Porsche 911 Targa, 1965

Fiat X1/9, 1972

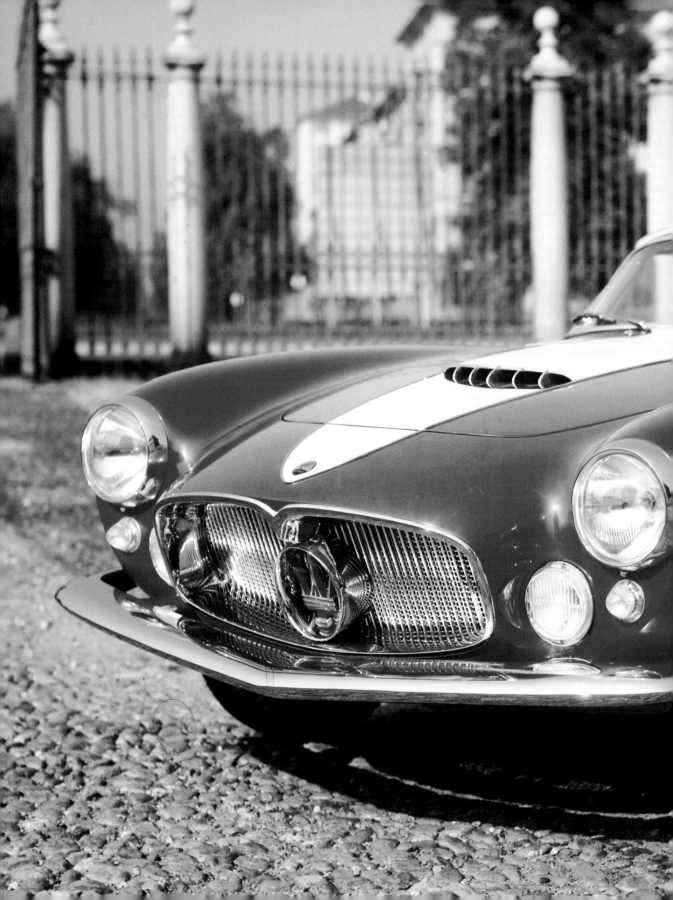

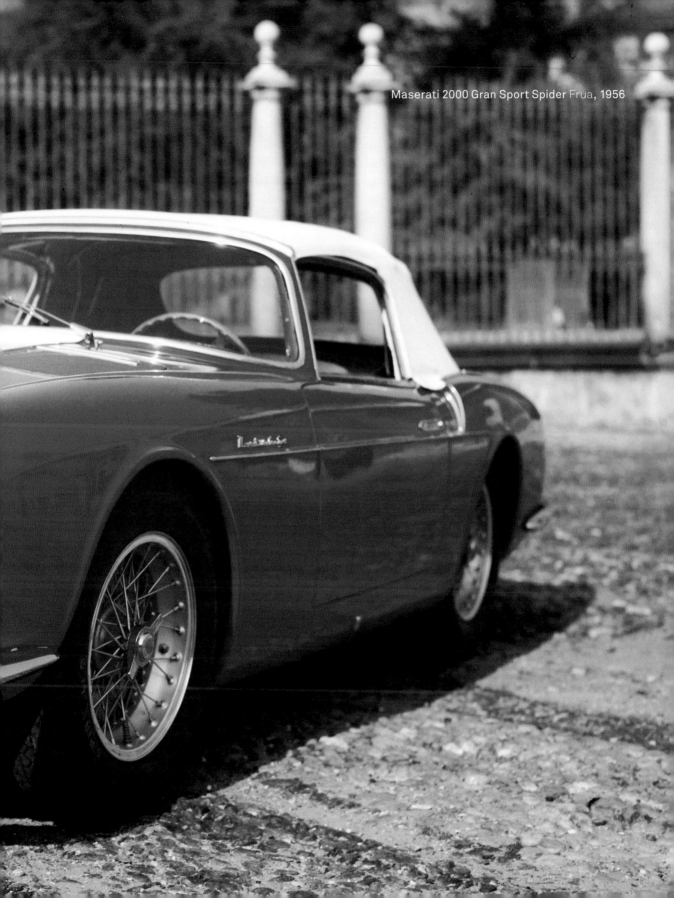

Maserati 2000 Gran Sport Spider Frua, 1956

GHIA

Giacinto Ghia's car bodies give automobiles wings. Wonders such as the Gilda or the fantastic Imperial limousines were the results of collaboration with Chrysler. Ghia built bridges in the automotive world: the Chrysler D'Elegance therefore became the Volkswagen Karmann-Ghia, the Lincoln Futura was turned into Batman's Batmobile. Kings ordered their city or beach vehicles here. These objects of desire were named Supergioiello and Supersonic. Subsequently, the Renault Floride, Volvo P1800 and the Fiat coupé each were emblazoned with that beautiful crest, before it went on to adorn the more beautiful Ford models.

Giacinto Ghias Karosserien verleihen Flügel. Aus der Zusammenarbeit mit Chrysler entstehen Wunder wie der beflügelte Gilda und die phantastischen Imperial-Limousinen. Ghia verbindet: Aus dem Chrysler D'Elegance entsteht der Volkswagen Karmann-Ghia, aus dem Lincoln Futura Batmans Batmobile. Könige bestellen hier ihre Stadt- und Strandwagen. Die Objekte der Begierde hören erst auf die Namen Supergioiello und Supersonic. Dann prangt das Wappen auf Renault Floride, Volvo P1800 und dem Fiat Coupé, bevor es die schöneren Ford-Modelle schmückt.

Les carrosseries de Giacinto Ghia donnent des ailes. Avec Chrysler, Ghia se surpasse. De cette collaboration résulteront de véritables merveilles comme la Gilda aux ailerons proéminents et la sublime série Imperial. Ghia forment des alliances multiples : la Volkswagen Karmann-Ghia est inspirée de la Chrysler D'Élégance, la Batmobile de Batman se base sur la Lincoln Futura. Il livre aux rois voitures de ville et de plage, des objets du désir nommés Supergioiello ou Supersonic. Plus tard, ce sont les Renault Floride, Volvo P1800 et la Fiat Coupé qui arboreront ce blason, avant d'aller orner les plus beaux modèles de Ford.

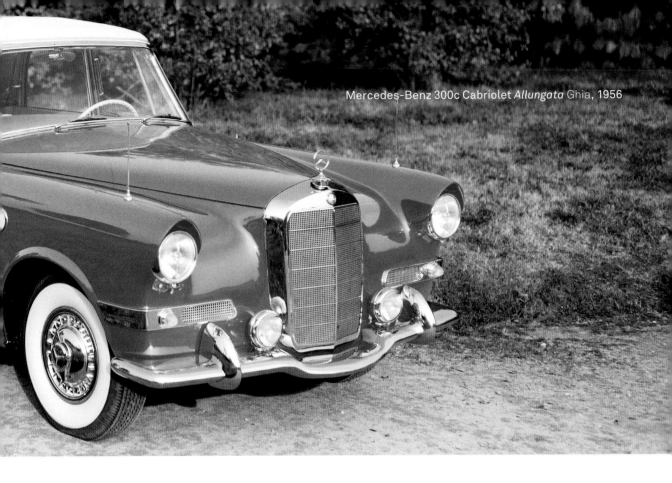

Mercedes-Benz 300c Cabriolet *Allungata* Ghia, 1956

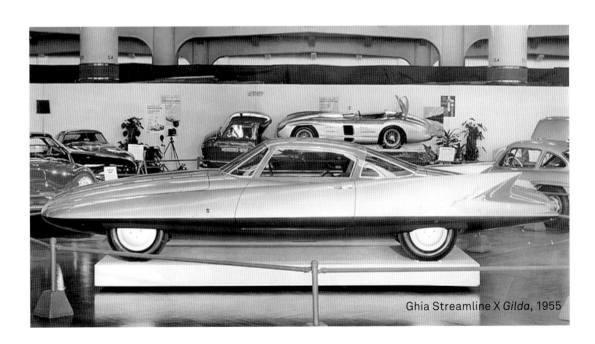

Ghia Streamline X *Gilda*, 1955

PININFARINA

God and the automobile. At the age of twelve, young Battista 'Pinin' Farina was an apprentice: at seventeen he was already head of design at *Stabilimenti Farina*, his brother's factory. He established *Carrozzeria Pinin Farina* at the age of 37. At 50, he was a star, celebrated all over the world, his face plastered everywhere in the States. The autodidact did not draw. His cars were created directly in metal, at his workshop. The fifties were his golden years. The *gran signore* passed away in 1966, at a time when his *carrozzeria*, working on behalf of the world's première marques and customers, had reached its creative peak. Yet elegance remained an affair of honour at the house of Pinin

Gott und das Automobil. Mit zwölf ist der kleine Battista „Pinin" Farina Lehrling, mit siebzehn bereits Designchef bei Stabilimenti Farina, dem Werk seines Bruders. Mit 37 gründet er seine Carrozzeria Pinin Farina. Mit 50 wird er weltweit wie ein Star gefeiert, sein Gesicht plakatiert die Staaten. Der Autodidakt zeichnet nicht. Seine Autos – am liebsten Lancia – werden direkt aus Blech, in der Werkstatt erschaffen. Die Fünfziger sind seine goldenen Jahre. Der Gran Signore stirbt 1966, als seine Carrozzeria, die für die besten Marken und die besten Kunden der Welt arbeitet, ihren kreativen Höhepunkt erreicht. Doch Eleganz bleibt weiterhin Ehrensache im Hause Pinin Farinas. Sohn Sergio verkörpert das Motto

Dieu et la voiture. À douze ans Battista « Pinin » Farina est apprenti, à dix-sept ans il est designer en chef de Stabilimenti Farina, l'atelier de son frère. À 37 ans, il fonde les Carrozzeria Pinin Farina. À 50 ans, il est une star acclamée de par le monde. Ses voitures – de préférence des Lancias – cet autodidacte ne les dessine pas. Il les forme en atelier, directement à partir de la tôle. Ses années d'or seront les années 50. Le Gran Signore s'éteint en 1966, alors que sa Carrozzeria est à l'apogée et qu'elle sert les plus grandes marques et les plus prestigieux clients du monde. Chez Pinin Farina, l'élégance est une affaire d'honneur, une philosophie incarnée parfaitement par son fils, Sergio. Ingénieur, entrepreneur,

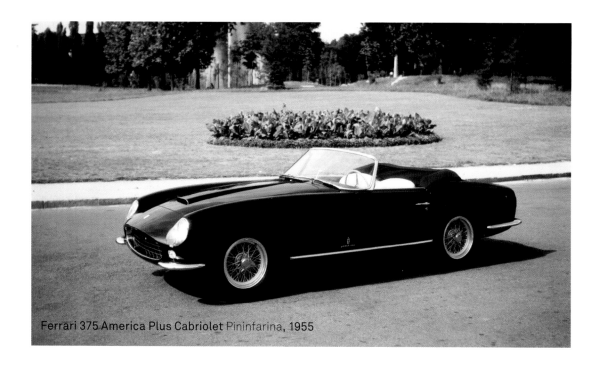

Ferrari 375 America Plus Cabriolet Pininfarina, 1955

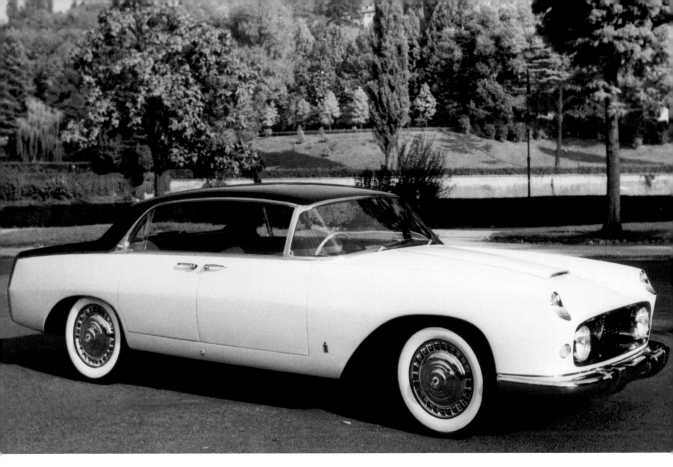

Lancia Aurelia Florida Berlina Pininfarina, **1955**

Farina. His son, Sergio, embodies this motto best: he is not a designer, but an engineer, businessman, president of the Confederation of Industry and senator of the republic. Handpicked designers took care of the house's taste on his behalf. The recipe for success consisted of stylistic continuity, creative panache and uncompromising sophistication. Pininfarina always knows how to surprise at the right time, like in 1955, when the Lancia Florida gave the automobile a modern body shape, and in 1966, with the presentation of no fewer than four Spider models for Alfa Romeo, Ferrari and Fiat, each one of them more handsome than the last.

am besten: Er ist kein Designer, sondern Ingenieur, Unternehmer, Präsident des Verbands der Industrie und Senator der Republik. Für ihn hüten auserwählte Designer den Geschmack des Hauses. Die Schöpfungen sind zum Erfolg prädestiniert, Kunden halten die Treue. Das Erfolgsrezept besteht aus stilistischer Kontinuität, kreativem Elan und kompromissloser Feinheit. Zur richtigen Zeit weiß Pininfarina immer wieder zu überraschen. 1955 mit dem Lancia Florida, der dem Automobil eine moderne Form verleiht, und 1966 mit gleich vier Spider-Modellen für Alfa Romeo, Ferrari und Fiat, eins davon schöner als das andere.

président de la Fédération des Industriels et sénateur de la République, il n'est pas designer. Ce sont donc des designers externes, triés sur le volet qui veillent au style de la maison. Les créations plaisent immanquablement et la clientèle est fidèle. Continuité stylistique, élan créatif et raffinement sans compromis sont les ingrédients de ce succès. Sans oublier un sens du timing, grâce auquel Pininfarina lance toujours au bon moment des modèles qui étonnent, dont la Lancia Florida en 1955 qui marque la naissance de la voiture moderne et les quatre modèles spider pour Alfa Romeo, Ferrari et Fiat qui se surpassent de beauté en 1966.

Battista Pinin Farina

The impeccable eye of Pinin Farina: an employee tells him that a Ferrari showcar is ready for the paintshop. Pinin criticises the rear as being too wide: three millimetres needs to be taken away on each side. The decision is taken not to make any changes, as 'the old man' wouldn't notice anyway, once the car has been painted. With that done, Pinin returns, looks at the shining car and immediately leaves again. He asks the foreman into his office: "I'm sorry, I was wrong, we need to take *another* three millimetres away".

Das Auge des Pinin Farina: ein Mitarbeiter meldet, dass ein Ferrari-Prototyp bereit für die Lackierung sei. Pinin aber ist das Heck zu breit – je Seite sollten daher bitte drei Millimeter weggenommen werden. Man entscheidet schließlich, nichts zu ändern, da „der Alte" nichts merken werde, sobald der Wagen lackiert ist. Pinin wirft einen Blick auf den glänzenden Ferrari, geht wieder. Er bittet den Meister ins Büro: „Verzeihung, ich habe mich geirrt, wir müssen noch drei Millimeter wegnehmen".

L'œil de Pinin Farina : un employé annonce qu'un prototype Ferrari destiné à un salon vient d'être terminé. Pinin, trouvant l'arrière trop large, demande une retouche de trois millimètres de chaque côté. L'équipe décide de ne rien changer, se disant qu'une fois la voiture peinte, le vieux maître ne s'apercevra de rien. Après un coup d'œil sur la voiture terminée, Pinin sort de l'atelier, fait venir l'ouvrier dans son bureau et lui demande, en s'excusant de s'être trompé, de supprimer encore trois millimètres.

Fiat 1800 Coupé Speciale Pininfarina, 1962

MASERATI

The marque with the *Tridente Bolognese* unjustly lives in the shadow of the Prancing Horse from Maranello. During the fifties, Maserati was just as successful at racing as before the war. And those who consider a Ferrari a toy of the *nouveaux riches* definitely prefer a Maserati. The rivalry is obvious: the Superleggerabodied 3500 G.T. was Maserati's emphatic answer to the Ferrari 250 GT. Yet confronted with Maserati's 5000 G.T., the most exclusive and powerful automobile of its time, even Ferrari remained speechless.

Die Marke mit dem Bologneser Dreizack lebt zu Unrecht im Schatten des Pferdes aus Maranello. Maseratis Erfolge im Rennsport sind in den Fünfzigern so zahlreich wie bereits vor dem Krieg. Wem ein Ferrari zu sehr Spielzeug für Neureiche ist, für den ist ein Maserati genau das Richtige. Die Rivalität ist unübersehbar: der 3500 G.T. mit Superleggera-Karosserie ist Maseratis klare Antwort auf den Ferrari 250 GT. Doch angesichts Maseratis 5000 G.T., dem exklusivsten und stärksten Automobil jener Zeit, bleibt selbst Ferrari sprachlos.

Maserati, la marque au trident de Bologne, vit aujourd'hui injustement dans l'ombre du cheval de Maranello. Les innombrables victoires en course automobile, remportées par les bolognais avant la guerre et dans les années 50 n'y changeront rien. D'autre part, leur rivalité est établie : ceux pour qui une Ferrari fait nouveau riche, se tournent vers Maserati. Les marques se copient : la 3500 G.T. avec carrosserie superlégère vient en réponse directe à la Ferrari 250 GT. Mais, face à la Maserati 5000 G.T., la voiture la plus puissante et la plus classe de l'époque, Ferrari restera sans réplique.

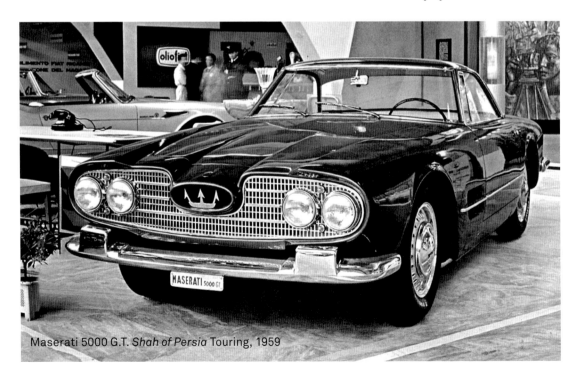

Maserati 5000 G.T. *Shah of Persia* Touring, 1959

Maserati 3500 G.T. *Dama Bianca* Touring, 1957

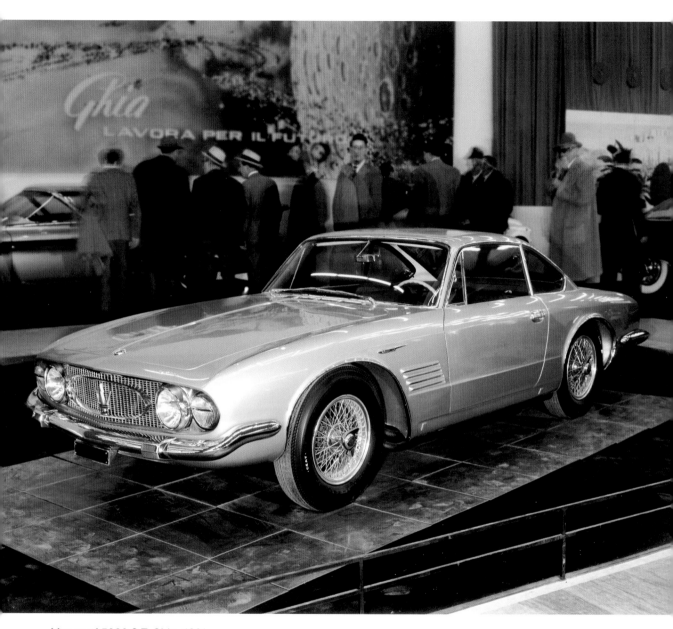

Maserati 5000 G.T. Ghia, 1961

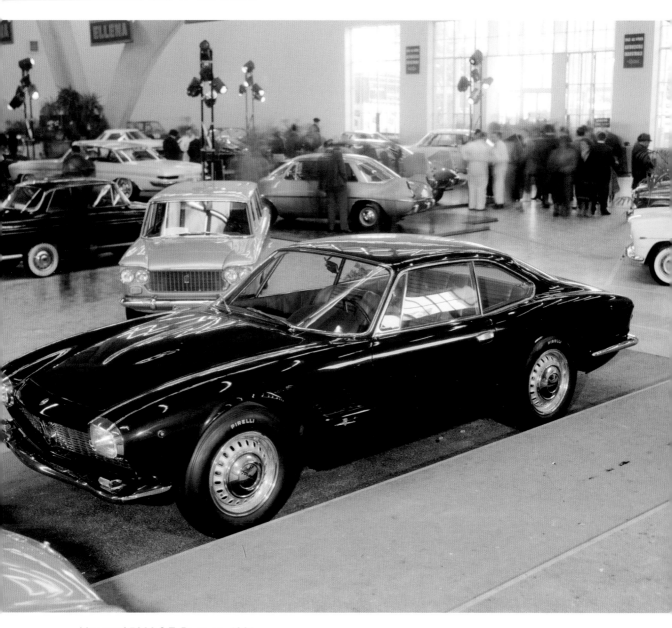

Maserati 5000 G.T. Bertone, 1961

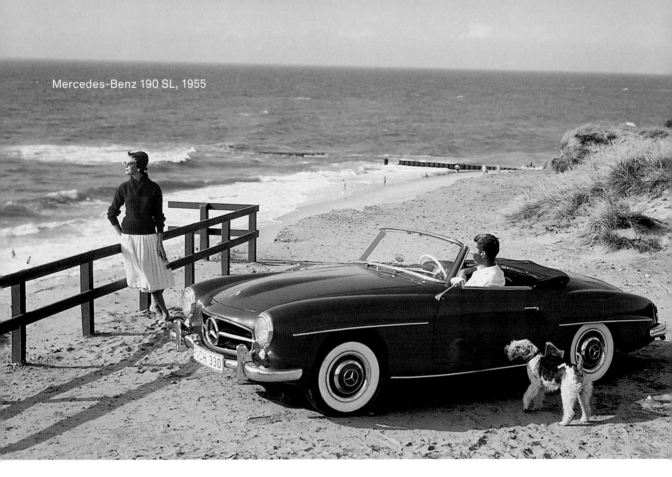

Mercedes-Benz 190 SL, 1955

MAX HOFFMAN

As an export pioneer, the Viennese, Max Hoffman, opened an automobile showroom on New York's Park Avenue, immediately after the end of the war. Alfa Romeo and Fiat, Austin Healey and Jaguar but, above all, BMW, Mercedes-Benz, Porsche and, in a sense, Volkswagen too, get a toe-hold the United States thanks to Hoffman. And vice versa. The gentleman, who lives in a house by architect Frank Lloyd Wright, is a master at scouting trends. He understands what the Americans like and has it built in Europe. Therefore the Porsche Speedster is just as much Hoffman's idea as is the Mercedes SL.

Als Pionier des Exports eröffnet der Wiener Max Hoffman direkt nach Kriegsende an der New Yorker Park Avenue einen Automobil-Showroom. Alfa Romeo und Fiat, Austin Healey und Jaguar, vor allem aber BMW, Mercedes-Benz, Porsche und gewissermaßen auch Volkswagen lernen durch Hoffman Amerika kennen. Und umgekehrt. Der Gentleman, der in einem Haus des Architekten Frank Lloyd Wright residiert, ist ein Meister im Aufspüren von Trends. Er begreift, was die Amerikaner mögen, und lässt es in Europa bauen. So ist der Porsche Speedster genauso Hoffmans Idee wie der Mercedes SL.

Pionnier de l'exportation, le viennois Max Hoffman ouvre, juste après la guerre, un show-room automobile sur la Park Avenue de New-York. Grâce à lui, Alfa Romeo et Fiat, Austin Healey et Jaguar, mais surtout BMW, Mercedes-Benz, Porsche et dans une certaine mesure Volkswagen entrent en contact avec les Etats-Unis et vice-versa. Ce gentleman qui réside dans une des maisons de l'architecte Frank Lloyd Wright a le don de détecter les tendances. Il comprend les goûts des Américains et commande en Europe les modèles qu'ils apprécieront. Hoffman souffle l'idée de la Speedster à Porsche et de la SL à Mercedes-Benz.

ALBRECHT GRAF GOERTZ

When Max Hoffman advised the designer Albrecht Goertz to send a few sketches to Munich, he could not have suspected the ramifications. The presentation of the BMW 503 and 507 models promptly put Goertz in the limelight. The 507 sports car in particular turned out to be a darling of the public, but, even so, the car is both extremely unprofitable and highly iconic for BMW. Its 'long-legged' body evoked the appearance of a scantily-dressed young woman, something that was rather provocative for the time.

Als Max Hoffman dem Designer Albrecht Goertz empfiehlt, doch mal ein paar Skizzen nach München zu schicken, kann niemand ahnen, was für Auswirkungen dies haben würde. Denn die Vorstellung der neuen Modelle BMW 503 und 507 befördert Goertz schlagartig ins Rampenlicht. Insbesondere der offene Sportwagen 507 hat es der Öffentlichkeit angetan – und das obwohl er für BMW äußerst unrentabel ist. Mit seiner hochbeinigen Anmutung hat der Münchner Roadster die – für jene Zeit – provokante Ausstrahlung einer Dame mit einem viel zu knappen Kleid.

Quand Max Hoffman suggère au designer Albrecht Goertz d'envoyer quelques unes de ses esquisses à Munich, il ne peut imaginer les retentissements de son conseil. Goertz devient célèbre du jour au lendemain suite à la présentation de ses modèles BMW 503 et 507. Le public appréciera tout particulièrement le cabriolet de sport 507, pourtant à peine rentable pour BMW, et aux allures presque vulgaires. Monté sur de trop grandes roues, le roadster munichois fait penser à une dame à la robe délibérément trop courte.

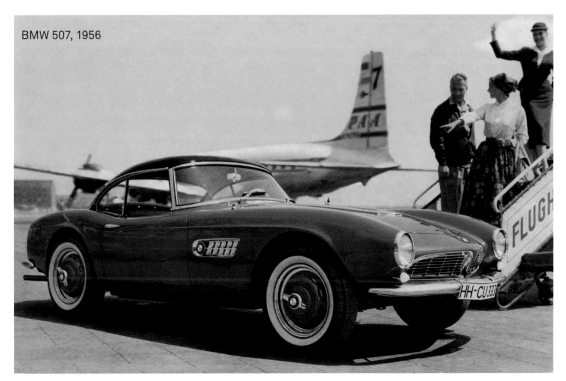

BMW 507, 1956

 Aus der Reihe der großen *Achtzylinder*

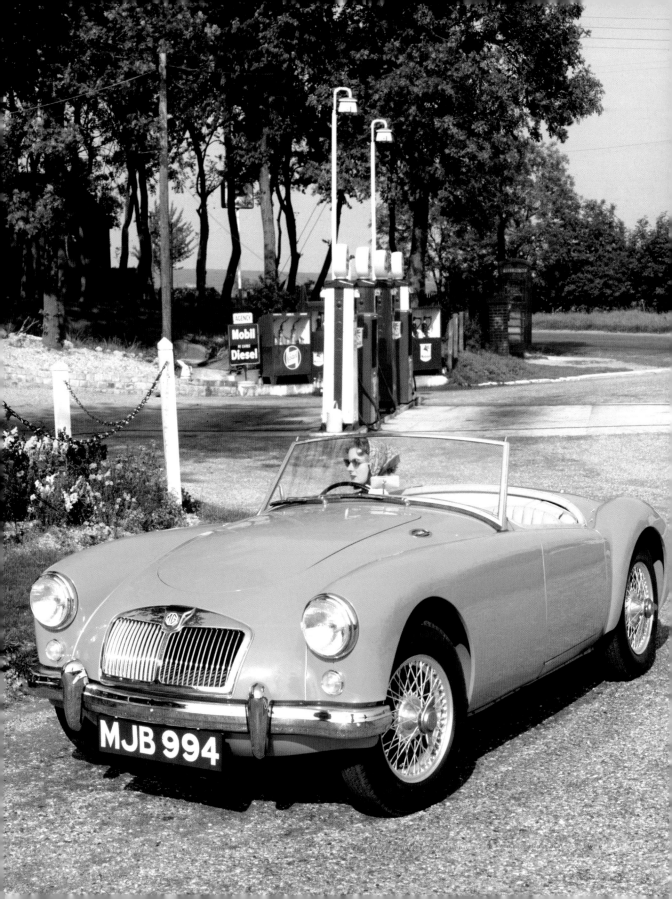

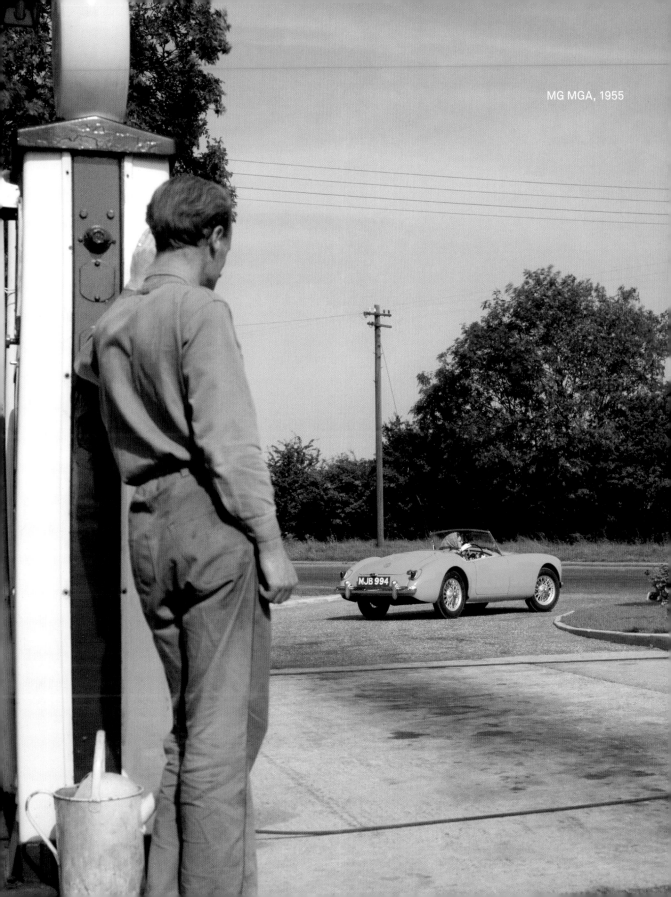

MG MGA, 1955

Austin Healey 3000, 1959

Triumph TR6, 1968

ROADSTER

One of the few revolutions of British design was brought about when the MG A broke with the pre-war tradition of protruded wings in 1955. Together with the larger Austin Healey, it embodies the archetypal, classic British roadster. The contoured belt line, which runs into a small door just ahead of the wheel arch, was characteristic. Driver and passenger were at one with the elements. Triumph, in contrast, was seen as being innovative and extravagant. Triumph's design, by Michelotti of Italy, was always surprising: the Herald was fashionable, the TR4 elegant, the Spitfire youthful. The TR6, a TR4 as revised by Karmann in Germany, intones the swan song for this automotive concept, which was popular all over the globe.

Es ist eine der seltenen Revolutionen im britischen Design, als 1955 der MG A mit der Vorkriegstradition fliegender Kotflügel bricht. Gemeinsam mit dem größeren Austin Healey stellt er das Sinnbild des klassischen britischen Roadsters dar. Typisch ist die geschwungene Gürtellinie, die kurz vor dem Radlauf in eine niedrige Tür mündet. Fahrer und Beifahrer sind eins mit den Elementen. Triumph gilt hingegen als innovativ und extravagant. Das Design, von Michelotti aus Italien, ist immer überraschend: modisch beim Herald, elegant beim TR4, jugendlich beim Spitfire. Der TR6, ein von Karmann in Deutschland überarbeiteter TR4, stimmt den Schwanengesang eines in aller Welt beliebten Automobilkonzeptes an.

La sortie en 1955 de la MG A qui rompt avec la tradition d'avant-guerre des ailes renflées marque une des rares révolutions du design britannique. La MG A et l'Austin Healey deviennent les archétypes du roadster britannique, caractérisé par la ligne de caisse horizontale arquée, délimitée à l'arrière par une porte basse, sur laquelle elle s'achève avant la courbure du passage des roues. Conducteur et passager ne font qu'un avec les éléments. D'un autre côté, il y a Triumph, plus innovateur et extravagant, dont le style signé par l'Italien Michelotti se réinvente à chaque modèle : très mode avec l'Hérald, élégant avec la TR4 et jeune avec la Spitfire. Mais déjà la fin de ce concept automobile, tant apprécié, pointe à l'horizon avec la TR6, une TR4 retravaillée par Karmann en Allemagne.

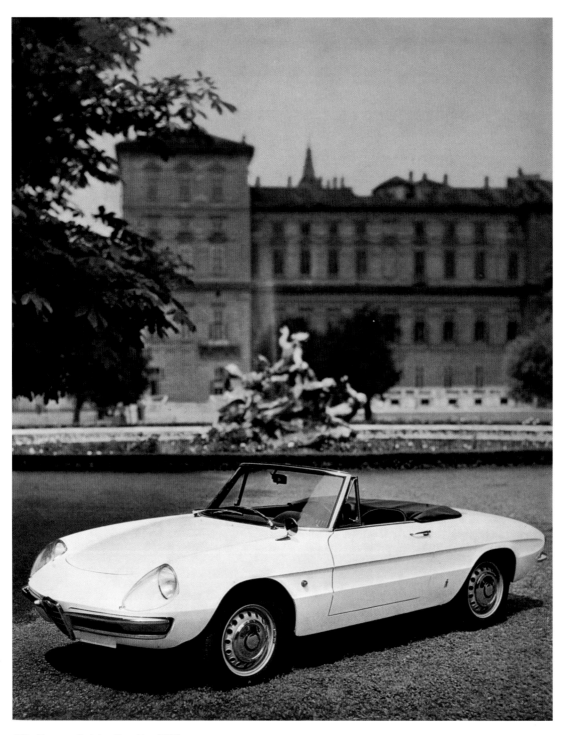

Alfa Romeo Spider *Duetto*, 1966

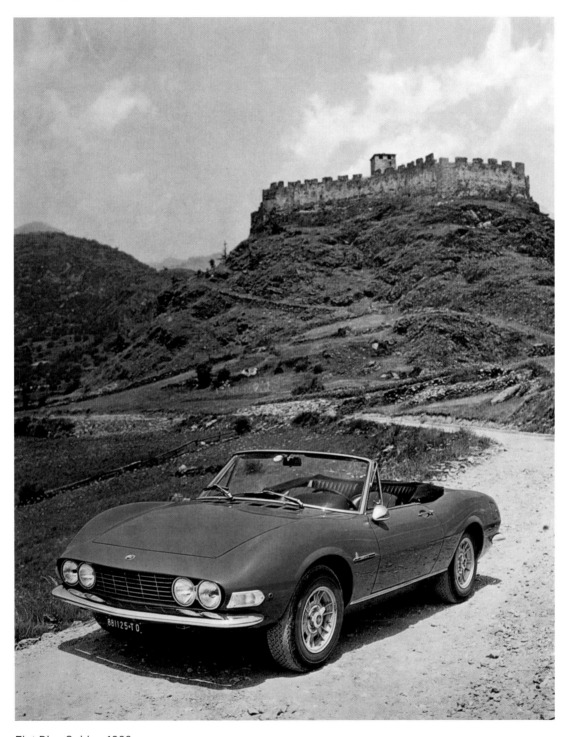

Fiat Dino Spider, 1966

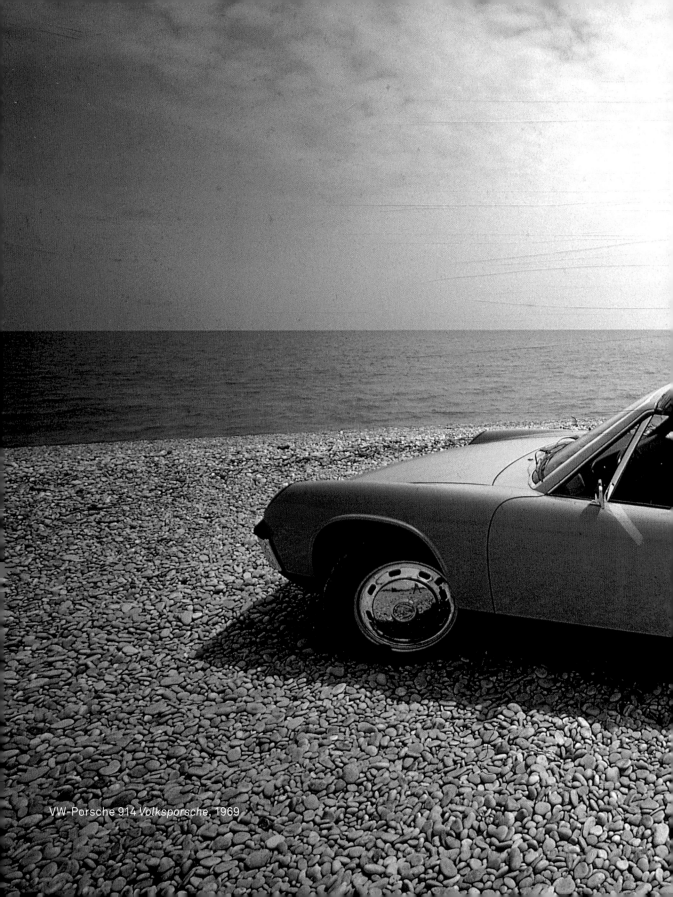

VW-Porsche 914 *Volksporsche*, 1969

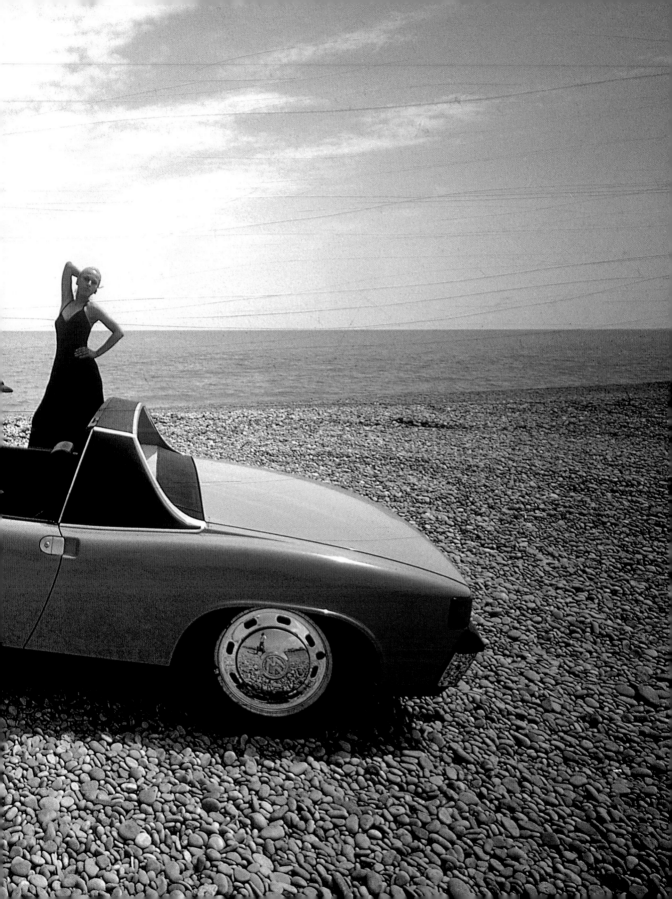

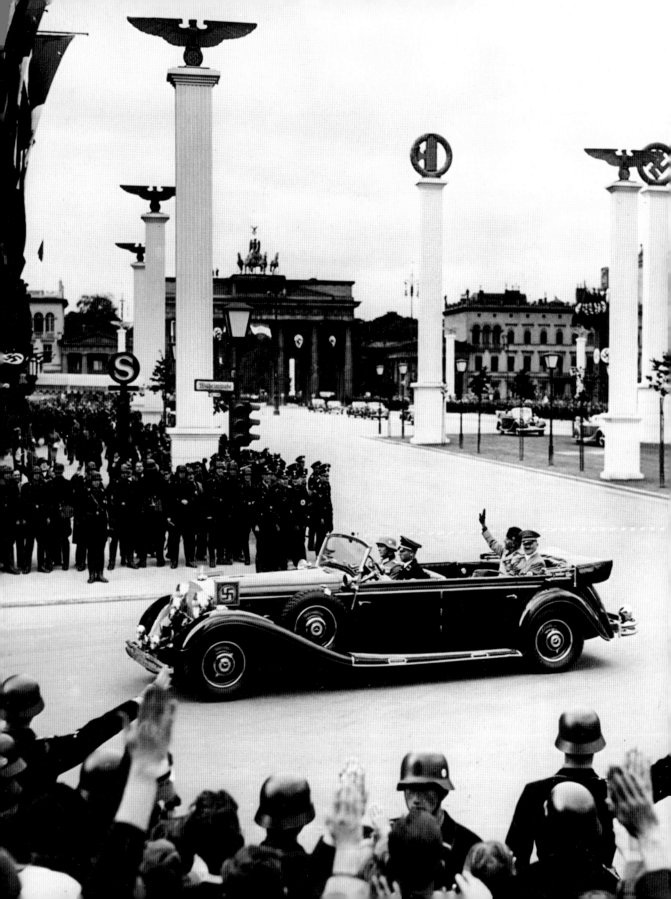

MOTUS SYMBOLS

In pre-war times, Europe's fascist dictators liked to bask in the automobile's progressive image. Mussolini would pilot sleek race cars in front of turning cameras and Hitler—who did not own a driving licence—personally devised a car for his people. With almost fanatical obsession, they each had the longest, mightiest and most modern state limousines made to order. During parades, the cars increased the aura of these two small men and were transformed into mobile podiums: a symbol of their power. Thanks to their ubiquity in newspapers and propaganda films, the black limousines became a popular myth. In post-war times—in 1953, to be precise—Queen Elizabeth II's coronation became the first global TV event. The world is beginning to think in images.

Berlin 1937: Die faschistischen Diktatoren Europas sonnen sich im progressiven Image des Automobils. Mit nahezu fanatischer Obsession lassen sich Mussolini und Hitler die längsten, mächtigsten und modernsten Staatskarossen nach Maß fertigen. Die Paradelimousine potenziert die Aura dieser kleinen Männer und wird als mobiles Podest zum Machtsymbol. Ihre Allgegenwart in Zeitungen und Propagandafilmen macht die dunkle Limousine zum Volksmythos. London 1953: die Krönung Königin Elizabeths II. ist das erste globale TV-Ereignis. Die Welt beginnt in Bildern zu denken. Die junge Königin übergeht das Auto und fährt in der Staatskutsche von 1762 vor: acht Pferde, sieben Meter, vier Tonnen, überall Gold. Dieser viktorianische Traditionalismus soll

Avant la guerre, les dictateurs fascistes européens utilisent l'image progressiste de la voiture pour leur propagande personnelle. Sous l'emprise d'une obsession quasi fanatique, Mussolini et Hitler passent commande de voitures d'apparat fabriquées sur mesure censées battre tous les records aussi bien par leur taille, leur puissance, que leur modernité. Érigés sur leur piédestal mobile, ces hommes de petite taille voient ainsi leur aura décupler. Les limousines de parade font la démonstration de leur puissance. Omniprésentes dans les journaux et les films de propagande, ces voitures de couleur sombre deviennent un mythe populaire. Après la guerre, en 1953, le couronnement de la reine Elizabeth II est le tout premier événement télévisé à portée mondiale. Le

Berlin, 1937

The pompous ride in the 'Big Mercedes' leaves an imprint on the collective image.

Die theatralische Spazierfahrt im Großen Mercedes prägt das kollektive Bild.

Savamment orchestrées, les promenades en la Grande Mercedes, marquent l'imaginaire collectif.

The young queen eschewed the automobile in favour of being driven up to her wedding in her state carriage, dating from 1762: eight horses, seven metres long, four tons heavy, gold everywhere. In the eye of the beholder, the images of the pompous gilt carriage and the mighty black state car merged. Good and evil are united. The myth of the limousine reaches a state of perfection.

THE STATE LIMOUSINE

The pre-war elite was struggling with the aspiring middle class, which was, in turn, dreaming of a modern lifestyle. While the *nouveaux riches* were becoming increasingly demanding, the 'old money' returned to Victorian values. The 'Fine English Car Tradition', made up of stylistic elements somewhere between Greek temple and Buckingham Palace—such as a characteristic radiator grille and wings full of

London, 1953

Real gold, real horses: the new Queen is conveyed in the style of the good old days.

Echtes Gold, echte Pferde: Die neue Königin fährt wie in der guten alten Zeit.

De l'or et des pur-sang : la nouvelle reine roule comme au bon vieux temps.

klarmachen: die Guten sind zurück. Im Auge des Publikums verschmelzen die Bilder der pompösen goldenen Kutsche und der mächtigen schwarzen Staatskarosse. Gut und Böse vereinen sich. Der Mythos Limousine reift zur Perfektion.

STAATSLIMOUSINEN

Die Vorkriegselite hadert mit dem aufsteigenden Bürgertum, das vom modernen Lebensstil träumt. Während die Neureichen beginnen, Ansprüche zu stellen, zieht sich das „alte Geld" ins Viktorianische zurück. Man goutiert „The English Fine Car Tradition" mit Stilelementen zwischen griechischem Tempel und Buckingham Palace. Markanter Kühlergrill und schwungvoll ausgeprägte Kotflügel werden geschätzt, das funktional-bürgerliche Stufenheck hingegen wird kaschiert. Wer will, erkennt in Großbritannien zwei miteinander verwandte

monde commence à penser en termes d'images. À la voiture, la jeune reine préfèrera la calèche d'État de 1762 parée de milles dorures, tirée par huit chevaux, longue de sept mètres et pesant quatre tonnes. Le traditionalisme victorien sert à marquer le retour des « justes ». Aux yeux du public, les bons et les mauvais se mélangent à l'image de cette pompeuse calèche dorée, entourée de puissantes limousines d'État noire. Le mythe de la limousine atteint la perfection.

LIMOUSINES D'ÉTAT

L'élite d'avant-guerre voit d'un mauvais œil l'arrivée de cette bourgeoisie montante qui rêve d'un style de vie moderne. Alors que les nouveaux riches commencent à exprimer leurs revendications, les riches établis, eux, se replient dans le victorianisme. On se repaît de cette « English Fine Car Tradition » aux élé-

verve—was greatly appreciated, yet the functional, as well as bourgeois, notchback was hidden away. Two related British schools of styling can be identified at this time: on the one hand, there is the sinuous, sensuous, shaped-by-the-wind Jaguar Mk VII and, on the other, there is the upright, jutting, impenetrable Rolls-Royce Silver Dawn. The latter also featured the marque's first standard factory-built body. These two worlds merged in the smooth 1955 Silver Cloud, which remained true to the stepless carriage shape, whose semantics could not be more obvious: the show begins with the mighty machine and ends with mighty people. The chauffeur and luggage are both irrelevant. It was the Big Mercedes, of all cars, that was surprising in this regard with its democratic shape, leading to its being christened the 'Bonn Volkswagen'. But the 300's long tail is deceptive: symbolism is sacrificed only to safety, as the rear was not a boot in the Mercedes engineers'

Gestaltungsschulen: einerseits die gewundene, sinnliche, vom Winde verwehte des Jaguars Mk VII, andererseits die aufrechte, verwinkelte, undurchdringliche des Silver Dawn, des ersten Rolls-Royce mit einer Standardkarosserie. Im sahnigen Silver Cloud treffen 1955 beide Welten aufeinander, aber es bleibt bei der Kutschenform, deren Semantik eindeutig ist: Die Show beginnt mit der mächtigen Maschine und endet mit mächtigen Menschen. Chauffeur und Gepäck sind irrelevant. Ausgerechnet der neue Große Mercedes überrascht da mit demokratischer Form, weswegen man ihn auch „Bonner Volkswagen" nennt. Doch das lange Heck des 300 täuscht: Er opfert die Symbolik einzig der Technik. Die Heckstufe ist für die Mercedes-Entwickler kein Kofferraum, sondern Sicherheitsknautschzone. Trotzdem stellt der Stil des 300 – imposant, streng, raffiniert – die ideale Fortsetzung des fortschrittlichen Mercedes-Benz-Designs der 1930er Jahre

ments décoratifs oscillant entre le temple grec et le Buckingham Palace. Calandres prononcées et ailes renflées sont de mise, les poupes aux coffres fonctionnels se font discrètes. L'œil avisé reconnaitra en Grande-Bretagne deux écoles de style, distinctes mais apparentées : l'une aux lignes flexueuses, sensuelles et éphémères que la Jaguar Mk VII illustre parfaitement, et l'autre, au style droit, anguleux, compact et impénétrable adoptée pour la Silver Dawn, cette toute première Rolls-Royce habillée d'une carrosserie de série. La Silver Cloud de 1955, elle, mélange les deux styles. Une voiture surprend, la Grande Mercedes 300, dont la forme démocratique à longue poupe lui vaudra le nom de « Volkswagen de Bonn ». La symbolique importe peu, sacrifiée au profit de la technicité : cette poupe trompeuse n'abrite pas le coffre mais correspond à la zone de déformation. Par son style imposant, sévère et raffiné, la 300 est dans la droite ligne du design progres-

Jaguar Mk VII, 1950

Rolls-Royce Silver Dawn, 1949

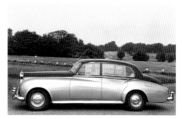

Rolls-Royce Silver Cloud, 1955

eyes, but a safety crumple zone. And yet the 300's style—imposing, stern, refined—represented the ideal continuation of Mercedes-Benz's advanced designs of the 1930s. This is not very surprising, given the fact that Adenauer's Mercedes, like Hitler's limousine, was designed by Hermann Ahrens, head of Sindelfingen's special body department. Heads of state, popes and kings were won over by his designs, whose parade style was still very much the same as it always was. In 1964, the state limousine's swan song arrived in the shape of the rigorous, unadorned—in a word, perfect—Mercedes 600. Though sumptuous and, in Pullmann guise, clearly following in the tradition of the state limousine, its design concept was thoroughly *bourgeois*. It actually had not been endowed with as much ornament as its smaller siblings. In all its perfection, the 600 was a *ne plus ultra*—the last of its era, just as the formerly stalwart Rolls-Royce was performing a daring

dar. Kein Wunder: So wie Hitlers Limousine, trägt auch Adenauers Mercedes die Handschrift Hermann Ahrens', seines Zeichens Leiter der Sonderwagenabteilung in Sindelfingen. Staatschefs, Päpste und Könige greifen zu, am Paradestil ändert sich wenig. 1964 gibt die Staatskarosse dann ihren Schwanengesang in Form des rigorosen, schlichten – in einem Wort: perfekten – Mercedes 600. Er ist zwar prächtig und steht als Pullmann-Versionen deutlich in der Tradition der Staatskarossen, doch sein Designkonzept ist bürgerlich. Er wird sogar mit weniger Schmuck versehen als seine kleinen Markenbrüder. In all seiner Perfektion ist der 600 das Nonplusultra – das letzte einer Ära, denn ausgerechnet Rolls-Royce wagt 1965 einen mutigen Salto Mortale. Der Silver Shadow ist geradlinig, sachlich, überschaubar. Gegenüber dem Cloud wirkt er fast unsichtbar. Sein Stufenheck ist unübersehbar. Der Besitzer steigt auch noch vorne ein und fährt selbst. Eine Kulturrevolu-

siste de Mercedes-Benz des années trente. Rien de plus normal, puisque la limousine d'Adenauer porte, tout comme celle d'Hitler en son temps, la signature d'Hermann Ahrens, directeur du département des modèles hors-série de Sindelfingen. Chefs d'État, papes et rois, tous sont convaincus. Le style limousine de parade évolue peu. En 1964, c'est le chant du cygne de la limousine de parade avec la Mercedes 600 dont la sobriété et la rigueur formelle touchent à la perfection. Somptueuse cette version Pullmann est dans la pure tradition des limousines d'État et pourtant, moins ornementée que ses consœurs, son design est de concept bourgeois. Dans toute sa perfection la 600 est le nec plus ultra – la dernière de son ère, dont Rolls-Royce sonnera définitivement le glas en 1965 en osant un saut de la mort des plus téméraires avec une Silver Shadow sobre, rectiligne et fonctionnelle. Face à la Cloud, elle passe presque inaperçue à l'exception d'une poupe marquée. Son

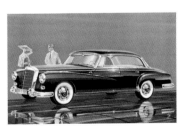

Mercedes-Benz 300 *Adenauer*, 1951

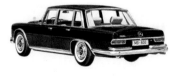

Mercedes-Benz 600, 1964

about-face in 1965. The Silver Shadow was straight-laced, matter-of-fact and of manageable size. The owner even sat at the front and drove himself. A cultural revolution, and an anticipation, as the elitist limousine shape was gradually losing its right to exist. As class became available to the masses, the state limousine transmogrifies into a fleet car. Only as a metal expression of hierarchical company structures—in which the fleet car still ought to be a saloon—does the concept survive to this day: C for the manager, E for the director, S for the executive. The coronation's illusion gives way to the reality of the taxi ride.

GOLDEN CUT

Despite fabulous aesthetics, the limousine remained a strictly chauffeur-driven car, whose qualities are best experienced from the back seats. And even if the owners actually wanted to drive themselves, it seems incon-

tion. Und eine Vorwegnahme, denn die elitäre Limousinenform verliert allmählich ihre Existenzberechtigung. Klasse wird zu Masse, die Staatslimousine zum Flottenfahrzeug. Lediglich als metallgewordener Ausdruck hierarchischer Konzernstrukturen – innerhalb welcher der Firmenwagen immer noch eine Limousine zu sein hat – überlebt der Mythos bis heute: C für den Manager, E für den Direktor, S für den Vorstand. Die Illusion der Krönungszeremonie weicht der Realität der Taxifahrt.

GOLDENER SCHNITT

Trotz fabelhafter Ästhetik gilt die Limousine als Chauffeurwagen, dessen Qualität am besten im Fond erlebbar wird. Wenn die Herrschaften fahren möchten, ist es unvorstellbar, dass sie sich in den engen, oft durch eine Glasscheibe getrennten Fahrerraum hineinzwängen. Das ist weniger eine Frage des Komforts denn der Symbolik: In einer Limousine

propriétaire s'installe à l'avant et prend le volant. Une véritable révolution culturelle, anticipation de changements futurs. Bientôt la limousine élitaire perd sa raison d'être. Le très haut de gamme de prestige cède la place à la production de masse, la limousine d'État à la voiture d'entreprise. Le symbole hiérarchique de la limousine ne survit au mythe que dans l'entreprise où la voiture, bien plus que du métal, est attribuée en fonction du rang occupé dans l'organigramme : la classe C revenant aux managers, la classe E aux directeurs et la classe S aux membres du conseil d'administration. L'illusion créée par la cérémonie de couronnement fait place à la réalité du transport en taxi.

COUPE DIVINE

Malgré son esthétique magnifique, la limousine ne peut se défaire de son image de voiture à chauffeur, dont on apprécie au mieux les qualités assis sur la ban-

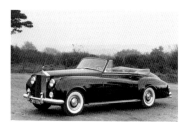

Rolls-Royce Silver Cloud Drop Head Coupé, 1959

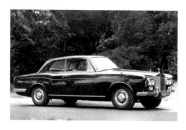

Rolls-Royce Corniche, 1971

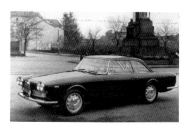

Alfa Romeo 2000 Praho Touring, 1960

ceivable that they might squeeze themselves into the tight driver's compartment, which was separated by a glass window. This was yet another matter of symbolism, rather than convenience: a limousine simply has to have the chauffeur at the front. This explains the drab pointlessness of smaller limousines, which are not worthy of this designation. If upper class ladies or gentlemen felt the urge to drive themselves, they simply take the coupé. The classic coupé's design concept is simple: take a limousine and shorten its wheelbase. Two long, handsome doors and a roof that is ever so slightly shorter and softly tapering towards the boot lid remain. The front seats are clearly accentuated. This is important, as the coupé must be distinguished from the two-door saloon: it is, after all, a mass-market product. The front remains untouched and the rear is only discreetly tapered, for the coupé is not supposed to be used as a sports car, but to waft along

erwartet man eben vorne den Chauffeur. Damit erklärt sich die biedere Sinnlosigkeit kleinerer Limousinen, die dieser Bezeichnung nun gar nicht würdig sind. Wenn die Herrschaften selber fahren möchten, dann in einem Coupé. Das Designkonzept des klassischen Coupés ist einfach: Man nehme eine Limousine, kürze den Radstand und verlängere die Vordertüren. Übrig bleibt ein verkürztes Dach, das sanft in Richtung Heckklappe abfällt. Die Betonung liegt eindeutig auf der vorderen Sitzreihe – soll man doch ein Coupé von einer gewöhnlichen zweitürigen Limousine immer unterscheiden können. Die Front bleibt gänzlich unberührt, und das Heck wird nur dezent verjüngt. Als Snobmobil schlechthin glänzt das Coupé mit wenig Mehrleistung und viel weniger Nutzwert als die Limousine – dafür ist es wahnsinnig teuer, also chic. Paul Bracqs Meisterwerk, das Mercedes 220 SEb Coupé mit Amerika-inspiriertem Hardtop-Design verlangt einen

quette arrière. Pour ces messieurs, il est inconcevable, même si l'envie leur venait de conduire, d'aller se faufiler dans l'étroite cabine souvent séparée des sièges arrière par une vitre. Plus que l'espace, le problème est d'ordre symbolique : dans une limousine le siège avant est celui du chauffeur. D'où le caractère grotesque de ces petites limousines, tout à fait indignes de ce nom. Au niveau du concept, le coupé c'est tout simplement une limousine à l'empattement raccourci, avec deux belles et longues portes et un toit légèrement abaissé et incliné vers l'arrière. L'accent y est mis sur les places avant de la voiture. Cela importe pour bien faire la distinction entre un coupé et ce produit de masse qu'est la berline deux portes. L'avant reste inchangé et l'arrière va en s'effilant légèrement, car, ne nous méprenons pas, le coupé n'est pas non plus une voiture de sport, il se doit de glisser majestueusement. Voiture de snob par excellence, ses performances dépassent à peine cel-

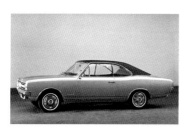

Opel Commodore, 1964

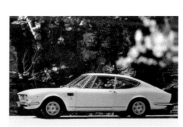

Fiat Dino Coupé, 1966

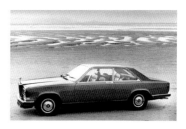

Rolls-Royce Camargue, 1975

majestically. As the definitive snob mobile, the coupé provides less extra performance and a lot less practicality for an extremely high price. Paul Bracq's masterpiece, the Mercedes-Benz 220 SEb Coupé, with its gorgeous, American-inspired hard top design, asked for a 50% premium over the limousine, even though it was equipped with the exact same engine. Rolls-Royce's Camargue was by far the most expensive car the world had seen for many years. Even more opulent, and often the exhibitionist's choice, was the cabriolet conversion: the result was basically a coupé with a thick fabric roof, hence the British calling it a 'drophead coupé'. During the sixties, the fashionable trend of the elongated fastback gave the coupé a more compact, sportier form. Elegantly cut limousine, camouflaged sports car and, later on, even sports saloon with four doors—over time, the coupé seems to have stood for both everything and nothing.

Preisaufschlag von 50 % gegenüber der Limousine; der Rolls-Royce Camargue ist jahrelang das mit Abstand teuerste Automobil der Welt. Prächtiger, und des Öfteren ein Fall für Exhibitionisten, ist der Umbau zum Cabriolet: Im Grunde genommen entsteht so ein Coupé mit dickem Stoffdach, weswegen die Briten es konsequenterweise Drophead-Coupé nennen. Während der Sechzigerjahre verleiht die modische Welle des langgezogenen Fastbacks dem Coupé dann eine kompaktere, sportlichere Form. Mal fein geschnittene Limousine, mal getarnter Sportwagen, später sogar Sportlimousine mit vier Türen – das Coupé steht im Laufe der Zeit für alles und nichts.

POPULUXE

Als 1953 der Mercedes mit Ponton-Linie kommt, wird das Limousinendesign damit nur minimal bürgerlicher. Die symbolische Spannung des Mercedes mündet in einem Zwiespalt: ei-

les de la berline, il est du reste fort peu pratique et de surcroit extrêmement cher. Le chef d'œuvre de Paul Bracq, la Mercedes 220 SEb Coupé pourvu d'un superbe toit coûte, à performances égales, 50 % plus cher que la version berline. Encore plus somptueuses et convenant aux tempéraments exhibitionnistes, les versions cabriolet sont en fait des coupés équipés d'un toit en toile, ce qui leur vaudra à juste titre chez les anglais le nom de « Coupé drophead ». Dans les années soixante la mode du fastback étiré oblige alors le coupé à adopter des airs plus sportifs et compacts. Berline joliment coupée, ou voiture de sport camouflée, ou même plus tard berline sportive à quatre portes, avec le temps le coupé, repris à toutes les sauces, finit par perdre de son sens.

POPULUXE

La ligne Ponton qui réapparait en 1953 chez Mercedes n'apporte qu'une légère touche démocrati-

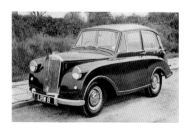

Triumph Mayflower, 1949

Austin A30, 1951

POPULUXE

When the Pontoon-style Mercedes was launched in 1953, it rendered saloon design ever so slightly more 'middle-classy'. The Mercedes' symbolic tension led to a dichotomy: on the one hand "good star on all roads", on the other hand an imposing instrument of power. In James Bond movies, the black German car always belonged to the villain. This kind of tension was effective: the petty *bourgeois*, who would actually be well served by a Volkswagen, were dreaming of the saloon car. However, in the end, most had to make do with a miniature. Therefore, the Triumph Mayflower was pretending to be a 'Baby Rolls' and Austin's A30 is was doing its best not to twist its ankle while treading in Jaguar's footsteps. But this was just a transitional phase, as Hollywood and the television preached the 'American Way of Life' with a vengeance. Thomas Hine calls this combination of

nerseits „guter Stern auf allen Straßen", andererseits Ehrfurcht erregendes Machtinstrument. In James-Bond-Filmen gehört das schwarze deutsche Auto unweigerlich zum Bösewicht. Diese Spannung erzielt Wirkung: Kleinbürger, die eigentlich mit einem Volkswagen gut bedient wären, träumen von solch einer Limousine. Letztendlich reicht vielen dann aber doch eine Miniatur. Daher versucht sich der Triumph Mayflower als Baby-Rolls, während der Austin A30 dem Jaguar hinterhertappt. Es ist eine Übergangsphase, denn Hollywood und Fernsehen propagieren mit Nachdruck den American Way of Life. Populuxe nennt Thomas Hine diese Mischung aus tief verwurzelter Volkstümlichkeit und oberflächlichem Luxus. Europa schminkt sich mit Chrom und zweifarbiger Lackierung: In Deutschland triumphiert Borgwards Isabella, ein Chrysler für Herrn Biedermann. Selbst die schlichten Fiats und die konservativsten Briten geben sich plötz-

que au design façon limousine. Elle garde son ambivalence au niveau de la symbolique. « Bonne étoile sur toutes les routes », la Mercedes est aussi cet instrument de pouvoir qui inspire le respect. Dans les films de James Bond, la berline noire allemande est inévitablement associée aux méchants. Et cette ambivalence est loin de lui nuire. En effet, le petit bourgeois à qui siérait davantage une Volkswagen continue d'en rêver. Nombre d'entre eux préféreront quand-même une version plus petite comme la Mayflower de Triumph qui se prend pour une bébé-Rolls ou l'Austin A30 qui imite une Jaguar. Dans cette phase de transition, alors qu'Hollywood et la télévision propagent avec insistance le mode de vie américain, règne un mélange de traditionalisme bien enraciné et de luxe superficiel que Thomas Hine désigne sous le terme de « populuxe ». L'Europe se maquille au chrome et aux vernis deux tons : en Allemagne c'est la Borgwards Isabella, cette Chrys-

Opel Kapitän P 2.5 *Schlüsselloch*, 1958

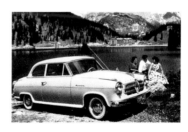

Borgward Isabella TS, 1961

Fiat 1400 A, 1954

deep-rooted folklore and superficial luxury 'populuxe'. Europe was putting on chrome and twin-tone colour schemes: in Germany, the Borgward Isabella, a Chrysler for Mr Mediocrity, became a smash hit. And even simple Fiats, along with the conservative Britons, all of a sudden slapped on garish colours. Next up was the panoramic windscreen, before Europe's small car bodies drop deep onto small wheels, in order to appear longer and slimmer. Some of the results of this pursuit will doubtless raise a smile today. The design dialogue between Italy and the US gave the world the tail fin. Originally invented by German and Italian engineers to improve aerodynamics, it was then copied by American stylists hoping to raise sales. The tail fin was turned into bombastic ornament that whetted the Europeans' appetites. It is a matter of symbolism: chrome and fins represented the Queen's gold and crown. With such accoutrements, Johnny Mediocrity's middle class

lich bunt. Dann kommt die Panoramascheibe, bevor Europas kleine Karosserien auf kleine Räder tief hinabfallen, um länger und schlanker zu wirken. Manches Ergebnis dieses Strebens regt heute zum Schmunzeln an. Der Designdialog zwischen Italien und den USA präsentiert der Welt die Flosse. Von deutschen und italienischen Ingenieuren zur Verbesserung der Aerodynamik erfunden, wird sie von amerikanischen Stilisten kopiert, um die Verkaufszahlen zu steigern. Aus der Heckflosse wird bombastische Dekoration. Das wollen dann auch die Europäer. Hier kommt es auf die Symbolik an: Chrom und Flossen sind Gold und Krone der Königin. Damit ausgestattet, besiegt Ottos Bürgermobil Elizabeths Staatskutsche. Dabei ist es unwesentlich, ob der Barockstil das Auto schöner oder funktionaler macht. Denn die Europäer ersehnen gar nicht die Flosse, sondern Amerika – selbst wenn sie damit zu spät kommen. 1960 entfallen die Protuberanzen

ler pour honnêtes petits bourgeois, qui fait un triomphe. Même les Fiat aux airs sobres et les conservatrices anglaises prennent subitement des couleurs. Puis viennent les pare-brises panoramiques, avant que les petites carrosseries européennes ne soient montées sur des petites roues pour paraître plus longues et plus minces. Avec le recul, les produits de ces essais font parfois sourire. Un autre exemple fera le tour du monde, l'aileron arrière né du dialogue entre designers italiens et américains. Au départ inventé par des ingénieurs allemands et italiens pour améliorer les performances aérodynamiques, l'aileron copié par des stylistes américains servira surtout à catapulter les ventes. Il est ensuite dégradé au rang d'accessoire décoratif pompeux que, très vite, les Européens désireront aussi. Là encore tout est symbole : le chrome et l'aileron correspondent à l'or et à la couronne de la reine. Ainsi parée, la berline bourgeoise de Monsieur-tout-le-monde surpasse la calèche

Ford Thunderbird, 1955

Auto Union 1000 Spezial, 1957

mobile vanquished Elizabeth's *caroche*. In this context, it does not matter if its baroque style makes the car more beautiful or more functional. What Europeans were longing for was not the tail fin itself, but America, even though they were effectively too late because, in 1960, the Cadillac's rear lost its protuberance. But Fiat, Peugeot and Mercedes still went ahead and introduced theirs anyway. In 1961, Ford flattened the T-Bird's rear. Auto Union continues to produce a copy of the outgoing model with its enormous fins. The Wolseley Hornet, Riley Elf and Autobianchi Bianchina are nothing more than the Mini and 500 design icons wearing too much rouge: automotive transvestites. Even Alfa Romeo's Giulia tried to imitate the Ford Edsel. What was a flop in the New World became a hit on the Old Continent. Any questions regarding its meaningfulness are ultimately redundant, as the Chevrolet Corvair finally gave the US cars a new shape: horizontal, flat, una-

vom Heck des Cadillacs, Fiat, Peugeot und Mercedes führen sie trotzdem ein. 1961 bügelt Ford das Heck des T-Bird glatt. Auto Union produziert weiterhin eine Kopie des Vormodells mit Riesenflossen. Wolseley Hornet, Riley Elf und Autobianchi Bianchina sind nichts weiter als die Designikonen Mini und 500 mit Flossen und Schminke – automobile Transvestiten. Selbst der Alfa Romeo Giulia versucht sich als Imitat des Ford Edsel. Dort Flop, hier Top. Die Frage der Sinnhaftigkeit ist letztlich hinfällig, denn der Chevrolet Corvair gibt den US-Autos 1960 eine neue Linie: horizontal, flach, ungeschminkt. Fiat, Simca, NSU und Hillman kopieren schamlos. Auf Heckmotorwagen wie Volkswagen 1500, Fiat 850 oder Renault 8 übertragen, kommt die Kleinlimousine wie eine zu dick gepuderte Imitation daher. Trotzdem (oder gerade deswegen) überlebt sie, mit und ohne Schminke, bis heute.

de la Reine Élisabeth. Peu importe alors que le style baroque représente ou non une amélioration esthétique ou technique. Les Européens ont envie de l'aileron en tant qu'élément du rêve américain, même s'ils y viennent avec retard. En 1960, alors que ces protubérances disparaissent chez Cadillac, les constructeurs Fiat, Peugeot et Mercedes, eux, les introduisent. En 1961, quand Ford aplatit les tôles arrière de la T-Bird, Auto Union sort une copie du modèle précédent aux gigantesques ailerons. Tels des travesties, les Wolseley Hornet, Riley Elf et autres Bianchina d'Autobianchi ne sont rien d'autres que des imitations maquillées et affublées d'ailerons de ces icônes du design automobile que sont la Mini ou la 500. Même la Giulia d'Alfa Romeo s'essaye en Ford Edsel. Outre-Atlantique un flop, en Europe le top. Il est inutile de chercher une finalité à ces reprises, car en 1960 la Chevrolet Corvair qui définira une nouvelle vision américaine de la poupe –

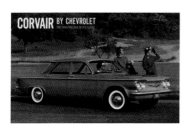

Corvair by Chevrolet, 1960

Alfa Romeo Giulia, 1962

Fiat 1500, 1961

dorned. Fiat, Simca, NSU and Hillman copied it shamelessly. Adapted to rear-engined cars such as the Volkswagen 1500, Fiat 850 or Renault 8, the small saloon suddenly came across like a fake. Despite all that (or maybe even because of it) the small saloon survives to this day.

INTELLECTUAL STYLE

Still weak from the effects of the Second World War, the modern avant-garde was but a shadow of its former self post-1945. The design bomb of Hiroshima eradicated the desire for 'the next big thing', and the new realism offered refuge. Many intellectuals had emigrated to the US, where the principles of rationalism fell on fertile soil. Thus dogmatic modernity was turned into the International Style: transparent, open, sober yet, at the same time, warmer than any previous European avant-garde experiment. After its premiere at the 1954 Milanese Triennale, an exhibition on Scan-

STIL INTELLEKTUELL

Vom Weltkrieg geschwächt, bleibt von der modernen Avantgarde kaum etwas übrig. Die Designbombe von Hiroshima löst den Wunsch nach „the next big thing" in seine Bestandteile auf – man sucht nun Zuflucht im neuen Realismus. Viele Intellektuelle sind nach Amerika ausgewandert, wo die Prinzipien des Rationalismus auf fruchtbaren Boden stoßen. Aus der dogmatischen Moderne wird so der International Style: transparent, offen, schlicht – aber auch wärmer als jedes bisherige europäische Avantgarde-Experiment. Nach dem Auftritt auf der Mailänder Triennale 1954 tourt eine Ausstellung über skandinavisches Design bis 1958 quer durch Europa und Amerika. Sie repräsentiert einen „blonden" Stil: cool, distinguiert, raffiniert. 1957–58 pulsiert die Kultur weltweit in nie gesehener Frequenz: Das glatte, bronzene Seagram Building, entworfen vom deutschamerikanischen Duett Mies van

horizontale, plate et sans chrome – est aussitôt copiée sans vergogne par Fiat, Simca, NSU et Hillman. Transposé sur des voitures à moteur arrière comme la Volkswagen 1500, la Fiat 850 ou la Renault 8, ce style trop fardé ne leur va pas. Malgré ce côté travesti ou est-ce justement pour cela, la limousine miniature, avec ou sans maquillage, survivra jusqu'à aujourd'hui.

STYLE INTELLO

En 1945, déjà fortement affaiblie par la première guerre mondiale, l'avant-garde européenne est presque complètement anéantie. La bombe d'Hiroshima dissipe les envies de créer « the next big thing » – on se réfugie dans le nouveau réalisme. De nombreux intellectuels émigrent aux Etats-Unis, où les principes du rationalisme y trouvent un sol fertile. Le modernisme dogmatique laisse place au « Style international » transparent, ouvert et sobre – mais aussi bien plus chaleureux que toutes les précédentes expé-

Panhard Dyna Z, 1953

Citroën DS 19, 1956

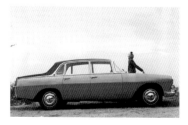

Lancia Flaminia, 1957

dinavian design toured the US and Europe until 1958. It represents a 'blonde' style: cool, distinguished, refined. From 1957–58, the global culture pulsated at a frequency never seen before: the clean, bronze Seagram Building, designed by the German-American duet of Mies van der Rohe and Philip Johnson, gave architecture a new quality. At the same time, Yves Saint Laurent rolled out his 'trapeze line' at Dior: a clear and geometrical, yet at the same time lavish and loose cut. That same year the Soviet Union sent the Sputnik satellite into space. The time was obviously ripe for something new, so experiments in the form, execution and identity of the automobile were order of the day. The Panhard Dyna Z, a hi-tech sublimation of shell design, and the Citroën DS, a non-car somewhere between astronautics and bionics, were envoys of the French avant-garde. The year of Sputnik and trapeze was also the year when mass production of the Lancia Flaminia, based

der Rohe und Philip Johnson, verleiht der Architektur eine neue Qualität. Yves Saint Laurent bei Dior propagiert die Trapezlinie: einen klaren und geometrischen, gleichzeitig aber großzügigen und freien Schnitt. Im selben Jahr schickt die Sowjetunion den Satelliten Sputnik ins All. Die Zeit ist so reif für Neues, dass eifrig mit Form, Bauweise und Identität des Automobils experimentiert wird. Der Panhard Dyna Z, eine Hi-Tech-Sublimation der Muschelform und die Citroën DS, ein Nicht-Auto zwischen Raumfahrt und Bionik, sind Ausläufer der französischen Avantgarde. Im Jahr von Sputnik und Trapez startet das Serienmodell der Lancia Flaminia, nach einem Entwurf von Pininfarina. Geometrische Kantenlinie, klar gegliederte Volumina und feine Lichtspiele sorgen für eine Neuausrichtung des Automobildesigns. Die Linie ist geboren. Die Glasflächen erweitern sich, die Dachkonstruktion wird leichter: im Intellectual Car bewundert man das Pano-

riences avant-gardistes européennes. En 1957–1958, la culture bouillonne de partout comme jamais auparavant : avec le Seagram Building, tour à la façade lisse de couleur bronze dessinée par le duo germano-américain Mies van der Rohe et Philip Johnson, l'architecture entre dans une nouvelle dimension. Au même moment, Yves Saint Laurent développe pour la maison Dior la ligne « Trapèze », une coupe à la fois claire et géométrique mais aussi ample et libre. Les temps sont mûrs pour l'innovation. Et l'automobile n'est pas en reste. Forme, mode de construction, image, l'expérimentation ne connaît pas de limite. La Panhard Dyna Z, une voiture haute technologie en forme de coquillage sublimé et la Citroën DS, cette non-voiture entre l'objet aérospatial et bionique, sont les tenants de l'avant-garde française. L'année du Spoutnik et de la ligne « Trapèze » marque également l'arrivée de la Lancia Flaminia, une voiture de série conçue sur

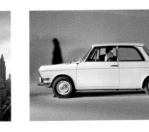

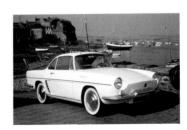

Dior *Ligne Trapèze*, 1957
Seagram Buildung, 1957

BMW LS Luxus, 1962

Renault Floride, 1958

on a design by Pininfarina, commenced. Geometrical, edgy lines, clearly structured volumes and subtle play with light caused a shift in the direction of automotive design. Glass areas were expanded, roof constructions got lighter: in an 'intellectual car', one could admire the panorama as if sitting in a skyscraper's rooftop restaurant. Form defeats decoration. In 1960, Uwe Bahnsen mixed the geometric with the organic at Ford. The soft Taunus 17M—also known as the 'bath tub'—became the prototype for the flowing line. Next, Peugeot's 404 and BMW's LS adapted Yves Saint Laurent's 'trapeze line'.

BMW's *Neue Klasse* then set the trapeze in motion. Its negatively slanted face, designed by Giovanni Michelotti, set a precedent. This kind of intellectuality boosted quality, as well as variety: there were no parallels whatsoever between the Rover P6, the British companion piece to the DS, and

rama wie vom Roof-Restaurant eines Wolkenkratzers. Form siegt über Dekoration. 1960 mischt Uwe Bahnsen bei Ford Geometrisches mit Organischem. Der weichgespülte Taunus 17M – genannt „Badewanne" – wird zum Urbild der fließenden Linie. Peugeots 404 und BMWs LS nehmen Yves Saint Laurents Trapezlinie auf.

Die neue Klasse von BMW setzt 1965 dann das Trapez in Bewegung. Ihr negativ geneigtes Gesicht, ein Entwurf Giovanni Michelottis, macht Schule. Diese Intellektualität fördert Qualität und Vielfalt: zwischen Rover P6, dem britischen Pendant zur DS, und Opel Admiral, dem deutschen Pendant zum amerikanischen Pontiac, gibt es keine Parallelen. Der NSU Ro80 ist der Letzte dieser Gattung: 1967 ist er gleichzeitig zu konservativ und zu extrem. Mit Raffinement und einzigartiger Linie und Technik nötigt er den Kunden zur Entschlossenheit. Ein Design, das

un modèle de Pininfarina. Les lignes géométriques et anguleuses, les volumes bien structurés et le traitement subtil des phares carénés impriment une nouvelle tendance sur le design automobile. La forme l'emporte sur l'aspect décoratif. En 1960, Uwe Bahnsen crée pour Ford la Taunus 17M, surnommée aussi « baignoire » en raison de ces lignes douces, un mélange à la fois géométrique et organique qui marque l'émergence de la « ligne coup de vent ». La Peugeot 404 et la BMW LS reprennent à leur compte la forme « Trapèze » d'Yves Saint Laurent.

Le trapèze, le voilà donc en mouvement, à partir de 1965 quand BMW lance la Neue Klasse, dont l'avant en angle inversé dessiné par Giovanni Michelotti fera école. On ne se contente plus d'illustrer, mais on pense véritablement en termes de forme automobile. Qualité et diversité résultent de ce concept intellectuel : ainsi il n'y a aucune ressemblance entre

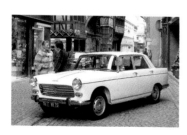

Peugeot 404, 1960

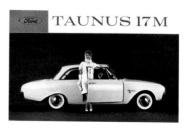

Ford Taunus 17M *Badewanne*, 1960

the Opel Admiral, the German companion piece to the American Pontiac. The NSU Ro80 was the last of its breed: in 1967 it was both old and new. Its refinement, as well as its unique shape and technology, required decisiveness on the part of the customer. A design that challenges the intellect marks the owner out as a special person. Risky, irretrievable, confident: these car experiments anticipated Erich Fromm's question regarding 'having' and 'being'. They opened the world up for something new. This makes the automobile not just a mere status, but a veritable 'motus symbol'.

den Intellekt fordert, qualifiziert dessen Besitzer zum besonderen Menschen. Riskant, unwiederbringlich, selbstbewusst: Diese Auto-Experimente nehmen Erich Fromms Frage über Haben oder Sein vorweg. Sie öffnen die Welt für das Neue. Automobile sind somit kein bloßes Status-, sondern ein wahrhaftiges Motus-Symbol.

une Rover P6, le pendant britannique de la DS, et une Opel Admiral, le pendant allemand de la Pontiac américaine. La NSU Ro80 est la dernière du genre : en 1967 ce modèle est à la fois désuet et trop nouveau. Raffinée et unique par ses qualités esthétiques et techniques, elle oblige le client à faire montre de détermination. C'est un design qui met l'intellect à l'épreuve et fait de son propriétaire un homme différent. À haut risque, ces expériences pleines d'assurance ne donnent pas droit à l'erreur et anticipent l'interrogation d'Erich Fromm sur l'« avoir ou être ». Elles préfigurent un monde nouveau. Les voitures ne sont plus seulement des symboles de statut social mais de véritables symboles de mouvance.

Rover P6 2000, 1964

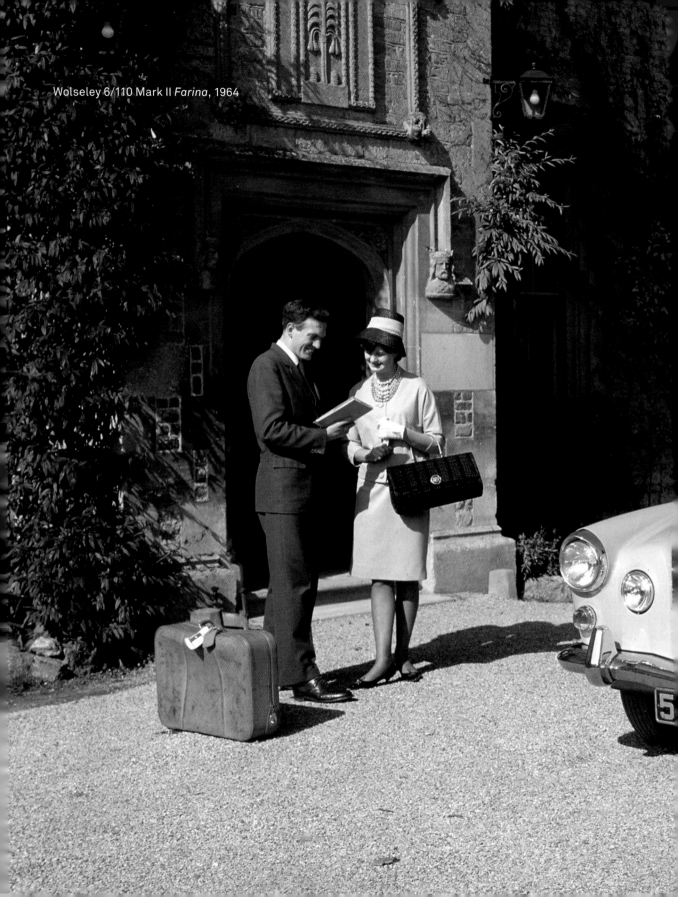

Wolseley 6/110 Mark II *Farina*, 1964

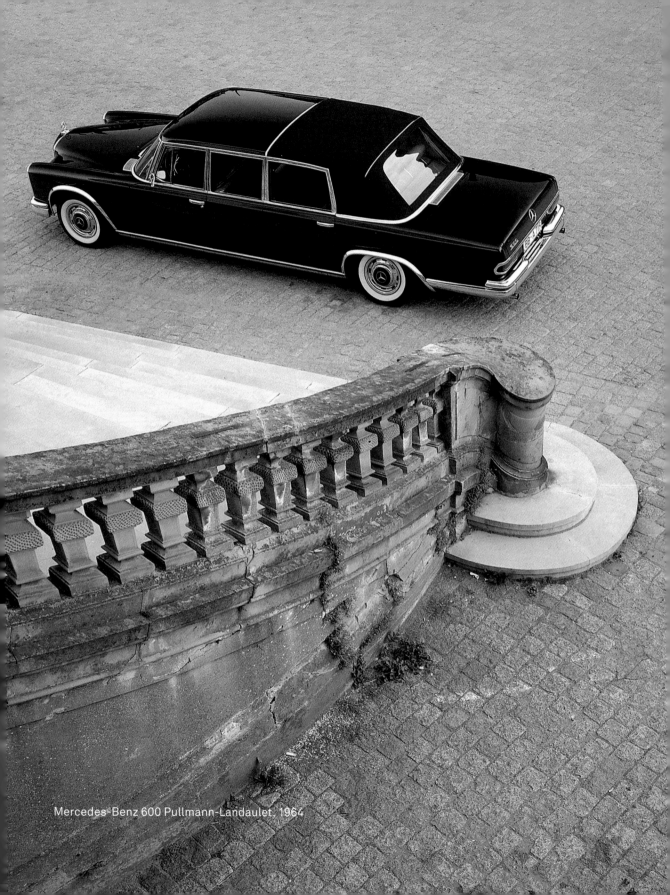

Mercedes-Benz 600 Pullmann-Landaulet, 1964

PAUL BRACQ

Bracq's golden decade at Mercedes-Benz began in 1957, when he joined the design department. In 1961, in sharp contrast to the tail fin saloon, his 220 SEb hardtop coupé defined a line of reduced, timeless elegance that simply could not be better proportioned. Translated onto the 230 SL with its prominent pagoda roof, Bracq's style appears ethereal, hushed and, yet, somehow sporty. His masterpiece is the big Mercedes 600: a car of imposing stature, whose stylistic consistency lends it an air of noble humbleness.

Bracqs goldenes Jahrzehnt bei Mercedes-Benz beginnt 1957 als Mitglied der Stilistikabteilung. Mit dem 220 SEb Hardtop-Coupé von 1961 definiert er, im Gegensatz zur Heckflossenlimousine, eine Linie reduzierter, zeitloser Eleganz, die besser proportioniert nicht sein könnte. Übertragen auf den 230 SL mit markantem Pagodendach wirkt Bracqs Handschrift ätherisch, leise – und doch sportlich. Sein Meisterwerk ist der Große Mercedes 600: Ein Wagen von imponierender Statur, der in seiner gestalterischen Stringenz der Staatslimousine den Duft edler Demut verleiht.

La décennie d'or commence pour Bracq en 1957, chez Mercedes-Benz, où il est membre du département style. Avec le coupé « hardtop » 220 SEb, aux antipodes des berlines à ailerons arrière, il propose en 1961 une ligne minimaliste, à l'élegance intemporelle, qui ne pourrait montrer de plus belles proportions. Transposé sur la 230 SL au toit pagode le style de Bracq se fait éthéré, discret et sportif à la fois. Son chef d'œuvre est la Grande Mercedes 600. Cette voiture à la stature imposante, au style dénué de compromis, confère à la limousine de parade un air de noblesse empreint d'humilité.

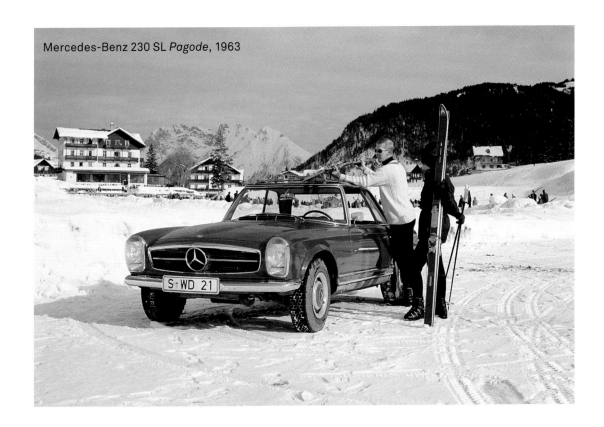

Mercedes-Benz 230 SL *Pagode*, 1963

Mercedes-Benz 220 SEb Coupé, 1961

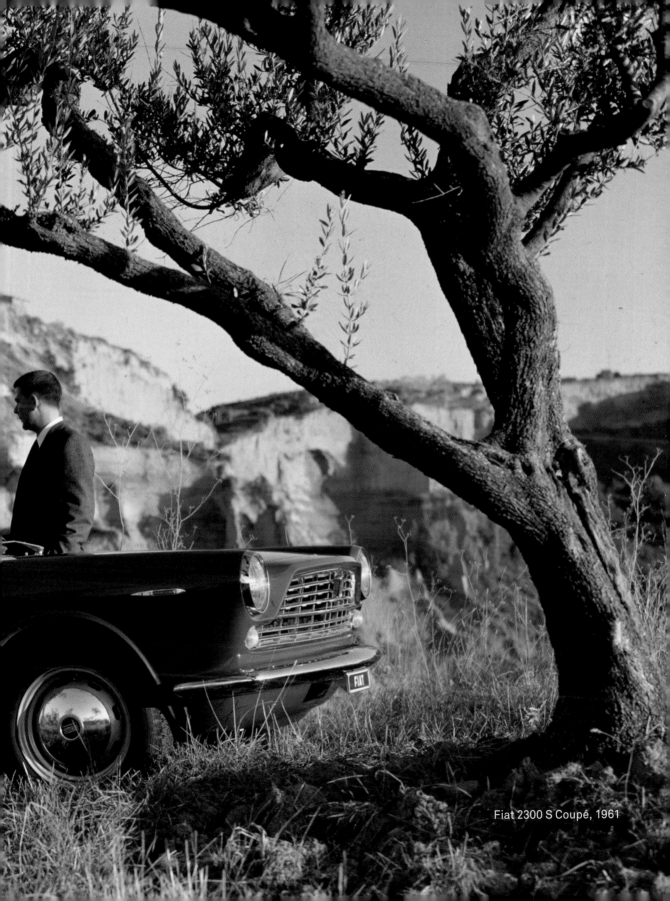

Fiat 2300 S Coupé, 1961

ROLLS-ROYCE

To argue whether Rolls-Royce ever built "the world's best car" is unnecessary. No matter whether the marque explains that the ticking of the clock is the loudest sound inside its cars or specifies their offerings' performance as 'adequate'. The claim itself adds to the myth of the cars with their unique Pantheon grille, as does some people's irrefutable belief that Rolls-Royce only builds cars for kings and nobility (and not just as often for a considerably more dubious clientele). Engineer Henry Royce and salesman Charles Rolls actually believed that even a humble component, if well-resolved, could exude excellence. This principle fitted the style of the head of design, John Blatchley: regal yet measured. In 1955, the incarnation of the classy limousine, the Silver Cloud, was more conservative looking than Blatchley would have liked. But with the sensationally modelled Silver Shadow he later on achieved that rare feat of combining Rolls-Royce's virtues with modernity and 'common' proportions. No matter which model, any Rolls-Royce is more of a symbol than a form: design for eternity.

Zu diskutieren, ob Rolls-Royce je „das beste Auto der Welt" gebaut hat, ist müßig. Egal ob die Marke erklärt, das Ticken der Uhr sei das lauteste Geräusch im Innenraum ihrer Fahrzeuge oder deren Leistung mit „ausreichend" angibt – die Behauptung alleine trägt zum Mythos der Autos mit dem unverwechselbaren Pantheongrill bei, genauso wie der unwiderlegbare Glaube mancher, Rolls-Royce baue Fahrzeuge nur für Könige und Adelige (und nicht mindestens genauso oft für zwielichtigere Gestalten). Der Konstrukteur Henry Royce und der Händler Charles Rolls fanden übrigens, dass selbst eine bescheidene Komponente, wenn gut gelöst, Exzellenz ausstrahlt. Das Prinzip passt gut zum Stil des Chefdesigners John Blatchley: majestätisch und trotzdem maßvoll. Das Sinnbild der edlen Kutsche, der Silver Cloud, sieht 1955 noch konservativer aus, als es Blatchley lieb ist. Doch mit dem sagenhaft modellierten Silver Shadow gelingt ihm später das Kunststück, Rolls-Royce-Tugenden mit Modernität und „bürgernahen" Proportionen zu verbinden. Egal welches Modell, ein Rolls-Royce ist mehr Symbol als Form: Design für die Ewigkeit.

Il serait vain de chercher à savoir si oui ou non la Rolls-Royce est la plus belle voiture jamais construite au monde. Vraies ou fausses, les affirmations de la marque, qui qualifie de « suffisantes » les performances de la voiture, en tout état de cause, ces affirmations contribuent largement au mythe de cette voiture à l'incomparable grille de calandre en forme de fronton grec. De même, la croyance selon laquelle seuls les rois et les nobles achètent des Rolls-Royce se maintient dans l'imaginaire collectif. Henry Royce et Charles Rolls étaient de l'avis que toute pièce, même la plus modeste, pour peu qu'elle soit exécutée parfaitement, peut respirer l'excellence. Ce principe trouve son expression dans le style majestueux mais tout en mesure, signé de la plume de John Blatchley, designer en chef de la marque. La Silver Cloud de 1955, ce symbole du noble carrosse, pêche, même pour un Blatchley, par excès de conservatisme. C'est avec la superbe Silver Shadow qu'il réussira l'alliance difficile des valeurs traditionnelles de Rolls-Royce avec la modernité qui implique, entre autres, des proportions plus « bourgeoises ». Quel que soit le modèle, plus que principe esthétique, le design de la Rolls-Royce est avant tout symbole d'éternité.

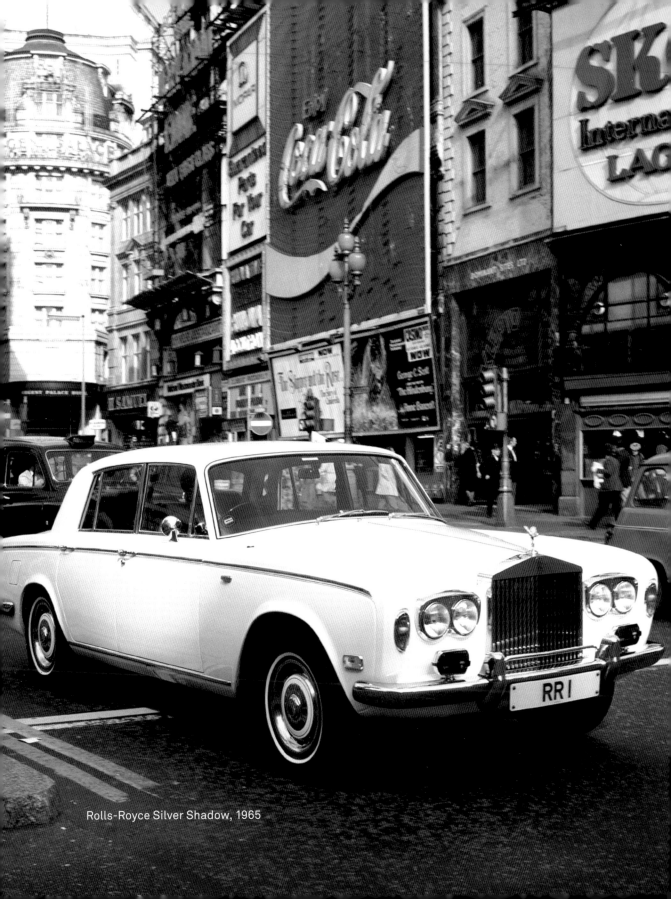

Rolls-Royce Silver Shadow, 1965

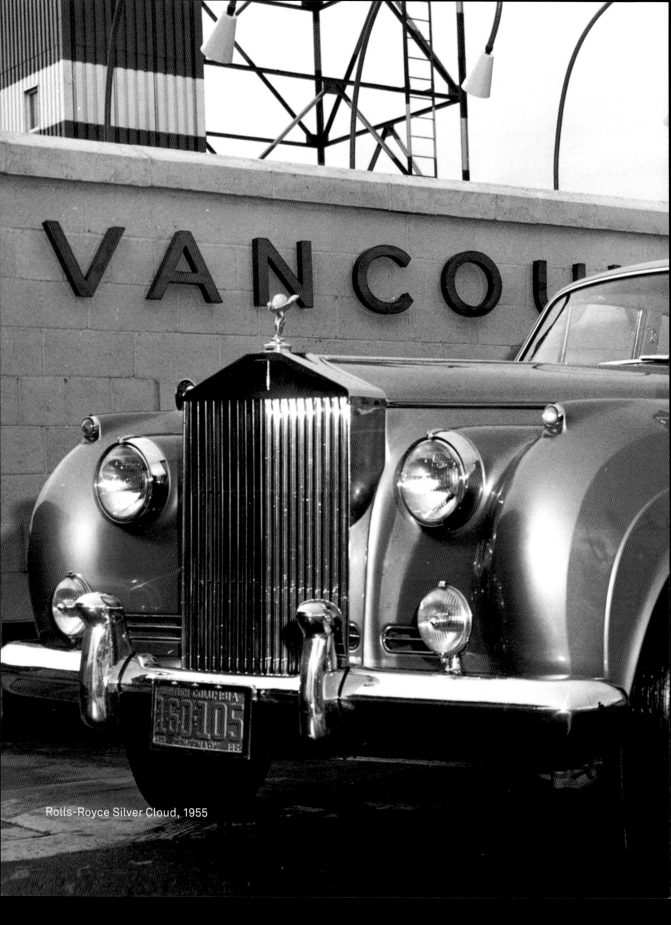

Rolls-Royce Silver Cloud, 1955

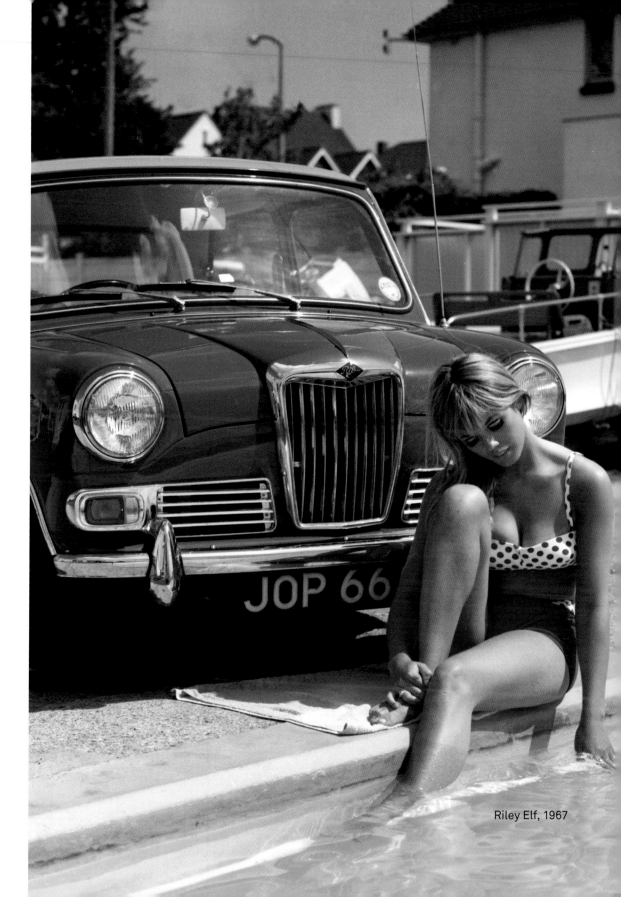

Riley Elf, 1967

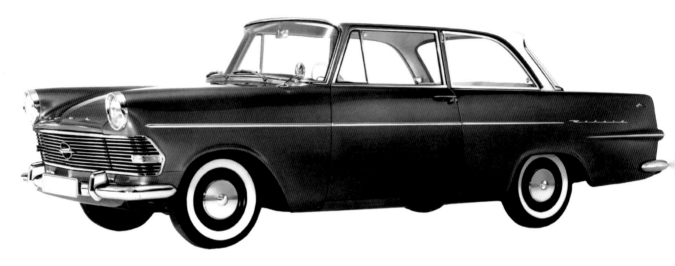

Opel Rekord Limousine, 1960

OPEL

Opel's model names indicated the pride of the *Wirtschaftswunder* years: ranging from Kadett to Rekord, from Kapitän to Diplomat, there was a car for almost every rank. It was not just the deep pockets of parent company General Motors which facilitated this, but also the American know-how and flair, a large asset and a decisive difference when compared to the spartan Volkswagen in those progress-obsessed years. Not for nothing do the Opel models leave an impression of shrunken road cruisers: Opel is able to interpret the Populuxe style in a very handsome fashion. Atten-

Opels Modellbezeichnungen zeugen vom Stolz der Wirtschaftswunderjahre: vom Kadett über Rekord, vom Kapitän bis zum Diplomat gibt es ein Auto für beinahe jeden Rang. Dabei sind nicht nur die tiefen Taschen der Konzernmutter General Motors hilfreich, sondern auch das amerikanische Knowhow und Flair – in diesen fortschrittsverliebten Jahren ein großer Trumpf und ein entscheidender Unterschied zum spartanischen Volkswagen. Nicht umsonst erwecken viele Opel-Modelle den Eindruck geschrumpfter Straßenkreuzer. Den Populuxe-Stil kann Opel

Les appellations des modèles Opel reflètent le fier esprit des années du miracle économique : de la Kadett en passant par la Rekord, de la Kapitän à la Diplomat, à chaque grade, sa voiture. L'important capital financier de la maison maire General Motors, mais aussi le savoir-faire américain et l'opulence du style constituent les pièces clés du succès de la marque, grâce auxquelles, en cette époque progressiste, Opel se distingue clairement de Volkswagen au style plus spartiate. On ne s'étonnera donc pas que ces voitures aient des airs de petits chars militaires. Opel

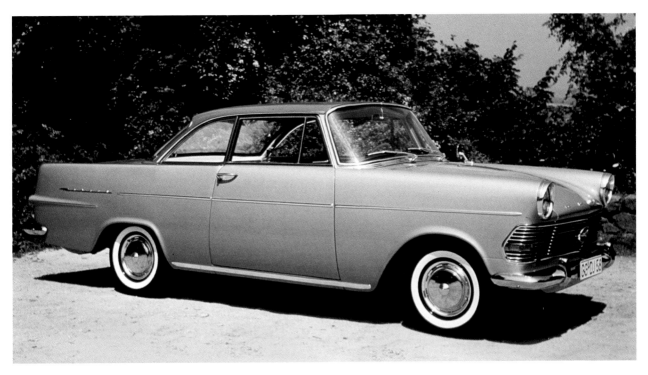

Opel Rekord Coupé, 1961

tion is paid to details, even down to the image difference between a two-door saloon and a coupé. The latter must clearly distinguish itself at all costs: due to its extreme sweeping roofline, the Rekord coupé is hence called the 'racing boot'. Beyond the mass-market models, the constant exchange of engineers and designers resulted in cars with a distinct US flavour, like the Diplomat or the 'Mini Corvette', the Opel GT.

sehr hübsch interpretieren. Dabei wird auch auf Details, wie den Unterschied zwischen zweitüriger Limousine und Coupé, geachtet. Letzteres muss sich klar abheben, koste es, was es wolle: Aufgrund ihres extremen Dachschwungs nennt man daher das Rekord Coupé den „rasenden Koffer- raum". Abseits der Massenmodelle sorgt der rege Austausch von Technikern und Designern für Fahrzeuge mit ausgeprägtem US- Aroma, wie den Diplomat oder die „Mini-Corvette", den Opel GT.

maîtrise le style « populuxe » à merveille. Entre une berline deux portes et un coupé la différence est dans le détail, auquel un soin particulier est apporté. Le coupé doit se distinguer de la berline, coûte-que-coûte, comme le coupé Rekord dont le toit à la découpe fougueuse lui vaudra des sobriquets explicites. En outre, des véhi- cules très américains, comme le Diplomat ou cette « mini-corvette » qu'est la GT, voient le jour, à l'écart des modèles de masse, à la faveur d'échanges fréquents entre techni- ciens et designers.

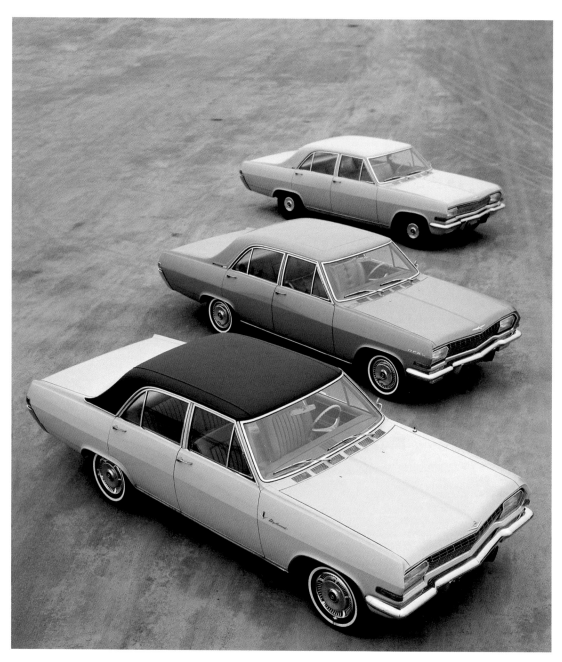

Opel Diplomat, 1964

NSU Prinz 4, Advertising "drive prince and be king", 1962

FLAMINIO BERTONI

It was actually an Italian who was responsible for the legendary body shapes of Citroën's models. Bertoni's artistic ideas became the perfect packaging for the Citroën engineers' avant-garde developments, although he—in the tradition of the *artiste*—actually did his best to hide the automobiles' technical aspects. For him, cars were pure pieces of art, therefore he considered the engine a mere nuisance. Bertoni generally saw his most famous creation, the DS, in a somewhat critical light. He lovingly called the people's goddess 'Hippopotame'. At the last minute, he desperately changed its roof: the characteristic indicator nacelles were hence created as pure *trompe-l'œil* . Yet the temperamental Bertoni was most enthusiastic about the idiosyncratic form of the Ami 6: to him, it represented pure art.

Tatsächlich steckt ein Italiener hinter der Form der legendären Citroëns. Bertonis gestalterische Ideen werden zur perfekten Verpackung für die avantgardistischen Entwicklungen der Citroën-Ingenieure, obwohl er – ganz traditioneller bildender Künstler – sich tatsächlich bemüht, die technischen Aspekte der Fahrzeuge zu kaschieren. Für ihn sind Automobile reine Kunstwerke, bei dem etwa ein Motor nur stört. Überhaupt sieht Bertoni seine berühmteste Schöpfung, die DS, recht kritisch. Des Volkes Göttin nennt er liebevoll „Hippopotame". Verzweifelt verändert er in letzter Minute ihr Dach: die charakteristischen Blinker-Trompeten entstehen so als reines Trompe-l'Œil. Begeistert ist der temperamentvolle Bertoni hingegen von der eigenwilligen Form des Ami 6: Sie ist für ihn pure Kunst.

C'est en fait un italien qui se cache derrière les Citroën aux formes légendaires. L'esthétique de Bertoni habille à merveille les projets avant-gardistes des ingénieurs de Citroën; même si l'artiste qu'il est, fidèle à une conception traditionaliste des beaux-arts, fera tout pour en masquer les côtés techniques. À ses yeux les voitures sont de pures œuvres d'art qui ne sauraient s'accommoder d'un moteur trop visible. Bertoni, d'ailleurs, voit la DS, sa création la plus fameuse, d'un œil très critique. Bien qu'adulée par le public, il la surnomme affectueusement « l'hippopotame ». Proche du découragement, c'est à la toute dernière minute qu'il redessine le toit et y appose ces clignotants arrière en trompe-l'œil si caractéristiques. L'impétueux Bertoni est par contre très féru de l'Ami 6, qu'il considère comme une œuvre d'art à l'état pur.

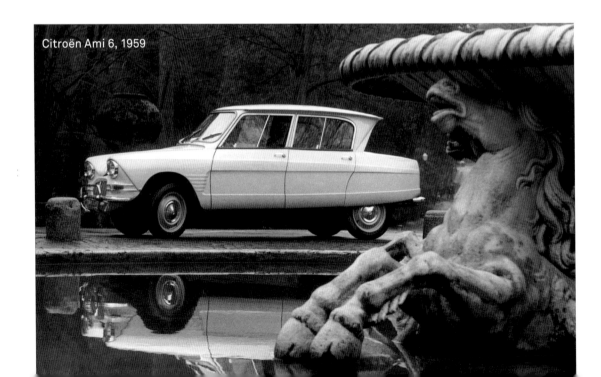

Citroën Ami 6, 1959

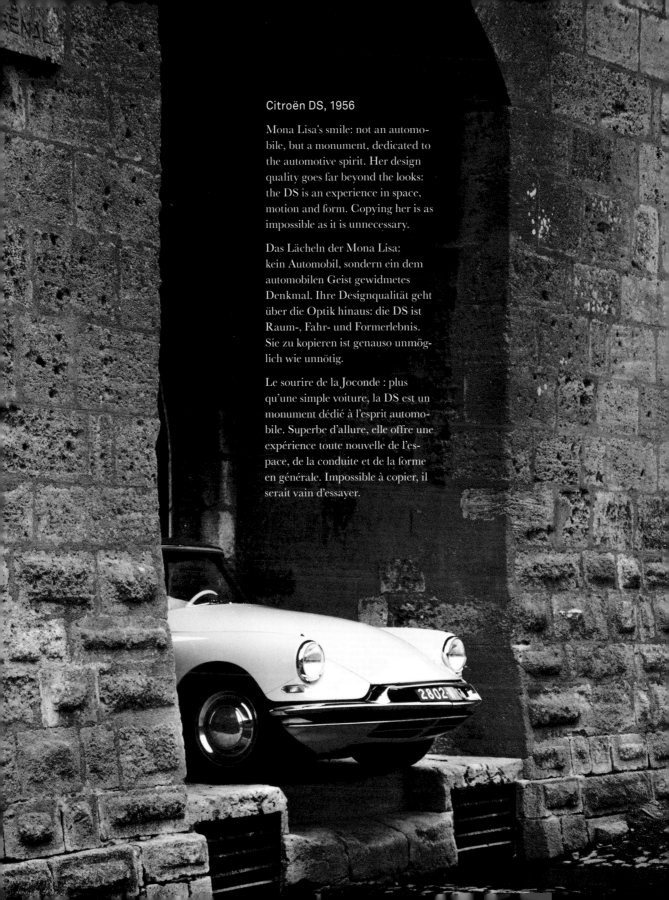

Citroën DS, 1956

Mona Lisa's smile: not an automobile, but a monument, dedicated to the automotive spirit. Her design quality goes far beyond the looks: the DS is an experience in space, motion and form. Copying her is as impossible as it is unnecessary.

Das Lächeln der Mona Lisa: kein Automobil, sondern ein dem automobilen Geist gewidmetes Denkmal. Ihre Designqualität geht über die Optik hinaus: die DS ist Raum-, Fahr- und Formerlebnis. Sie zu kopieren ist genauso unmöglich wie unnötig.

Le sourire de la Joconde : plus qu'une simple voiture, la DS est un monument dédié à l'esprit automobile. Superbe d'allure, elle offre une expérience toute nouvelle de l'espace, de la conduite et de la forme en générale. Impossible à copier, il serait vain d'essayer.

GIOVANNI MICHELOTTI

His cars are more famous than their creator could ever be. Giovanni Michelotti worked as a freelancer, usually in co-operation with Alfredo Vignale, on behalf of whose body manufacturing company he designed the very first Ferraris. Michelotti's creativity knew no boundaries, yet he still managed to work in executive positions in the international automotive industry. He was unofficial chief designer at both Triumph and DAF in the sixties. On occasion, it was difficult to determine exactly what he authored. A case in point is BMW: he was a consultant on the 700, as well as the *Neue Klasse* and the big six-cylinders. What is certain is that his life's work comprises 1,200 car body designs, among them the *Italia*-style interpretation of the Triumph TR3.

Seine Autos sind bekannter als ihr Schöpfer es je sein könnte. Giovanni Michelotti arbeitet als Freiberufler, am liebsten zusammen mit Alfredo Vignale, für dessen Karosseriewerk er die ersten Ferrari gestaltet. Michelottis Kreativität ist ungehemmt, und doch gelingt es ihm, führende Funktionen in der Internationalen Automobilindustrie auszuüben. Bei Triumph und DAF ist er in den Sechzigern inoffizieller Designchef. Zum Teil ist es schwierig zu bestimmen, was genau aus seiner Feder stammt. So auch im Falle BMW: Beim 700 ist er genauso beratend tätig wie bei der „Neuen Klasse" und den großen Sechszylindern. Fest steht, dass Michelottis Lebenswerk gut 1200 Karosserien umfasst – darunter die Interpretation des Triumph TR3 im italienischen Stil.

Jamais la popularité de Giovanni Michelotti n'atteindra celle de ses voitures. Giovanni Michelotti, designer freelance, travaille de préférence avec le carrossier Alfredo Vignale, pour lequel il conçoit les premières Ferrari. Designer débordant de créativité, il sait se faire une place au plus haut niveau de l'industrie automobile internationale. Dans les années 60, par exemple, il occupe officieusement le poste de designer en chef chez Triumph et DAF. Par contre, il est difficile de déterminer précisément ce qui est de son cru. Ainsi chez BMW par exemple, il mène une activité de consultant pour la 700, la « Neue Klasse » et des six cylindres. Une chose est sûre, on porte à son actif plus de 1200 carrosseries, dont une élégante interprétation à « l'italienne » de la Triumph TR3.

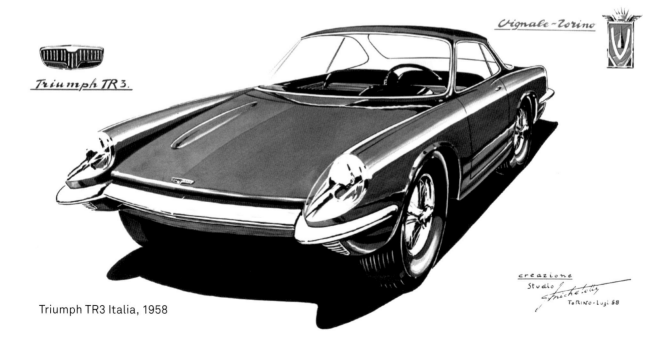

Triumph TR3 Italia, 1958

DAVID BACHE

When looking for an explanation for Rover's change from the manufacturer of staid and solid saloons to the producer of the dynamic —and faintly radical—SD1, one inevitably comes across the name of long-standing head of design, David Bache. Son of a football international, over the years, he developed an increasingly eccentric dressing style, just as he rigorously modernised Rover design. The slick style and dynamic personality of his Rover P6, the British equivalent of the French Goddess DS, remain unsurpassed.

Auf der Suche nach einer Erklärung für die Wandlung der Marke Rover vom Hersteller bieder-solider Limousinen zum Produzenten des dynamischen und zart radikalen SD1 stößt man zwangsläufig auf den Namen des langjährigen Chefdesigners David Bache. Der Sohn eines englischen Fußballnationalspielers kleidet sich nicht nur mit zunehmendem Alter immer exzentrischer, sondern modernisiert das Rover-Design auch rigoros. Unübertroffen sind der schnelle Stil und die dynamische Persönlichkeit seines Rover P6, des englischen Pendants zur französischen Göttin DS.

Pour comprendre la métamorphose de la marque Rover, un constructeur de solides berlines bourgeoises qui crée tout à coup la dynamique et radicale SD1, il faut avoir entendu parler de David Bache, son designer en chef pendant de longues années. Fils d'un joueur de l'équipe nationale anglaise de football, s'il s'habille de manière de plus en plus excentrique les années passant, il modernise surtout radicalement le style Rover. Équivalent anglais de la DS française, sa P6, au style nerveux et à la personnalité dynamique, est unique et reste inégalée.

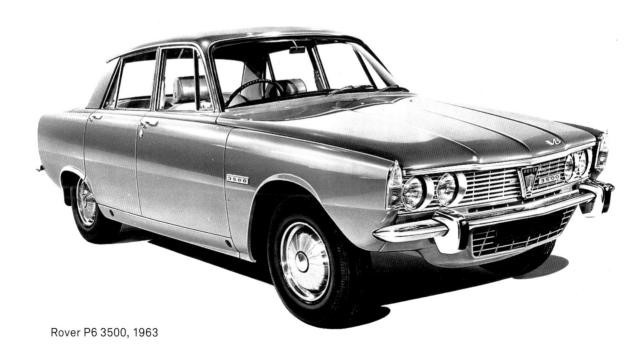

Rover P6 3500, 1963

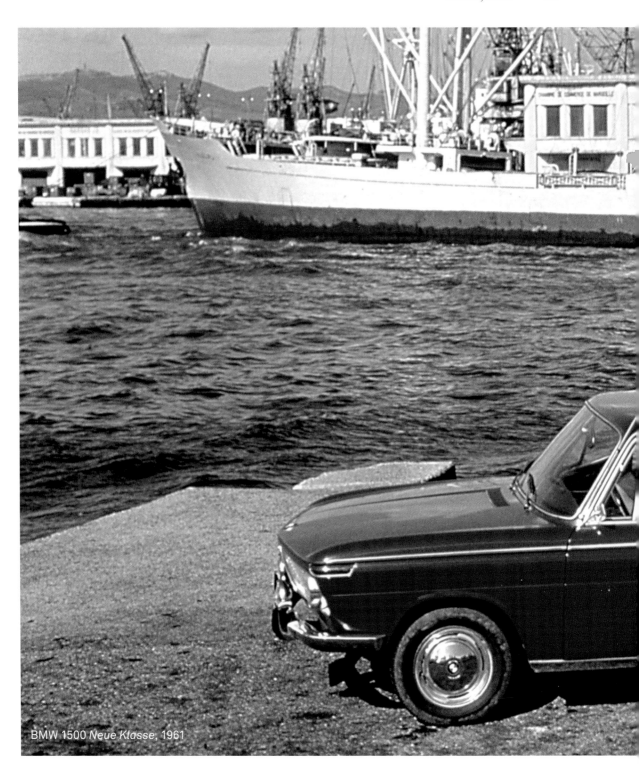

BMW 1500 *Neue Klasse*, 1961

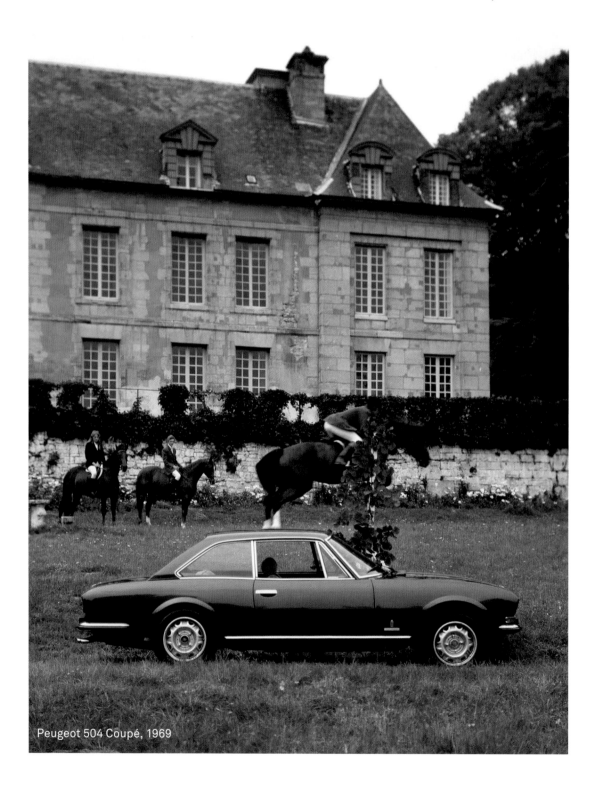

Peugeot 504 Coupé, 1969

PEUGEOT

If the marque with the lion does not seem French enough, it is probably due to the design. Unique in the industry is the company's liaison with Pininfarina, which has been ongoing since 1951. Pininfarina's first project on behalf of Peugeot, the 1955 403 saloon, was a global success. The loyal collaboration has resulted in both high-volume models and niche vehicles: the coupés, convertibles and shooting brakes made by Pininfarina are a class of their own. The Peugeot style steers clear of the typical French extravagance: it is tasteful and intellectual, if frequently a bit too modest. The moulded trapeze-shaped headlights, introduced with the 504, were a precious touch of class that landed Peugeot within sniffing distance of Mercedes-Benz in the sixties.

Wenn die Marke mit dem Löwen einem zu wenig französisch vorkommt, dann liegt es am Design. Einmalig für die Industrie ist die Liaison mit Pininfarina, die seit 1951 besteht. Pininfarinas erster Wurf für Peugeot, die Limousine 403 von 1955, ist ein Welterfolg. Aus der treuen Kollaboration resultieren Volumenmodelle wie Nischenfahrzeuge: Von Pininfarina gebaute Coupés, Cabriolets und Shooting-Breaks sind eine Klasse für sich. Der Peugeot-Stil bleibt der typisch französischen Extravaganz fern: Er ist stilvoll und intellektuell, wenn auch häufig etwas zu brav. Als Designmerkmal gelten die mit dem 504 eingeführten Trapez-Scheinwerfer, ein kostbarer Hauch von Klasse, der Peugeot in den Sechzigern in Rufweite von Mercedes-Benz führt.

On dit souvent que la marque au lion n'est pas très française, que son design est atypique, et on n'a pas tort. La raison, la voilà : depuis 1951, Peugeot collabore avec Pininfarina. Une telle longévité est inégalée dans l'industrie. En 1955, le tout premier modèle issu de cette coopération, la 403, obtient un succès mondial. Puis viennent les gros modèles ainsi que des véhicules de niche comme les coupés, cabriolets et breaks de chasse. Signés Pininfarina, ils font classe à part. Le style Peugeot n'a rien de cette extravagance typiquement française, il est retenu, intellectuel, au risque d'être trop sage. Introduits avec la 504, les phares en trapèze sont un signe de reconnaissance qui lui confère une certaine classe et permette à la marque d'atteindre dans les années 60 une réputation proche de celle de Mercedes-Benz.

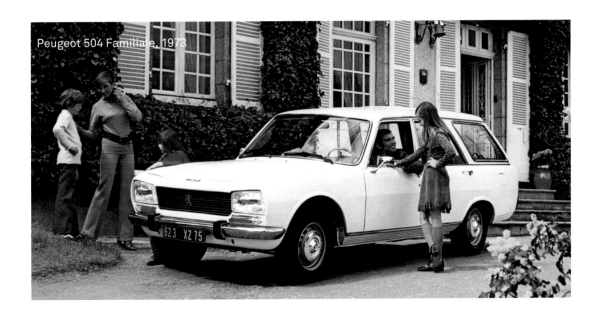

Peugeot 504 Familiale, 1973

CLAUS LUTHE

Claus Luthe originally started a career in car body construction out of necessity, which led him to NSU in Neckarsulm. In 1967, his styling of a new executive saloon created a stir: with its new proportions and avant-garde form, the Ro80 was simply inspirational. It may not have possessed a wedge shape, but it had, instead, a long wheelbase, short overhangs, a high rear and

Aus der Not heraus beginnt Claus Luthe eine Karriere im Karosseriebau, die ihn zu NSU in Neckarsulm führt. Seine Gestaltung einer neuen Mittelklasselimousine im Jahre 1967 gerät zum Paukenschlag: Der Ro80 begeistert mit neuen Proportionen und avantgardistischer Form. Eine Keilform besitzt er freilich nicht, dafür einen langen Radstand,

Claus Luthe fait, par nécessité, ses débuts chez un carrossier, avant d'entrer chez NSU à Neckarsulm. Il dessine en 1967 la Ro80, une nouvelle berline qui fait sensation grâce à sa ligne avant-gardiste : pas de silhouette en coin bien sûr mais un empattement important, des porte-à-faux courts, une poupe relevée et un avant arrondi, qui, un quart de siècle plus tard, n'ont pas

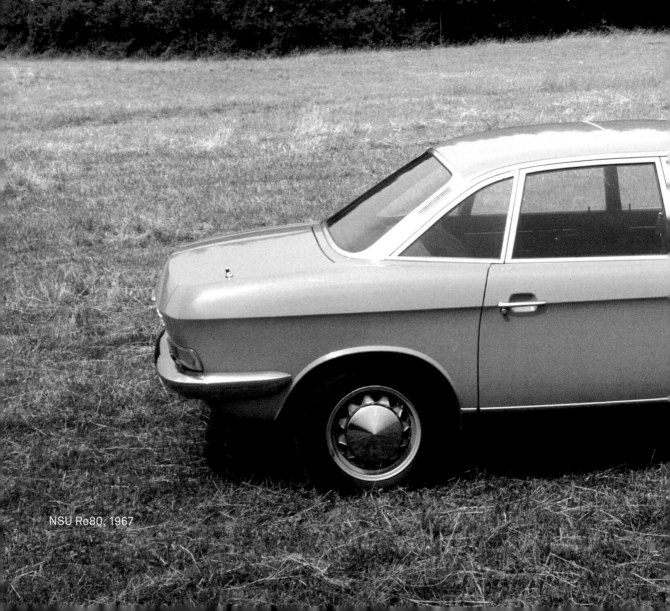

NSU Ro80, 1967

a rounded off front that are still modern a quarter century later. This milestone of German design opened doors for him, finally landing him at the the helm of BMW's styling department. Thanks to his new 7 series, the Munich marque established itself as the dynamic alternative for the business man in 1986, finally on a par with Mercedes.

kurze Überhänge, ein hohes Heck und eine abgerundete Front, die ein Vierteljahrhundert später noch zeitgemäß sind. Dieser Meilenstein öffnet Luthe die Türen und führt ihn zum Chefsessel der BMW-Designabteilung. Mit seinem 7er etablieren sich die Münchner 1986 als dynamische Alternative für den Business Man – und endlich auf Augenhöhe mit Mercedes.

pris une ride. Ce jalon du design allemand ouvre des portes à son concepteur et le mène à la tête du département design de BMW. En 1986, avec la nouvelle série 7, il permet à la firme munichoise d'apparaître comme une alternative dynamique aux yeux des hommes d'affaires et de faire enfin jeu égal avec Mercedes.

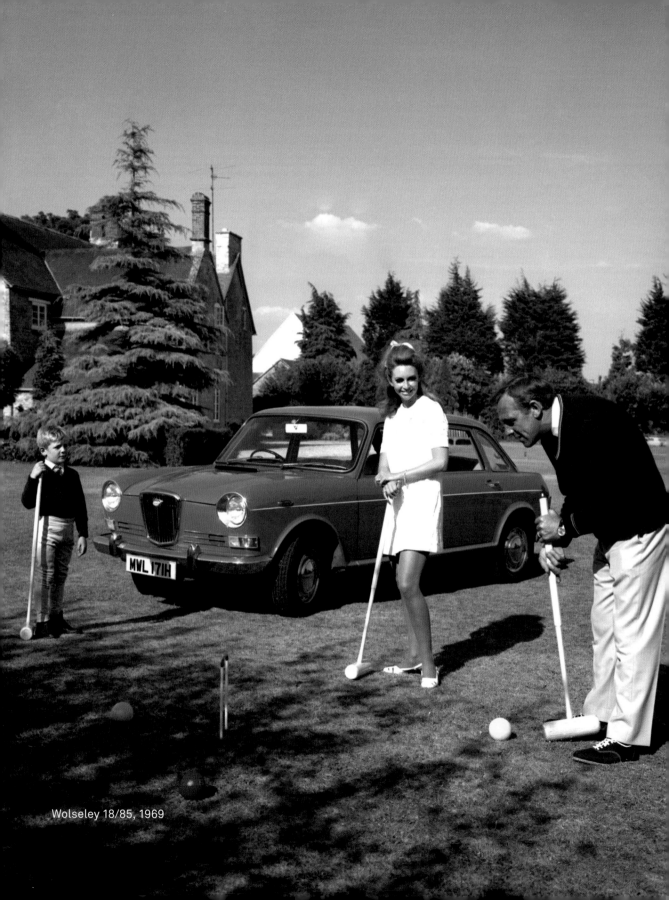

Wolseley 18/85, 1969

BMC

The British Motor Company is created in 1952 through the merger of the Austin Motor Company with the Nuffield Organisation. The at the time biggest British car manufacturer unites the Austin, Austin Healey, MG, Riley, Vanden Plas, Wolseley and later on Jaguar marques under one roof. This creative brand chaos is almost insurmountable. The Mini is availably in Austin Seven, Morris Mini Minor, Riley Elf or Wolseley Hornet guise—the last two featuring funny body tuning, Populuxe style. Oftentimes just a grille and two badges are supposed to make a haphazard product range appeal to a conservative market. This excessively eccentric strategy does not stand a chance in export markets. In 1968, BMC and the Leyland Motor Corporation merge to create British Leyland—the creation of a British General Motors is seen as the last resort. But under the new name, and expanded by the Land Rover, Rover and Triumph brands, conditions do not improve. Too confused is the product range, in which designs from the fifties compete with new, and frequently quirky models, while promising cars fall victim to the generally poor build quality. A pity.

Die British Motor Corporation geht im Jahre 1952 aus der Fusion der Austin Motor Company mit der Nuffield Organisation hervor. Der seinerzeit größte britische Autohersteller vereint die Marken Austin, Austin Healey, MG, Morris, Riley, Vanden Plas, Wolseley und später Jaguar unter einem Dach. Dieses kreative Markenchaos ist kaum zu bewältigen. So kann man einen Mini als Austin Seven, Morris Mini Minor, Riley Elf oder Wolseley Hornet kaufen – die beiden Letzten mitsamt lustigem Karosserietuning im Populuxe-Stil. Häufig sind es kaum mehr als ein Grill und zwei Plaketten, die ein willkürlich zusammengefügtes Produktsortiment einem konservativen Markt schmackhaft machen sollen. Diese bis zum Umfallen exzentrische Strategie hat im Export keine Chance. 1968 tun sich dann BMC und die Leyland Motor Corporation zur British Leyland zusammen – als letzte Hoffnung soll eine britische Antwort auf General Motors erschaffen werden. Doch unter dem neuen Namen und bereichert um die Marken Land Rover, Rover und Triumph wird die Lage nicht besser. Zu wirr die Produktpalette, in der Konstruktionen aus den Fünfzigerjahren neuen, oftmals skurrilen Modellen Konkurrenz machen, während viel versprechende Fahrzeuge unter der allgemein schlechten Fertigungsqualität leiden. Schade eigentlich.

La British Motor Corporation naît en 1952 de la fusion de l'Austin Motor Company avec la Nuffield Organisation. Le plus grand constructeur britannique de l'époque rassemble sous un même toit les marques Austin, Austin Healey, MG, Morris, Riley, Vanden Plas, Wolseley et, plus tard, Jaguar. Cet enchevêtrement créatif de marques est difficile à gérer. Ainsi la Mini est lancée à la fois en version Austin Seven, Morris Mini Minor, Riley Elf et Wolseley Hornet – ces deux dernières étant habillées d'amusantes carrosseries au style « populuxe ». Souvent assemblés arbitrairement en gamme, les produits, censés attirer une clientèle conservatrice, ne varient que par un détail minime, tel l'apport d'une grille de calandre. Cette stratégie excentrique à l'excès n'a aucune chance à l'export. En 1968, BMC et la Leyland Motor Corporation fusionnent en un groupe destiné à faire concurrence au géant américain General Motors. Ni le nouveau nom de British Leyland, ni la palette élargie aux marques Land Rover, Rover et Triumph, n'apporteront de solution. L'éventail de produits reste trop complexe : des modèles des années 50 concurrencent de nouveaux modèles souvent extravagants, alors que les modèles les plus prometteurs pêchent par une qualité insuffisante. Quel dommage !

Daimler Double Six Vanden Plas Saloon, 1972

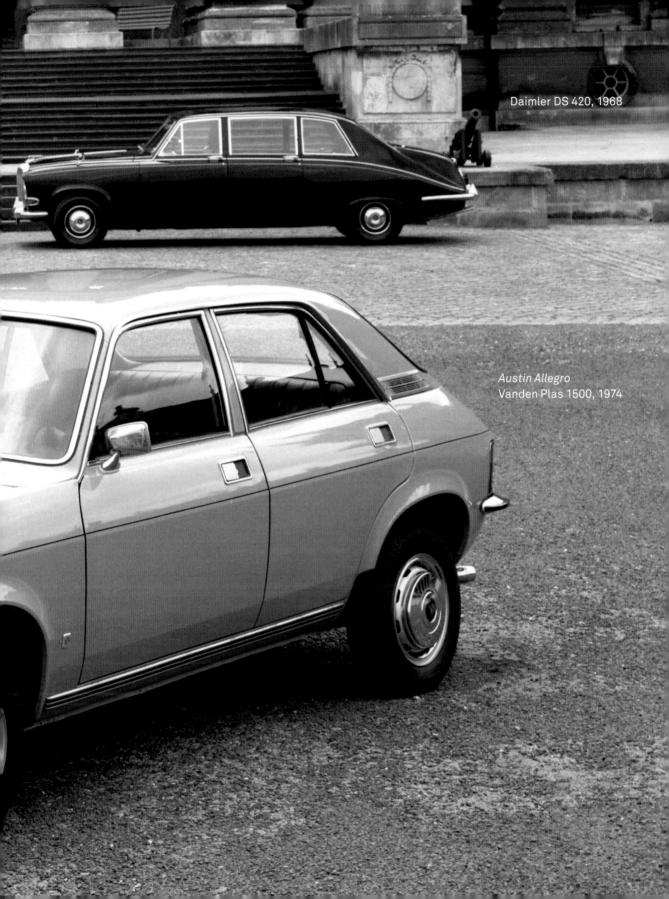

Daimler DS 420, 1968

Austin Allegro
Vanden Plas 1500, 1974

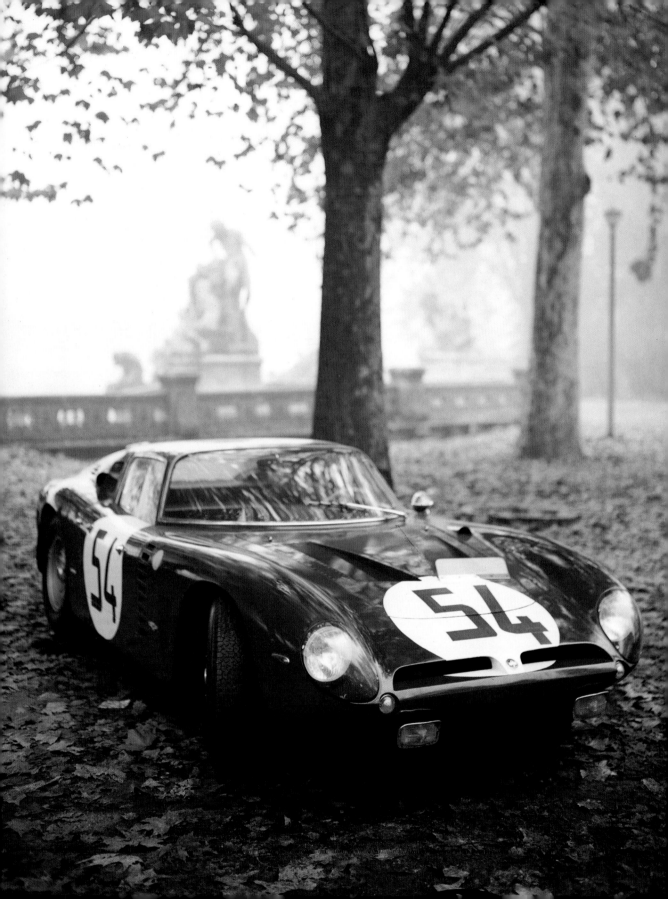

MACHOMOBILE

In 1962, changes to the regulations in the FIA world championship revolutionised the concept of the sports car: it was the birth of the Gran Turismo class. A GT should comprise an enclosed body, two seats and a boot. Just like any normal car, in fact. Since the organisers feared a boring spectacle, they initially raised the engine capacity limit to four litres, later further increasing it to to five. From now on, real macho men would drive GT cars. Jim Douglas, racing car driver in the Disney comedy *The Love Bug* explained why: "Without the right car, I'm half the man."

Eine Änderung im Reglement der FIA-Weltmeisterschaft revolutioniert 1962 das Sportwagenkonzept: Es ist die Geburtsstunde der Gran-Turismo-Klasse. Zwei Sitzplätze, einen Kofferraum und einen Rückspiegel müssen sie aufweisen, wie ein normales Automobil. Da die Rennveranstalter eine langweilige Show befürchten, wird die Hubraumgrenze zunächst auf vier, später gar auf fünf Liter erhöht. Wahre Machos können auf einen GT nicht lang verzichten. Jim Douglas, Rennfahrer in der Disney-Komödie *Ein toller Käfer*, erklärt wieso: „Without the right car I am half the man."

En 1962, un changement de règlement du championnat du monde des constructeurs de la FIA révolutionne le concept de voiture de sport et marque la naissance de la GT – classe grand tourisme. Ainsi, les GT doivent désormais répondre aux critères suivants : être biplace, avoir une carrosserie fermée, un coffre et un rétroviseur. Rien de plus banal jusque là. Sauf que, par crainte d'un spectacle fade, les organisateurs du championnat autorisent les grosses cylindrées, d'abord de quatre puis de cinq litres. Dès lors, les hommes virils – les machos – ne roulent plus qu'en

Iso Grifo A3/C, 1963

Andropause: in the 1960s, the race car gave way to the 'café racer': the car for instant macho.

Wechseljahre: In den 1960ern weicht der Rennwagen dem Café Racer: dem Auto für den Instant Macho.

Changement d'époque : dans les années 60, les voitures de course font place aux modèles pour machos.

SUPER GT

The FIA regulations actually changed much less than anticipated. Grand Tourers, those fast, big touring cars, were still known from pre-war days, created by Bugatti, Mercedes-Benz and Alfa Romeo. The GT monicker first surfaced in 1951, along with the Lancia Aurelia B20. With or without a GT badge, the 1955 Ferrari 250, 1958 Aston Martin DB4 and the 1961 Jaguar E-Type were all, each in their own way, thoroughbred GT cars. After all, the GT term stands for a certain spirit, rather than a simple car recipe. A GT must always be bigger, faster and better looking. Towering above everything else, or, more bluntly put, just being 'super', as implied by the modish names from those times: Supersonic, Superamerica, Superflow, Superfast. Even the superlight Superleggera bodies made by Touring were becoming increasingly more opulent: these were no longer racing cars, but luxurious

SUPER GT

Grand Tourer, große und schnelle Reisewagen, kennt man noch aus Vorkriegszeiten von Bugatti, Mercedes-Benz und Alfa Romeo. Der Begriff GT taucht 1951 mit dem Lancia Aurelia B20 auf. Mit oder ohne GT-Bezeichnung sind der Ferrari 250 von 1955, der Aston Martin DB4 von 1958 oder der Jaguar E-Type von 1961 ebenfalls, jeder auf seine Art, reinrassige GT-Wagen. Doch der Begriff GT steht eher für einen gewissen Geist denn für eine eindeutige Autorezeptur. Ein GT muss immer größer, immer schneller, immer schöner sein. Alles überragen, super sein – das implizieren die modischen Namen jener Zeit: Supersonic, Superamerica, Superflow, Superfast. Die superleichten Superleggera-Karosserien aus dem Hause Touring werden immer opulenter: Sie sind keine Rennautos mehr, sondern luxuriöse Boliden zum Angeben, Bestandteil eines Lifestyle-Konzeptes. Kaum ein Fahrer ist in der

GT. Jim Douglas, coureur automobile dans la comédie de Disney *Un amour de coccinelle* en explique la raison ainsi: « Sans la voiture adéquate, je ne suis pas un homme à part entière ».

SUPER GT

Le règlement adopté par la FIA n'aura pas l'effet escompté. La GT a bien du mal à se définir. Avant la guerre, les voitures Grand tourisme existaient déjà, c'étaient alors des véhicules spacieux et rapides destinés à couvrir de longues distances, comme les Bugatti, les Mercedes-Benz et les Alfa Romeo. Le concept de GT n'apparaît pourtant qu'en 1951 avec l'Aurelia B20 de Lancia. Mais avec ou sans particule, toutes, tant la Ferrari 250 de 1955, que l'Aston Martin DB4 de 1958 ou la Jaguar Type E de 1961, sont d'authentiques GT. Car le concept GT, bien plus qu'une formule technique, est une attitude. Toujours plus rapide, plus grande et plus prestigieuse, la GT est la voi-

Ferrari 400 SA Superfast II
Pininfarina, 1960

'bruisers', ideal for showing off. They were part of a lifestyle concept. Hardly any driver was able to effectively use their power, but that is not what they were built for. Being aware of this power and presenting it visually was good enough to make an impression, and to be impressed. In 1964, as MI6 agent 007 hunted down the fiendish Goldfinger in an Aston Martin DB5, he also delivered irrefutable arguments: GT drivers not only have a licence to kill, but also to bed the most beautiful women. Due to their formal characteristics—the extra long bonnet, sloped windscreen, short rear end, accommodation for two—the super GTs of the sixties quickly came to be considered archetypal classics. They obeyed Enzo Ferrari's romantic principle of the horse drawing the carriage. Meanwhile, on the race track, it was the Cooper's mid-engine configuration—the set-up that made Jack Brabham Formula 1 world champion in 1959—that was taking hold, as it allowed the

Lage, ihre Leistung auszunutzen, dafür sind sie aber auch nicht gedacht. Es reicht das Wissen um die Leistung, und deren gestalterische Inszenierung, um zu beeindrucken – und selber beeindruckt zu werden. Als Geheimagent 007 im Aston Martin DB5 den Schurken Goldfinger jagt, liefert er unumstößliche Argumente: GT-Fahrer haben die Lizenz zum Töten und zum Verführen der schönsten Frauen. Dank formaler Charakteristika – extralange Motorhaube, geneigte Frontscheibe, kurzes Heck, Platz für zwei Personen – gelten die Super-GTs der Sechziger als archetypische Klassiker. Sie folgen Enzo Ferraris romantischem Prinzip vom Pferd, das den Wagen zieht. Auf der Rennstrecke geht man allerdings zur Mittelmotorkonstruktion des Cooper über, mit dem Jack Brabham 1959 Formel-1-Weltmeister wird. So auch 1963 Ferrari und Porsche: Der 250P und der 904 kaschieren die neuartige Konstruktion mit relativ klassischer Optik. Verbit-

ture des superlatifs. Bref, tout doit être « super » comme l'indiquent les noms de l'époque : Supersonic, Superamerica, Superflow, et autres Superfast. Les carrosseries superleggera de chez Touring perdent leur caractère de voiture de course pour devenir d'opulents bolides de luxe, des objets de prestige, des accessoires de life-style. Rares sont les conducteurs capables d'en apprécier toute la puissance mais qu'importe, là n'est pas leur raison d'être. Leurs propriétaires se satisfont du seul potentiel technique du véhicule et la mise en scène de sa puissance les impressionne et fait impression autour d'eux. Et, lorsqu'en 1964, l'agent secret 007, au volant de son Aston Martin DB5, poursuit le méchant Goldfinger, il ne fait plus alors aucun doute : les conducteurs de GT ont dorénavant le permis de tuer et celui de séduire les plus belles femmes. Capot extra-long, pare-brise incliné, coffre court et places limitées à deux sont les attributs qui confèrent aux Super GT des années 60 leur

Sean Connery, Aston Martin DB5 *Goldfinger*, 1964

performance of the ever-growing engines to be fully exploited. In 1963, Ferrari and Porsche followed suit, the 250 P and 904 race cars trying to hide their novel configuration under a relatively traditional look. Still bitter after his failed attempt at taking over Ferrari, Henry Ford II ordered the construction of his own mid-engined race car in England: the GT 40. Both straight and shallow, slender and sturdy, the GT 40 gave the GT car a new identity. And the racing driver, too. Neither a rebel nor gentleman driver, this new kind of hero's name was Jacky Ickx: handsome, sophisticated, fast, smart—the racetrack's Alain Delon. His counterpart was the über-cool Steve McQueen, who, in the crime movie *The Thomas Crown Affair* and the racing drama *Le Mans*, grew into the archetypal automobile macho man. Fascinated by the GT 40, newcomer Ferruccio Lamborghini hastily ordered that a mid-engined chassis be prepared and given form by Bertone. The year 1966 was turn-

tert über den gescheiterten Versuch, Ferrari zu übernehmen, lässt Henry Ford II in England einen eigenen Mittelmotorrennwagen bauen. Geradlinig und flach, schlank und stämmig: Mit dem GT 40 erhält der Gran Turismo eine neue Identität. Wie auch der Rennfahrer. Weder Rebell, noch Gentleman-Driver – der neue Heldentyp heißt Jacky Ickx: attraktiv, gediegen, schnell, klug. Ein Alain Delon der Rennstrecke. Sein Pendant ist der coole Steve McQueen, der im Krimi *Thomas Crown ist nicht zu fassen* und dem Rennsportdrama *Le Mans* zum Urtypen des Automobil-Machos reift. Vom GT 40 fasziniert, lässt Newcomer Ferruccio Lamborghini in Windeseile ein Mittelmotor-Chassis vorbereiten und von Bertone karossieren. 1966 wird zum Jahr des Miura. Er ist zu extrem, um wahr zu sein und von völlig neuen Proportionen geprägt: Die Schnauze ist niedrig und kurz, mit nach vorne gerücktem Cockpit, hinter dem ein Koloss von Motor thront. Das

titre de grand classique. Pour exploiter au mieux la puissance de moteurs toujours plus gros, on passe sur les circuits au moteur central arrière avec la Cooper conduite par Jack Brabham avec laquelle il devient champion du monde de Formule 1 en 1959. La Ferrari 250 P et la Porsche 904 de 1963 malgré leur apparence relativement classique adoptent également cette nouvelle disposition. Henry Ford II, vexé par la tentative manquée de rachat de Ferrari, lance en Angleterre la construction d'une voiture de course à moteur central arrière, la GT 40. Rectiligne, plate, élancée et robuste, la ligne des GT évolue. L'image du pilote de course aussi. Ni rebelle, ni gentleman, le nouveau héros a du caractère, il est intelligent, vif et beau. Jacky Ickx, l'Alain Delon des circuits, en est le représentant. Au cinéma, l'archétype du pilote, c'est Steve McQueen dans le film policier *L'Affaire Thomas Crown* et dans la comédie dramatique *Le Mans* dont le rôle interprété avec beaucoup

Porsche 904, 1963

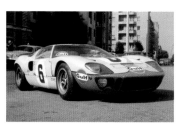

Ford GT 40 MkI *Le Mans 69*, 1965

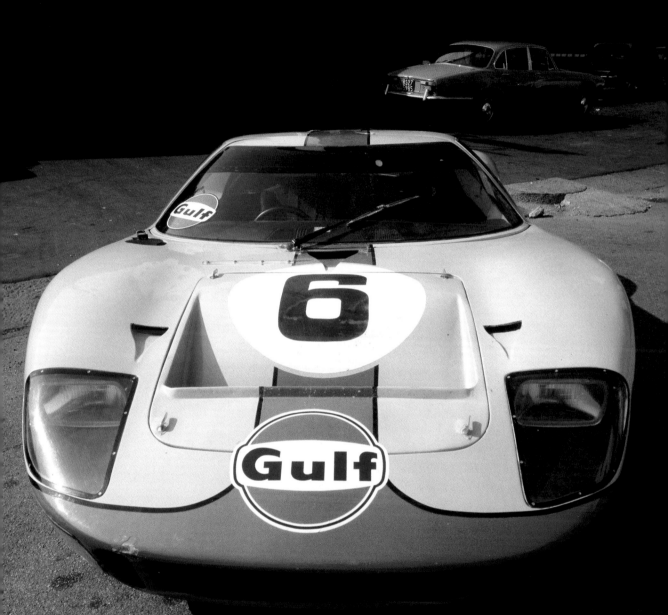

Ford GT 40 MkI *Le Mans 69*, 1965

ing into the year of the Miura. It was too extreme to be true and, due to its engineering, defined by completely new proportions: the front was low and short, the driver lay far to the front, behind almost a shop window, with a colossus of an engine at his back. The rear was cliff-like, black and hollow. The supercar's aesthetics were pared down for sensualism and senselessness. Too wide and lacking visibility, the Miura offered absolutely no practical advantages whatsoever, not to mention the fact that only kamikaze pilots would ever dare get near its claimed top speed of 190 mph, due to a crippling lack of aerodynamics. The Miura was certainly not used for racing, but that is of no matter, because the Italian car was a sinfully expensive but perfect boulevard racer and, as such, neither status nor motus, but a radical sex symbol.

This made all the difference because, exempted from the performance function, the supercar's

Heck ist steil, schwarz und hohl. Der Besitzer liegt wie im Schaufenster. Die Ästhetik des Supersportwagen ist auf Sinnlichkeit und Sinnlosigkeit abgerichtet. Zu breit und unübersichtlich zum Fahren, bietet der Miura Null Nutzwert, abgesehen von einer angeblichen Höchstgeschwindigkeit von 300 km/h – der sich, mangels Aerodynamik, nur Kamikaze-Piloten anzunähern trauen. Bei Rennen wird der Miura erst recht nicht eingesetzt. Das macht aber nichts, denn als sündhaft teurer Boulevard-Racer ist der Italiener weder Status- noch Motus-, sondern radikales Sex-Symbol.

Von der reinen Leistungsfunktion befreit, erlangt das Design des Sportwagens eine außerirdische Dimension, die kaum Bezug zum Alltag hat. Beginnend mit dem Miura kennt die Design-Extravaganz keine Grenze mehr, bis sie im brutalen Body-Building eines Ferrari Testarossa 1984 kulminiert: Schließlich muss die aufre-

de décontraction fait du pilote automobile un symbole de virilité. Fasciné par la GT 40, Ferruccio Lamborghini, nouveau venu dans le cercle des constructeurs, fait réaliser en un temps record un châssis à moteur central qu'il fait habiller d'une carrosserie Bertone. 1966 est l'année de la Miura. Trop extrême pour être de ce monde, son architecture implique des proportions inédites : le nez est court et bas, l'habitacle dans lequel le pilote semble allongé comme dans une vitrine est rejeté vers l'avant pour faire place à un moteur colossal à l'arrière. La poupe est affûtée et creuse. La « supercar » est certes sensuelle mais elle est absurde : trop large, elle offre une très mauvaise visibilité et ne présente aucun atout réel hormis ses 300 km/h au compteur, que seuls des kamikazes tenteront d'atteindre, au vu de ses mauvaises qualités aérodynamiques. En conséquence, et cela ne surprend guère, la Miura est absente des compétitions. D'un prix exorbitant, elle

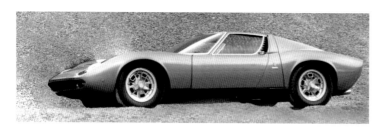

Lamborghini Miura, 1966

design acquired an extra-terrestrial dimension that bore little relation to reality. Beginning with the Miura, design extravagance shrugged off all boundaries, until it culminated in the absolute wedge: in the end, the exciting shape had to compensate for quite a few painful disappointments. Paradoxically—and if they are not simply kept inside heated garages as mere collector's items—most supercars are only ever used for brief tours over the weekend, at a modest pace, just to make sure nothing goes *kaputt*.

SUPER SEDAN

The title of a German conservative party political broadcast—part of the 1961 campaign—summed up the atmosphere of the sixties: 'A rise without limits'. The five-millionth Beetle had just left the assembly line and everybody is doing very well indeed, thank you. It was a golden era for the motorist: money and fuel were abundantly available and roads

gende Form für manch leidvolle Erfahrung kompensieren. Paradoxerweise werden die Supersportwagen, sofern sie nicht als bloße Sammelobjekte in beheizten Garage konserviert werden, auch höchstens für die kurze Wochenendfahrt eingesetzt – und zwar bei behutsamem Tempo, damit auch ja nichts passiert.

SUPER SEDAN

Der Titel eines Werbefilms der deutschen Konservativen anlässlich des Wahlkampfs 1961 bringt die Stimmung der Sechzigerjahre auf den Punkt: „Aufstieg ohne Ende". Der fünfmillionste Käfer rollt vom Band, allen geht es gut. Für Automobilisten sind es goldene Jahre: Geld und Benzin sind reichlich vorhanden, auf den Straßen gibt es kein Tempolimit. Die Familien der Babyboomer wollen schnellen Spaß haben. Jaguar-Boss William Lyons erkennt, dass der klassische Sportwagenkunde, der am Samstag Rennen fährt, wie auch der klas-

est idéale pour arpenter les boulevards en faisant ronfler les moteurs. Plus qu'un simple objet de prestige, qu'un véhicule ultra puissant, c'est avant tout un véritable sex-symbol.

Et voilà toute la différence : le design de la voiture de course délivré de toute considération de fonctionnalité atteint une dimension surnaturelle totalement déconnectée de la vie quotidienne. Avec la Miura, le design automobile entre dans une ère d'extravagance sans limite, d'excès total où la forme sert à faire oublier certains déficits. Paradoxalement, lorsqu'elles ne finissent pas comme objet de collection au fond de garages chauffés, ses supercars servent tout juste à effectuer de petites ballades le week-end … à vitesse modérée, cela s'entend.

SUPER SEDAN

« La croissance sans limite », le titre d'un film tourné par la CDU, le parti conservateur allemand,

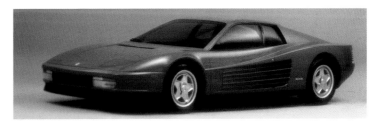

Ferrari Testarossa, 1984

were free. The baby boomers' families want to have some fun, and quick. Jaguar boss William Lyons, recognised that the typical sports car customer, who goes racing on Saturdays and the classic saloon driver, who is only ever interested in comfort, are dying breeds. New standards needed to be complied with in order to remain successful in the American market: a Chevrolet with eight cylinders, five litres and 250 HP was seen as the standard on the new continent. This led to the decisive inspiration in 1959, to take an everyday saloon car and fuse it with racing technology. Thus, the inoffensive Jaguar 2.4 Litre gained disc brakes for a 220 HP 3.8 litre engine. The 'Le Mans Winner' Mark II was met by an enthusiastic market, despite its somewhat old-fashioned silhouette. And this was just the beginning, as David Brown stretched the Aston Martin DB4 by two doors, creating the Lagonda Rapide. Sketched around the 5000 G.T.'s racing engine, Frua

sische Limousinenkunde, den einzig Gediegenheit interessiert, Auslaufmodelle sind. Um am Markt bleiben zu können, muss man mit neuen Standards zurechtkommen: Ein Chevrolet mit acht Zylindern, fünf Litern und 250 PS gilt in Übersee als Mittelmaß. 1959 führt das zur entscheidenden Idee: Man nehme eine Alltagslimousine und versetze sie mit Renntechnik. Der brave Jaguar 2,4 Litre bekommt so den „Le Mans Winner" 3,8-Liter-Motor mit 220 PS. Trotz gestriger Linienführung wird der 200-km/h-schnelle Mark II begeistert aufgenommen. David Brown verlängert einen Aston Martin DB4 um zwei Türen und erschafft den Lagonda Rapide.

Um den Rennmotor des 5000 G.T. herum entwirft Frua den Maserati Quattroporte: eine schlichte, rassige, luftige Limousine, die über 225 km/h schnell ist – für die damalige Zeit eine Sensation. Es entsteht ein neues Genre: das der Super Sedans.

pour la campagne électorale de 1961 est très révélateur de l'ambiance euphorique qui règne dans les années 60. La coccinelle est alors produite à plus de cinq millions d'exemplaires et la bonne santé de l'économie profite à tous. C'est l'âge d'or des automobilistes : l'argent et l'essence ne manquent pas et les routes ne connaissent pas les limitations de vitesse. Les parents des baby-boomers veulent s'amuser et sans attendre. William Lyons, le directeur de Jaguar, constate l'évolution de la clientèle. Deux types se font rares, le client de la voiture de course destinée à disputer les rallyes du dimanche, et celui de la berline conventionnelle, surtout soucieux de qualité. Quant au marché américain, pour s'y maintenir, il faut s'adapter à de nouveaux standards. Outre-Atlantique, la Chevrolet huit cylindres avec moteur de cinq litres et 250 chevaux se classe en effet tout juste dans le moyen de gamme. De cette constatation décisive naît en 1959 une architecture automobile nou-

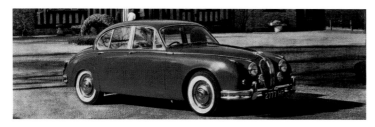

Jaguar MK II, 1959

shaped the Maserati Quattroporte: an unadorned, racy, lithe saloon with a top speed of more than 140 mph—nothing short of a sensation at the time. A new genre was created: the super sedan. In 1968, Mercedes-Benz followed the trend and transplanted the 600 limousine's mighty V8 into the S-Class. Jaguar created the ultimate masterpiece in the shape of the XJ6: timelessly classical, its long, low and curvy shape becomes the epitome of the sports saloon. With the 2500-2800, BMW redefined its own market position: progressive, dynamic, elegant, these cars spoke the language of the self-made captain of industry. Like their country's economic power, the performance of these limousines seemed to know no upper limits: hence Jaguar's changing the XJ6 into the twelve-cylinder XJ12 5.3 litre. Mercedes equipped the next S-Class with a 6.9 litre engine and, in 1976, Maserati unveiled a new Quattroporte with a 300 HP, 4.9 litre engine. Aston Martin's futuristic

1968 transplantiert Mercedes-Benz den mächtigen Achtzylinder der 600 Limousine in die S-Klasse. Jaguar kreiert mit dem XJ6 das absolute Meisterwerk. Zeitlos klassisch, wird die lange, niedrige und geschwungene Karosserie zum Sinnbild der Sportlimousine. Mit dem 2500-2800 definiert BMW die eigene Position neu: progressiv, dynamisch, elegant. Die Superlimousinen sprechen die Sprache des modernen Industriekapitäns. Und des Selfmademan. Wie deren Wirtschaftskraft scheint auch die Leistung dieser Limousinen nach oben keine Grenzen zu kennen:

Jaguar macht aus dem XJ6 einen zwölfzylindrigen XJ12 mit 5,3 Liter. Mercedes baut in die nächste S-Klasse eine 6,9-Liter-Maschine, und Maserati bringt 1976 den neuen Quattroporte mit 4,9 Litern und 300 PS. Als gestalterischer Höhepunkt gilt der futuristische Aston Martin Lagonda: außen Keil, innen Quarz. Doch die Ölkrisenjahre

velle par croisement de la berline et de la voiture de course. Ainsi la timide Jaguar 2,4 litres se voit dotée d'un moteur - vainqueur au Mans - de 3,8 litres et de 220 ch ainsi que de freins à disques. Malgré une ligne quelque peu démodée, la Mark II et ses 200 km/h sont accueillis avec enthousiasme. Et ce n'est que le début. David Brown crée plus tard la Lagonda Rapide en ajoutant deux portes à l'Aston Martin DB4. Frua élabore, quant à lui, la Maserati Quattroporte, une berline sans fioritures, légère et racée, mue par le moteur de course de la 5000 G.T. Elle dépassera les 225 km/h, une vitesse record à l'époque. La « super sedan », cette nouvelle catégorie de voiture, est bien là. En 1968, sur la même lancée, Mercedes-Benz équipe la Classe S du moteur huit cylindres de la 600. Puis vient la XJ6 de Jaguar, un chef d'œuvre absolu : sa ligne classique et intemporelle aux lignes courbes, longues et basses fera référence en matière de berline de sport. Avec ses modèles

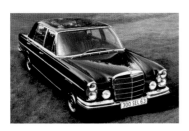

Mercedes-Benz 300 SEL 6.3, 1968

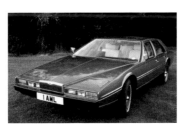

Aston Martin Lagonda, 1976

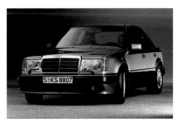

Mercedes-Benz 500 E, 1991

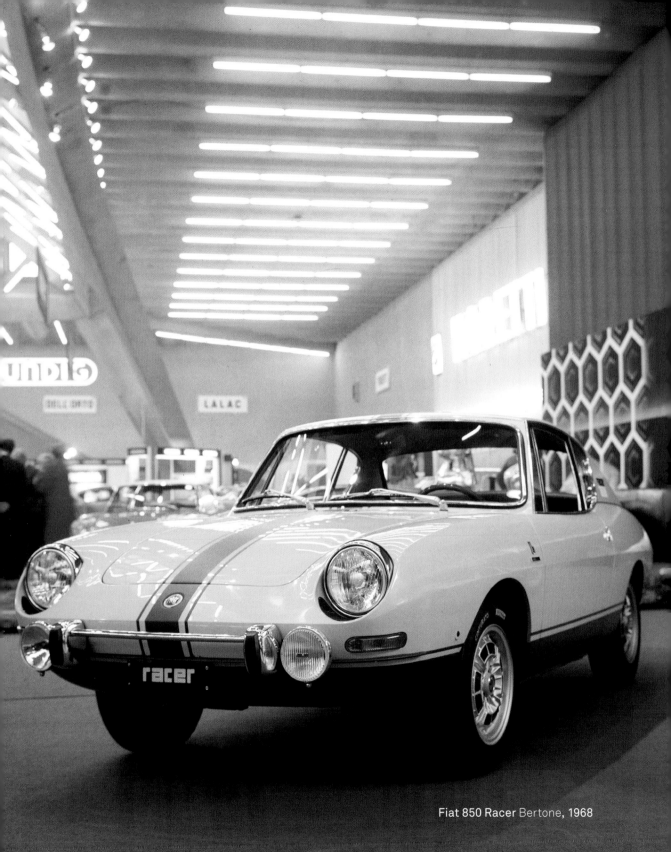

Fiat 850 Racer Bertone, 1968

Lagonda defined the stylistic pinnacle: wedge from the outside, quartz on the inside. But those oil crisis years thwarted the daring British Car's success. And even after the oil crises had passed, the industry's prospects appeared bleak. As a consequence, the sports saloons hid themselves behind the cover of the automotive middle class. This meant that only its somewhat wider wings revealed the Mercedes-Benz 500E as a 'Porsche slayer' and the Lancia Thema 8.32 could electronically deploy a rear spoiler from its boot lid, once the Ferrari engine's performance was called upon. Automotive design discovers the ambivalent strategy of flashy understatement.

RALLY

The middle-class variant of the supercar traces its roots right back to rally racing, which was quite a crowd puller in the late 1960s. It is the last of the down-to-earth motorsport competitions: you

bremsen den wagemutigen Briten. Und danach sieht es für die Branche noch düsterer aus. Die Sportlimousine tarnt sich unter dem Deckmantel der Mittelklasse. So enttarnen lediglich die etwas breiteren Kotflügel den Mercedes-Benz 500E als Porsche-Killer. Und dem Lancia Thema 8.32 wächst elektrisch ein Spoiler aus der Heckklappe, sobald die Leistung des Ferrari-Motors in Anspruch genommen wird. Automobildesign entdeckt die ambivalente Strategie des auffälligen Understatement.

RALLYE

Die bürgerliche Variante des Supercars hat ihre Wurzeln im Rallyesport, der Ende der 1960er Jahre ein wahrer Publikumsmagnet ist. Es ist der letzte volksnahe Motorsportwettbewerb: Man muss weder zur Rennstrecke fahren noch ein Ticket zahlen, um Spaß zu haben. Ein Name fasziniert alle: Monte Carlo, die Winterrally, in deren Takt Claude

2500 et 2800, BMW se repositionne : progrès, dynamisme et élégance sont les maîtres-mots. Les nouvelles berlines sportives parlent à ces capitaines de l'industrie moderne que sont les managers ; leur force économique est au reflet des performances apparemment sans limite des moteurs. Esthétiquement, on atteindra des sommets inégalés avec la très futuriste Lagonda d'Aston Martin : un intérieur tout en affichages à quartz, emballé dans un extérieur anguleux taillé à l'avant en lame de couteau. Mais la crise pétrolière nuit au succès de cette anglaise de choc. Et après la crise, le secteur automobile broie du noir. Les berlines de sport cachent alors leurs effets sous des allures de routière. Sur la Mercedes 500E, seules des ailes élargies trahissent son ambition, celle de rafler à Porsche la palme du haut de gamme. Sur la Thema 8.32 de Lancia, les constructeurs mettent au point un aileron électrique qui ne se déploie que lorsque le moteur, conçu par

have to drive to the rally circuit yourself, but there's no need to pay for a ticket to have a good time. At that time, one name fascinated everybody: Monte Carlo, the winter rally, whose beat informs Claude Lelouch's automotive romantic film *A Man and a Woman*. Johnny Everyman can relate to the drivers and co-pilots, since they are driving the same cars as him: Mini, Fiat, Citroën, Opel, Ford, Renault. Superficial tuning is enough to turn the family's four seater into a rally car: wider rims, auxiliary head lamps, a tachometer and, of course, matte black war paint. The latter's function had been scientifically proven: it prevents any distracting reflections on the bonnet caused by the glaring sun. The manufacturers quickly sensed the positive effects on their image and recognised the sales potential of these sporty variants. Each country cheered on its own hero: John Cooper was the engine tuner for the Mini, Amédée Gordini for Renault, Carlo Abarth for Fiat.

Lelouch den Automobilliebesfilm *Ein Mann und eine Frau* inszeniert. Otto Normalbürger identifiziert sich mit den Piloten, schließlich fährt man dieselben Autos: Mini, Fiat, Citroën, Opel, Ford, Renault. Leichtes Tuning reicht aus, um aus dem Familienviersitzer einen Rallyewagen zu machen – breitere Felgen, Zusatzscheinwerfer, ein Tachometer und selbstverständlich Kriegsbemalung. Ein Hit ist die mattschwarze Lackierung der Haube: Techno-Look. Rasch spüren die Hersteller den positiven Imagetransfer sportlicher Derivate.

Jedes Land hat dabei seine eigenen Helden: John Cooper gilt als bester Tuner für den Mini, Amédée Gordini für Renault, Carlo Abarth für Fiat. Die Männer Europas lieben deren Mini-Cooper, R8-Gordini und Autobianchi A112 Abarth. Weltmeister Lancia bietet den Fulvia Coupé in einer HF-Montecarlo-Version. Ob Opel Kadett oder Fiat 128: Die Bedeutung des Rallye-Looks

Ferrari, tourne à plein régime. Le design automobile découvre la stratégie de l'understatement.

RALLYE

La version bourgeoise de la « supercar » trouve son origine dans les rallyes automobiles de la fin des années 60 ; une époque où les foules se rendent encore en voiture au pied des pistes pour assister gratuitement à ces dernières compétitions automobiles populaires. Un événement suscite la fascination générale, c'est Monte-Carlo, ce rallye d'hiver qui rythme l'action du film de Claude Lelouch *Un homme et une femme*, film d'amour et véritable hommage à l'automobile. Les Monsieur Tout-le-monde s'identifient alors aux pilotes qui conduisent comme eux des Mini, des Fiat, des Citroën, des Opel, des Ford, et autre Renault. Un léger tuning suffit à transformer la moindre quatre places en voiture de rallye avec jantes élargies, phares supplémentaires, tachymètre et bien

Porsche 911, 1965

Saab 96 GT, 1962

All over Europe, men were in love with their Mini Coopers, R8-Gordinis and Autobianchi A112 Abarths. Lancia offered the world champion Fulvia coupé in an HF Montecarlo version that sold for four years longer than originally planned, due to high demand. No matter if it was an Opel Kadett or Fiat 128: the importance of the rally look for automotive design was enormous. From now on, chrome and wood would be frowned upon as old-fashioned and stuffy: cool cars glare in matte black, inside and out. At first, it was still painted metal that provided the sheen, but the increasing use of plastics at the beginning of the seventies led to a whole new, synthetic automotive aesthetic.

ist für das Automobildesign enorm. Fortan gelten Chrom und Holz als altmodisch und bieder: Coole Autos glänzen innen wie außen mattschwarz. Zunächst ist es noch lackiertes Metall, doch mit dem Einsatz von Kunststoff zu Beginn der 1970er Jahre entwickelt sich eine völlig neue, synthetische Automobilästhetik.

sûr ce noir mat, dont la fonction scientifiquement prouvée, est d'absorber les reflets gênants du soleil sur le capot ! Très vite les constructeurs comprennent le transfert positif qui s'opère et le potentiel de vente que les versions sport représentent. La gente masculine européenne adore ses Mini-Cooper, ses R8-Gordini et ses Autobianchi A112 Abarth. Lancia, champion du monde des constructeurs, met sur le marché la Fulvia Coupé version HF Montecarlo qui sera vendue quatre années de plus que prévu. Opel Kadett Rallye ou Fiat 128 Rally, le look rallye est omniprésent dans le design automobile. Dès lors, le chrome et le bois font ringards et bourgeois : cool est la voiture qui en jette de sa couleur noir mat, à l'intérieur comme à l'extérieur. Dans les années soixante-dix, le métal laqué des débuts cède la place au plastique. L'ère du synthétique dans l'esthétique automobile est en marche.

Opel Kadett Rallye, 1967

Renault R12 Gordini, 1971

Fiat 128 Rally, 1973

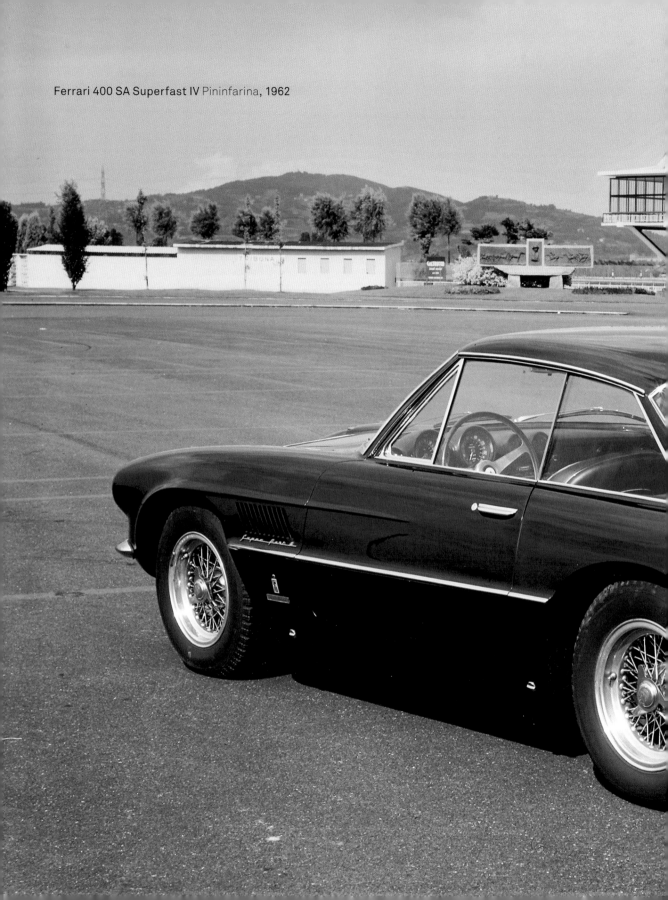

Ferrari 400 SA Superfast IV Pininfarina, 1962

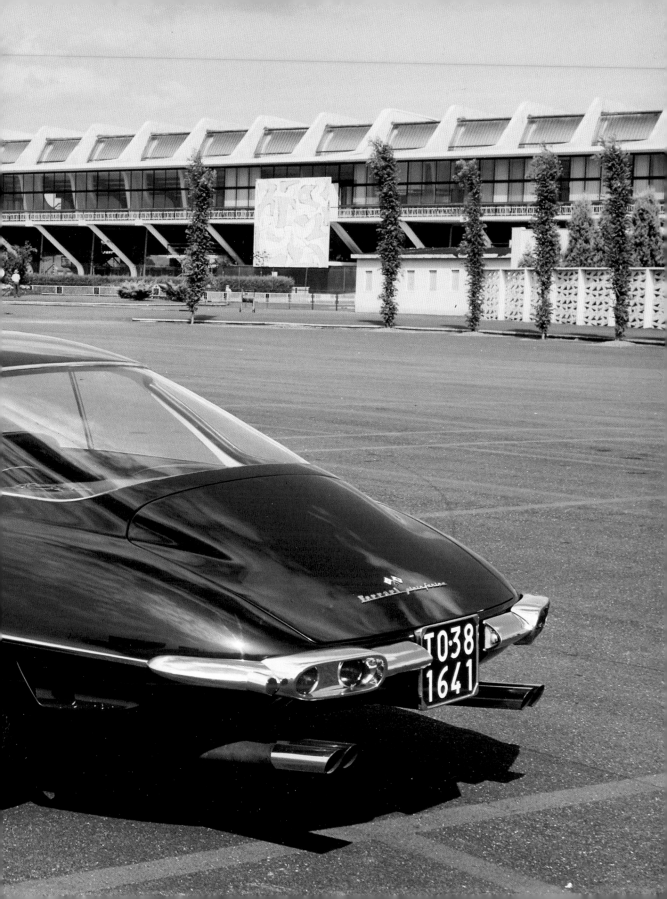

MALCOLM SAYER

The fact that Sayer referred to himself as an 'aerodynamicist' says a lot about the E-Type designer's *modus operandi*. Aesthetics played a secondary role in Sayer's book: he cared more about reaching aerodynamic perfection by employing mathematical formulae. And yet the way he shaped the E-Type, with its phallic front and pert *derrière*, led to the most erotic form in automotive history.

Die Tatsache, dass Sayer sich selbst als Aerodynamiker bezeichnet, sagt viel über die Arbeitsweise des E-Type-Designer aus. Die Ästhetik ist für Sayer sekundär – ihm ist wichtiger, mit Hilfe mathematischer Formeln aerodynamische Perfektion zu erlangen. Und trotzdem gestaltet er mit dem durch und durch plastischen E-Type mit Phallus-Front und Spitz-Po die erotischste Form der Automobilgeschichte.

Que Malcolm Sayer se définisse comme un ingénieur en aérodynamique en dit long sur les méthodes de travail du concepteur de la Type E. Les considérations esthétiques lui importent peu. Son objectif : atteindre par des formules mathématiques la perfection aérodynamique. Il n'en conçoit pas moins, avec la Type E, son capot viril et sa croupe féminine, la forme la plus érotique de l'histoire automobile.

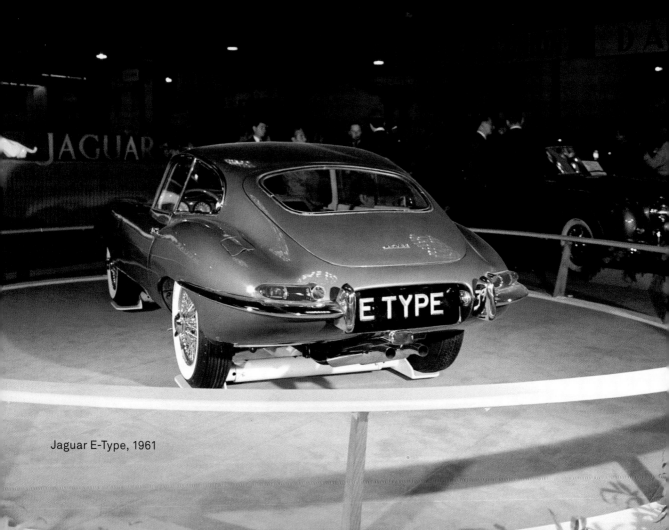

Jaguar E-Type, 1961

William Lyons, Jaguar E-Type, 1961

JAGUAR

The character of the Jaguar marque is inseparably linked with its founder, William Lyons. Lyons was a penny-pincher and, therefore, the less-important components did not always need to be of the highest quality. On the other hand, he gave his engineers plenty of scope for their advanced designs. And the Jaguar boss, with his artist's eye, personally took charge of the cars' body shapes, leading to two and a half decades of milestone after milestone leaving the company's factory at Browns Lane in Coventry. Notwithstanding sports

Der Charakter der Marke Jaguar ist mit dem ihres Gründers William Lyons untrennbar verbunden. Lyons ist knauserig, weshalb unwichtigere Technikkomponenten nicht immer von allerhöchster Qualität sein müssen. Andererseits lässt er seinen Ingenieuren für ihre fortschrittlichen Konstruktionen weitgehend freie Hand. Und über die Form der Fahrzeuge wacht der Jaguar-Chef persönlich und mit dem Auge eines Künstlers, weshalb in zweieinhalb Jahrzehnten ein Meilenstein nach dem anderen die Fabrikhallen der Browns Lane in

Le caractère de la marque est indissociable de celui de son fondateur, William Lyons. Comme l'homme est pingre, les composants techniques secondaires ne sont pas systématiquement haut de gamme. D'un autre côté, il laisse largement carte blanche à ses ingénieurs et à leurs innovations, tout en veillant personnellement, avec l'œil d'un artiste, à la forme des véhicules. Vingt-cinq ans durant, des modèles d'anthologie sortiront de l'usine de Browns Lane à Coventry. Qu'il s'agisse de voitures de course comme la XK120 et la Type E

Jaguar XJ6, 1969

The English Castle (AD 1346)

The 204 KPH Fortress (AD 1970)

The beautiful Jaguar XJ6 2.8 litre 4.2 litre

JAGUAR

IMPORTEUR FUR DIE DEUTSCHE SCHWEIZ: EMIL FREY AG, ZURICH IMPORTATEUR POUR LA SUISSE ROMANDE: GARAGE PLACE CLAPAREDE SA, GENEVE
IMPORTATORE PER TICINO: GARAGE C. CENCINI, LUGANO

cars such as the XK120 and E-Type or saloons like the Mk II, Mk X or the XJ, Jaguar is the opposite of conservative: progressive, but without being avant-garde. Thanks to their ravishing surfaces and striking proportions, the Lyons-era Jaguar models embodied the proverbial cat-like elegance. There was no stopping the cars' success: they drove just the way they looked and were never overpriced.

Coventry verlässt. Egal ob Sportwagen wie XK120 und E-Type oder Limousinen wie Mk II, Mk X oder XJ – Jaguar ist alles andere als konservativ, sondern fortschrittlich, ohne Avantgarde zu sein. Mit bestechend geformten Oberflächen und auffälligen Proportionen verkörpern die Jaguar-Modelle der Lyons-Ära die sprichwörtliche katzenartige Eleganz. Da die Autos auch so fahren, wie sie aussehen, und dazu nicht überteuert sind, steht dem Erfolg nichts im Weg.

ou de berlines telles que la Mk II, la Mk X ou la XJ, Jaguar ne fait preuve d'aucun conservatisme mais se montre au contraire moderne sans toutefois verser dans l'avant-gardisme. Des lignes séduisantes et des proportions saisissantes confèrent aux modèles de l'ère Lyons l'élégance proverbiale des félins. Et comme leur conduite est à l'image de leur apparence et que leur prix n'est pas exorbitant, leur succès est assuré.

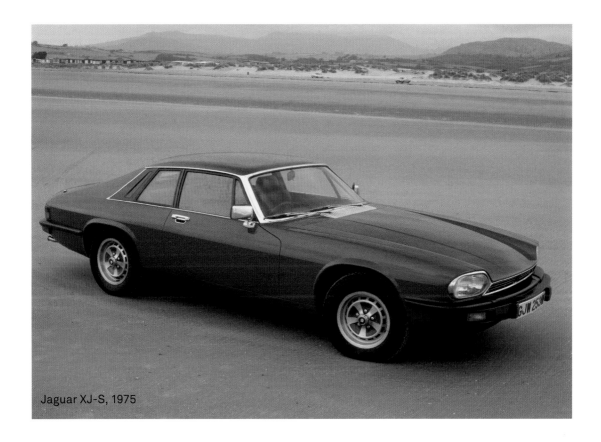

Jaguar XJ-S, 1975

Iso Grifo Lusso, 1964

PIETRO FRUA

The temper of a giant, of someone who would dare to leave Farina and Ghia in anger, is hardly noticeable in the handwriting of Pietro Frua. He was the king of his *carrozzeria's* drawing board and did not feel the need to prove anything to anyone. Freshness, originality and moderation constitute his body or work, in particular the fetching Renault Floride. He even nonchalantly restrained the power of a Maserati: the Mistral and Quattroporte are poetic compositions of dynamic effortlessness and stylistic understatement: The International Style, made in Italy.

Das Temperament eines Riesen, der es wagen konnte, Farina und Ghia im Streit zu verlassen, erkennt man in der Handschrift Pietro Fruas kaum. Am Zeichenbrett seiner Carrozzeria ist er König und braucht nichts zu beweisen. Frische, Originalität und Maß bezeichnen sein Werk, vor allem beim schmucken Renault Floride. Selbst die Kraft eines Maserati bändigt er mit Nonchalance: Mistral und Quattroporte sind poetische Kompositionen dynamischer Leichtigkeit und stilistischen Understatements – International Style, made in Italy.

On ne perçoit guère dans la signature de Pietro Frua le tempérament d'un géant capable de quitter Farina et Ghia sur une dispute. Devant la planche à dessin dans son atelier de carrosserie, il n'a rien à prouver. Fraîcheur, originalité et équilibre caractérisent son travail, en particulier sur la jolie Renault Floride. Il parvient même à discipliner la fougue d'une Maserati : la Mistral et la Quattroporte sont des créations poétiques respirant la légèreté, le dynamisme et la pondération stylistique. Un style international *made in Italy*.

Maserati Mistral, 1963

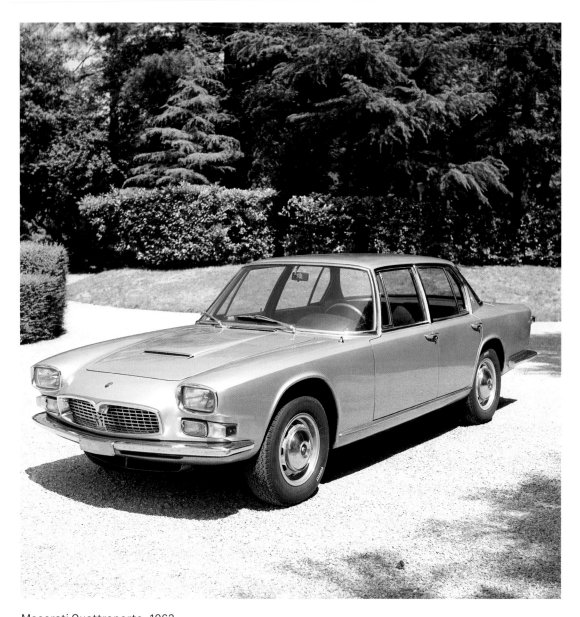

Maserati Quattroporte, 1963

The class of the 1960s: the lowered waistline and the panoramic glasshouse lend the mighty Maserati a composed, lean appearance.

Die Klasse der 1960er: die heruntergezogene Gürtellinie und das panoramische Greenhouse verleihen dem mächtigen Maserati ein unaufgeregtes, schlankes Aussehen.

L'élégance des années 60 : la ligne de caisse surbaissée et la large surface vitrée confèrent à la puissante Maserati une silhouette sereine et élancée.

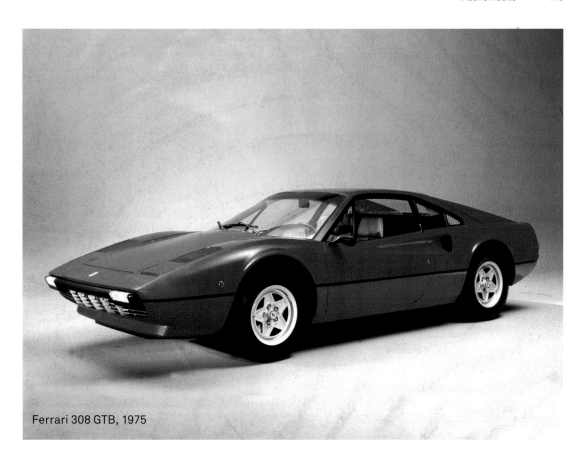

Ferrari 308 GTB, 1975

FERRARI

The famous racing team was facing its litmus test in the sixties. A piqued Enzo Ferrari withdrew from sales negotiations with Ford and then employed the help of Fiat to build the Dino, Italy's Porsche slayer. The Coupé and Spider were marketed by Fiat, while Ferrari was in charge of the mid-engined GT. As it only had six cylinders, it must not be called a Ferrari. With Tony Curtis behind the wheel in the TV series *The Persuaders*, the red runabout turned into a Maranello icon all the same.

Die Ära klassischer Sportwagen-konstruktion neigt sich dem Ende zu: In den Sechzigern steht der be-rühmte Rennstall vor seiner Reife-prüfung. Pikiert lässt Enzo Ferrari den Verkauf an Ford platzen und baut mit Hilfe von Fiat den Dino, Italiens Porsche-Killer. Coupé und Spider vermarktet Fiat, Ferrari den Mittelmotor-GT. Weil dieser nur sechs Zylinder hat, darf er nicht Ferrari heißen. Trotzdem wird der rote Flitzer, mit Tony Curtis am Steuer in der Fernsehserie *Die Zwei*, zur Ikone von Maranello.

L'époque des voitures de sport classiques touche à sa fin : dans les années 60, la célèbre écurie s'apprête à entrer dans l'âge adulte. Vexé, Enzo Ferrari annule la vente à Ford et construit avec l'aide de Fiat la Dino, qui aura raison de Porsche. Fiat commercialise les versions Coupé et Spider, Ferrari la GT à moteur central, qui ne pourra porter le nom de Ferrari car elle ne compte que six cylindres. Le bolide rouge n'en sera pas moins immor-talisé par Tony Curtis dans la série télé *Amicalement vôtre*.

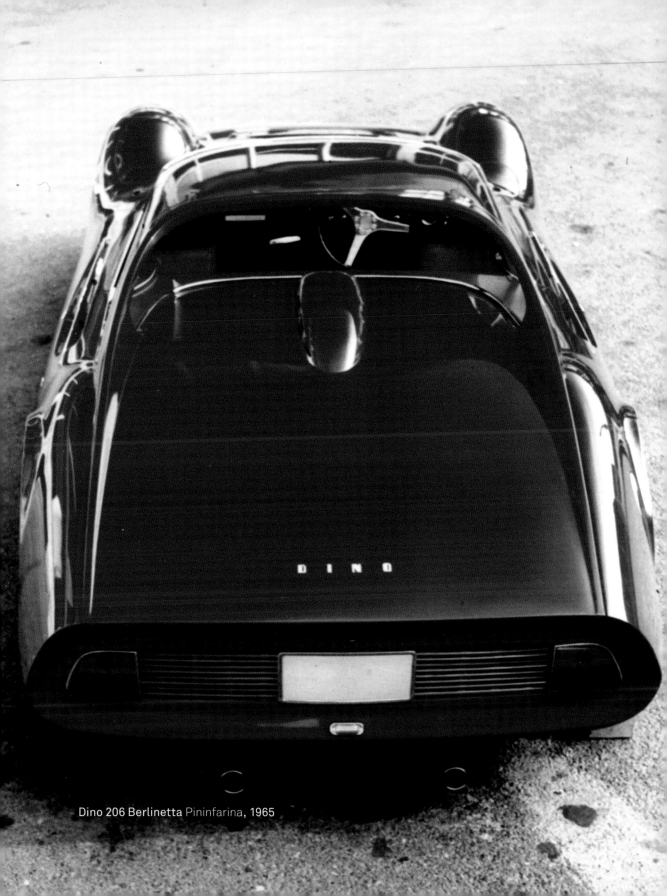

Dino 206 Berlinetta Pininfarina, 1965

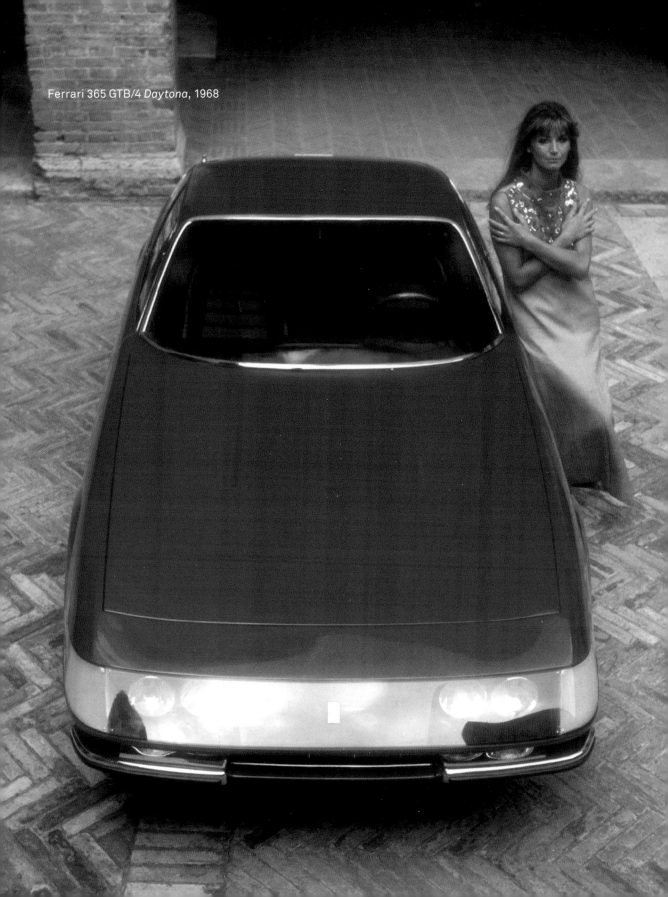

Ferrari 365 GTB/4 *Daytona*, 1968

The role of hero in the Dino project was played by Aldo Brovarone. Pininfarina's man with the golden hand created the flying buttresses and gave a face to classic Ferraris with the Superfast line. In the 1965 Dino, a sculptural masterpiece, he combined both with a charismatic arrow profile. But automotive history's first wedge was, at that point, too daring for the tastes of Ferrari and Pininfarina. As a consequence, Brovarone's design was ironed out before it went into mass production: unique, gorgeous, yet ephemeral.

The head of the racing team, Enzo Ferrari, was a romantic, who did not appreciate opposing views. Derring-do and a lot of horses beneath the bonnet were all that mattered to him. Both 365 models, the Daytona as well as *Il Gobbone*, were the last of the romantic Ferraris and, in 1968–71, somewhat of a stylistic contradiction. By employing a perspex cover on the one hand and black integrated bumpers on the other, they were supposed to combine radicalism with classicism. Pininfarina's chief designer, Leonardo Fioravanti, managed to bring everything together over the years: Ferrari's tradition, the wedge shape and pop-up headlamps. Even Ferrari finally gives in, and the Dino's successor, *Magnum P.I.'s* 308, becomes the brand's ultimate icon.

Die Heldenrolle im Dino-Projekt spielt Aldo Brovarone. Der Mann mit der goldenen Hand hat die Dachfinnen erfunden und mit der Superfast-Linie den klassischen Ferraris ein Gesicht gegeben. Im Dino von 1965, einem plastischen Meisterwerk, verbindet er beides mit einem markanten Pfeilprofil. Doch der erste Keil der Automobilgeschichte erscheint Ferrari und Pininfarina noch zu gewagt. Plattgebügelt findet Brovarones Entwurf den Weg in die Serie: einmalig, wunderschön und dennoch ohne Keil kurzlebig.

Rennstall-Chef Enzo Ferrari ist ein Romantiker, der sich ungern widersprechen lässt. Für ihn zählen Mut und viele Pferde unter der Fronthaube. Beide 365er, der Daytona und der „Buckelige" sind die letzten romantischen Ferrari und 1968–71 ein stilistischer Widerspruch. Der eine soll mit Plexiglas-Verkleidung, der andere mit schwarzer Integralstoßstange versuchen, Radikalität mit Klassik zu verbinden. Erst mit der Zeit gelingt es Pininfarina-Designchef Leonardo Fioravanti alles zu vereinen: Ferraris Tradition, Keilform und Klappscheinwerfer. Dann gibt auch Ferrari nach – und des Dinos Nachfolger, *Magnums* 308, wird zur endgültigen Markenikone.

Aldo Brovarone est au centre du projet Dino. Dessinateur de génie de Pininfarina, à l'origine des ailerons de toit et de la forme des Ferrari classiques avec la gamme Superfast, il reprend ces deux attributs pour créer le saisissant profil en flèche de la Dino de 1965, véritable chef-d'œuvre esthétique. Mais la première silhouette en coin de l'histoire automobile semble trop audacieuse à Ferrari et Pininfarina. Une fois aplati, le projet trouve le chemin de la fabrication en série : unique, magnifique mais éphémère sous cette forme.

Enzo Ferrari est un romantique qui n'aime pas être contredit. Ce qui compte pour lui, ce sont le courage et la puissance sous le capot. Les deux F 365, la Daytona et la « bossue », sont les derniers modèles romantiques de la marque et, en 1968–71, un paradoxe stylistique. Elles sont censées allier radicalité et classicisme, l'une avec un carénage en plexiglas, l'autre avec des pare-chocs noirs. Il faudra attendre que le designer en chef de Pininfarina, Leonardo Fioravanti, parvienne à combiner tradition, silhouette en pointe et phares escamotables pour que Ferrari se laisse convaincre : la 308 de *Magnum* succède à la Dino et devient la nouvelle icône.

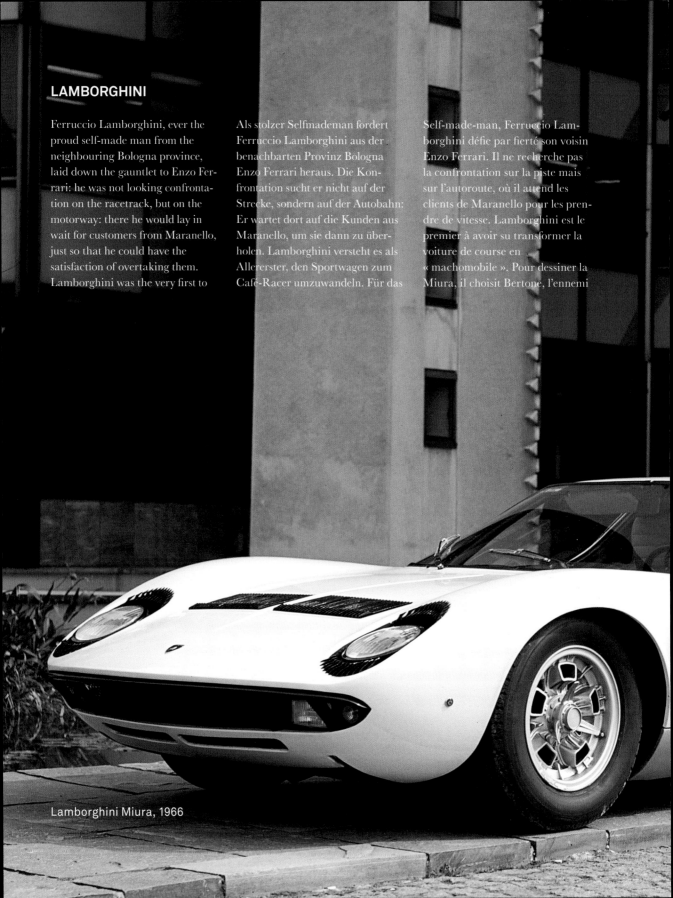

LAMBORGHINI

Ferruccio Lamborghini, ever the proud self-made man from the neighbouring Bologna province, laid down the gauntlet to Enzo Ferrari: he was not looking confrontation on the racetrack, but on the motorway: there he would lay in wait for customers from Maranello, just so that he could have the satisfaction of overtaking them. Lamborghini was the very first to

Als stolzer Selfmademan fordert Ferruccio Lamborghini aus der benachbarten Provinz Bologna Enzo Ferrari heraus. Die Konfrontation sucht er nicht auf der Strecke, sondern auf der Autobahn: Er wartet dort auf die Kunden aus Maranello, um sie dann zu überholen. Lamborghini versteht es als Allererster, den Sportwagen zum Café-Racer umzuwandeln. Für das

Self-made-man, Ferruccio Lamborghini défie par fierté son voisin Enzo Ferrari. Il ne recherche pas la confrontation sur la piste mais sur l'autoroute, où il attend les clients de Maranello pour les prendre de vitesse. Lamborghini est le premier à avoir su transformer la voiture de course en « machomobile ». Pour dessiner la Miura, il choisit Bertone, l'ennemi

Lamborghini Miura, 1966

convert the old sports car into the trendy café racer. For the design of the Miura, he specifically selected Pininfarina's arch-rival Bertone and gave free reign to twenty year-old rookie designers. With brutal performance figures, ostentatious presence and the name of a fighting bull, Lamborghini's testosterone-fuelled toy provoked the shame of a society in turmoil.

Design des Miura steuert er gezielt Pininfarinas Erzrivalen Bertone an und lässt dort zwanzigjährigen Designer-Frischlingen freie Hand. Mit brutalen Leistungsangaben, einer unübersehbaren Erscheinung und dem Namen eines Kampf-stiers provoziert Lamborghinis testosterotisches Spielzeug das Schamgefühl einer Gesellschaft im Umbruch.

juré de Pininfarina, et donne carte blanche à des jeunots de vingt ans. Avec ses performances inouïes, son aspect inédit et son nom, celui d'un taureau de combat, le jouet testostéronique de Lamborghini bouscule une société en mutation.

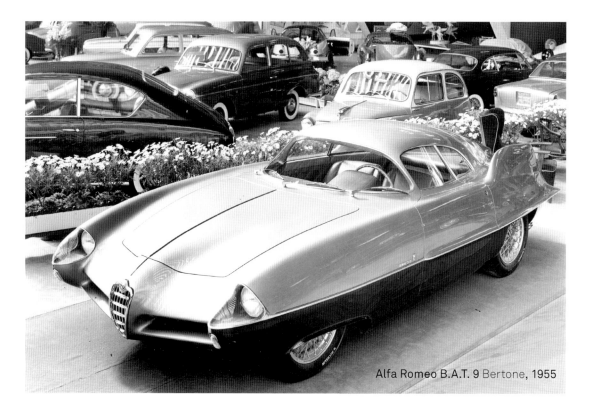

Alfa Romeo B.A.T. 9 Bertone, 1955

FRANCO SCAGLIONE

Franco Scaglione's body shapes are as complex as was his personality. In 1953–55, Carrozzeria Bertone's *prima donna* overwhelmed the public with the BAT trilogy, the winged aerodynamic-technical Berlinettas for Alfa Romeo. Being both at once a visionary and a magician, Scaglione was as capable of turning a pre-war car into a dream as he was of giving one dream two different body shapes (Giulietta Sprint and SS). He remained true to his style right up to the high point that culminated his career as a freelancer: the fantastic Alfa Romeo 33 Stradale.

Franco Scagliones Formen sind so komplex wie seine Persönlichkeit. Die Primadonna der Carrozzeria Bertone überwältigt 1953–55 mit der BAT-Trilogie, den beflügelten Aerodynamisch-Technischen-Berlinettas für Alfa Romeo, das Publikum. Als Visionär und Zauberer kann Scaglione gleichermaßen gut ein Vorkriegsfahrzeug in einen Traum verwandeln, wie einem Traum gleich zwei Formen zu verleihen: Giulietta Sprint und SS. Seinem Stil bleibt er bis zum gleichzeitigen Gipfel und Abschluss seiner Karriere als Selbstständiger treu: dem phantastischen Alfa Romeo 33 Stradale.

Les silhouettes de Franco Scaglione sont aussi complexes que sa personnalité. La star de la carrosserie Bertone fait forte impression en 1953–55 avec la trilogie BAT, les berlines aérodynamiques techniques ailées, dessinées pour Alfa Romeo. Visionnaire et magicien, il sait aussi bien transformer un véhicule d'avant-guerre en voiture de rêve que faire d'un rêve deux réalités : la Giulietta Sprint et la SS. Il restera fidèle à son style jusqu'à la fantastique Alfa Romeo 33 Stradale, qui marquera à la fois le point culminant et la fin de sa carrière d'indépendant.

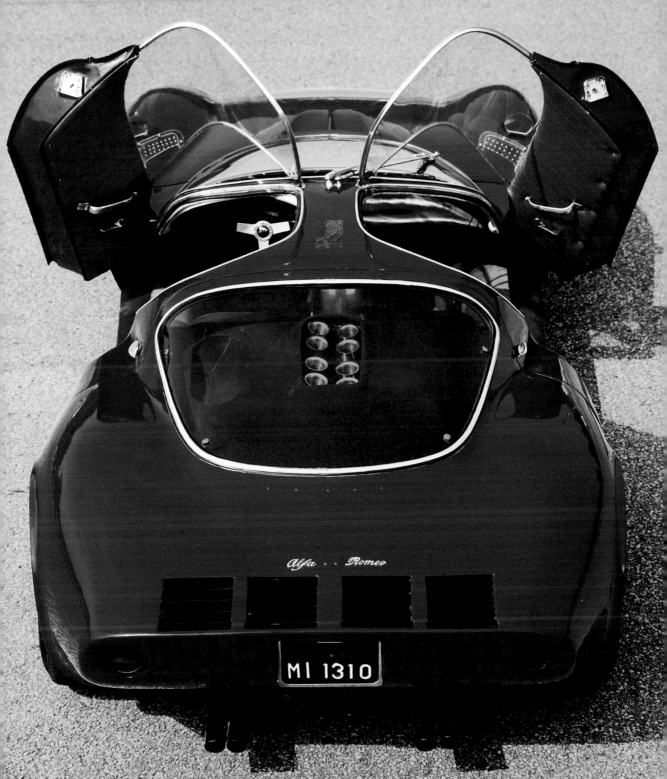

Alfa Romeo 33 Stradale, 1967

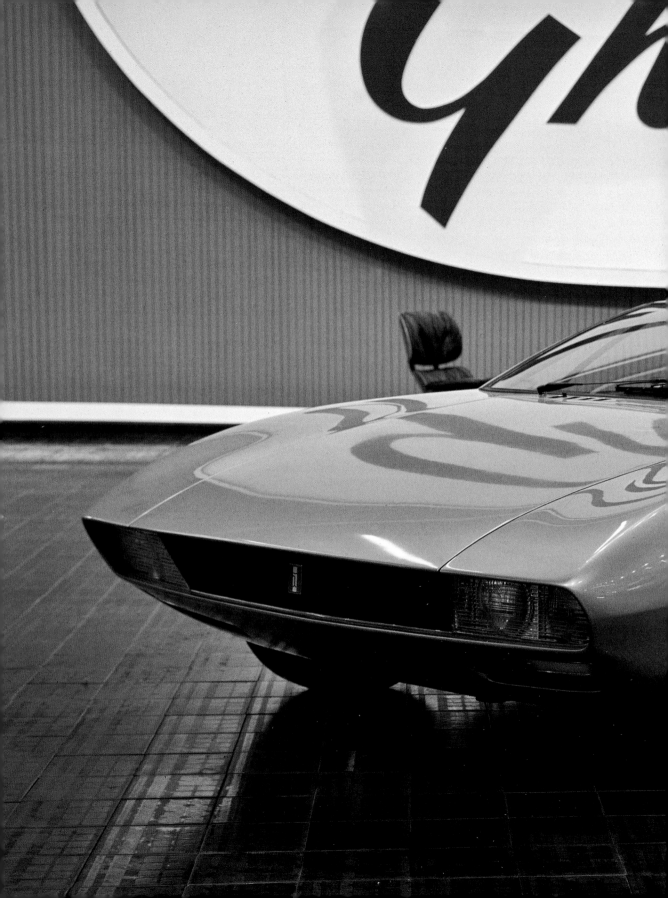

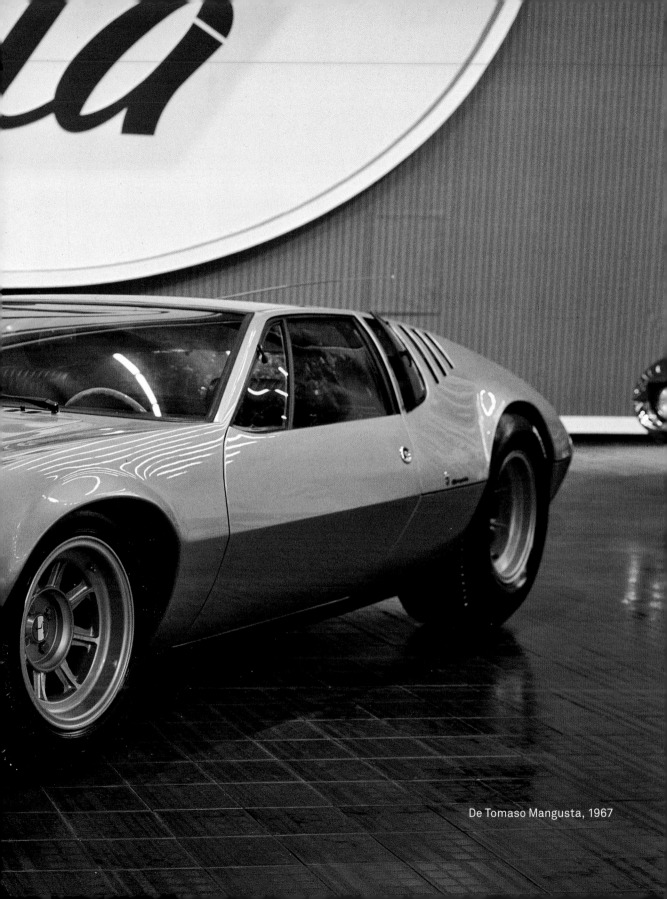

De Tomaso Mangusta, 1967

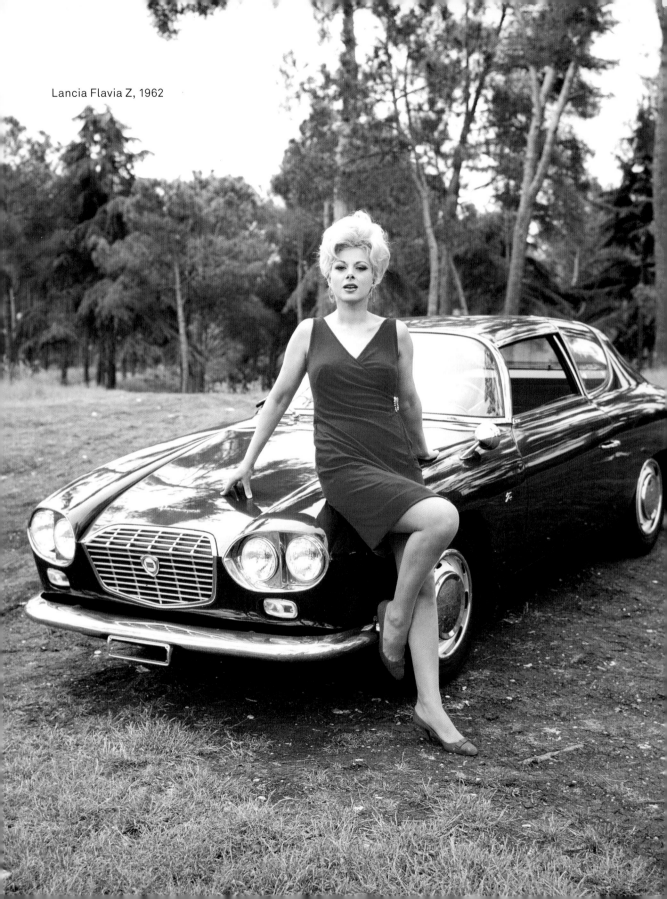

Lancia Flavia Z, 1962

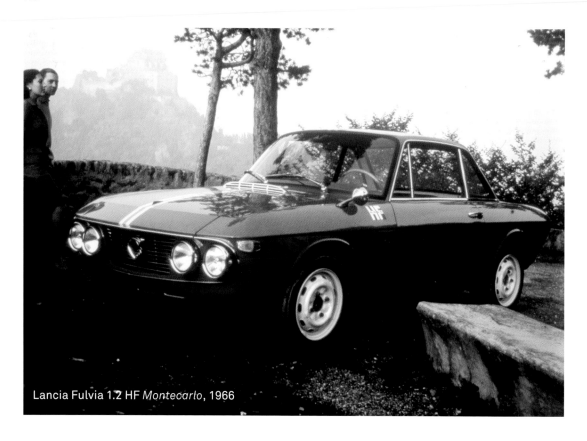

Lancia Fulvia 1.2 HF *Montecarlo*, 1966

LANCIA

Vincenzo Lancia's lance went into battle on behalf of many causes: ideal body shapes and race cars, modern standards and luxury limousines. Pininfarina created design milestones on this basis, while Zagato built masterly athletes. Good taste is a point of honour for the Lancia clientele: one commits to the Lancia *cavalleria's* code of chivalry and preferably orders right-hand drive cars. Lancia receives its last honour as part of the rally championship: this era begins with the Fulvia HF *Montecarlo*, the paradigm of the compact sports car of the seventies.

Wofür die Lanze des Vincenzo Lancia nicht alles in den Kampf gezogen ist: Idealformen und Rennfahrzeuge, Moderne Standards und Luxuskarossen. Daraus schuf Pininfarina Designmeilensteine und Zagato Meister des Sports. Stil ist für Lancia-Kunden Ehrensache: man verpflichtet sich dem Ritterlichkeitskodex der Lancia-Cavalleria und bestellt am liebsten einen Rechtslenker. In der Rallyemeisterschaft wird Lancia die letzte Ehrung zuteil: Diese Ära nimmt mit dem Fulvia HF Montecarlo, Vorbild des Kompaktsportlers der Siebziger, ihren Lauf.

Vincenzo Lancia s'est battu sur tous les fronts : formes idéales et voitures de course, véhicules de série et carrosseries de luxe. Quand on est client de Lancia, le style est une affaire d'honneur : on se doit de respecter un code de conduite fondé sur les valeurs chevaleresques de la « Cavalleria Lancia » et on préférera une voiture avec volant à droite. Les championnats de rallye seront pour Lancia un couronnement. La Fulvia HF Montecarlo, qui préfigure la voiture de sport compacte des années soixante-dix sera le point de départ de cette *success story*.

Renault R8 Gordini, 1965

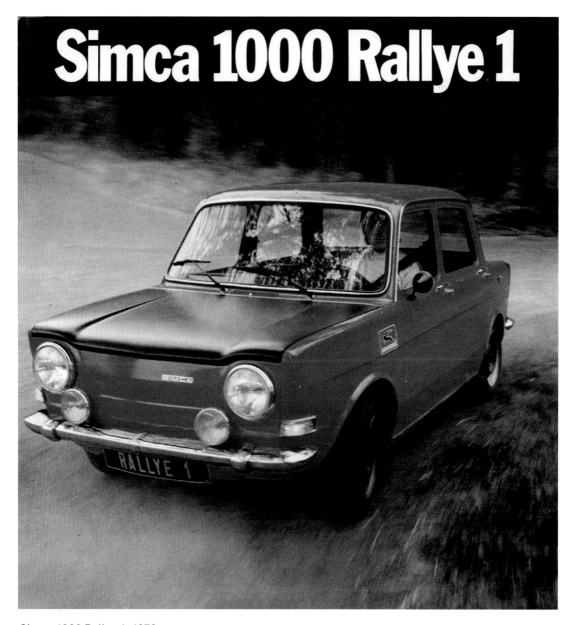

Simca 1000 Rallye 1

Simca 1000 Rallye 1, 1970

Striped decals, auxiliary headlights, wide tyres, a sports steering wheel and, above all, lots of matte black: the 'rally' look forces a radically new aesthetic on the people's car.

Streifenaufkleber, Zusatzscheinwerfer, breite Reifen, ein Sportlenkrad und vor allem viel Mattschwarz: der Rallye-Look zwingt dem Volksmobil eine radikal neue Ästhetik auf.

Adhésifs sur les portières, phares additionnels, pneus larges, volant de course et surtout un total covering noir mat : le look rallye impose à la voiture populaire une toute nouvelle esthétique.

BMW 2800, 1972

INTERNATIONAL STYLE

During the 1960s, the European Community was established: customs are abolished to a greater extent, enabling free movement of travellers. Eurovision broadcasts gather people together for *Jeux Sans Frontières* (*It's a Knockout!*). Global action is the order of the day. In 1964, Stockholm hosted the first exhibition on American Pop Art. Office towers were rising from the ground, their open-plan offices furnished with Herman Miller's Action Office System. Italian *disegno radicale* showcased subversive living environments. Limitless freedom of thought. The introduction of the birth control pill in 1961 kick-started the sexual revolution, bringing in its wake freedom in relationships and shaking the very concept of

In den Sechzigerjahren gilt endlich freier Personenverkehr, Zölle werden weitestgehend abgeschafft. Das Eurovision-Fernsehen bündelt die Völker in einem *Spiel ohne Grenzen*. Man beginnt, international zu agieren. 1964 findet in Stockholm die erste Ausstellung über amerikanische Pop-Art statt. Überall wachsen Büro-Hochhäuser. Ihre offenen Großräume sind mit dem Action-Office-System von Herman Miller eingerichtet. Italienisches Disegno Radicale präsentiert subversive Wohnlandschaften. Man beginnt, offen zu denken. Die Markteinführung der Antibabypille 1961 entfaltet eine sexuelle Revolution, aus der eine unvorstellbare Beziehungsfreiheit resultiert. Der Mythos Familie

Les années soixante marquent les débuts de la Communauté Européenne : la libre circulation des personne. À la télévision, les peuples se rencontrent dans les « Jeux sans Frontières » de l'Eurovision. Une internationalisation s'amorce. En 1964 a lieu à Stockholm la première exposition de Pop-Art américain. Partout sont édifiées les premières tours de bureaux à espaces de travail décloisonnés et meublés avec l'Action Office System d'Herman Miller. Le courant italien du « Design radical » conçoit des paysages domestiques subversifs. Le temps est à la remise en cause des idées préconçues. La mise sur le marché de la pilule contraceptive en 1961 provoque une révolution sexuelle qui permet une incroyable liberté. Le

Autobianchi Primula, 1964

Smoke, sex, storage: the family transport's transformation into a mobile cubicle as an instance of automotive change.

Rauch, Sex, Kofferraum: automobiler Wandel von der Familienkutsche hin zum mobilen Alkoven.

Cigarette, sexe, grand coffre : elle fait la transition entre la limousine de grand-papa et l'alcôve sur roues.

family. With individualism on the rise, even the European middle classes began to liberate themselves from outmoded role models and to develop a lifestyle of their own. In order to complete this lifestyle, husbands and wives needed one thing above all: a new kind of automobile.

OPEN SPACE

The classic estate car does not properly suit the ambitious citizen's image. An estate not only loses in performance compared with the traditional saloon car; its main function as a utility vehicle also lends it an air of work-a-day ordinariness. Despite some manufacturers' best efforts to spruce up the estate, the sensible all-rounder had not yet lost that whiff of the aspiring proletariat. As a matter of fact, the prestige marques avoided the tail-heavy shape like the plague. So an automobile appealing to the emancipated citizen's flexibility, openness and drive would be ideal: an

wackelt. Man beginnt, individuell zu planen. Allmählich emanzipiert sich das europäische Bürgertum von verstaubten Vorbildern und entwickelt einen eigenen Lebensstil. Um ihn zu vervollständigen, brauchen Mann und Frau schon wieder ein neues Automobil.

OPEN SPACE

Ins Bild des aufstrebenden Bürgers passt der klassische Kombiwagen noch nicht. Nicht nur, dass ein Kombi gegenüber der klassischen Limousine an Leistung einbüßt, sein Hauptberuf als Lieferwagen verleiht ihm das Image eines Arbeitsgeräts. Wenn auch mancher Hersteller sich Mühe gibt, den Kombis einen Hauch von Schminke zu geben, riecht der vernünftige Alleskönner zu sehr nach aufstrebendem Proletariat. Tatsache ist, dass Nobelmarken die hecklastige Form wie die Pest meiden. Ideal wäre ein Automobil, das die Flexibilität, die Offenheit und die Dynamik

mythe de la famille est ébranlé et l'individualisme s'annonce. Peu à peu les modèles poussiéreux de la bourgeoisie européenne sont mis au rebus au profit d'un nouveau style de vie qui, bien sûr, appelle une voiture d'un nouveau genre.

OPEN SPACE

La voiture familiale classique ne convient plus à cette nouvelle bourgeoisie en pleine expansion. Non seulement le break est moins performant que la berline, mais en plus son côté « voiture de livraison » ne plaît plus guère. Malgré les efforts déployés par certains constructeurs pour la rendre plus élégante et masquer son côté pratique, son image « classe ouvrière montante » lui colle à la tôle. Les grandes marques la boudent d'ailleurs et cherchent à concevoir une voiture qui illustre la flexibilité, l'ouverture et le dynamisme du bourgeois émancipé. Une voiture décloisonnée comme un bureau « open space », qui soit à la fois pratique et d'allure mo-

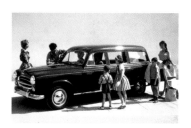

Peugeot 403 Familiale, 1957

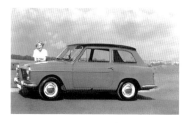

Austin A40, 1959

open space on wheels, packaging useful substance inside a progressive mantle. The Pininfarina-styled Austin A40 from 1958, a chic compact car with a steep rear hatch, led the way. Three years later, Renault invented the agile, robust mini estate in the shape of the R4. Thanks to its triumph of function over form, the French car quickly became a political symbol of the youth revolution. In contrast, the 1964 Autobianchi Primula was fine-tuned for bourgeois elegance. Its softly sloped rear actually hid a practical, optional hatch. With its technical layout—the *schema Giacosa*, featuring transverse engine, front-wheel drive and McPherson suspension and a size of roughly 3.7 metres—the Primula established the compact car class as we know it. The year 1965 belonged to the Renault R16, whose sloped hatch connected the short rear with a floating roof, beneath which an innovative, super-flexible interior concept could be found. The R16 was a successful crossover model,

des emanzipierten Bürgers anspricht. Ein Open Space auf Rädern, nützlich in der Substanz, aber progressiv im Bild. Der von Pininfarina gestylte Austin A40 von 1958, ein schicker Kompaktwagen mit steiler Heckklappe, zeigt den Weg. Drei Jahre später erfindet Renault mit dem R4 den agilen, rustikalen Minikombi. Weil Substanz über Form siegt, wird der Franzose zum politischen Symbol der Jugendrevolution. Auf bürgerliche Eleganz ist der 1964er Autobianchi Primula abgestimmt, dessen sanft geneigtes, hübsch geknicktes Heck auf Wunsch eine praktische Klappe verbirgt. Das technische Schema Giacosa mit Quermotor, Frontantrieb und McPherson-Aufhängung, sowie die Größe von 3,7 Meter machen ihn zum Gründer der Golf-Klasse. 1965 ist das Jahr des Renault R16. Eine schräge Klappe verbindet das kurze Heck mit dem fließenden Dach unter dem sich ein innovatives, superflexibles Innenraumkonzept verbirgt. Eine gelungene Kreuzung

derne. L'Austin A40 signée par Pininfarina en 1958, une berline compacte avec hayon droit, ouvre la voie. Trois ans plus tard, Renault invente avec la R4 le mini-break coupé : cet utilitaire agile peu préoccupé de belles formes deviendra un véritable symbole politique pour la génération 68. Tout l'inverse donc de la Primula d'Autobianchi de 1964 qui, elle, se veut d'une élégance bourgeoise même si elle révèle aussi de belles qualités pratiques avec un vaste espace de rangement sous son hayon légèrement incliné et allongé sur l'arrière. Sa ressemblance avec la Morris 1100 d'Issigoni ne peut être niée. L'agencement technique, façon Giacosa avec moteur transversal, traction avant et suspensions type McPherson ainsi que sa petite taille font que la Primula peut être considérée comme précurseur de la Golf. 1965 voit naître la Renault 16. Sa forme est innovante : un hayon incliné relie l'arrière du véhicule à un grand toit fuyant abritant un habitacle au concept

Autobianchi Primula, 1964

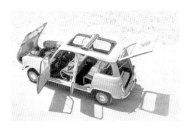

Renault R4, 1961

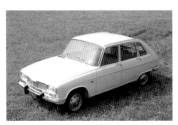

Renault R16, 1965

smack in the middle between estate and saloon car, and would remain in production for 15 years. Its silhouette remains unique, but its concept significantly influenced 1970s and 80s automotive design, as the shapes of the Simca 1100, Austin Maxi and Audi 100 Avant demonstrate.

SPORTS ESTATE

In order to reach the peak of contemporary taste, the open space concept was lacking in only one area: sportiness. Yet, in 1961, Jaguar's E-Type already had presented the idea of a rear hatch, which, funnily enough, opened sideways. In 1963, Maserati unveiled the Mistral, including a panoramic rear window integrated into the boot lid. A poor man's E-Type, the MG B GT was a roadster with a hatchback and, hence, conceptually an all-new interpretation of the Gran Turismo. But the first proper sports estate was built by Reliant, based on a design concept by Ogle: the

zwischen Kombi und Limousine, bleibt der R16 15 Jahren in Produktion. Eigenständig in der Linie, sein Konzept beeinflusst maßgeblich das Automobildesign der 70er und 80er Jahre, wie Simca 1100, Austin Maxi und Audi 100 Avant beweisen.

SPORTKOMBI

Um auf der Höhe der Zeit zu sein, fehlt dem Prinzip Open-Space-Design nur eines: GT-Sportlichkeit. Bereits 1961 zeigt der Jaguar E-Type die Idee einer Heckklappe, die sich lustiger Weise seitlich öffnet. Maserati bringt 1963 den Mistral, dessen große Heckklappe eine Panorama-Heckscheibe integriert. Ein „Poor man's E-Type", der MG B GT ist ein Touren-Roadster mit Heckklappe. David Brown lässt wenige Exemplare des Aston Martin als Shooting-Brake mit steiler Heckklappe bauen. Wie der Name sagt, um Hund und Gewehr schnell auf die Jagd zu schleppen.

combinant innovation et flexibilité d'utilisation. Ce mélange réussi de break et de berline, unique à son arrivée sur le marché, exercera une forte influence sur le design automobile des années 70 et 80. Dans la même veine sortiront d'autres modèles, dont la Simca 1100, l'Austin Maxi et l'Audi 100 Avant.

LES BREAKS SPORTIFS

Sportivité, voici l'attribut qui manque au design « open space » pour être vraiment de son temps. Dès 1961, la Jaguar Type E surprend avec un hayon arrière à ouverture latérale. En 1963, Maserati sort la Mistral qui se caractérise, elle, par un hayon arrière avec vitre panoramique intégrée. En version moins huppée sort le MG B GT qui peut être décrit comme un roadster avec hayon mais surtout offre une toute nouvelle interprétation du concept Grand Tourisme. Très exclusive par contre, la version break de chasse avec hayon droit

Simca 1100, 1967

Reliant Scimitar GTE, 1968

1967 Scimitar GTE. A clever design, at the front it is a racy GT with a brawny engine, but its tail is elongated, incorporating a rather steep hatch. The rear seats can be folded, creating a flat, long and particularly sumptuously lined boot. Not just luggage stowage but also, if we're being honest, an implied, inviting space for a lie-down. The louvres of the Lancia Beta HPE hinted even more emphatically at a specific kind of intimacy. All these factors make the sports estate one of the most interesting of the modern kinds of automobile: from Fiat's 128 3P via BMW 02 Touring to the Opel Monza, top class was available in every format, interpreted with much imagination: Renault even offered a sports estate-cum-convertible version of its model 17.

FASTBACK

In view of such social dynamics, the image of the classic saloon car à la Mercedes-Benz was starting to appear conservative and old-

Sehr snobistisch. Ein echtes Sportkombi ist der Scimitar GTE von Reliant mit einem Design von Ogle. Das Konzept ist denkbar klug: vorne rassiger GT mit bulligem Motor, hinten lang gezogenes Heck mit mehr oder minder steiler Heckklappe. Die hintere Rückbank lässt sich klappen, so dass ein flacher, langer und vor allem schön verkleideter Kofferraum entsteht. Keine Lade-, sondern vor allem implizierte Liegefläche. Im Lancia Beta HPE deuten Lamellenjalousien auf eine gewisse Intimität. Der Sportkombi ist mit die interessanteste Automobilform der Moderne: Sie bietet vom Fiat 128 3P über den BMW 02 Touring bis zum Opel Monza in jeder Größe große Klasse und wird mit viel Fantasie interpretiert – vom Renault 17 gibt es gar eine Sport-Kombi-Kabriolett-Version.

FLIESSHECK

Bei so viel gesellschaftlicher Dynamik wirkt das Image der klas-

de l'Aston Martin, en soi déjà très select, que David Brown fait sortir en nombre limité, est à l'origine conçue pour permettre le transport des chiens et des fusils de chasse. Le premier break de chasse digne de ce nom est le Reliant Scimitar GTE dessiné par le concepteur Ogle en 1967. Le concept est intelligent, il combine une GT pure sang avec moteur puissant à l'avant et une poupe étirée, fermée par un hayon quasiment droit. Une fois rabattue, la banquette laisse place à un vaste coffre plat joliment tapissé plus proche du couchage que d'une surface de rangement. Sur la Lancia Beta HPE, l'ajout de stores à lamelles suggère même une certaine intimité. Le break sportif est l'un des modèles les plus intéressants de l'époque moderne. De la Fiat 128 3P à l'Opel Monza en passant par la BMW 02 Touring, le break quelque soit sa taille a toujours beaucoup de classe. Inspirant de nombreux dessinateurs automobiles, il a été décliné

BMW Touring 2000 tii, 1971

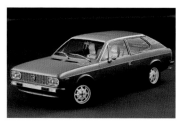

Lancia Beta HPE *High Performance Estate*, 1974

fashioned. It did not cater to the desire for contemporary design, which is why Pininfarina re-invented the aerodynamic saloon, adopting a roof that flowed smoothly towards the rear, abruptly ending in a Kamm tail. The illusion of Jaray's streamlined shape was kept alive in this new form: straight, geometric, flat. In keeping with the Zeitgeist, safety obtained top priority. The BMC 1800 was intended to be first of a new kind of international class, combining dynamics and upmarket style. Passengers and their luggage were allowed to travel under one roof. But, in 1967, this concept is too audacious for the British Motor Company. At Citroën, however, audacity is common practice, so the French immediately adopted the idea: first for the GS, then for the CX. Low front end, trapezoidal headlights, flat grille: all of a sudden an everyday car, of all things, appeared fascinatingly alien, and thanks to its futuristic interior, which included dashboard satellites, the

sischen Limousine, am Beispiel Mercedes-Benz, altmodisch konservativ. Es entspricht nicht ganz dem Wunsch nach einem zeitgemäßen Design. Pininfarina erfindet die aerodynamische Limousine neu. Das lange Dach fliesst reibungslos nach innen, endet aber abrupt in ein steiles Kamm-Heck. Die Illusion der Stromlinienform lebt in neuer Form weiter: geradlinig, fließend, flach. Der BMC 1800 will Exponent einer neuen internationalen Klasse sein, Dynamik mit gehobenem Stil verbinden. Mensch und Gepäck dürfen unter gemeinsamem Dach reisen: Transportiert wird kein Gepäck mehr, sondern Sportausrüstung und Shopping-Ware. Der British Motor Corporation ist 1967 das Konzept zu mutig, Citroën übernimmt die Idee in die Grand Série. Niedrige Front, Trapezscheinwerfer, flacher Körper: Plötzlich wirkt das Alltagsauto auf faszinierende Weise fremd. Ein futuristisches Interieur mit Satelliten bringt noch mehr Sensation. Auch Lancia und Alfa

à l'envi ; pour preuve, la Renault 17 sortie en version cabriolet.

FASTBACK

Dans une société moderne marquée par la rapidité des évolutions, la berline conventionnelle de type Mercedes-Benz semble bien dépassée. Sa forme fait rétro. Pininfarina ré-invente alors la berline aérodynamique au toit effilé, dessiné d'un seul trait qui s'achève brusquement par un hayon tronqué. Son design bas aux lignes droites et géométriques reprend à son compte le concept d'aérodynamisme développé par Jaray. Dépourvue de hayon, elle se caractérise par une excellente rigidité de la carrosserie et satisfait ainsi aux critères de sécurité devenus déterminants. La BMC 1800 se veut le modèle d'une nouvelle classe internationale, à la fois élégante et dynamique. Passagers et bagages voyagent certes sous un même toit mais occupent néanmoins des espaces distincts propices à arrêter les bruits. Trop

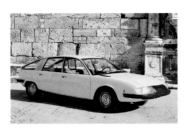

BMC 1800 Pininfarina, 1967

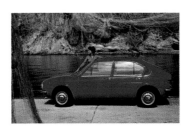

Alfa Romeo Alfasud, 1971

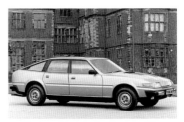

Rover SD1 3500, 1976

French car became a sensation. Lancia and Alfa Romeo also quickly made the new shape their own, as did, eventually, Rover, whose 3500 had a very sporty, but not very British, appearance: a Ferrari Daytona in saloon shape. This SD1, Car of The Year in 1977, introduced the fastback and the hatch to the executive classes.

ARCHITECTURES

Driven by the open space philosophy, the designers now drafted their automobiles as an interaction between external form and internal space. The car was being seen as architecture: a horizontal tower block. The urge to arrange volumes neatly, organise glass and metal geometrically and smooth out the body shell as far as possible was gaining momentum. In 1970, two cars showed the future direction: the Range Rover and the Fiat 130 Coupé were both definitive in their homogenous style and unique significance. The Range Rover's secret is that it

Romeo bekennen sich zur neuen Form. Letztlich sogar Rover: Der 3500 SD1 ist sehr sportlich, kaum britisch: ein Ferrari Daytona in Limousinenform. Das Auto des Jahres 1977 bringt Fließheck und Heckklappe sogar in die Oberklasse.

ARCHITEKTUREN

Vom Gedanken des Open Space getrieben, lebt Automobildesign im Zusammenspiel zwischen Außenform und Innenraum. Das Auto wird als Architektur betrachtet, ein horizontales Hochhaus. Man spürt das Bedürfnis, die Volumina sauber zu gliedern, Glas und Blech geometrisch zu ordnen, die Haut weitestgehend zu glätten. Zwei Autos von 1970 zeigen, in welche Richtung es geht: Der Range Rover und der Fiat 130 Coupé sind in ihrem Stil homogen, in ihrer Bedeutung einmalig. Noch pflegt der Fiat das Image des städtischen Gentlemans – ein Hebel ermöglicht dem Fahrer, der Beifahrerin die Tür

osé pour la British Motor Corporation en 1967, le concept est repris immédiatement par un Citroën plus audacieux, sur la GS d'abord puis sur la CX. Avec sa proue très basse, ses phares en forme de trapèze et sa calandre plate, cette voiture de tous les jours surprend et fascine. Futuriste aussi, la « lunule » et les satellites. La nouvelle ligne plaît. Lancia et Alfa Romeo s'en inspireront ; Rover également, avec la 3500, une sportive qui abandonne le look british pour prendre des allures de Ferrari Daytona. Surnommée SD1 et élue voiture de l'année en 1977, elle sera la première berline de luxe à adopter le Fastback.

ARCHITECTURES

Sous l'influence du concept « open space », les designers automobiles jouent sur la complémentarité des lignes extérieures et intérieures. La voiture est pensée comme un bâtiment à l'architecture horizontale. Les enjeux esthétiques sont

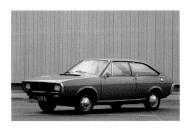
Renault R15, 1971

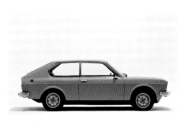
Fiat 128 3P Berlinetta, 1975

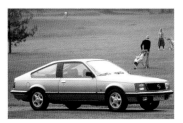
Opel Monza, 1978

encapsulated the upheavals of the 1970s: disturbed by the culture war, the urban aristocracy fled to the countryside, where the Range Rover—which is as classy, sober and as tall as a fortress—more than proved its worth. At the same time, Citroën was working on the SM, a floating sculpture, looking as if it was taken straight out of Kubrick's *2001: A Space Odyssey*. Porsche introduced the 928, a car defined by pure function from the inside out, a synthesised, almost too-perfect construction. At the beginning of the seventies, Giorgetto Giugiaro was developing the basis of modern car architecture. The Scirocco and Golf, his major works on behalf of Volkswagen, defined a new aesthetic and structural rationality. Giugiaro gave substance to the form, as was evident in the rear hatch's massive profile and the components' perfect congruity. Through the Lancia Megagamma prototype, he postulated the concept of the 'tall car': a vertically designed car occupying less

zu öffnen. Der Range Rover trifft den Spleen der 70er Jahre ins Herz: Gestört durch den Kulturkonflikt, wandert der Stadtadel aufs Land. Edel und schlicht zugleich, hoch wie eine Burg, der RR – magisches Kürzel – kommt ihm wie geschaffen. Parallel arbeitet Citroën an der SM, eine schwebende Skulptur wie aus Kubricks *2001*. Porsche gibt den 928, von Innen nach Außen Funktion pur. Eine synthetische, fast zu perfekte Konstruktion, die ästhetisch 30 Jahre voraus ist. Zu Beginn der 70er entwickelt Giorgetto Giugiaro die Grundlage moderner Automobilarchitektur. Mit Scirocco und Golf formuliert der Italiener eine neue ästhetische und konstruktive Rationalität. Die Form erhält neue Substanz, erkennbar im massiven Profil der C-Säule, in der soliden Heckklappe, in der perfekten Kongruenz der Bauteile. Mit dem Prototyp Lancia Megagamma prägt er das Konzept des höhen Automobils. Ein in die Höhe gebaute Auto braucht weniger Platz, bietet

les volumes qu'il faut structurer, l'agencement parfait de la tôle et du verre et la couche externe à la polissure parfaite. En 1970, deux voitures, uniques en leur genre, sont les archétypes de cette tendance : la Range Rover et la Fiat 130 Coupé. Du haut de son châssis surélevé, la Range Rover, robuste, simple et élégante tel un château-fort chasse le mal-être des années 70. De son côté, Citroën travaille à la SM, une sculpture flottante sortie tout droit de « l'Odyssée de l'Espace » de Stanley Kubrick. Porsche créé la 928, une merveille de fonctionnalité à l'intérieur comme à l'extérieur, une construction d'une synthèse presque trop parfaite. Au début des années 70, Giorgetto Giugiaro jette les bases de l'architecture automobile moderne. La Golf et la Scirocco, ses premiers travaux pour Volkswagen, définissent une nouvelle esthétique empreinte d'un rationalisme constructif. Il donne aux formes une substance, reconnaissable au profil massif du hayon et à la par-

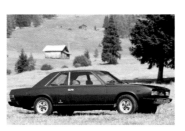

Fiat 130 Coupé, 1971

Porsche 928, 1977

space outside and offering more space on the inside. Finally, he managed to perfect the people's car concept with the Fiat Panda. Almost a T-shirt-on-wheels, Giugiaro's Panda is the automotive equivalent of Le Corbusier's living machine. Right after the oil crisis, Giugiaro's rational architecture appealed to the motorist's immediate needs, turning the designer into a hero and his creations into archetypes of the eighties. The sober, precise geometry of the Volvo 740 followed this lead, as did Renault's Espace, the first dynamic people carrier. Its name tells the whole story: a flexible interior and a performance-orientated image all of a sudden mesh together beautifully. It was a completely new way of driving and looking at the world. Automotive design has reached a conceptual peak.

mehr Innenraum. Schließlich gelingt ihm mit dem Fiat Panda die Vollendung des Volks-Wagen-Konzeptes. Ein T-Shirt auf Rädern: Giugiaros Panda ist ein Existenzminimum, das automobile Equivalent der Wohnmaschine Le Corbusiers. Unmittelbar nach der Ölkrise spricht Giugiaros rationale Architektur die Bedürfnisse der Automobilisten an. Seine Autos sind Sinnbild der 80er Jahre. Flexibilität im Innenraum geht mit einem leistungsorientierten Image zusammen. Man denke an die schnörkellose, präzise Geometrie des Volvo 740. Man denke an den Renault Espace, den ersten sportlichen Großraumwagen, dessen Name Programm ist. Es ist eine völlig neue Art zu fahren, auf die Welt zu schauen. Automobildesign am konzeptionellen Höhepunkt.

faite congruence des éléments. Avec son prototype Megagamma, Lancia invente le concept de la voiture haute qui permet d'accroître l'espace intérieur et de gagner de la place en largeur et en longueur. Avec la Fiat Panda, le concept créé pour Volkswagen atteint son accomplissement. La Panda est à la voiture ce que le t-shirt est au vêtement, l'expression du strict minimum vital, une « machine à rouler » à l'instar de la machine à habiter de Le Corbusier. Apparue immédiatement après la crise du pétrole, l'architecture rationnelle de Giugiaro répond parfaitement aux attentes des automobilistes. Il devient un véritable héros et ses voitures sont le symbole des années 80. Parmi elles, on peut citer la Volvo 740 à la géométrie précise et sans fioritures ou la Renault Espace, le premier van sportif au nom évocateur avec un intérieur modulable synonyme de performance.

Lancia Megagamma Italdesign, 1978

Renault Espace 2000 GTS, 1984

MG MGB GT, 1965

RENAULT

Beginning with its nationalisation in 1945, Renault stood between Peugeot's bourgeoisie and Citroën's intellectualism. The government's direction did not demand a people's car but, rather, automobiles for the French *citoyen*: sophisticated, autonomous, free-spirited. Status symbolism plays as small a role as cerebral masturbation. Renaults are, as an eighties advertising slogan claims, "cars to live in". The free automotive life starts in 1960 with the R4. It is considerably less radical, but more mature than the small Citroëns. Nobody needs more from a car. The spartan R4 is stylistically irrelevant, it is the mini-estate-convertible-saloon's concept that makes the difference: as an anti-symbolic car, employed as a political statement. The R16, as authored by freelance designer Philippe Charbonneaux, brings dynamics and flexibility to the stronghold of the middle classes. In 1965, he anticipated the downfall of the classic family image with a fastback, a rear hatch and a variable interior and at the same time also liberated the *citoyen* from the Peugeot saloons' dull symbolism, as well as from the forced narcissism of the quintessential automotive icon: the Citroën DS. Qualities that can later, thankfully, also be found in the Espace and Twingo.

Mit der Verstaatlichung 1945 versetzt „die Regie" Renault in die goldene Mitte zwischen Peugeots Bürgertum und Citroëns Intellektualismus. Die (staatliche) Regie lässt keinen Volks-Wagen bauen, sondern Autos für den französischen Citoyen: aufgeklärt, eigenverantwortlich, frei. Status-symbolik spielt dabei ebenso wenig eine Rolle wie Selbstbefriedigung. Renaults sind, wie ein Werbe-claim der Achtziger auf den Punkt bringt, „Autos zum Leben". Das freie Automobilleben beginnt 1960 mit dem R4. Er ist weit weniger radikal, dafür aber erwachsener als die kleinen Citroëns. Mehr Auto braucht keiner. Stilistisch ist der spartanische R4 nicht erwähnens-wert, dafür glänzt die Mini-Kombi-Cabrio-Limousine konzeptionell: als antisymbolisches Auto, das sich zum politischen Statement wandelt. Der R16, das Werk des freischaffenden Designers Philippe Charbonneaux, bringt Dynamik und Flexibilität in die Hochburg der Mittelklasse. 1965 antizipiert er mit Fließheck, Heckklappe und variablem Innenraum den Untergang des klassischen Familienbilds und befreit den Citoyen gleichzeitig von der biederen Symbolik der Peugeot-Limousine sowie von der gezwungenen Selbstverliebtheit der Automobilikone schlechthin: der Citroën DS. Qualitäten, die man später im Espace und dem Twingo gerne wiederfindet.

Devenu « régie » en 1945 du fait de la nationalisation de l'entreprise en 1945, Renault va occuper un créneau à mi-chemin entre la bour-geoise Peugeot et l'intellectuelle Citroën. La régie (nationale) ne construit pas des voitures du peuple mais des automobiles destinées au citoyen français, homme éclairé, autonome, libre. Avec Renault, ce n'est ni le statut social qui compte ni le plaisir purement personnel. Les Renault sont – le slogan publi-citaire des années quatre-vingt en résume bien la philosophie –, des « voitures à vivre ». Ce vivre libre commence en 1960 avec la 4L. Elle est beaucoup moins jusqu'aubou-tiste que les petites Citroën mais plus adulte. On n'a pas besoin de plus en matière de voiture. La R4 est une voiture spartiate sans véri-table style. Ce qui n'est pas le cas de la berline-break-coupé-cabriolet qui brille par sa conception : un véhicule qui ne se veut pas symbole de quelque chose mais l'expression d'un choix politique. La R16, dont le design est l'œuvre du styliste Philippe Charbonneaux, fait in-cursion dans le fief des voitures de gamme moyenne et les sorte de la routine. Apparue en 1965 cette ber-line-break à hayon dont l'habitacle est transformable à volonté annonce la fin de la limousine familiale classique : dès lors l'usager-citoyen peut s'affranchir et de la symbolique pépère représentée par la limousine Peugeot et du mythe que constitue la Citroën DS, autant de qualités qu'on aimera retrouver plus tard dans l'Espace et la Twingo.

Renault R4, 1961

Renault R16, 1965

Saab 95, 1960

SAAB

A Saab is more aeroplane than automobile. To this end, in 1946, Sixten Sason styled a wing-shaped people's car. The model 92 was leading the way to the future, with its uninterrupted flanks, sealed underbody, front engine, front-wheel drive and independent suspension. It made easy work on bad tarmac and achieved great success as a rally car. Even the 1959 model 95 gave Saab wings: its roof spoiler made the car faster and kept the rear window clean. Saab's icon was born in 1974, once again based on a design by Sason. The 99's Combi-Coupé version is characterised by a roof featuring a Jaray-style wing profile and a concave rear. In 1977, a turbo-engined 99 was turning people's heads, and its successor, the 900, turned out to be the coolest ride of the eighties.

Ein Saab ist mehr Flugzeug als Automobil. Sixten Sason gestaltet dementsprechend 1946 einen Volks-Wagen in Flügelform. Der 92 ist zukunftsweisend: durchgehende Seitenflanken, voll verkleideter Unterboden, Frontmotor, Frontantrieb, Einzelradaufhängung. Auf schlechten Straßen ist er der König, als Rallyemaschine siegreich. Selbst dem 95 von 1959 verleiht Saab Flügel: Der Dachspoiler macht den Wagen schneller und hält die Heckscheibe sauber. Saabs Ikone wird 1974 erneut nach einem Entwurf Sasons geboren. Die CombiCoupé-Version des 99 charakterisieren ein Dach mit Flügelprofil im Jaray-Stil und das konkave Fließheck. 1977 macht ein Turbomotor die Menschen auf den 99 heiß, und dessen Nachfolger, der 900, mausert sich zur coolsten Karre der Achtziger.

Une Saab est plus avion qu'automobile. Sixten Sason conçoit donc en 1946 une voiture avec des ailerons rappelant les ailes d'un avion. Cette Saab 92 est innovatrice : éléments latéraux de la carrosserie d'une seule pièce, revêtement intégral du soubassement de carrosserie, motorisation et traction avant, suspension à roues indépendantes. Saab dote aussi son modèle 95 d'ailerons : le spoiler de toit accroît les performances de la voiture et maintient propre la lunette arrière. C'est à nouveau Sason qui dessine en 1974 ce qui va devenir le modèle phare de Saab. La Saab 99 CombiCoupé se caractérise par un toit à profil aérodynamique façon Paul Jaray et un hayon concave. En 1977, on s'arrache la 99 version turbo et le modèle qui suit, la 900, devient la caisse la plus cool des années quatre-vingt.

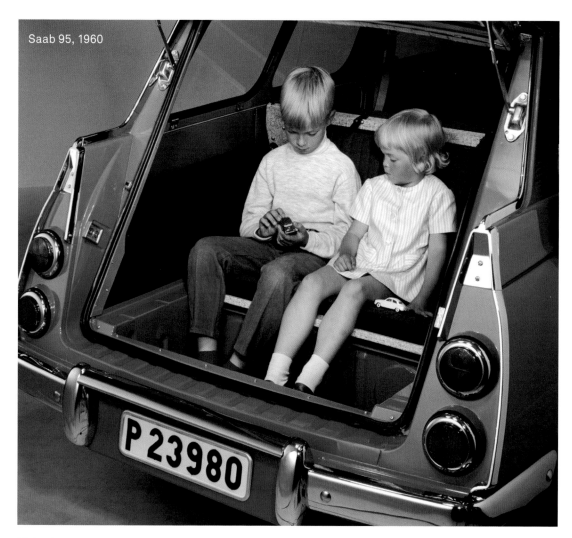

Saab 95, 1960

Living Luggage

A bench in the boot turns the 4.12 m-short Saab 95 into a miraculous space for up to seven people.

As safe as an aeroplane, in 1972, the model 99 is the first European automobile with bumpers in accordance with US standards.

Eine Sitzbank im Kofferraum macht aus dem 4,12 m kurzen Saab 95 ein Raumwunder für bis zu sieben Personen.

Sicher wie ein Flugzeug ist das Modell 99 1972 das erste europäische Automobil mit Stoßstangen nach amerikanischer Norm.

Bien que de longueur réduite, la Saab 95 comporte dans le coffre une banquette déployable et permet de transporter jusqu'à sept personnes.

Aussi sûre qu'un avion, le modèle 99 de 1972 est le premier véhicule européen avec un pare-choc aux normes américaines.

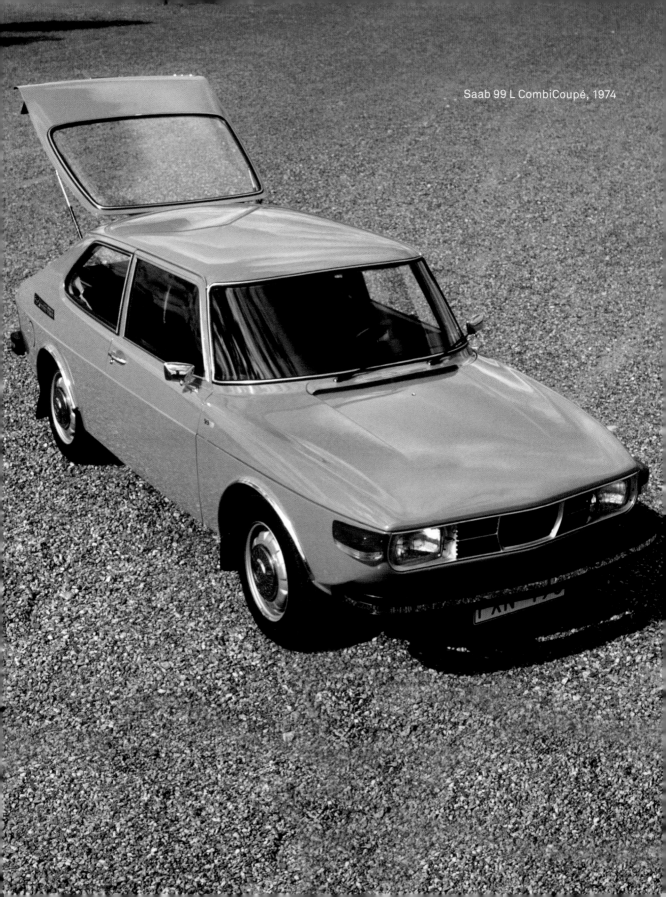

Saab 99 L CombiCoupé, 1974

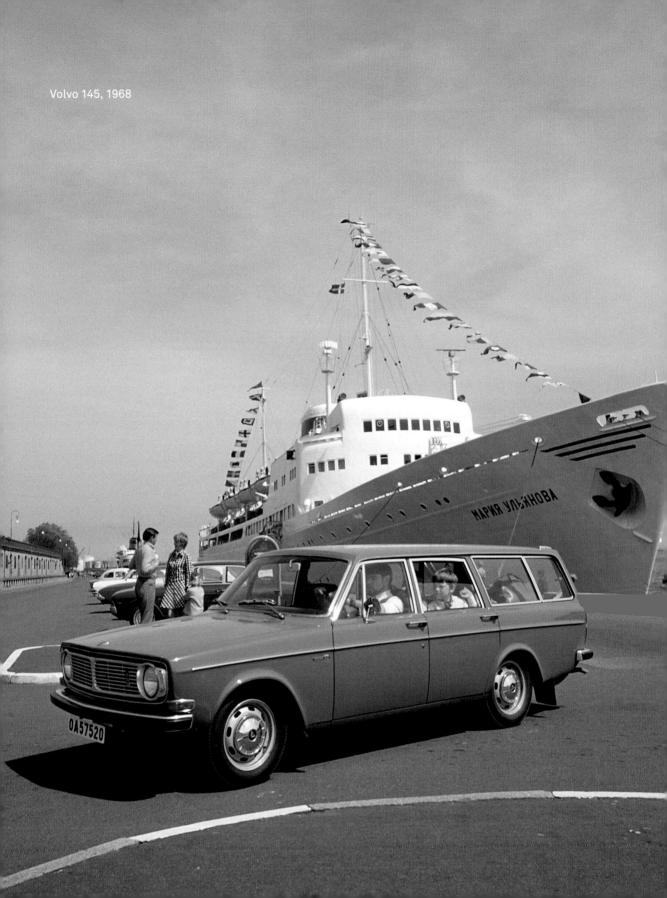

Volvo 145, 1968

VOLVO

The great Swedish name is Volvo. In 1966, Jan Wilsgaard's design of the 140 series embodied the principles of the International Style: linear, matter-of-fact, suffused with light. A high-rise on wheels. The bumpers' rubber lip and the typically wide shoulder are enough to turn the 145 estate version into the epitome of safe family transport. The succeeding 240 series built its eternal glory on a foundation of extra-thick bumpers. Volvo's sporty side would always remain in the shadow of this archetype: born at Ghia in Italy, the gorgeous P1800 becomes famous as TV trouble-shooter's Simon Templar's 'company car'. The ensuing 1971 living luggage ES version can thank its sloped glass hatch for the exciting 'snow white's coffin' nickname.

Der große Schwede heißt Volvo. Jan Wilsgaards Design der Reihe 140 verkörpert 1966 die Prinzipien des International Style: geradlinig, sachlich, lichtdurchflutet. Ein Hochhaus auf Rädern. Die Gummilippe auf der Stoßstange und die typische breite Schulter reichen aus, um die Kombiversion 145 zum Inbegriff der sicheren Familienkutsche zu machen. Die Nachfolgerreihe 240 baut ihren unsterblichen Ruhm auf extradicken Stoßstangen. Die sportliche Seite von Volvo lebt stets im Schatten dieses Urbilds: In Italien bei Ghia geboren, wird der bildhübsche P1800 als Dienstwagen des TV-Detektiven Simon Templar berühmt. Die darauffolgende ES-Version verdankt 1971 ihrer schrägen Glasheckklappe die aufregende Bezeichnung „Schneewittchensarg".

La grande marque suédoise s'appelle Volvo. On retrouve dans le design de la série 140 dû à Jan Wilsgaard en 1966 les principes du style international : ligne droite, sans fioritures, habitacle hyper-lumineux. La bande caoutchouc sur le pare-choc et son aspect trapu si typiques suffisent pour faire de la version break 145 l'incarnation de la berline familiale offrant la sécurité maximum. Des pare-chocs ultra-larges font la renommée de la génération suivante, les 240 et immortalisent l'image de la marque. Née en Italie chez Ghia, la merveilleuse P1800, voiture de fonction du détective Simon Templar dans les séries télévisées, devient vite célèbre. La version ES qui lui succède est surnommée « le cercueil de blanche-neige » à cause de son hayon oblique vitré.

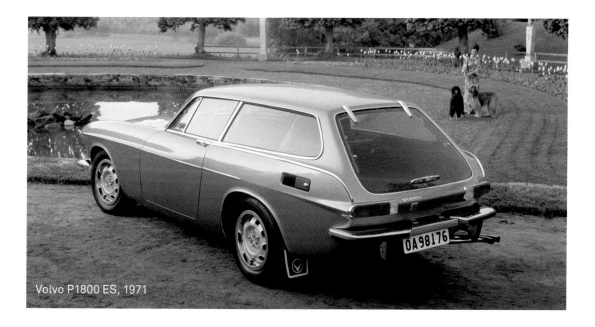

Volvo P1800 ES, 1971

PAOLO MARTIN

No matter which task Paolo Martin sets himself to, he has always choosen, often against the will of others, the radically contrary approach. His graphical Ferrari 512 S Modulo, a monument of the automotive form, became Pininfarina's figurehead. Trying to breathe new life into the British industry, he designed the BMC 1800 with an aerodynamic fastback, all-round glazing and rear hatch. Everybody was thrilled. But the Britons rejected it. Citroën was the first to adapt the idea and established the shape as the symbol of the revolutionary family car. Mercedes-Benz employed details such as the ribbed rear lights and the side louvres. Completely different in its appearance was Martin's Fiat 130 coupé: a rational architecture on wheels, which could hardly be more minimalist.

Egal mit welchem Thema Paolo Martin sich beschäftigt, er wählt, häufig gegen den Willen anderer, den radikal entgegengesetzten Weg. Sein grafischer Ferrari 512 S Modulo, ein Monument der Automobilform, wird zu Pininfarinas Aushängeschild. Beim Versuch, der britischen Industrie frischen Atem einzuhauchen, zeichnet er dem 1800 ein aerodynamisches Fließheck mit Rundumverglasung und Heckklappe. Alle sind begeistert, doch die Briten lehnen ab. Citroën übernimmt die Idee als erster und macht die Form zum Sinnbild des revolutionären Familienwagens. Mercedes-Benz bedient sich Details wie der geriffelten Rückleuchten und der Seitenjalousien. Völlig anders gibt sich Martins Fiat 130 Coupé: eine rationale Architektur auf Rädern, wie sie minimalistischer kaum sein könnte.

Paolo Martin choisit, lui, dans tout ce qu'il touche, une orientation radicalement différente, souvent envers et contre tous. Sa Ferrari 512 S Modulo, à la plastique très élégante, est un fleuron du design automobile : elle deviendra la signature de Pininfarina. Pour tenter de faire souffler un vent nouveau sur l'industrie britannique, il dote la 1800 d'un hayon aérodynamique presqu'entièrement vitré. L'accueil est enthousiaste, mais les Britanniques n'en veulent pas. Citroën est le premier à reprendre l'idée et fait de cette forme le symbole de la familiale révolutionnaire. Mercedes-Benz s'en inspire pour les feux arrière nervurés et les stores pare-soleil pour vitres de custode. La Fiat 130 Coupé dessinée par Martin se présente de façon radicalement différente : minimaliste à souhait, une architecture rationnelle sur roues.

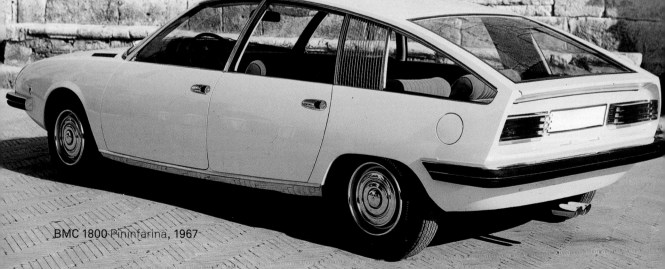

BMC 1800 Pininfarina, 1967

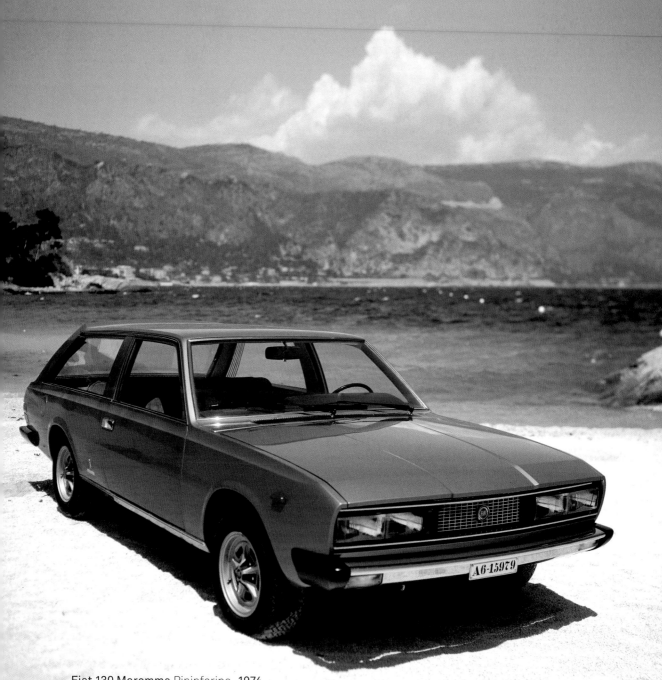

Fiat 130 Maremma Pininfarina, **1974**

This one-off, the golden Maremma, based on Martin's 130 coupé and built on behalf of Fiat boss Gianni Agnelli, is the most elegant interpretation of the sports-estate concept.

Dieses für Fiat-Chef Gianni Agnelli auf Basis von Martins 130 Coupé angefertigte Unikat, der goldene Maremma, ist die eleganteste Interpretation des Sportkombikonzepts.

Prototype conçu spécialement pour le patron de Fiat Gianni Agnelli sur la base du 130 Coupé dessiné par Paolo Martin, la Maremma est la traduction la plus élégante du concept break sportif.

Citroën GS, 1970

The sleek body makes Citroën's
1970 Grand Série fast, quiet and
efficient. Design as radical as it is
up-to-date.
.

Die schnittige Karosserie macht
Citroëns Grand Série von 1970
schnell, leise und verbrauchsarm.
Radikales Design auf der Höhe
der Zeit.

Sa carrosserie aérodynamique
fait de la Citroën Grande Série de
1970 une voiture rapide, silen-
cieuse et sobre. Design radical,
totalement à la page.

Citroën SM, 1970

ROBERT OPRON

During his first job interview, Citroën's design chief, Flaminio Bertoni, threw Opron's sketches on the floor, describing them as worthless. Yet, later on, Opron would succeed Bertoni and would not only revise Bertoni's DS, but would also find an avant-garde style that was very much his own with the GS and CX models, and particularly with Sa Majesté, the SM. Opron's cars generate the fascination of UFOs and, after a long break, propelled Citroën right back to the acme of automotive coolness.

Beim ersten Vorstellungsgespräch verteilt Citroën-Chefdesigner Flaminio Bertoni Oprons Zeichnungen noch auf dem Boden und bezeichnet sie als wertlos. Später wird Opron Nachfolger Bertonis und überarbeitet nicht nur dessen DS, sondern findet mit den Modellen GS, CX und vor allem „Sa Majesté", dem SM, zu einem eigenen, avantgardistischen Stil. Oprons Autos üben die Faszination von UFOs aus und befördern Citroën nach langer Pause mit Nachdruck wieder auf den Olymp automobiler Coolness.

Lors de son premier entretien d'embauche, le designer en chef de chez Citroën, Flaminio Bertoni étale les dessins d'Opron et les décrète « sans valeur ». Plus tard Opron succède à Bertoni et retravaille non seulement ses DS, mais surtout trouve avec les modèles GS, CX et surtout « Sa Majesté », la SM, son propre style, un style avant-gardiste. Les voitures d'Opron fascinent comme des OVNI et propulsent Citroën, après une longue absence, à nouveau au sommet de la coolitude automobile.

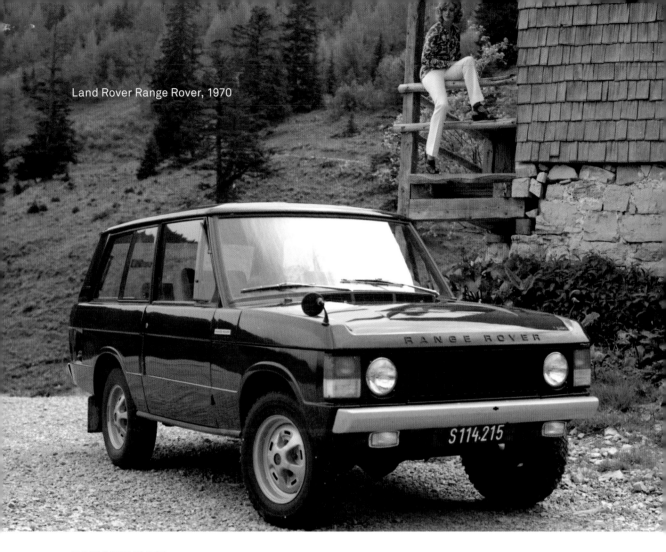

Land Rover Range Rover, 1970

RANGE ROVER

It takes an engineer as besotted with simplicity as Charles Spencer King to develop a vehicle that is as symbolically epochal as it is immensely useful. With permanent all-wheel drive, a powerful engine, subtle architecture and, last, but not least, imposing stature, the first Range Rover established a class of its own. An exclusive niche vehicle, whose sophistication the later SUV derivatives cannot even dream of.

Es bedarf eines auf Simplizität versessenen Ingenieurs wie Charles Spencer King, um ein ebenso symbolisch epochales, wie immens nützliches Fahrzeug zu entwickeln. Mit permanentem Allradantrieb, edler Motorisierung, subtiler Architektur und nicht zuletzt imposanter Statur begründete der erste Range Rover eine eigene Klasse. Ein exklusives Nischenfahrzeug, von dessen Niveau die späteren SUV-Ableger nicht einmal träumen können.

Il faudra un ingénieur épris de simplicité comme Charles Spencer King pour développer un véhicule qui non seulement fera date comme symbole d'une époque mais dont la dimension utilitaire sera considérable. Avec ses quatre roues motrices, sa noble motorisation, son architecture raffinée et last but not least sa stature imposante, la Range Rover a créé une catégorie de voiture à part. Un véhicule de niche, somptueux, sans équivalent, avec lequel les SUV, ses petits frères, ne pourront rivaliser.

Porsche 924, 1976

Porsche 911, 1976

PORSCHE

Predestination means that the first proper Porsche designs would never reach the same levels of acceptance as the Beetle-derived 356 and its scion, the 911. In fact, the better cars came on the market at the wrong time and under the wrong premises. Both the small 924 and the large 928 were simply too perfect. The ur-Porsches' rough sportiness, intransigence and idiosyncratic character were missing. In exchange, one got ride comfort with superior roadholding, attention to safety aspects and a flexible interior, including a rear hatch. Nobody had built better cars. But, unsettled by the oil crisis, Porsche's advertising sings a song that could not be any more cheerless: the big 928 is thus turned into a "multifunctional vehicle that needs little

Die Vorbestimmung führt dazu, dass die ersten echten Porsche-Konstruktionen niemals die Akzeptanz des Käfer-Derivats 356 mitsamt seines Ablegers, des 911, erreichen würden. Tatsächlich kommen die besseren Autos zur falschen Zeit und unter den falschen Prämissen auf den Markt. Sowohl der kleine 924, als der große 928 sind einfach zu klug. Die raue Sportlichkeit, die Kompromisslosigkeit und der eigenwillige Charakter des Ur-Porsche fehlen ihnen. Dafür gibt es Fahrkomfort bei bester Straßenlage, ein Sicherheitskonzept und einen flexiblen Innenraum samt Heckklappe. Niemand baut Besseres. Doch von der Ölkrise verunsichert, singt Porsches Werbung ein Lied, das freudloser nicht sein könnte:

Le projet est défini de telle manière que les premières vraies Porsche à être construites n'allaient jamais rencontrer l'écho de la 356 qui était un dérivé de la Volkswagen coccinelle et du modèle successeur, la 911. En effet ces voitures, bien qu'améliorées, arrivent sur le marché au mauvais moment et sous des auspices défavorables. Aussi bien la petite 924 que la grande 928 sont tout simplement trop subtiles. Il leur manque la sportivité animale de la Porsche primitive, sa radicalité et son originalité. En contrepartie elles ont une excellente tenue de route qui assure confort de conduite et sécurité et un habitacle modulable avec hayon. C'est le top de la construction automobile. Mais fragilisé par la crise du pétrole, Porsche choisit un message

Porsche 924, 1976

maintenance". The too-small 924, whose "fair levels of consumption" are "assuringly sensible", offers "more driving safety – both active and passive". But nobody dreams of a Porsche's stowage space, so far removed from the image of the delightfully dangerous 550 Spyder in which James Dean met his untimely death. So, maybe Porsche does not want to replace the 911, which is still to die for, after all. A lost opportunity, then: with front-engine design, brawny proportions and a sleek design that was 25 years ahead of its time, the 928 justly received the Car of the Year award in 1978.

Der zu große 928 wird zum „multi-funktionellen Fahrzeug, das wenig Wartung braucht". Der zu kleine 924 – „fair im Verbrauch" und „beruhigend vernünftig" – bietet „mehr Fahrsicherheit – aktive und passive". Doch niemand träumt vom Kofferraum eines Porsche, in dem ein James Dean ja wohl kaum sterben könnte. Den 911, immer noch „zum Verlieben schön", will Porsche nun möglicherweise doch nicht ersetzen. Eine vertane Chance: Mit Frontmittelmotor-Konstruktion, bulligen Proportionen und einem Smooth Design, das seiner Zeit um 25 Jahre voraus ist, wird der 928 zu Recht Auto des Jahres 1978.

publicitaire on ne peut plus terre-à-terre. La 928 surdimensionnée devient « un véhicule multifonction nécessitant peu d'entretien ». La trop petite 924 devient « peu exigeante en carburant », « sage et raisonnable » et garante « d'une sécurité active et passive accrue ». Mais qui rêve d'une voiture qu'un James Dean n'aurait pas choisie pour y rouler à tombeau ouvert ? La 911, qui reste « d'une beauté à vous faire craquer », Porsche n'envisage alors pas de la remplacer. Une occasion ratée : avec un moteur V8 installé en position avant, une forme un peu massive et un design lisse, en avance de 25 ans sur son temps, la 928 est, à juste titre, élue en 1978 voiture européenne de l'année.

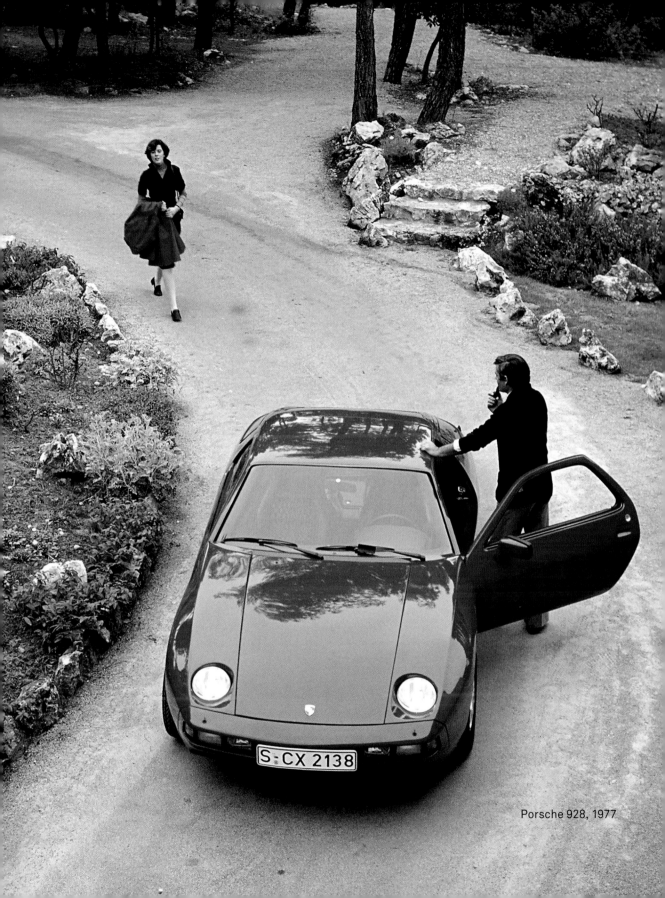

Porsche 928, 1977

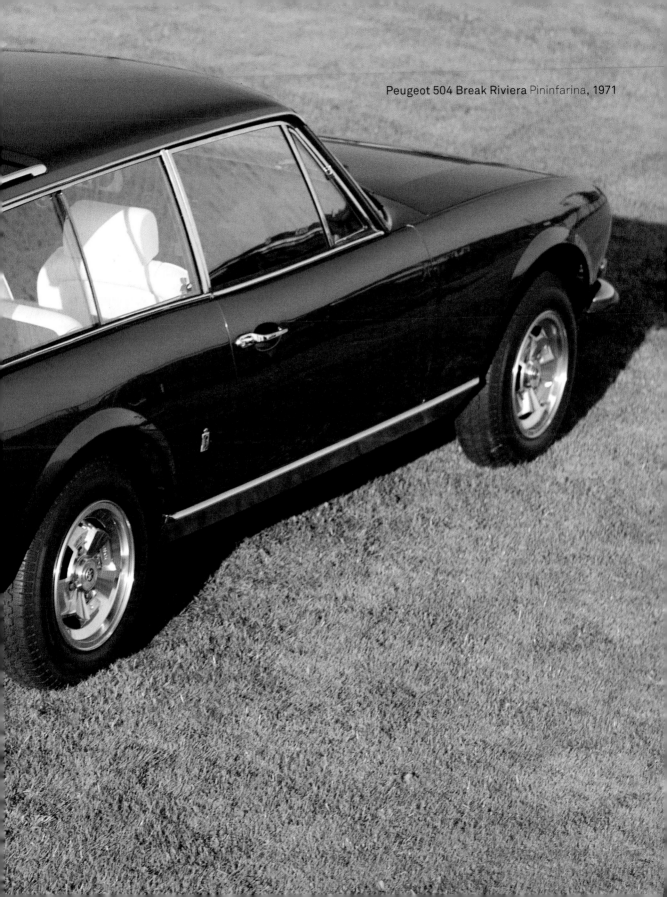

Peugeot 504 Break Riviera Pininfarina, 1971

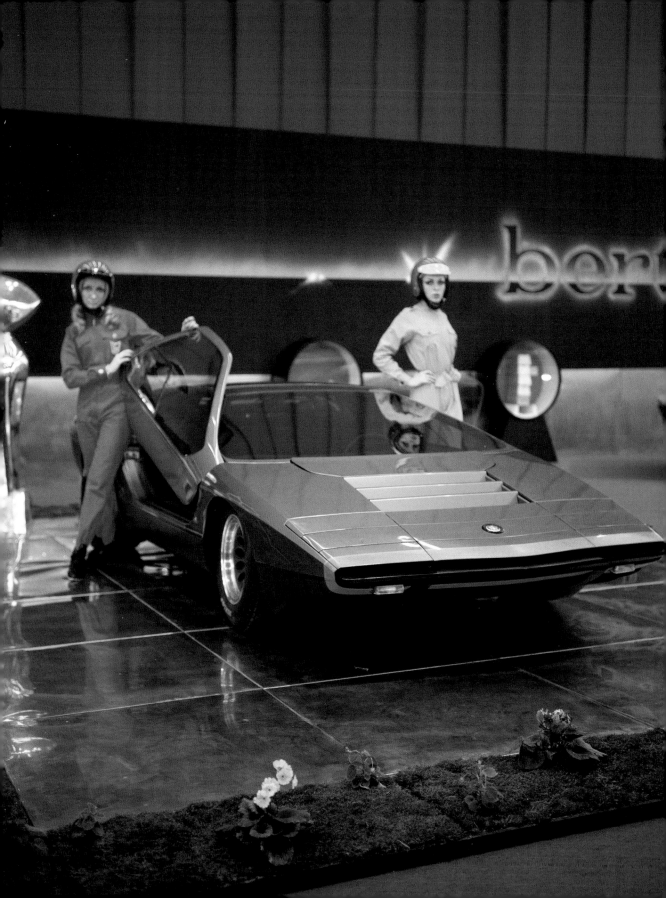

RADICAL

The cultural revolution began on November 4th, 1966 as Florence falls victim to a flood disaster. Thousands of young people from all over the globe help to save works of art from the archives and museums. Wading through the mud, the young saviours philosophise about the Vietnam War and Pop Art, rant against the academy and come to the conclusion that a radical renunciation of the social and political conservatism currently in power is needed. In 1967 Muhammad Ali, the greatest of all boxers, refuses to enlist for military service. The greatest car designers of those days are of the same generation: Gandini, 29, is head of design at Bertone; Giugiaro, also 29, is about to leave Ghia and establish his own com-

Am 4. November 1966 beginnt die Kulturrevolution: Florenz wird von einer Flutkatastrophe heimgesucht. Tausende Jugendliche aus aller Welt helfen mit, Kunstschätze aus Archiven und Museen zu retten. Durch den Schlamm watend, philosophieren die Retter über Vietnamkrieg und Pop-Art, wettern gegen die Akademie und kommen zu der Erkenntnis, dass eine radikale Abkehr vom herrschenden sozialen und politischen Konservativismus notwendig ist. 1967 weigert sich Muhammad Ali, „The Greatest" unter den Boxern, den Wehrdienst anzutreten. Die größten Automobildesigner jener Zeit gehören derselben Generation an. Gandini, 29, ist Designchef bei Bertone; Giugiaro, ebenfalls 29,

Le 4 novembre 1966 donne le coup d'envoi de la révolution culturelle : la ville de Florence est touchée par des inondations catastrophiques. Des milliers de jeunes gens affluent du monde entier pour aider à la sauvegarde des œuvres d'art menacées par les eaux dans les archives et les musées. Les pieds dans la boue, ces volontaires héroïques philosophent sur la guerre du Vietnam et le pop art, vitupèrent contre l'Académie, et concluent qu'il est temps de se détourner radicalement du conservatisme politique et social ambiant. En 1967, Mohamed Ali, le plus grand des boxeurs, refuse de faire son service militaire. Les grands designers automobiles de l'époque sont issus de cette génération de révolutionnaires. Gan-

Alfa Romeo 33 Carabo Bertone, 1968

Spice Girls and Space Car: Bertone's Carabo takes a swipe at classical elegance.

Bertones Carabo rechnet mit der klassischen Eleganz ab.

La Carabo de Bertone règle son compte à l'élégance classique.

pany, Italdesign; Martin, at just 24, leaves Michelotti for Pininfarina. Their own revolution is about to begin. In May 1968, the streets of Paris are burning. As in Florence, the photos depicting this revolt all include one element: old cars; destroyed old cars.

WEDGE CUT

Geneva, spring 1967. Marcello Gandinis incredible Marzal lands on Planet Earth. It is a piece of art, inside and out: facetted, silvery, transparent, its face hidden behind a slim, black slit. Its passengers are exposed like mannequins behind a shop window, lying on silvery bucket seats, beneath glass gullwing doors and a glass roof. All mechanical elements are treated as a 'black hole', just like that year's astronomical discovery: the rear bonnet has been replaced by a matte black, three-dimensional, hexagonal armour plate. The Marzal was a time bomb. Gandini's second coup exploded in 1968 in the shape of the Carabo, a pro-

gründet Italdesign; Martin, erst 24, verlässt Michelotti gen Pininfarina. Ihre Revolution nimmt ihren Anfang. Im Mai 1968 beben die Straßen von Paris. Was auf den Bildern der Revolte, wie einst in Florenz, nicht fehlen darf: Automobile. Zerstörte alte Automobile.

KEILSCHNITT

Genf, Frühling 1967. Der unglaubliche Marzal von Marcello Gandini landet auf dem Planeten Erde. Innen und außen ein Gesamtkunstwerk: facettiert, metallisch, transparent. Das Gesicht durch einen schmalen, dunklen Schlitz kaschiert. Wie Exponate im Schaufenster liegen die Passagiere auf silbrigen Schalensitzen, hinter gläsernen Flügeltüren und unter einem Glasdach. Alles Mechanische wird wie ein „Schwarzes Loch" – analog der astronomischen Entdeckung des Jahres – behandelt: die Heckmotorhaube wird durch eine mattschwarze, dreidimensionale Sechseck-Pan-

dini devient à 29 ans responsable du design chez Bertone ; au même âge Giugiaro quitte Ghia pour se mettre à son compte et fonder Italdesign ; Martin n'a que 24 ans lorsqu'il quitte Michelotti pour rejoindre Pininfarina. Leur révolution commence. En mai 1968 les rues de Paris tremblent. Et sur les images de la révolte, comme à Florence, figurent immanquablement des voitures, des carcasses de vieilles voitures détruites.

LIGNES EN COIN

Genève, Printemps 1967. La Marzal, cet incroyable objet roulant conçu par Marcello Gandini débarque sur la planète terre. Vue de l'intérieur comme de l'extérieur, c'est une œuvre d'art totale, superbement composée de surfaces facettées, argentées et transparentes. La calandre, son visage, est occultée par un fin bandeau sombre. Comme un joyau exposé dans une vitrine, le passager, sous un toit et derrière des portes papillons en vitre, y est allongé dans

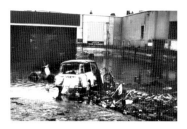

Firenze, 1966

Paris, 1968

totype based on Alfa Romeo's 33 race car. It marked the mid-engined construction's final shape, consisting of a radically erased face, a flat bonnet merging seamlessly into the windscreen and with all its visual weight concentrated at the rear. All this resulted in the wedge shape: a radical change in the ruling aesthetic principles of the automobile. There were technical, as well as symbolic reasons for the wedge. As speeds increased, the classic streamline was reaching its limits: the automobile would lift off, losing contact with the road. In order to counteract this lifting force, Chaparral began fitting his race cars with tall rear spoilers. Going one step further, and turning the rear as a whole into one spoiler seemed to be a sensible idea. To generate downforce in that area, the rear needed to be raised, which inevitably led to a wedge profile. The wedge shape might not be more aerodynamic than the drop shape, but it enabled a safe deployment of enormous forces close to the ground. Sym-

zerplatte ersetzt. Der Marzal ist eine Zeitbombe, die 1968 explodiert. Gandinis zweiter Streich heißt Carabo, ein Prototyp auf Basis des Alfa Romeo 33 Rennwagens. Durch ihn erlangt die Mittelmotorbauweise ihre endgültige Form: mit radikal weggradiertem Gesicht, flacher, ohne Übergang in die Windschutzscheibe wachsender Motorhaube und komplett auf die Heckpartie konzentriertem optischem Gewicht. Es ist die Keilform: eine radikale Umstellung des bisher geltenden ästhetischen Automobilprinzips. Für den Keil gibt es technische und symbolische Gründe. Mit zunehmender Geschwindigkeit stößt die klassische Stromlinie an ihre Grenze: Das Automobil hebt ab. Um dieser Auftriebskraft entgegenzuwirken, beginnt Chaparral seine Rennautos mit hohen Heckspoilern auszustatten. Da erscheint die Idee, gleich das ganze Heck als einen Spoiler zu betrachten, sinnvoll. Um dort Anpressdruck zu erzeugen, wächst es in die Höhe,

un siège-baquet argenté. Tous les détails mécaniques disparaissent dans un « trou noir », qui est d'ailleurs la découverte astronomique de l'année. Véritable bombe à retardement, la Marzal explose en 1968. Le prochain coup de Gandini sera la Carabo, un prototype sur la base d'une voiture de course, l'Alfa Romeo 33 grâce auquel l'architecture à moteur central arrière trouve sa forme définitive. Ultraplate, avec à l'avant un visage radicalement biseauté d'où émerge le pare-brise pour finir sans transition sur le capot arrière, sa forme oblige le regard à se déplacer vers l'arrière de la voiture, son centre de gravité optique. La « ligne en coin » constitue un renversement radical des principes esthétiques du design automobile, dont l'apparition s'explique tant sur le plan technique que symbolique. En effet, le principe classique d'aérodynamisme arrive à ses limites : la vitesse augmentant, les voitures ont tendance à décoller. Pour réduire la portance, Chaparral

Chaparral 2F, 1977

Lotus 56 Turbine, 1968

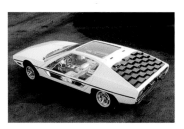

Lamborghini Marzal Bertone, 1967

bolically, it is the ultimate shape of victory: a sign of man's resistance to undesirable phenomena. In Giugiaro's Bizzarrini Manta prototype, front, windscreen, roof and rear merged into one form. It was the first sighting of the 'One Box' design. The years 1967–68 also saw great change at Pininfarina: in Turin, Leonardo Fioravanti's Ferrari Daytona, which had been unveiled in Paris, found itself parked opposite Paolo Martin's Alfa Romeo 33 spider. The Alfa concept's perfect wedge was light years ahead of the production-model Ferrari. In 1971, Lamborghini announced a successor to the Miura. It was called the Countach and appeared sinuous and tortured into shape at the same time. In short: radical. An aesthetic elemental force, challenging both the driver and the observer. Not a car for the road, but a machine for hyperspace. Official top speed: 195 mph. The Countach sentenced the classic automotive shape to death. Nonplussed, for the first time Ferrari dared to embark

was zwangsläufig das Profil eines Keils ergibt. Die Keilform ist zwar nicht aerodynamischer als die Tropfenform, ermöglicht aber die sichere Entfaltung enormer Kräfte in Bodennähe. Symbolisch ist sie die ultimative Form des Sieges: ein Zeichen des Widerstands des Menschen gegen unerwünschte Naturphänomene. In Giugiaros Bizzarrini Manta-Prototyp verschmelzen Front, Windschutzscheibe, Dach und Heck zu einer Linie. Es ist die erste Sichtung des One-Box-Designs. 1967–68 sind auch Jahre der Veränderung für Pininfarina: dem in Paris vorgestellten Ferrari Daytona von Leonardo Fioravanti steht in Turin der Alfa Romeo 33 spider von Paolo Martin gegenüber. Der absolute Keil des Alfa-Konzepts ist dem eleganten Serien-Ferrari um Lichtjahre voraus. 1971 kündigt Lamborghini einen Nachfolger für den Miura an. Er heißt Countach und wirkt gleichzeitig geschmeidig und in Form gequält – kurzum: radikal. Eine ästhetische Urge-

équipe alors ses voitures de course de hauts ailerons arrière. L'idée de la forme en coin se développe ensuite par surélévation de l'arrière de la voiture qui fait alors office de spoiler et permet une meilleure adhérence de la voiture. Sur un plan strictement aérodynamique, la forme en coin n'est pas supérieure à la forme en goutte d'eau mais elle permet le déploiement de forces au sol énormes et stabilisantes. La forme en coin symbolise le « V » de la victoire, la victoire de l'homme sur la nature et ses phénomènes qu'il faut maîtriser. Le prototype de la Manta Bizzarrini dessiné par Giugiaro où l'avant, le pare-brise, le toit et l'arrière se fondent en une ligne unique, marque la toute première apparition du design monocorps. Les années 1967–68 sont d'ailleurs des années de grands changements chez Pininfarina alors que la Ferrari Daytona de Leonardo Fioravanti présentée à Paris fait face au 33 spider d'Alfa Romeo de Paolo Martin présenté à Turin.

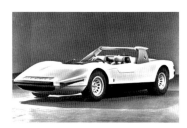

Alfa Romeo 33 spider Pininfarina, **1971**

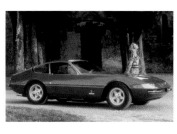

Ferrari 365 GTB/4 *Daytona*, **1968**

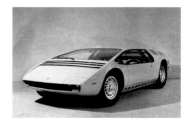

Bizzarrini Manta Italdesign, **1968**

on an affair with Bertone to shape the Dino's successor. For licence holder Innocenti's new Mini, Gandini ends the wedge-shape roof end with a spoiler. And "a wedge called Giulietta" redefines the saloon car's proportions. Its waistline ends in a challengingly short and high rear. Even when stationary, the Giulietta seems to be dynamically leaning toward the front. The wedge called for courage, which Britain, of all the car-producing countries, managed to muster: Lotus produced a proper 'super wedge' in the shape of the Esprit, "styled by Giugiaro" and approved by 007. Next up came the quirky, four-seater Elite. Triumph provoked the middle class with the TR7 and parent company Leyland then went on to deeply upset it with the Princess. Aston Martin finally outraged everybody with the Lagonda. While her wedge-cut hairstyle was turning figure skater Dorothy Hamill into a star, the wedge shape proclaimed its revolutionary message: the front is shallow, the grille

walt, die Fahrer wie Betrachter gleichermaßen herausfordert. Kein Auto für die Straße, sondern eine Maschine für den Hyperraum. Offizielle Höchstgeschwindigkeit: 315 km/h. Der Countach verurteilt die klassische Automobilform zum Tode. Verunsichert wagt Ferrari für den Nachfolger des Dino einen Seitensprung mit Bertone. Im neuen Mini für Lizenznehmer Innocenti lässt Gandini dann das keilförmige Dach in einem Spoiler enden. Und ein „Keil namens Giulietta" definiert die Proportionen der Limousine neu. Deren Gürtellinie endet in einem gewöhnungsbedürftig kurzen und hohen Heck. Selbst im Stand neigt sich die Giulietta dynamisch nach vorne. Der Keil verlangt nach Mut, den nun ausgerechnet die Briten aufbringen. Lotus produziert mit dem Esprit, „Styled by Giugiaro", einen wahren Superkeil, der auch 007 gefällt. Darauf folgt der schräge Viersitzer Elite. Triumph provoziert die Bürgerschicht mit dem TR7, und Konzernmutter Ley-

À des années lumière du modèle de série classique adopté par Ferrari, la forme en coin est totale dans le concept de l'Alfa, où même la ligne de caisse horizontale est ascendante vers l'arrière. En 1971, Lamborghini annonce le lancement du modèle qui succèdera à la Miura : la Countach, radicale par sa ligne à la fois souple et ravageuse. Telle une force de la nature, son esthétique défie le conducteur autant que le contemplateur. Ce n'est pas une voiture, mais un hyperespace qui atteint la vitesse officielle de 315 km/h. La Countach signe l'arrêt de mort de la forme berline conventionnelle. Gandini, pour la nouvelle Mini d'Innocenti, étire la forme en coin du toit jusqu'au spoiler dans le prolongement. Puis vient la Giulietta qui réinvente les proportions de la berline. Sa silhouette plongeante s'achève par une poupe inhabituellement haute et courte. Même à l'arrêt, la Giulietta se penche dynamiquement vers l'avant. La ligne en coin demande du courage et ce sont jus-

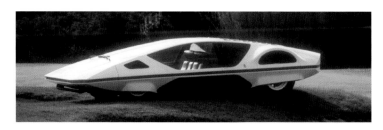

Ferrari 512 S PF Modulo Pininfarina, 1970

gone, the lights hidden behind a shutter—and all of a sudden the car no longer has a face. No matter whether Lamborghini, Ferrari, Lotus or Matra: all animals are equal, but some are more equal than others. A state of affairs that cannot last.

POP & ROLL

Above all, the cultural revolution meant a new handling of status symbolism. The world was becoming more laid-back, with skimpier fashion, an open lifestyle and more colourful cars. At the end of the sixties, the legendary Dune Buggy arrived from the US, an exultant automobile, very much in the Pop & Roll spirit. In contrast to the romantic beach cars of the 1950s, the Buggy jumped like a small frog and could be driven absolutely everywhere. Europe discovered the leisure vehicle as the automotive equivalent of the sexual revolution. The Mini Moke, a tent-on-wheels, created a furore in Paris and the Riviera. It was originally

land erschüttert sie nachdrücklich mit der Princess. Aston Martin empört schließlich alle mit dem Lagonda. Während Eisläuferin Dorothy Hamill mit ihrer Frisur im „Keilschnitt" zum Star wird, verkündet die Keilform ihre revolutionäre Botschaft: Die Front ist flach, der Grill fällt weg, die Scheinwerfer verschwinden hinter einer Klappe – und plötzlich hat das Auto kein Gesicht mehr. Egal ob Lamborghini, Ferrari, Lotus oder Matra: „Alle Tiere sind gleich – aber einige sind gleicher". Ein Zustand, der nicht andauern kann.

POP & ROLL

Die Kulturrevolution bedeutet also vor allem einen neuen Umgang mit Statussymbolik. Die Welt wird locker, die Mode knapp, der Lebensstil offen, die Autos bunt. Ende der 1960er kommt der Dune Buggy aus Amerika, ein frohlockendes Automobil, ganz im Geiste des Pop & Roll. Anders als der romantische Strandwagen

tement les anglais, une fois n'est pas coutume, qui en font preuve. Lotus lance l'Esprit au « styled by Giugiaro », une voiture qui magnifie ce style et qui saura séduire James Bond. Puis vient l'Elite, ce quatre places détonant. Triumph donne dans le registre de la provocation avec la TR7, tandis que Leyland, la maison mère, donne plutôt dans celui des émotions fortes avec la Princess. Enfin, Aston Martin offusquera tout le monde avec sa Lagonda. À la même époque, une patineuse artistique, Dorothy Hamill, crée la sensation avec sa coupe de cheveu aérodynamique. La ligne en coin véhicule un message esthétique révolutionnaire : l'avant s'aplatit, la calandre disparaît, les phares se rétractent, la voiture perd son visage. Que ce soient des Lamborghini, des Ferrari, des Lotus ou des Matra, toutes les voitures sont égales mais certaines le sont plus que d'autres : cela ne durera pas.

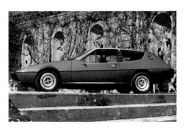

Lotus Elite, 1974

Alfa Romeo Giulietta, 1976

designed as a military vehicle, as was the VW Kübelwagen, a four-door Beetle covered in corrugated sheet steel, which the Americans appropriately refer to as 'The Thing'. Anti-conformist as always, Citroën introduced the Méhari, based on the 2CV: a house pet, made of colourful plastic: red, olive, orange, beige. Slow, anti-aesthetic, excessively spartan, the weird vehicle came to be a symbol of radical chic.

In Austria, Steyr-Puch painted its Haflinger Micro-Jeep bright red. But the Italians were the most creative: Pininfarina designs the Peugette 104, made of exchangeable body parts. The car consisted of a combination of just three repeating elements: two bonnets, two doors and four wings, each identical. Unfortunately it was never put into production, just like the A112 Giovani, an upbeat variation on the theme of the elegant, middle class city car by Autobianchi. Ultimately, these leisure vehicles were still a small luxury that not everybody could afford. Success called

der Fünfziger springt der Buggy wie ein Fröschlein und fährt wirklich überall hin. Europa entdeckt das Freizeitauto als automobiles Äquivalent der sexuellen Revolution. Der Mini Moke, ein Zelt auf Rädern, sorgt in Paris und an der Riviera für Furore. Ursprünglich war er als Militärfahrzeug vorgesehen, genau so wie VWs Kübelwagen, der viertürige, mit offenem Riffelblech verpackte Käfer, den die Amerikaner zutreffend schlicht „das Ding" nennen. Antikonformistisch wie immer, stellt Citroën den Méhari auf 2CV-Basis vor. Ein Haustier aus buntem Kunststoff: Rot, Oliv, Orange, Beige. Langsam, anti-ästhetisch, spartanisch bis zum Exzess – die Plastikkiste ist Sinnbild des radikalen Chics.

In Österreich färbt Steyr-Puch seinen Mikro-Jeep Haflinger knallrot. Am kreativsten sind die Italiener: Pininfarina entwirft den Peugette 104, samt austauschbarer Karosserieteile. Der Wagen besteht aus nicht mehr als zweimal derselben Haube, zweimal

POP & ROLL

La révolution culturelle est synonyme de remise en question des symboles de statut social. La société se décoince, les jupes se raccourcissent, les modes de vie se modifient, les voitures se mettent aux couleurs. À la fin des années soixante, la légendaire Dune Buggy américaine fait son entrée en scène, une voiture pleine de joie de vivre, tout à fait dans l'esprit pop & roll du moment. À l'inverse de la voiture de plage des années 50, elle n'est pas romantique, elle sautille comme une grenouille et permet d'aller partout. L'Europe découvre la voiture de loisirs qui rime si bien avec révolution sexuelle. La Mini Moke, une tente sur roues, fait fureur à Paris et sur la Riviéra. Initialement conçue pour un usage militaire, comme la « Kübelwagen » de VW, cette voiture à carrosserie ouverte, enveloppée de tôles cannelées est très justement surnommé « la chose » par les Américains. Citroën, toujours aussi anticonformiste, transforme

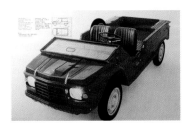

Citroën Méhari, 1968

Volkswagen Typ 181
Kurierwagen *The Thing*, 1969

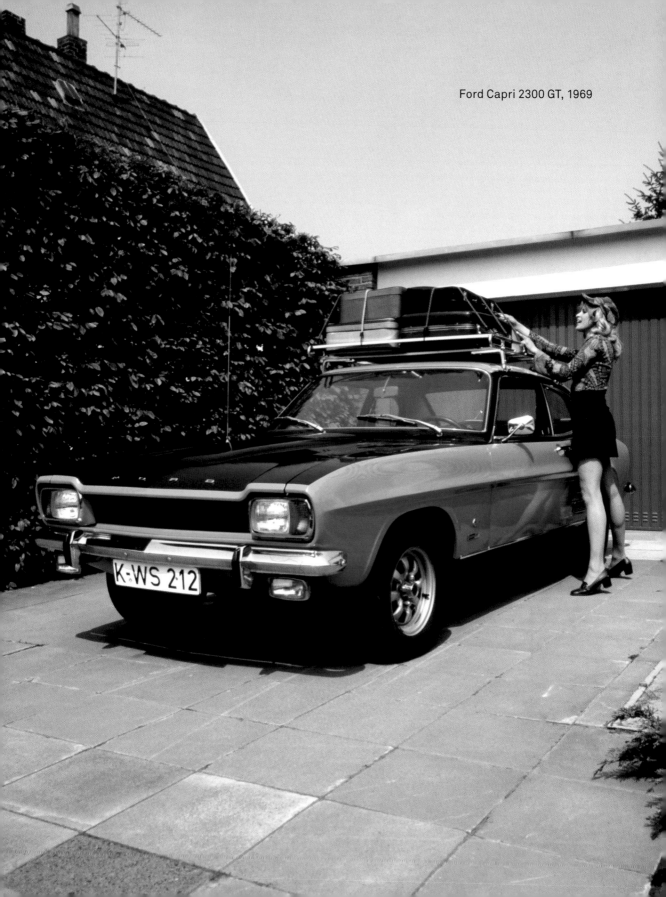

Ford Capri 2300 GT, 1969

for more utility. Therefore, Gandini stylised the dune buggy principle into the runabout concept, the result of which was the wedge-shaped Fiat X1/9 with its black targa roof. Following the idiosyncratic M 530 with its T-top, Matra unveiled the Rancho, a rugged outdoor version of the popular 1100. Due to its name, it was immediately mocked as the poor man's Range Rover. Porsche then developed the colourful 914, but officially called it a Volkswagen, due to political considerations. The little sports car promptly gained a reputation as the poor man's Porsche. Ford's Capri and Opel's Manta (Italian for 'stingray') and GT models could also be considered the poor European's Mustang and Corvette. But despite this—or just because of it—these cars turned out to be very successful indeed. After all, once in a lifetime everybody needs indulge themselves a little. And, unlike before, one could put this idea into practice without worrying too much. Because all these small pop

derselben Tür und viermal demselben Kotflügel. Leider geht er nicht in die Serie, ebenso wenig wie der A112 Giovani, eine peppige Variante des bürgerlich-eleganten Stadtwagens von Autobianchi. Letztendlich sind die Freizeitautos trotz allem ein kleiner Luxus, den sich nicht jeder leisten kann. Erfolg braucht mehr Nutzwert. Also stilisiert Gandini das Dune-Buggy-Prinzip zum Runabout-Konzept – Ergebnis ist der keilförmige Fiat X1/9 mit schwarzem Targadach. Nach dem eigenwilligen M 530 mit geteilten T-Top präsentiert Matra den Rancho, eine Wald-und-Wiesen-Version des populären 1100. Des Namens wegen wird er schnell als „Range Rover für Arme" verspottet. Porsche entwickelt den bunten 914 und nennt ihn dann aus politischen Gründen offiziell Volkswagen. Dieser wird wiederum als „Porsche für Arme" verhöhnt. Auch den Ford Capri und die Opel-Modelle GT und Manta (Italienisch für den amerikanischen Stingray) kann man

sa 2CV en Méhari, proposée en plastique rouge, vert olive, orange et beige. Lente, anti-esthétique et spartiate à l'excès – ce drôle d'animal est le symbole du chic radical. En Autriche, Steyr-Puch peint en rouge vif sa mini-jeep, la Haflinger. Les plus créatifs sont les italiens. Pininfarina dessine la Peugette 104 aux éléments de carrosserie interchangeables avec deux ensembles capot et ailes avant et arrière et portes identiques. Le prototype ne sera jamais produit en série, ni d'ailleurs celui de l'A112 Giovani une variante pleine de pep de la citadine à l'élégance bourgeoise de chez Autobianchi. Les voitures de loisirs demeurent un luxe que la plupart ne peuvent s'offrir et l'aspect pratique d'une voiture continue à être la clé de son succès commercial. Gandini crée alors sur le principe de la Buggy-Dune un concept runabout matérialisé par la Fiat X1/9 avec toit targa noir. Suite à la très originale M 530 au toit démontable en deux parties, Matra lance la Rancho, une version

Peugeot Peugette 104
Pininfarina, 1976

Opel GT, 1968

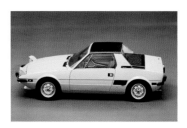

Fiat X1/9, 1972

PLASTIC FANTASTIC

mobiles appeared—in stark contrast to the Fascist automotive symbols of decades earlier—friendly.

At the dawn of the seventies, a plastic invasion was taking place. In 1972, the New York MoMA opens the exhibition 'Italy: The New Domestic Landscape', in which the ambassadors of a radical anti-design presented plastic landscapes and objects for living and the environment. Cini Boeri built Serpentone, a snake sofa made of polyurethane elements; Gatti, Teodoro and Paolini filled up the Sacco, creating a chair with an infinitely sculptable shape. De Pas, D'Urbino and Lomazzi's Blow rendered the classic Chesterfield inflatable and transparent. Both Joe Colombo's Tube lamp and Ettore Sottsass' Valentine typewriter also demonstrated that the whole world was gleaming in colourful plastic. But plastic also meant safety: the Americans were de-

als Mustang und Corvette des armen Europäers betrachten. Trotzdem – oder gerade deswegen – haben diese Autos einen Riesenerfolg. Einmal im Leben darf sich schließlich jeder etwas gönnen. Und anders als zuvor kann man diese Absicht nun sorglos in die Tat umsetzen. Denn all die bunten Pop-Mobile wirken, ganz im Gegensatz zu den faschistischen Automobilsymbolen Jahrzehnte zuvor, richtig sympathisch.

PLASTIC FANTASTIC

Zu Beginn der Siebziger erfolgt eine Invasion des Kunststoffs. 1972 eröffnet im New Yorker MoMA die Ausstellung Italy: The New Domestic Landscape. Die Vertreter des radikalen Anti-Designs präsentieren plastische Landschaften und Objekte für die Um- und Wohnwelt. Cini Boeri baut endlose Sofas zu einer Riesenschlange, Gatti, Teodoro und Paolini füllen den unförmigen Sessel Sacco. Mit Blow machen

tout terrain de la fameuse 1100. Par allusion à son nom, elle est vite affublée du sobriquet de « Range Rover du pauvre ». Porsche développe la 914 commercialisée sous la marque Volkswagen pour des raisons de marketing et qui sera aussi qualifiée de « Porsche du pauvre ». La Capri de Ford, les modèles GT de chez Opel ainsi que la Manta sont les Mustang et les Corvette du pauvre, européen en l'occurrence. Toujours est-il que ces voitures ont la côte et remporte un vif succès. Pour une fois, le rêve est à portée de toutes les bourses et vaut d'être réalisé, car à l'inverse de la voiture fasciste des décennies précédentes, ces « pop mobiles » revêtent des formes tout à fait sympathiques.

PLASTIQUE FANTASTIQUE

Au début des années 70 a lieu l'invasion du plastique. En 1972 se tient au MoMA de New York l'exposition Italy: The New Domestic Landscape. Les représentants de l'anti-design y montrent

Matra M530, 1967

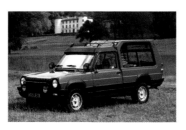

Matra-Simca Rancho, 1977

manding thick bumpers and padded dashboards. These things can be most easily produced using plastics. The rally sports' matte black trend hence turned out to be most convenient, as it enabled the liberal use of rough, unpainted plastics. The fact that Ferrari, Porsche and Lotus—who were all very much focused on the US market—were converting their cars to heavily feature black plastic detailing immediately enhanced the material's acceptance in the popular classes. Saab and Volvo were using plastic in particularly sturdy fashion, reinforcing their reputation as purveyors of safety products.

The Golf also gained thick, black bumpers: a short while later, practically every car followed suit. But plastic was only able to conquer the heart of Europe once it had developed a style of its own. In the best anti-conformist fashion, the Renault 5 caused a stir with its corrugated integral bumpers, made out of light grey plastic. The

De Pas, D'Urbino und Lomazzi den Chesterfield aufblasbar und transparent. Ganz egal ob Joe Colombos Rohr-Lampe oder Ettore Sottsass' Valentine-Schreibmaschine: die ganze Welt glänzt in buntem Plastik. Kunststoff bedeutet auch Automobilsicherheit: Die Amerikaner verlangen nach dicken Stoßstangen und gepolsterten Armaturenbrettern. Das lässt sich am einfachsten mit Kunststoff realisieren. Da kommt den Herstellern der Mattschwarz-Trend aus dem Rallyesport gerade recht, denn so lässt sich rauer, unlackierter Kunststoff problemlos einsetzen. Die Tatsache, dass Ferrari, Porsche und Lotus – denen der amerikanische Markt am Herzen liegt – ihre Fahrzeuge auf schwarz trimmen, erhöht auf Anhieb die Akzeptanz des Materials in der Volksklasse. Saab und Volvo festigen im Auge des Konsumenten ihren Ruf als Sicherheitsanbieter. Dicke, dunkle Stoßstangen bekommt auch der Golf, etwas später dann jedes Fahrzeug. Kunststoff macht Spaß. Gewohnt

des objets et des micro-architectures plastiques pour l'environnement domestique. Cini Boeri construit un canapé modulable en serpentin, Gatti, Teodoro et Paolini dessinent le Sacco, un pouf tout à fait informe empli de billes de polystyrène. De Pas, D'Urbino et Lomazzi fabriquent un Chesterfield gonflable et transparent, le Blow. Qu'il s'agisse de la lampe Tube de Joe Colombo ou de la machine à écrire Valentine d'Ettore Sottsass, le monde entier brille aux couleurs du plastique. Mais le plastique est aussi synonyme de sécurité automobile : les américains exigent des gros pare-chocs et des tableaux de bord rembourrés. Pour les réaliser le matériau idéal est le plastique. La mode du noir mat façon rallye arrangera bien les constructeurs qui pourront ainsi intégrer facilement le plastique brut, non-laqué à leurs créations. Le matériau est d'autant mieux accepté par les classes moyennes que Ferrari, Porsche et Lotus, très attachés au marché américain, eux-mêmes

Renault R5, 1972

Citroën Visa, 1978

Volvo 264 GLE *Grand Luxe Executive*, 1976

Citroën Visa's bumper grew to a size that allowed it to encompass the entire front grille. On the inside, plastic was used to create a futuristic-ergonomic dashboard, featuring floating satellites. In the case of the Seat Sport, the black bumper contained the entire grille, as did that of the Ferrari 365 GTC/4. A similar idea can be found in the contemporary Lancia Beta Montecarlo. Next to it, the 1978 Fiat Ritmo was probably the most daring creation of the seventies: at the front a strongly moulded, black bumper integrated spoiler, grille and the lower half of the round headlamps. At the rear, the bumper, forming a unit with the rear lights and the licence plate bracket, extended all the way to the hatch. All details were executed in plastic and presented with graphical competence: round door handles, pyramidal wing mirrors and, asymmetrically located on the bonnet, a three-part air intake. This 'plastic fantastic' look soon develops into a must-have. The spoiler turned out to be the peo-

antikonformistisch, provoziert der Renault R5 mit geriffelten Integralstoßstangen aus hellgrauem Kunststoff. Im Citroën Visa wächst die Stoßstange, bis sie den gesamten Frontgrill aufnimmt. Innen wird aus Kunststoff ein futuristisch-ergonomisches Armaturenbrett mit schwebenden Satelliten. Beim Seat Sport umfasst eine schwarze Stoßstange den gesamten Grill, genauso wie beim Ferrari 365 GTC/4. Eine ähnliche Idee findet man gleichzeitig beim Lancia Beta Montecarlo. Neben ihm stellt der Fiat Ritmo von 1978 die womöglich mutigste Kreation der Siebziger dar: Vorne integriert eine stark modellierte, schwarze Stoßstange Spoiler, Grill und die Hälfte der runden Scheinwerfer. Hinten wächst die Stoßstange, die eine Einheit mit Rückleuchten und Kennzeichenhalter bildet, bis zur Heckklappe. Sämtliche Details sind aus Kunststoff und grafisch gekonnt inszeniert: runde Türgriffe, pyramidale Rückspiegel und, asymmetrisch auf der

l'adoptent. Saab et Volvo l'utilisent pour renforcer aux yeux des consommateurs leur image de constructeurs soucieux de sécurité. La Golf, elle-aussi, sera équipée d'un gros pare-choc foncé, avant que les autres modèles de la marque ne suivent. Le plastique plaît. Anticonformiste comme à son habitude, Renault joue dans la provocation avec la R5 et son pare-choc intégral en plastique strié gris clair. Dans la Citroën Visa, le pare-choc croît jusqu'à intégrer toute la calandre. À l'intérieur, un tableau de bord et des satellites à l'ergonomie futuriste sont sculptés dans le plastique. Le pare-choc de la Seat Sport englobe également toute la calandre, idem sur la Ferrari 365 GTC/4 et à peu de choses près sur la Lancia Beta Montecarlo. La Fiat Ritmo ose un pare-choc de couleur foncée qui intègre à l'avant la calandre, le spoiler et la moitié des phares ronds et englobe à l'arrière toute la partie allant des phares, au support de la plaque d'immatriculation et au hayon.

Ferrari 365 GTC/4 *Il Gobbone*, 1971

Mercedes-Benz 500 SL, 1981

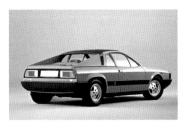

Lancia Beta Montecarlo, 1975

ple's darling: whether it was attached to the front, the rear or everywhere; the rubber lip gave every car a sporty note—even the Mercedes-Benz SL. From here on in, the application of black plastic—unbelievable, but true—will be considered *über*-cool. A design trend that saved many a car manufacturer's life.

Motorhaube gelegen, ein dreiteiliger Lufteinlass. Der phantastische Plastik-Look entwickelt sich zum Muss. Als Publikumsliebling entpuppt sich der aus dem Rennsport geerbter Spoiler: Egal ob vorne, hinten oder überall, die Gummilippe verleiht jedem Wagen eine sportliche Note – selbst im Mercedes-Benz SL gilt die Applikation als supercool.

Les nombreux éléments en plastique sont mis en scène avec beaucoup d'habileté : les poignées de porte sont rondes, les rétroviseurs en forme de pyramide, et la prise d'air en trois parties est montée à l'asymétrique sur le capot. Le look plastique est fantastique, c'est un véritable *must*. L'élément décoratif préféré du public est le spoiler en caoutchouc hérité des rallyes automobiles. À l'avant, à l'arrière ou ailleurs, cette lèvre en caoutchouc donne un air sportif à toutes les voitures – même la Mercedes-Benz SL s'y met. Et ce n'est pas tout : la tendance plastique va se révéler salvatrice pour bien des constructeurs.

Porsche 911 Turbo, 1974

Seat 1200 Sport Coupé *Bocanegra*, 1975

Fiat Ritmo, 1978

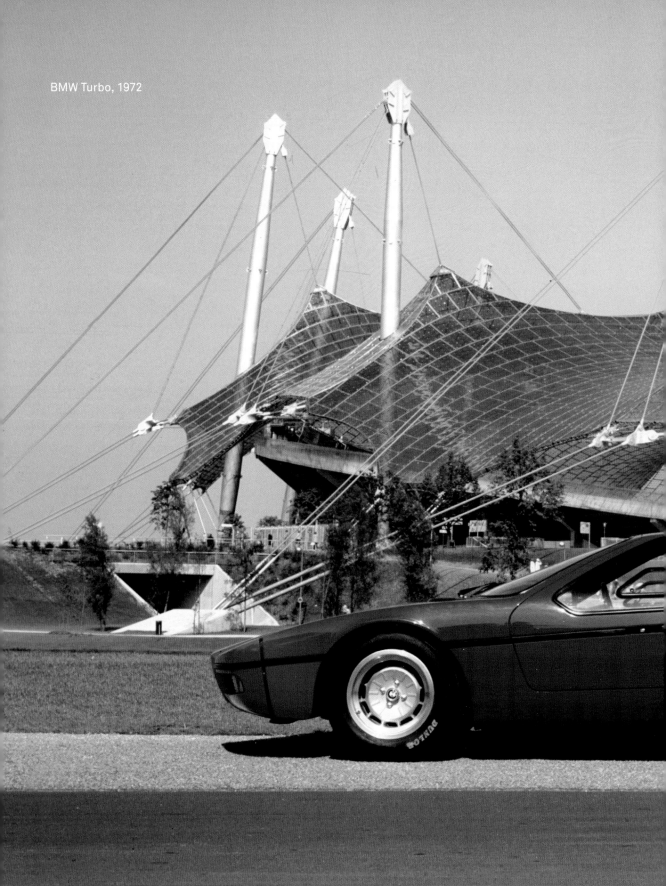

BMW Turbo, 1972

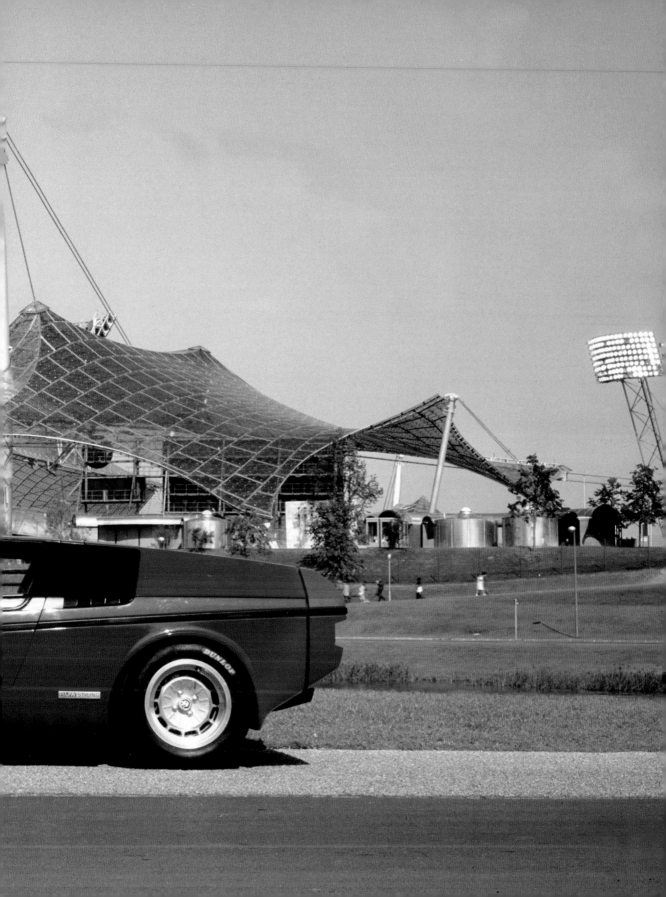

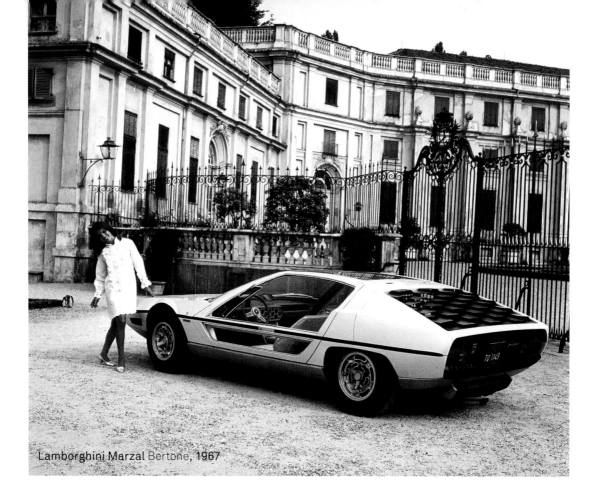

Lamborghini Marzal Bertone, 1967

MARCELLO GANDINI

Following an argument, Giugiaro left Bertone at the end of 1965. Gandini took over and quickly finished Giugiaro's Miura. Next up, after a brief pause for breath, is his Marzal. Gandini was just 29 years old, his creations a manifesto of occultism. He composed spatial architectures, tailored geometries, graphically structured surfaces and combined lucency with black holes. He was strictly averse to tradition and habit. He anticipates the future with a styling from the fourth dimension: his forms are never static, but constantly changing. He is the new avant-gardist.

Im Streit verlässt Giugiaro Ende 1965 Bertone. Gandini kommt und bringt schnell den Miura zu Ende. Nach einer kurzen Atempause folgt sein Marzal. Gandini ist erst 29, sein Werk ein Manifest der Geheimwissenschaft. Er komponiert Raumarchitekturen, schneidet Geometrien, strukturiert Oberflächen grafisch, verbindet Transparenz mit schwarzen Löchern. Tradition und Gewohnheit lehnt er strikt ab. Er antizipiert die Zukunft mit einer Gestaltung in der vierten Dimension: Seine Formen sind nie statisch, sondern verändern sich permanent. Er ist der neue Avantgardist.

En conflit avec Bertone, Giugiaro le quitte fin 1965. Arrive Gandini qui termine vite la Miura de Giugiaro. Avec avoir un peu soufflé, il dessine la Marzal. Gandini n'a que 29 ans, son œuvre est le manifeste d'une science qu'il garde secrète. Il compose des architectures spatiales, travaille sur la géométrie, structure graphiquement les surfaces, associe transparence et trous noirs. Il refuse catégoriquement tradition et routine. Il anticipe sur l'avenir avec des constructions à la quatrième dimension : ses formes ne sont jamais figées, mais se transforment en permanence. Le nouveau designer d'avant-garde, c'est lui.

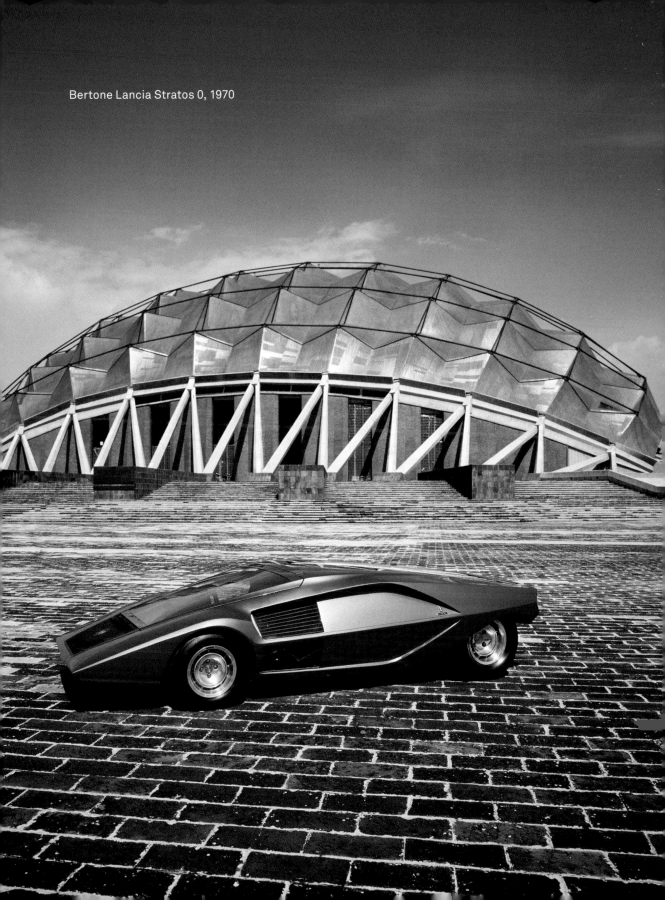

Bertone Lancia Stratos 0, 1970

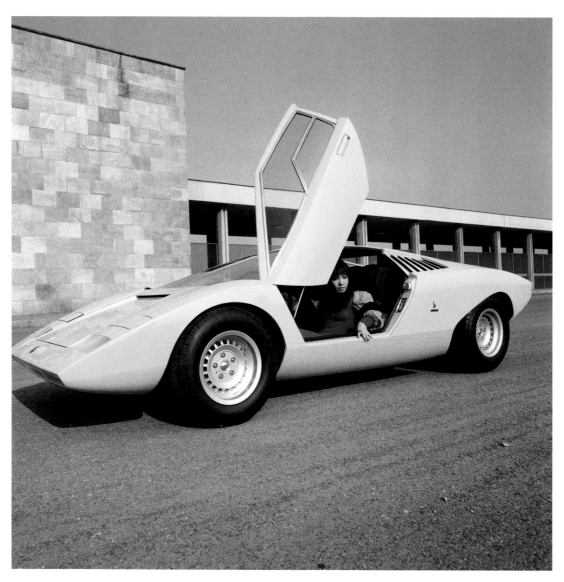

Lamborghini Countach Bertone, 1971

The Countach presented the supercar in its final form. Extraterrestrial and theatrical, like its doors, which, surprisingly, open upwards.

Der Countach verleiht dem Supercar seine endgültige Form. Außerirdisch und theatralisch wie seine Türen, die überraschend nach oben öffnen.

C'est la Countach qui donne sa forme définitive à la supercar. Elle est extra-terrestre et théâtrale à l'image de ses portes « coléoptères » qui s'ouvrent curieusement vers le haut.

BERTONE

The antagonism between Bertone and Pininfarina was boosting the quality of Italian automotive design. Nuccio Bertone was certainly capable of producing elegant designs, but he also liked to experiment just as much and simply thrived on provocation. He was helped by his fine nose for trends and three successive star designers: Scaglione, Giugiaro and Gandini. At the end of the sixties, Bertone proclaimed a revolution: his wedge shape was an act of violence that radically changed the automobile. The Countach, Stratos and X1/9 enthroned the revolutionary as King of the Seventies.

Der Antagonismus zwischen Bertone und Pininfarina treibt die Qualität italienischen Automobildesigns in den Höhe. Nuccio Bertone kann elegant gestalten, experimentiert aber genauso gerne und liebt die Provokation. Dabei helfen ihm ein feiner Riecher für Trends und drei aufeinanderfolgende Stardesigner: Scaglione, Giugiaro, Gandini. Ende der Sechziger proklamiert Bertone dann die Revolution: seine Keilform ist ein Gewaltakt, der das Automobil radikal verändert. Countach, Stratos und X1/9 inthronisieren den Revoluzzer zum König der Siebziger.

L'antagonisme entre Bertone et Pininfarina fait exploser la qualité du design automobile italien. Nuccio Bertone est un carrossier élégant mais qui aime tout autant l'expérimentation que la provocation. Il sera servi par une exceptionnelle capacité à capter l'air du temps et par ses trois designers stars successifs : Scaglione, Giugiaro et Gandini. À la fin des années soixante, Bertone opère un revirement complet : la forme en coin change brutalement et radicalement l'automobile. La Countach, la Stratos et la X1/9 consacrent le révolutionnaire Bertone roi des années soixante-dix.

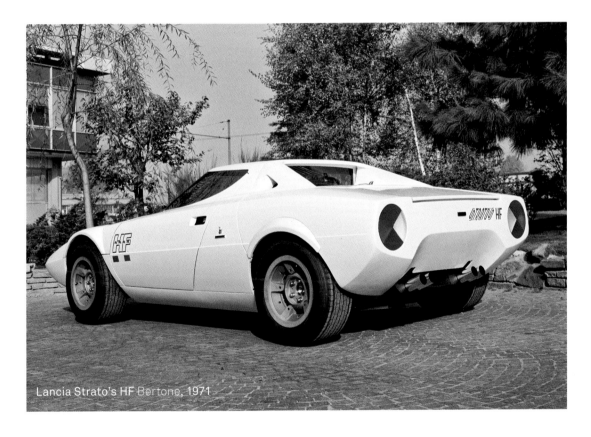

Lancia Strato's HF Bertone, 1971

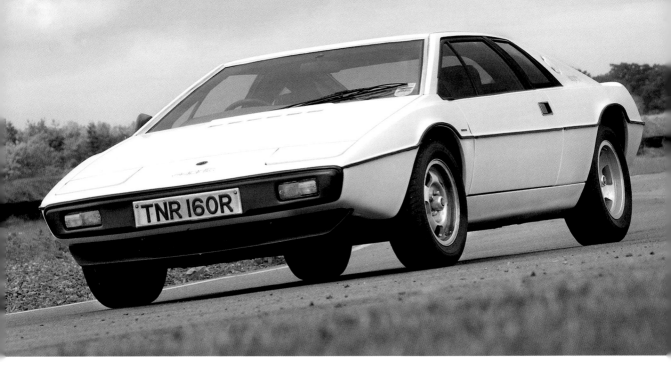

Lotus Esprit S1, 1976

LOTUS

Encouraged by its success in Formula 1, in the seventies, the British sports car manufacturer decided to enter the upper echelons of the automotive market. The superlight philosophy of yore was missing from the Esprit, which instead offered the most elegant wedge shape of all time: "styled by Giugiaro". The daring move pays off, so that, in 1977, even James Bond turns up in a white S1. Thanks to the Esprit-Eclat-Excel trilogy, Lotus is soon the name on everyone's lips. But suddenly, Colin Chapman, the company's founder, disappeared. Is he really dead? That is the topic of yet another myth.

Ermutigt durch den Formel-1-Erfolg, wagt die britische Sportwagenschmiede in den Siebzigern den Schritt in die Oberliga. Die Superleicht-Philosophie der früheren Konstruktionen findet man im Esprit vergeblich, dafür gibt es die eleganteste Keilform aller Zeiten – aus Italien, „styled by Giugiaro". Der mutige Schritt wird belohnt, 1977 taucht selbst James Bond im weißen S1 auf und ab. Mit der Trilogie Esprit-Eclat-Excel ist Lotus bald in aller Munde. Doch plötzlich verschwindet Firmengründer Colin Chapman. Ob er wirklich tot ist? Das ist Gesprächsstoff für einen weiteren Mythos.

Encouragée par son succès en Formule 1, l'écurie de sport britannique tente sa chance dans la cour des grands. La super-légèreté, philosophie des constructions antérieures, n'inspire plus ses modèles ; on y trouve par contre, venue d'Italie, « styled by Giugiaro », la ligne en coin, plus élégante que jamais. L'audace est récompensée ; en 1977 même James Bond apparaît de temps à autre dans une S1 blanche. Lotus est bientôt dans toutes les bouches, associée à Esprit-Éclat-Excel. Mais brusquement Colin Chapman, le fondateur de la firme disparaît. Est-il vraiment mort? De quoi alimenter un autre mythe.

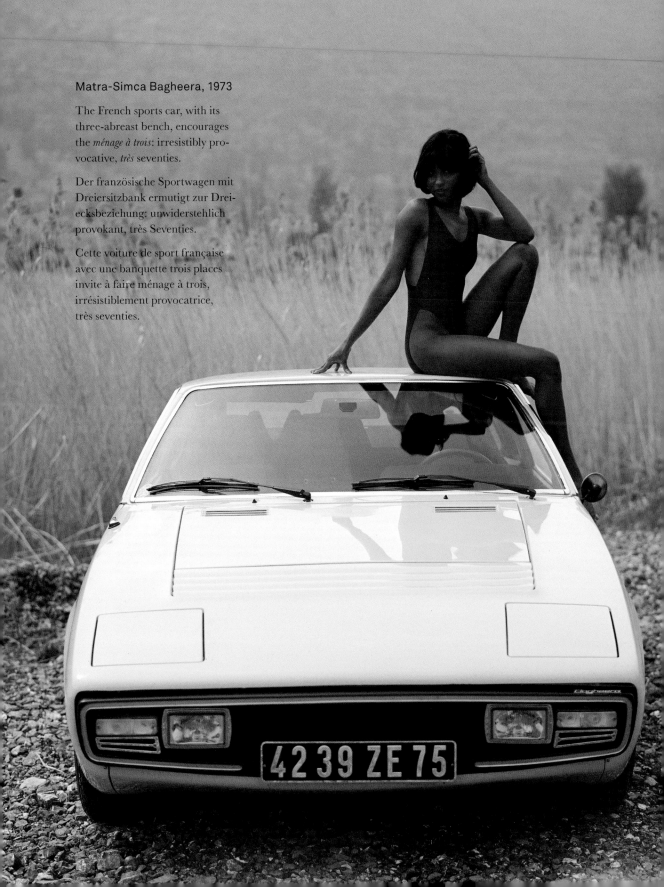

Matra-Simca Bagheera, 1973

The French sports car, with its
three-abreast bench, encourages
the *ménage à trois*: irresistibly pro-
vocative, *très* seventies.

Der französische Sportwagen mit
Dreiersitzbank ermutigt zur Drei-
ecksbeziehung: unwiderstehlich
provokant, très Seventies.

Cette voiture de sport française
avec une banquette trois places
invite à faire ménage à trois,
irrésistiblement provocatrice,
très seventies.

42 39 ZE 75

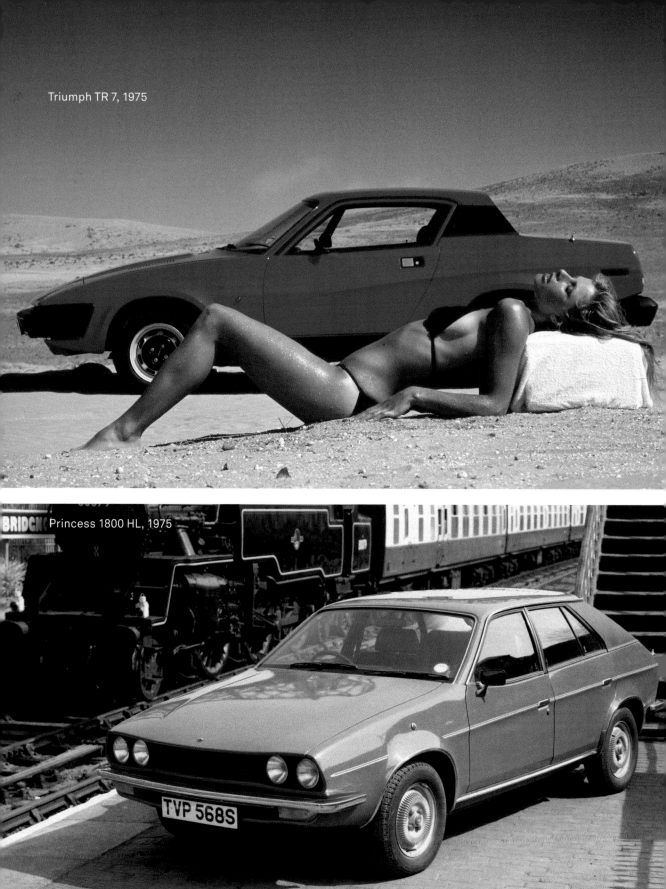

Triumph TR 7, 1975

Princess 1800 HL, 1975

TVP 568S

MANN & TOWNS

With just a bit of luck, Harris Mann and William Towns, chief designers at BMC and Aston Martin, respectively, could have gone down in history as visionaries. In the middle of the 1970s, they dared to do the unthinkable: to revolutionise the dusty, conservative image of the British automobile. In the end, both failed with their radical approaches, and the entire industry with them. No matter which judgement is ultimately delivered on the Princess and Allegro, the Triumph TR7 and the Aston Martin Lagonda and Bulldog, their style, somewhere between Wedge Cut, *Clockwork Orange* and Buckingham Palace, expresses a powerful, singular personality.

Mit etwas Fortune hätten Harris Mann und William Towns, Chefdesigner von BMC, respektive Aston Martin, als Visionäre in die Geschichte eingehen können. Mitte der 1970er wagen sie das Unvorstellbare: das angestaubte, konservative Image des britischen Automobils zu revolutionieren. Letztlich scheitern sie mit ihren radikalen Ansätzen, und die gesamte Industrie mit ihnen. Die mutigen Früchte der britischen Designrevolution werden eher als Kuriositäten, denn als Vorreiter angesehen. Egal wie das Urteil ausfällt: Der Stil von Princess und Allegro, Triumph TR7, Aston Martin Lagonda und Bulldog, zwischen Wedge Cut, *Clockwork Orange* und Buckingham Palace, drückt eine kraftvolle, singuläre Persönlichkeit aus.

Avec un peu de chance, Harris Mann et William Towns, stylistes en chef chez BMC et chez Aston Martin auraient pu entrer dans l'histoire comme deux visionnaires. Ils s'attaquent en effet à l'impossible : dépoussiérer complètement l'image conservatrice de l'automobile britannique. Malheureusement ils échouent dans leur projet radical et avec eux l'industrie toute entière. Leurs audaces apparaissent plutôt comme des curiosités que comme des tendances novatrices. Peu importe les jugements portés sur la Princess et l'Allegro, la Triumph TR7, l'Aston Martin Lagonda et la Bulldog : elles ont toutes, par leur style situé entre la coupe angulaire, *Orange mécanique* et Buckingham Palace, une forte personnalité et une indéniable singularité.

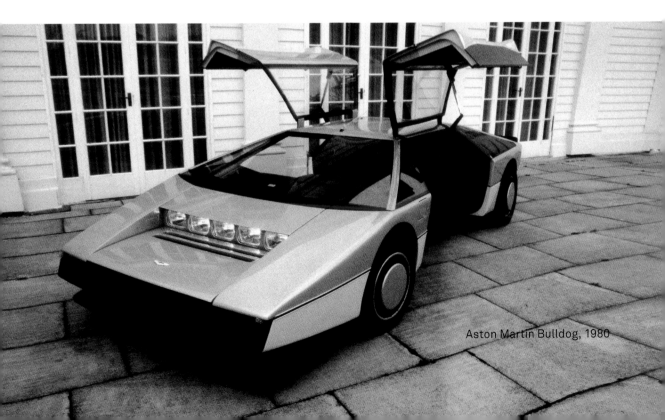

Aston Martin Bulldog, 1980

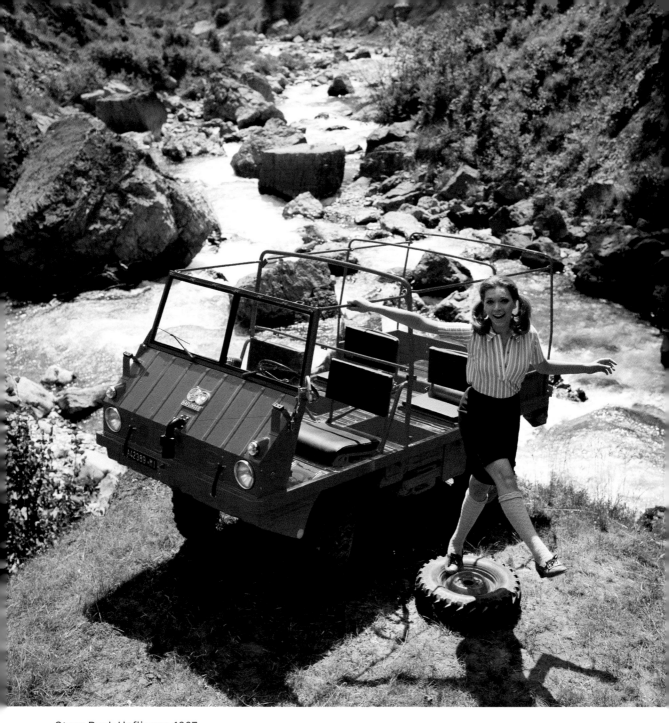

Steyr-Puch Haflinger, 1967

The rediscovery of nature, holidays and leisure time is part of the laid-back lifestyle of the seventies: small, colourful fun vehicles are becoming popular.

Die Wiederentdeckung der Natur, Urlaub und Freizeit gehören zum ungezwungenen Lebensstil der Siebziger: Kleine bunte Spaßmobile werden zum Sympathieträger.

La redécouverte de la nature, les congés et le temps libre font partie du style de vie des années soixante-dix : il y a un potentiel de sympathie pour les petits véhicules plaisir.

Austin Mini Moke, 1966

Autobianchi A112 Giovani Pininfarina, 1973

Austin Mini Clubman, 1972

Citroën 2CV France 3, 1983

Innocenti Mini 120, 1974

Citroën Dyane 6, 1980

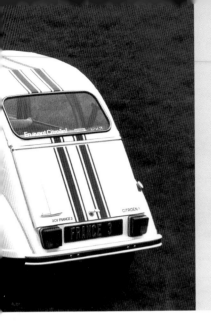
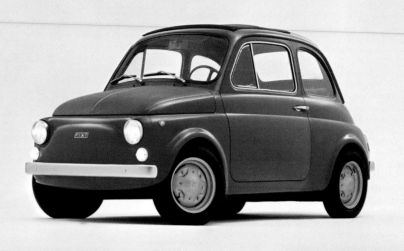

Fiat 500 R *Rinnovata*, 1972

Moving from round to square. Round headlights and soft curves are out. By putting on some sharp-edged, fashionable clothes, the people's classics, such as the Mini, the 2CV and the Cinquecento, were able to reinvent themselves.

Das Runde geht ins Eckige. Rund-scheinwerfer und sanfte Kurven sind völlig out. Durch modische Kleider mit Ecken und Kanten erfinden sich Volksklassiker wie Mini, Ente und Cinquecento neu.

On passe de l'arrondi à l'angle aigu. Finis les phares ronds et les courbures douces. Pour être dans le vent, les classiques comme la Mini, la 2CV et la Cinquecento se prêtent à un relookage tout en angles et en arêtes.

Fiat 126, 1972

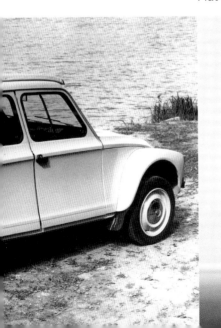

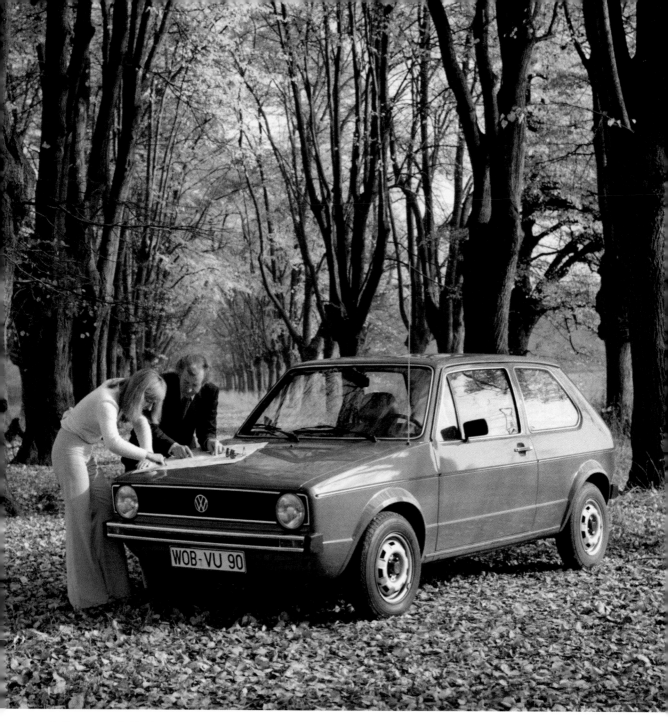

Volkswagen Golf, 1974

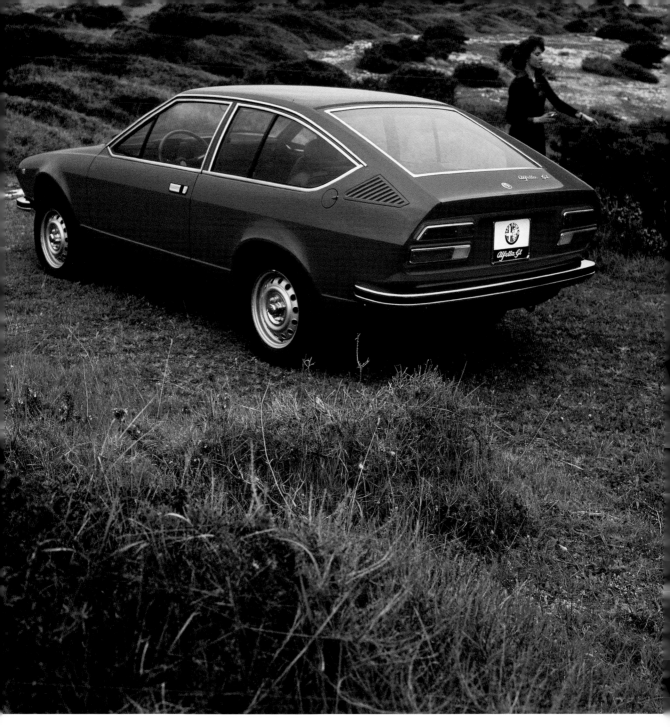

Alfa Romeo Alfetta GT, 1974

GIORGETTO GIUGIARO

At Bertone and Ghia, the Designer of the Century was displaying his talents with style-defining sports cars, ranging from the Alfa Romeo 2600 Sprint, which he drew up at the age of 21, to the De Tomaso Mangusta. At 30, he founded his own Italdesign studio and developed a passion for the automobile of the middle classes. His debut, the Alfasud, is ingenious. With the Scirocco and Golf, he lent Volkswagen a new image: these are icons of unpretentiousness and, at the same time, designs of unbelievable substance. In the process, he employed an uncompromisingly technical language that led him to a new automotive concept: rational architecture on wheels. Based on economic principles, the car grew in height, offering more, while simultaneously occupying less space. As a logical consequence of Ford's model T and the Citroën

Bei Bertone und Ghia offenbart der „Designer des Jahrhunderts" mit stilprägenden Sportwagen, vom Alfa Romeo 2600 Sprint, den er im Alter von 21 Jahren zeichnet, bis zum De Tomaso Mangusta, sein Talent. Mit 30 ist er selbstständig und entdeckt seine Leidenschaft für das bürgerliche Automobil. Sein Debüt heißt entsprechend Alfasud, ist raffiniert und vielleicht ein wenig modisch. Mit Scirocco und Golf gibt er Volkswagen ein neues Image: Ikonen der Bescheidenheit, gleichzeitig aber Designs mit unglaublicher Substanz. Dabei übt er eine kompromisslos technische Sprache, die ihn zu einer neuen Konzeption des Automobils führt: rationaler Architektur auf Rädern. Nach ökonomischen Prinzipien konstruiert, wächst das Auto in die Höhe, bietet mehr und nimmt dabei weniger Platz in Anspruch.

Chez Bertone et Ghia, le « designer du siècle » fait la preuve de son immense talent en dessinant des voitures de sport de grand style, de l'Alfa Romeo 2600 Sprint – qu'il dessine à l'âge de 21 ans – jusqu'à la De Tomaso Mangusta. À 30 ans il se met à son compte et découvre sa passion pour la voiture bourgeoise. Il débute avec un véhicule baptisé Alfasud, une voiture raffinée et un peu mode. Avec la Scirocco et la Golf, il imprime à Volkswagen une nouvelle image : archétype de la modestie, mais en même temps très design et incroyablement musclée. Son intransigeance sur le plan

2CV, the Fiat Panda was the last real people's car and Giugiaro's masterpiece. In the eighties, Giugiaro proved himself to be a master of aerodynamics with the Fiat Uno and Lancia Thema. Due to their perfect balance of practicality and style and usefulness and performance, his creations embody the absolute culmination of automotive design.

Als logische Konsequenz aus Ford T und Citroën 2CV ist der Fiat Panda der letzte wahre Volks-Wagen und Giugiaros Meisterwerk. Als Meister der Aerodynamik erweist Giugiaro sich in den Achtzigern mit Fiat Uno und Lancia Thema. Aufgrund ihrer perfekten Balance aus Sachlichkeit und Stil, Nutzwert und Leistung stellen seine Kreationen den absoluten Höhepunkt des Automobildesigns dar.

technique l'amène à changer de conception et à s'orienter vers une architecture totalement rationnelle. Construite selon des principes économiques, la voiture croît en hauteur, accroît ses possibilités et prend moins de place. S'inscrivant dans la suite logique de la Ford T et de la 2CV Citroën, la Fiat Panda est la dernière vraie voiture populaire et le chef d'œuvre de Giugiaro. Dans les années quatre-vingt, Giugiaro devient champion de l'aérodynamisme avec la Fiat Uno et la Lancia Thema. Ses créations représentent le summum du design automobile : équilibre parfait entre sobriété et style, utilité et performance.

Fiat Panda, 1980

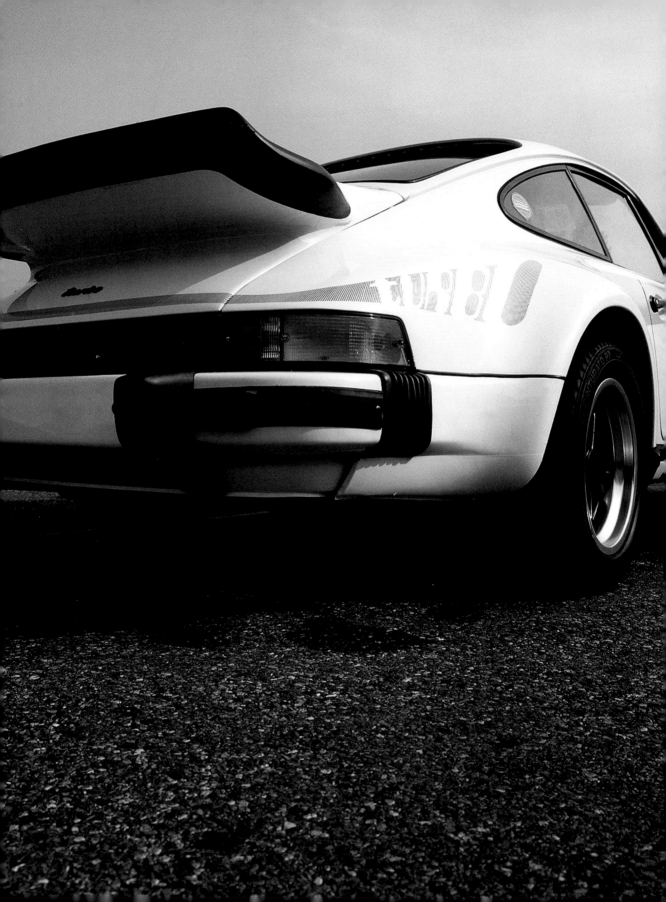

COSMETIX

The joy of driving ended abrubtly in October 1973. The Yom Kippur War initiated a protracted conflict, and OPEC took the decision to limit oil production. Car-free Sundays, speed limits and deprivation ensue. Europe was facing an even bigger problem: terrorism. The Red Army Fraction's implementation of *The Urban Guerilla Concept* in 1971 led to kidnapping, armed robberies and assassinations. The group's main target was the political and economic establishment—and their cars. The terrorists' symbolism was incisive: RAF leader Andreas Baader would drive a Porsche Targa, stolen from Formula 1 photographer, Rainer Schlegelmilch, while going about his business. In 1978, Italian prime minister Aldo Moro was taken hostage straight from the rear seat of a dark blue

Die „Freude am Fahren" endet im Oktober 1973. Mit dem Jom-Kippur-Krieg beschließt die OPEC eine Einschränkung der Erdölförderung. Es folgen auto-freie Sonntage, Tempolimits, Entbehrungen. Europa hat noch ein größeres Problem: den Terrorismus. Als die Rote Armee Fraktion 1971 beginnt, „Das Konzept Stadtguerrilla" in die Tat umzusetzen, hat das Entführungen, Raubüberfälle und Mordanschläge zur Folge. Im Visier stehen Mitglieder des politischen und wirtschaftlichen Establishments – und ihre Autos. Die Symbolik der Terroristen ist pointiert: RAF-Anführer Andreas Baader fährt dienstlich einen Porsche Targa, den er dem Formel-1-Fotografen Rainer Schlegelmilch gestohlen hat. 1978 wird der italienische Ministerpräsident Aldo

Le plaisir de conduire cesse en octobre 1973. La guerre de Kippour marque le début d'un long conflit, l'OPEP décide de réduire la production de pétrole. S'en suivent les interdictions de circuler les dimanches, les limitations de vitesse et autres restrictions. Pire encore, l'Europe voit s'abattre sur elle un fléau des plus préoccupants : le terrorisme. En 1971, la Fraction armée rouge met en pratique son « concept de guérilla urbaine », suivi d'une vague d'enlèvements, de braquages et de meurtres. Elles a pour cibles les membres de l'establishment politique et économique – et leurs voitures. Toute une symbolique, des plus percutantes, est mise en place : En 1978, le Président du conseil des ministres italien, Aldo Moro, est assis à l'arrière de sa Fiat 130

Porsche 911 Turbo, 1975

Spoiler and flared wings are the automobile's new make-up.

Spoiler und Kotflügelverbreiterung sind die neue Schminke des Automobils.

L'automobile se refait une beauté avec spoiler et ailes élargies.

Fiat 130. Some 55 days later, the Red Brigades handed over his corpse, inside the boot of a red Renault R4. Nobody dared drive a conspicuous car anymore. Middle class family saloons were armoured and some millionaires would, occasionally, hide in VW Beetles. The car as a symbol of freedom was replaced by the car bomb as a symbol of terror. In 1973, The Club of Rome published its study, *The Limits to Growth*. The end of the automotive era seemed to be drawing near.

BOMBSTER

The images of empty motorways during the car-free Sundays, the continuing consumer reticence, as well as wildcat strike action at the factories, caused the European car industry to grind to a halt. The ultimate economy mobile was needed to save the day. Cheap to produce, cheap to run: that way, the downfall should be averted. So, starting in 1975 Volkswagen started to build the

Moro von der Rückbank seines dunkelblauen Fiat 130 weg entführt. 55 Tage später übergeben die Roten Brigaden seine Leiche: im Kofferraum eines roten Renault R4. Mit auffälligen Autos traut sich nun keiner mehr auf die Straße. Bürgerliche Familienlimousinen werden gepanzert, und mancher Millionär versteckt sich gar im Käfer. Aus dem Automobil als Freiheitssymbol wird das Terrorsymbol der Autobombe. Der Club of Rome veröffentlicht 1973 die Studie *Die Grenzen des Wachstums*. Dazu passend präsentiert Porsche die Idee des Langzeitautomobils: robust, sparsam, wartungsfrei, für die Ewigkeit gebaut. Doch daraus wird nichts. Das Ende des automobilen Zeitalters scheint nah.

BOMBSTER

Die Bilder von leeren Autobahnen, die anhaltende Kaufzurückhaltung sowie die wilden Streiks in den Fabriken bringen die europäische Automobilindustrie

bleu marine lorsqu'il est enlevé. 55 jours plus tard, les brigades rouges rendent son corps dans le coffre d'une Renault 4 rouge. Personne n'ose plus prendre la route dans des voitures trop voyantes. On blinde les berlines familiales bourgeoises et certains millionnaires préfèrent rouler en coccinelle pour ne pas se faire remarquer. Du symbole de liberté qu'elle était, la voiture devient synonyme de terrorisme et de voiture piégée. Le Club de Rome publie en 1973 une étude intitulée *Les limites de la croissance*. Et Porsche lance, bien à propos, l'idée de la voiture durable qui serait solide, économique, à entretien minimal et construite pour l'éternité. Cette voiture, cependant, ne verra pas le jour. L'époque du tout voiture touche à sa fin.

ÂME DE BOLIDE

Les images d'autoroutes vides, la retenue persistante des consommateurs et les grèves sauvages

Talbot-Sunbeam Lotus, 1979

Renault R5 Alpine, 1976

Polo. Fiat had already commissioned Giugiaro to design a rugged all-rounder, the Panda. Small cars were socially acceptable and in keeping with the Zeitgeist. Then, the manufacturers identified a niche: since big cars with big engines were *passé*, they began to put big engines into small cars. Thanks to its injection engine and its 110 HP, the Golf GTI offered plenty of potency under its classless cloak. In 1977, Saab converted the 99 Combi Coupé to turbo power: the passer-by saw Middle class, the driver got 145 HP. But Sunbeam was about to leap into the lead with the Talbot Lotus: 150 HP propelling only 3.8 metres of car. In 1980, Audi's Quattro ignited the afterburner. What looked for all the world like an unremarkable derivative of the Audi 80 was actually a bomb with a turbo engine and permanent all-wheel drive. Spoiler, alloy wheels and discreet war paint—matte black with silver or red accents—were part of the standard look of the 'bombster'. Fuel

zum Stillstand. Der ultimative Sparwagen soll es richten: günstig zu produzieren, günstig zu fahren. Volkswagen baut ab 1975 den Polo. Kleine Autos sind sozialverträglich und passen gut in den Zeitgeist. Dann entdecken die Hersteller eine Lücke: Da große Autos mit großen Motoren aus der Mode sind, bauen sie nun große Motoren in kleine Autos ein. Dank Einspritzmotor und 110 PS hat der Golf GTI mächtig Kraft unter seinem klassenlosen Gewand. Saab stellt 1977 das 99 Combi Coupé auf Turbokraft um: Der Passant sieht Mittelklasse, der Fahrer spürt 145 PS. Sunbeam setzt sogleich mit dem Talbot Lotus zum Überholen an: 150 PS, verteilt auf 3,80 Meter Auto. Audi zündet 1980 mit dem Quattro den Nachbrenner. Was wie ein unauffälliges Derivat des Audi 80 aussieht, ist eine Granate mit Turbomotor und permanentem Allradantrieb. Spoiler, Leichtmetallfelgen und eine dezente Kriegsbemalung – mattschwarz mit silbernen oder roten Akzenten –

dans les usines entraînent le ralentissement de l'industrie automobile européenne. Dans cesconditions, l'ultime solution semble être la voiture économique, que l'on peut produire à moindre coûts et rouler à moin-dres frais. En 1975, en réponse à ce phénomène, Volkswagen sort la Polo. Les petites voitures ont la cote ; sociales, elles correspondent tout à fait à l'esprit de l'époque. Les constructeurs découvrent alors une nouvelle niche : les grosses cylindrées étant passées de mode, ils équipent des petites voitures de moteurs hyperpuissants. La Golf GTI, malgré une allure passe-partout sans appartenance à une classe sociale définie, déploie une sacrée puissance avec son moteur à injection et ses 110 ch. Saab présente en 1977 un combi coupé à turbocompresseur, le 99 : si le passant voit en elle un véhicule moyenne gamme, le conducteur, lui, assis sur 145 ch vrombissants ne s'y trompe pas. Mais voilà que sur la file de gauche, prête à doubler, pointe déjà la Talbot Lotus

Volkswagen Golf GTI, 1976

Lancia Delta 1.6 HF Turbo, 1983

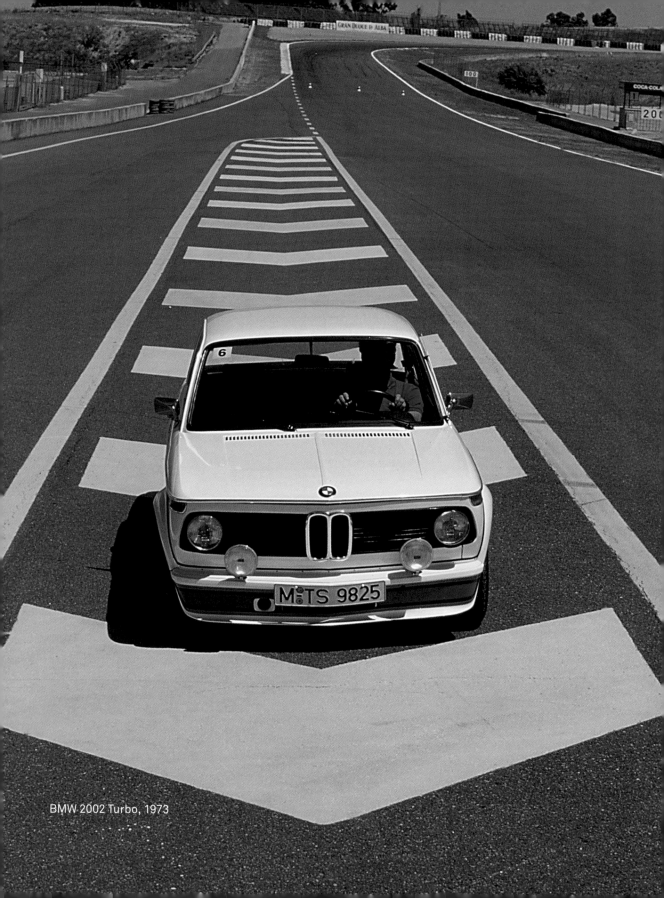

BMW 2002 Turbo, 1973

injection, turbocharger and four-wheel drive gave the car enthusiast the hots. And these ingredients could be put into almost any car without too much hassle. These discreet bruisers liked to wear black, both as camouflage and to stand out from the more colourful standard models, just like luxury limousines: status symbolism meets understatement. And yet, despite their grim colouring, the bombsters caused a pleasant display of fireworks, for they injected a new, badly needed appeal into the market and thus helped keep the automobile alive.

BODY LIFTING

Recession and inflation were the results of the crisis. Hardly any manufacturer could afford to finance expensive new developments anymore. Therefore, the industry made do with what it already had. Automotive design was entering its most bizarre—and possibly saddest—phase: the era of plastic surgery. The look of

gehören zum Standardlook der Bombster. Benzineinspritzung, Turbolader und Vierradantrieb machen den Autofan heiß. Und diese Ingredienzien können ohne großen Aufwand in beinahe jedes Auto eingebaut werden. Um sich zu tarnen und von den bunten Standardmodellen abzuheben, tragen die dezenten Kraftmeier am liebsten Schwarz, im Stil der Luxuslimousinen: Statussymbolik trifft Understatement. Trotz düsterer Farbgebung sorgen die Bombster für ein erfreuliches Feuerwerk, denn sie verleihen dem Markt den dringend benötigten, neuen Reiz.

BODYLIFTING

Auf die Krise folgen Rezession und Inflation. Kaum ein Hersteller ist in der Lage, teure Neuentwicklungen zu finanzieren. Daher macht die Industrie mit dem weiter, was sie hat. Das Automobildesign geht in seine skurrilste und möglicherweise traurigste Phase über – die der Schönheitsopera-

de Sunbeam : 150 ch pour 3,80 mètres de châssis. Puis, c'est Audi qui avec la Quattro en 1980 met le feu aux poudres en adoptant le principe de post combustion. Spoiler, jantes en alliage léger et peintures de guerre discrètes – noires mat avec des touches de rouge ou de gris argenté – sont les attributs standards de ces bolides. Viennent ensuite les moteurs à injection, turbocompresseur et transmission intégrale, dont le fana de voiture raffole, d'autant que ce sont des éléments simples à monter sur la quasi-totalité des véhicules. Pour se camoufler et se démarquer de la masse colorée des voitures standards, ces frimeuses vrombissantes choisissent volontiers une couleur décente, le noir, dans le style des limousines de luxe. Symboles de prestige, elles maîtrisent aussi l'art de l'understatement. Malgré leur couleur sombre, ces voitures d'un nouveau type sont un feu d'artifice d'idées et de créativité sur un marché de l'automobile en manque de stimulants.

Matra-Simca Bagheera Courrèges, 1974

Peugeot 205 Lacoste, 1984

Autobianchi Y10 Fila, 1985

older cars was 'spiced up' via cosmetic means. The simplest way of achieving this was by asking fashion designers for help. The reason behind this was the discovery of the magic of the brand during the seventies: Lacoste, Louis Vuitton, Gucci and Fendi all gained prestigious identities by prominent logo placement. The customer willingly became brand ambassador. While Giorgio Armani was launching the first fashion jeans in 1981 and Calvin Klein was offering the first branded underpants, Alfa Romeo tried its luck with the Alfasud Valentino, featuring copper metallic paintwork with black roof and gilt wheel rims. Matra Bagheera Courrèges, Peugeot 205 Lacoste and Autobianchi Y10 Fila also created a countermovement to the black-on-black bombsters: the white-on-white car. Only Lotus' JPS look remained unique. The cigarette pack's black with gold detailing created a striking colour trend, which could be seen on anything, ranging from Formula 1 race cars

tionen. Mit kosmetischen Mitteln peppt man den Look altbekannter Modelle auf. Am einfachsten funktioniert das, indem man einen Modedesigner zur Hilfe ruft. In den Siebzigern wird gerade die Magie der Marke entdeckt: Lacoste, Louis Vuitton, Gucci und Fendi verschaffen sich, dank prominent platzierter Logos, prestigeträchtige Identitäten. Der Kunde wird freiwillig zum Markenbotschafter. Giorgio Armani lanciert 1981 die ersten Modejeans, Calvin Klein prägt seinen Namen auf Unterhosen. Alfa Romeo versucht es mit dem Alfasud Valentino: in Kupfermetallic mit schwarzem Dach und goldenen Felgen. Matra Bagheera Courrèges, Peugeot 205 Lacoste und Autobianchi Y10 Fila kreieren den Gegentrend zum schwarz-schwarzen Bombster: das weiß-weiße Modeauto. Einzig der JPS-Look von Lotus genießt eine Alleinstellung. Das mit Gold linierte Schwarz der Zigarettenverpackung wird zum eklatanten Farbtrend, der vom Formel-1-

BODY–LIFTING

À la crise succède une période de récession et d'inflation. Le design automobile rentre dans sa phase la plus bizarre et certainement la plus triste, celle de la chirurgie esthétique. Les anciens modèles sont relookés à coup de petits moyens esthétiques. Les constructeurs font souvent appel aux grands couturiers de la mode comme Lacoste, Louis Vuitton, Gucci et Fendi. La magie des marques faisant son apparition dans les années 70, cette solution facile est fort efficace. En 1981, Giorgio Armani lance par ce moyen sa collection de jeans mode et Calvin Klein ses dessous. A contre-courant apparaissent les Matra Bagheera Courrèges, Peugeot 205 Lacoste et Autobianchi Y10 Fila dont le blanc-sur-blanc très à la mode contraste avec le noir-sur-noir des bolides frimeurs. Seul le look JPS de la Lotus est unique en son genre. Le liseré d'or sur fond noir du paquet de cigarettes créera la

Colin Chapman, Lotus JPS Look, 1978

to mopeds. And if cosmetics were not enough, there was always still the optional facelift. This was hardly rocket science, for it mainly meant simply replacing expensive metal components and heavy chrome with cheaper, lightweight, matte black plastics. Massive bumpers also helped in freshening up and making old cars all of a sudden appear modern again. The Italians and the French proved to be masters of this discipline, one which prestigious marques, such as BMW and Mercedes-Benz, sniffishly shied away from. During the eighties, the facelift ethos gained popularity: fundamental plastic surgery consequently ensued. Hence Fiat turned its attention to the eleven year-old 132 saloon and, with the help of new nose and rear, turned it into the Argenta. And Alfa Romeo even equipped its most famous model with oodles of plastic décor: so, in 1983, the Spider gained thick bumpers and a giant rear spoiler. In order to somehow make it sound modern, the result

Wagen bis zum Mofa überall auftaucht. Wenn Kosmetik nicht ausreicht, greift man zum Facelifting. Das ist keine große Kunst, denn meist werden lediglich teure Metallteile durch billigere Kunststoffteile und schweres Chrom durch leichtes Plastik-Mattschwarz ersetzt. Dicke Stoßstangen frischen den Look zusätzlich auf und lassen alte Autos plötzlich modern aussehen. Italiener und Franzosen meistern diese Spezialität, von der sich edle Marken naserümpfend fernhalten. In den Achtzigern greift das Facelifting-Ethos noch tiefer: Fundamentale Schönheitsoperationen sind die Folge. So widmet sich Fiat 1981 der elf Jahre alten 132 Limousine und macht sie, mit neuer Nase und neuem Po, zum Argenta. Alfa Romeo bestückt gar seinen berühmtesten Wagen mit üppigem Kunststoffdekor: Der Spider bekommt 1983 dicke Stoßstangen und einen gigantischen Heckspoiler. Damit es irgendwie modern klingt, nennt man das Ergebnis Aerodinamico. Aus der achtjäh-

tendance. De la Formule 1 à la mobylette, cette combinaison de couleurs se retrouve partout. Et quand les effets cosmétiques ne suffisent pas, les constructeurs ont recours au face-lifting, un remède des plus faciles d'emploi qui consiste à remplacer les pièces de métal chères par des pièces en plastique bon marché et les éléments richement chromés par du plastique noir mat. De gros pare-chocs viennent rafraîchir le look et donnent un air de neuf à de vieux modèles. Les Italiens et les Français excellent en la matière. Heureusement, les marques prestigieuses comme BMW ou Mercedes-Benz ne daignent pas s'aventurer dans pareils sentiers. Dans les années 80, le système du face-lifting s'établit et se transforme en body-lifting total. En 1981, la Fiat 132, vieille de onze ans, devient l'Argenta par opération du nez et de l'arrière-train. Alfa Romeo se laisse aller en 1983 à affubler son plus célèbre modèle, le Spider, d'éléments décoratifs exubérants en plastique, tels un pare-choc

Fiat 132, 1972

Fiat 132 2000, 1977

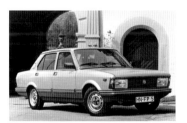

Fiat Argenta, 1981

was given the *Aerodinamico* monicker. In 1985, the eight year-old Giulietta was rechristened as the Alfa 75. The industry only managed to survive this sad decade with lots of bread, love and dreams.

POSTMODERN

After the revolution, a sense of insecurity and, thus, the refusal of any kind of idealism, prevails. In *The Postmodern Condition*, Jean-François Lyotard establishes the thesis of 'end of all great narratives'. To give form to a broken society, one simply falls back on tradition. Old pieces were re-used to compose something new. The result was not a symphony, but rather a disco mix, just like the 1979 Volkswagen Jetta. With its glued-on boot, the Golf had lost its ideal shape and was turned into a 'disco-mix' saloon. This postmodern aesthetic had the vague odour of classicism and rejected any kind of experimentation. As a result, the Citroën Visa

rigen Giulietta 1985 der Alfa 75. Dieses traurige Jahrzehnt überlebt die Branche mit viel *Brot, Liebe und Fantasie*.

POSTMODERNE

Auf die Revolution folgt Unsicherheit und somit die Ablehnung von jeglichem Idealismus. In *Das postmoderne Wissen* formuliert Jean-François Lyotard die These des Endes der großen Erzählungen. Um einer verletzten Gesellschaft Gestalt zu geben, greift man auf die Tradition zurück. Aus alten Teilen wird Neues komponiert. Das Resultat ist keine Symphonie, sondern ein Disco-Mix, wie etwa der 1979er Volkswagen Jetta. Der Golf mit aufgeklebtem Rucksack verliert seine logische Form. Die postmoderne Ästhetik riecht nach Klassik und lehnt jegliche Experimente ab. Der Citroën Visa erhält im Rahmen eines Faceliftings einen traditionellen Grill. Wie auch der Fiat Ritmo, von dem 1983 die Regata Limousine abgeleitet wird: ein Festival der

énorme et un spoiler arrière gigantesque. Et pour faire moderne, le résultat de cette chirurgie est nommé Aerodinamico. En 1984, l'Alfetta devient l'Alfa 90 après douze ans d'âge. Après huit ans, la Giulietta devient l'Alfa 75. L'industrie automobile passera le cap de cette décennie morose grâce à une bonne dose de *Pain, amour et fantaisie*.

POSTMODERNISME

La révolution fait place à une période d'incertitude et de refus de tout idéalisme. Dans *La Condition postmoderne : rapport sur le savoir*, Jean-François Lyotard énonce la thèse de la fin des métarécits. Et pour se ravigoter, cette société en pleine décrépitude se rabat sur la tradition. Les vieilles pièces sont recomposées à neuf. Loin de la symphonie, le résultat sonne plutôt comme un medley disco ; l'exemple type en est la Volkswagen Jetta de 1979. Quant à la Golf, affublée d'un sac à dos, elle perd sa forme logique et de-

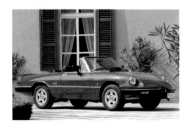

Alfa Romeo Spider *Aerodinamico*, 1983

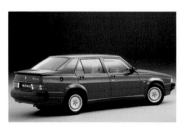

Alfa Romeo 75 3.0i V6 America, 1987

got a sensible grille as part of a face-lift, as did the Fiat Ritmo, which, in 1983, also gained a saloon derivative in the dull shape of the Regata, a patchwork of the banal, adorned with lashings of chrome. But it could—and it did—get even worse. The innovative fastbacks were now reshaped into the good old notchback: Simca's 1307, successful Car of The Year in 1976, accordingly became the Solara. Lancia's Beta was also trimmed: the resulting remains were christened the Trevi, after the historic Roman fountain. In 1981, it was the Saab CombiCoupés turn: the most expensive 900 was, from then on, called the CD Sedan, wearing a sloping rear clearly in discord with the rest of the car. Automotive design as a collage. Fortunately, this turned out to be only a transitional phase: in the background, a change of direction was already in the works.

Banalität, geschmückt mit einer Extraportion Chrom. Die radikalen Fließhecks werden schließlich zum guten, alten Stufenheck zurückgeformt: aus dem Simca 1307, dem erfolgreichen Auto des Jahres 1976, wird 1980 der Solara. Der Lancia Beta wird beschnitten: Das resultierende Überbleibsel nennt sich Trevi – wie der historische römische Brunnen. 1981 ist Saabs Combi-Coupé dran: der teuerste 900 heißt von da an CD Sedan und trägt ein schräg abfallendes, unpassendes Stufenheck. Obgleich das negative Urteil viel zu leicht fällt: Automobildesign als Collage ist eine notwendige Übergangslösung, die vielen Herstellern eine Zukunft sichert.

vient vide de sens. L'esthétique postmoderne a des relents de classicisme et refuse toute expérimentation quelle qu'elle soit. La Fiat Ritmo sert de modèle en 1983 à l'ennuyeuse Regata : une orgie de banalités servie avec une bonne dose de chrome. Finis les fastbacks novateurs, revoilà les tricorps avec leur bon vieux coffre arrière ! La Simca 1307, Voiture de l'année 1976, devient en 1980 Chrysler Solara. La Lancia Beta est édulcorée et donne la Trevi du nom de la célèbre fontaine romaine. En 1981, c'est au tour du Saab Combi-Coupé : la 900, ce modèle de luxe, devient la CD Sedan et se dote d'un hayon oblique disharmonieux. C'est l'art du collage appliqué au design automobile.

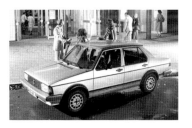

Volkswagen Jetta, 1979

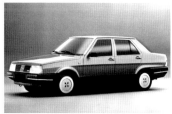

Fiat Regata, 1983

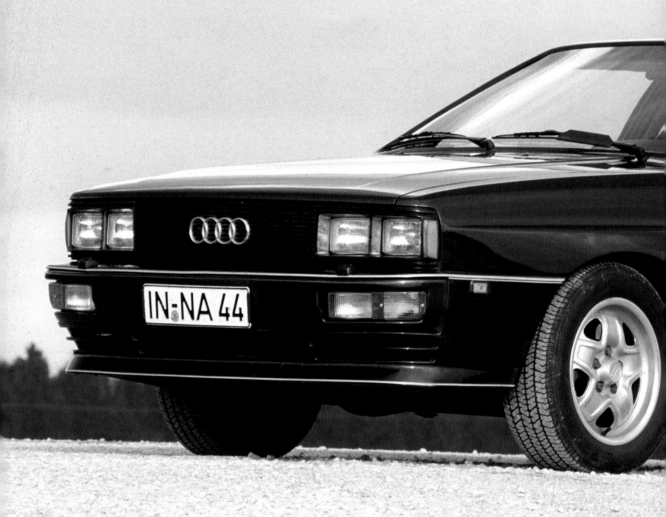

Audi Quattro, 1980

A name promises adventure.
Permanent all-wheel drive, as
introduced by the Range Rover,
became the trademark of the Audi
revolution in 1980. Inspired by the
exotic appeal of the Camel Trophy
and Paris–Dakar, the middle

Ein Name, der Abenteuer ver-
spricht. Der permanente Allrad-
antrieb, den man im Range Rover
kennt, wird 1980 zum Markenzei-
chen der Audi-Revolution.
Beflügelt durch die Exotik von
Camel Trophy und Paris–Dakar,

Un nom synonyme d'aventure. En
adoptant en 1980 la transmission
intégrale permanente réservée
jusque là aux Range Rover, Audi
opère sa révolution et fait de cette
nouveauté technique sa marque de
fabrique. Cette voiture de classe

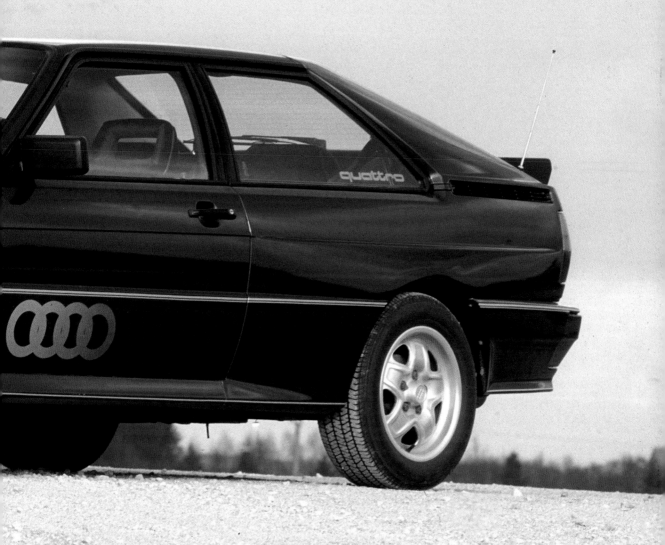

classes were now allowed to adorn themselves with the 4WD moni- cker, ideally in conjunction with Turbo, because that means the next level is *al massimo*, the highest of all frontiers, as sung in San Remo in 1982 by pop artist Vasco Rossi.

darf sich nun auch die Mittelkasse mit dem 4WD-Kürzel schmücken. Am besten gleich mitsamt Turbo, denn dann geht es einfach „al Massimo", an die Höchste aller Grenzen – die Pop-Sänger Vasco Rossi 1982 in San Remo besingt.

moyenne, à qui le Camel Trophy et le Paris–Dakar ont donné des ailes peut se parer désormais du sigle 4WD. Avec turbo, on va « al Massimo », aux limites du possible, comme le chanteur pop Vasco Rossi en 1982.

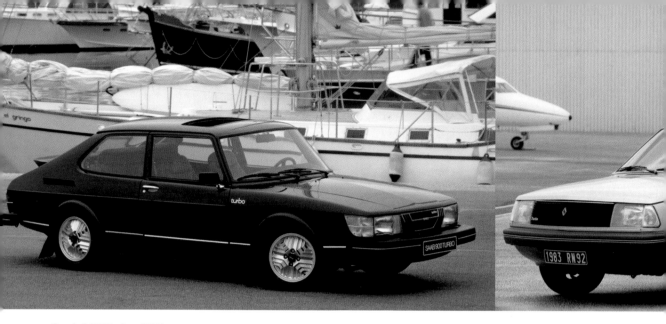

Saab 900 Turbo, 1979

Renault R18 Turbo, 1981

Alfa Romeo Giulietta Turbo Autodelta, 1982

Rover SD1 Vitesse, 1981

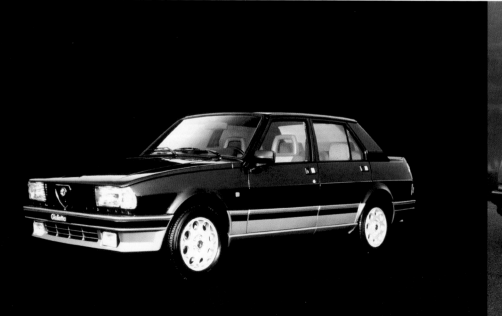

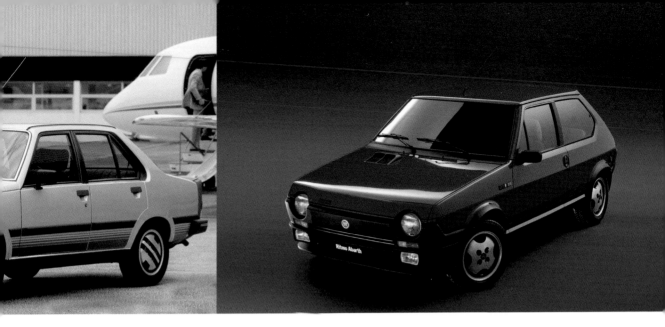

Fiat Ritmo 125 TC Abarth, 1981

The eighties' merry-go-round: silver, black, red, graphical, striped. The 1980s bourgeoisie were seeking a new sense of dynamics with the bombster look.

Achtzigerjahre-Karussell: Silber, Schwarz, Rot, grafisch, gestreift. Die Bürgerklasse der 1980er sucht mit dem Bombster-Look nach einer neuen Dynamik.

Les années 80 sont dominées par le gris métallisé, le noir, le rouge et les motifs géométriques. Avec le look « Bolide », l'automobile bourgeoise cherche un nouveau départ.

Renault R5 Turbo, 1980

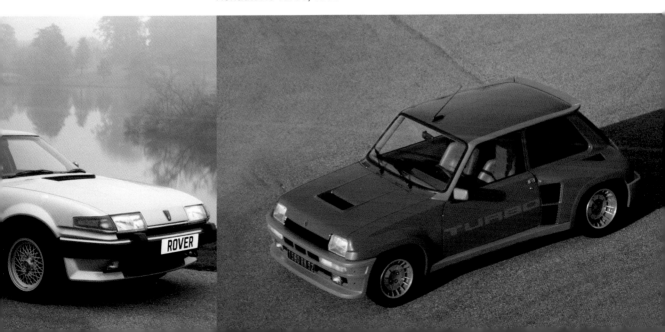

TURBO

The magic word of the eighties elicited hi-tech associations and promised hi-fun. Although it had originally been conceived as a stop-gap to increase automotive potency without having to develop large engines, thanks to Formula 1, the turbo becomes respectable. The small power packs, with their 1.5 litre capacity, reach the magic output of 1,000 hp. The power delivery is hard to tame and made the turbo the right car for *Rambo* and the *Terminator*, the movie idols of the decade. Beyond the turbo

Turbo, Biturbo, Intercooler. Ein Vokabular, das erotischer nicht sein kann. Das Zauberwort der Achtziger weckt Hi-Tech-Assoziationen und verspricht Hi-Fun. Seine schwer zu bändigende Leistungsentfaltung macht den Turbo zum Auto für *Rambo* und *Terminator*, die Filmidole des Jahrzehnts. Jenseits des Turbolochs bekommt das Auto einen schizophrenen Charakter, der perfekt zum Mann der 1980er passt: mal braver Manager Dr.

Turbo, biturbo, intercooler. Un vocabulaire on ne peut plus érotique. Mot magique des années quatre-vingt éveillant des associations high-tech et des promesses high-fun. Conçu à l'origine comme solution de fortune pour augmenter la puissance d'un véhicule, en faisant l'économie de moteurs plus gros, le turbo gagne, grâce à la Formule 1, ses lettres de noblesse. Les petits bolides de 1,5 litre atteignent ainsi la puissance prodigieuse de 1000 ch. En raison de leur tempérament fougueux, les turbos

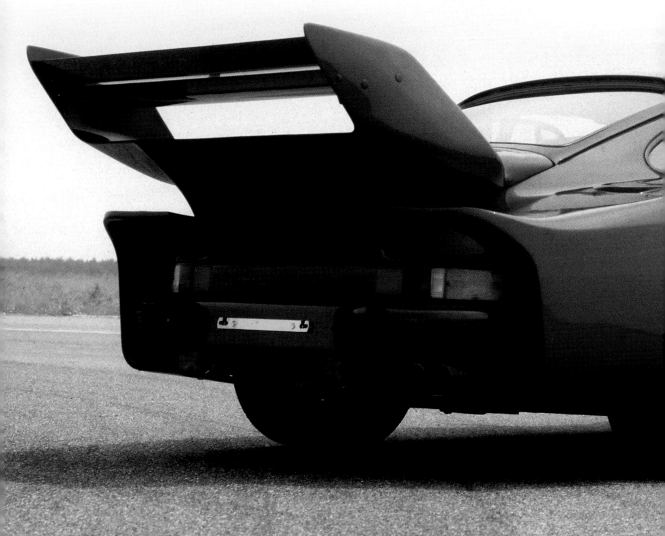

gap, the car gained a schizophrenic character that was perfectly in keeping with the man of the 1980s: sometimes respectable manager, Dr Jekyll, sometimes doped disco clubber, Mr Hyde. The turbo's hissing and the accompanying abrupt erection of the boost gauge are addictive indeed. Equally schizophrenic were the turbo car's aesthetics. This included flared wings for wide alloy wheels, all-round spoilers and appropriate war paint. The colour combination of black and red was symptomatic: political dynamite, which subconsciously obviously still holds great appeal.

Jekyll, mal gedopter Discogänger Mr. Hyde. Das Zischen des Turbo und die begleitende abrupte Erektion des Ladedruckanzeigers machen tatsächlich süchtig. Genauso schizophren ist die Ästhetik der Turbo-Autos. Es sind meist brave Serienfahrzeuge, häufig gar Mittelklasselimousinen, denen die Turbokur verschrieben wird. Dazu gehören ausgestellte Kotflügel für breite Leichtmetallfelgen, Spoiler rundum und eine passende Kriegsbemalung. Charakteristisch ist die Kombination Schwarz-Rot: politisches Dynamit, das im Unterbewusstsein offensichtlich noch große Anziehungskraft entfaltet.

apparaissent dans *Rambo* et *Terminator*, les films-culte de la décennie. En dehors du trou à l'accélération, la voiture acquiert ainsi un caractère schizophrène à l'image de l'homme des années quatre-vingt, tantôt Dr. Jekyll, gentil manager, tantôt Mr. Hyde, client dopé d'une discothèque. Le sifflement du turbo et, parallèlement, la montée brusque de l'indicateur de pression ont effectivement quelque chose d'excitant. L'esthétique des turbos est tout aussi schizophrène. Ce sont le plus souvent des véhicules de série fort sages, souvent d'ailleurs des berlines de classe moyenne, qu'on soumet à un traitement turbo. Ailes élargies pour recevoir des jantes larges en alliage léger, spoiler enveloppant et bariolage allant avec. La combinaison fréquente, c'est le noir et le rouge – une combinaison à forte charge politique qui, visiblement, conserve inconsciemment un grand pouvoir d'attraction.

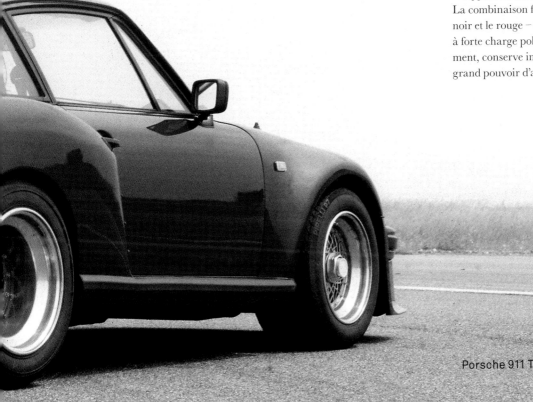

Porsche 911 Turbo TAG, 1983

Talbot-Simca Solara, 1980

Chrysler-Simca 1307, 1975

Saab 900 Sedan CD, 1981

Saab 900, 1978

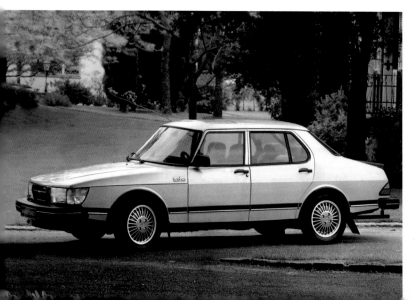

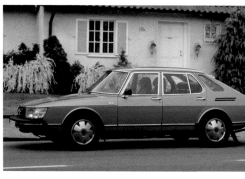

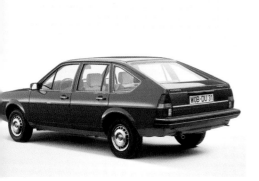

kswagen Passat, 1980

Volkswagen Passat Santana, 1981

The residents of 80 Staid Lane preferred conformity. Fastbacks were, therefore, decapitated with the guillotine. As a courtesy to Reagan, Thatcher and Kohl, the old-fashioned saloon, standard bearer of the bourgeoisie, must be reanimated.

Die Bewohner der Biederstraße 80 mögen es konform. Fließhecks werden daher mit dem Fallbeil geköpft. Reagan, Thatcher und Kohl zuliebe soll die alte Limousine, Bannerträger des Bürgertums, wiederbelebt werden.

Les habitants des zones pavillonnaires aiment la conformité. C'est l'arrêt de mort des bicorps à hayon. Pour un Reagan, une Thatcher et un Kohl, on fait renaître la vieille berline trois volumes, porte-drapeau de la bourgeoisie.

cia Beta 2000, 1975

Lancia Beta Trevi VX 1982

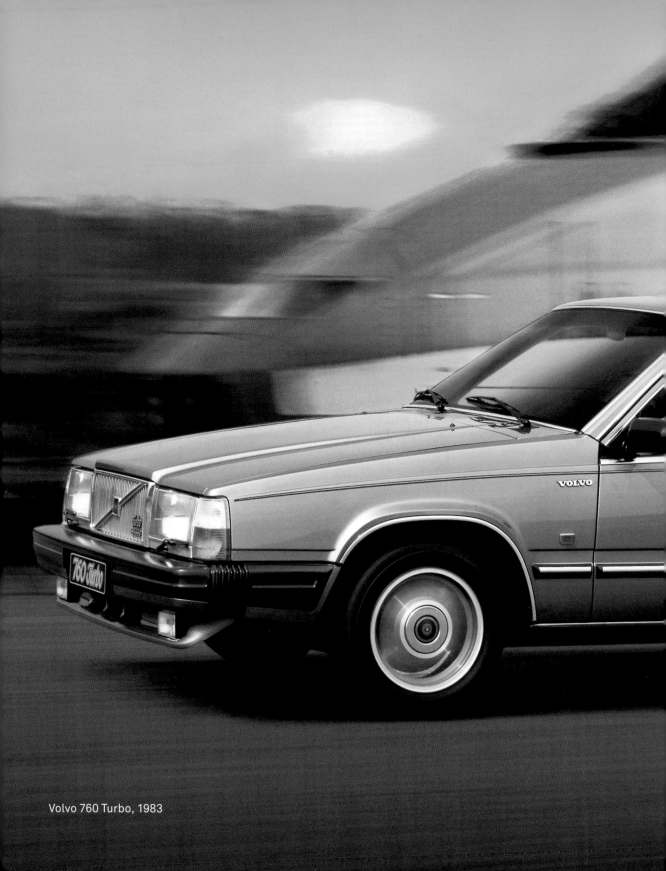

Volvo 760 Turbo, 1983

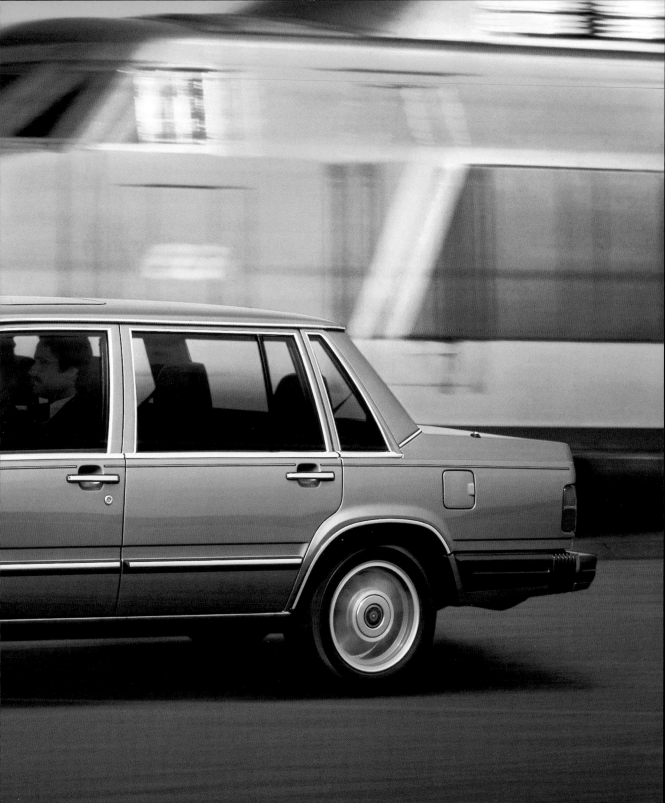

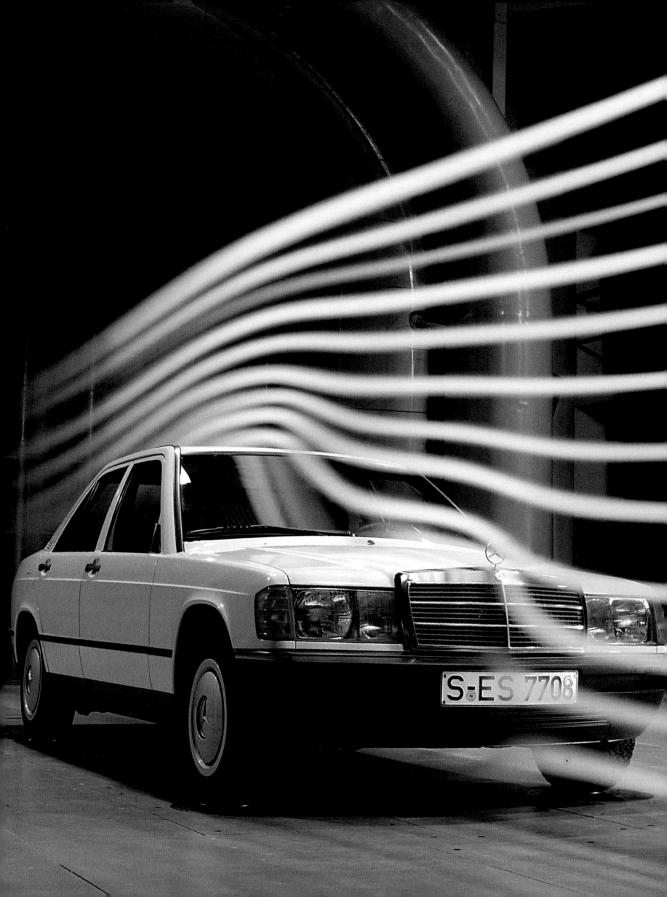

DYNAMIX

In 1981, Ronald Reagan was elected president of the United States and immediately pushed for deregulation and consolidation of the economy, as well as for rearmament. The Iron Lady, Margaret Thatcher, queen of the conservatives, was 'cleaning up' Great Britain, just as Prince Charles and young Lady Diana Spencer were getting married before an audience of 750 million spectators. In Germany, the mighty Helmut Kohl had just come to power. The good old days were back, though just a little bit different. The cool, brutalist machine aesthetics of the Centre Pompidou and the Lloyd's Building were much admired and the appeal of loft living was being discovered. It was the dawn of the hi-tech era. People were expressing a desire to regain control over

1981 wird Ronald Reagan Präsident der Vereinigten Staaten und macht sich umgehend für Deregulierung und Stärkung der Wirtschaft bei gleichzeitiger militärischer Aufrüstung stark. Während die „eiserne Lady" Margaret Thatcher, Königin der Konservativen, in Großbritannien aufräumt, heiratet Prinz Charles die junge Lady Diana Spencer – und weltweit schauen 750 Millionen dabei zu. In Deutschland gelangt der gewaltige Helmut Kohl an die Macht. Die guten alten Zeiten sind wieder zurück, nur wieder ein bisschen anders. Man bewundert die coole, brutale Maschinenästhetik des Centre Pompidou und des Lloyd's Buildings und entdeckt die Loft-Ästhetik für sich. Es ist der Anbruch der High-Tech-Ära. Man(n) will nun die Kontrolle über sein Umfeld, nach

En 1981, Ronald Reagan fraîchement élu Président des États-Unis d'Amérique se lance dans un vaste projet de dérégulation et de consolidation de l'économie qui s'accompagne d'un renforcement de l'armement militaire. Margaret Thatcher, la « dame de fer », est en pleine restructuration de la Grande-Bretagne au moment du mariage du Prince Charles et de la jeune Lady Diana Spencer, suivi par 750 millions de spectateurs à travers le monde. En Allemagne, l'imposant Helmut Kohl arrive au pouvoir. Le bon vieux temps est de retour, enfin presque. L'esthétique libre et brutale inspirée des machines, dont le Centre Pompidou et le Lloyd's Building sont des exemples fameux, force l'admiration et le style loft convainc. C'est l'éclosion du high-tech, une période où la gente mas-

Mercedes-Benz 190, 1982

Gone with the wind, the automotive shape is seeking perfection.

„Vom Winde verweht" sucht die Automobilform nach Perfektion.

La voiture cherche la forme parfaite : autant en emporte le vent !

their surroundings after years of uncertainty. Richard Gere, the naked *American Gigolo*, was wearing Armani, driving a black Mercedes-Benz SL and wishing for a hi-fi stereo system. The graphic equaliser's mechanical-dynamic aesthetics—feeder, controllers, fluorescent display et al—influenced the entire decade. Quartz was the name of an Audi prototype by Pininfarina: Giugiaro was studying digital cockpit systems and tattooing hi-tech symbols on his triplet study Aztec, Aspid and Asgard. Postmodern pluralism was spreading. The entertainment business was also helping shape the eighties, especially thanks to the TV series *Dallas*. It histrionically depicted the family life of unscrupulous oil tycoon J. R. Ewing, a macho man in a business suit. *Dynasty* followed this pattern closely in 1981: John Forsythe, Linda Evans and Joan Collins schemed together and against each other for control of gold, money and big business. Thanks to commercial broad-

Jahren der Unsicherheit, wiedererlangen. Richard Gere, der frontal nackte *Mann für gewisse Stunden*, trägt Armani, fährt Mercedes-Benz SL in Schwarz und wünscht sich eine Hifi-Stereoanlage. Die mechanisch-dynamische Ästhetik des Equalizers – mitsamt Schiebern, Reglern und fluoreszierendem Display – prägt die gesamten Achtziger. Quartz heißt ein Audi-Prototyp von Pininfarina; Giugiaro widmet sich digitalen Cockpitsystemen und tätowiert Hi-Tech Symbole auf die Haut seiner Drillingsstudie Aztec, Aspid und Asgard. Postmoderne Pluralität ist auf dem Vormarsch. Auch die Unterhaltungsbranche verleiht den Achtzigern Gestalt, vor allem dank der Fernsehserie *Dallas*. Darin wird das Familienleben des skrupellosen Ölmagnaten J.R. Ewing, eines Machos im Business-anzug, theatralisch dokumentiert. Der Zuschauer lernt, dass in Texas alle Welt Mercedes-Benz fährt. 1981 folgt, im gleichen Muster, die „Dynasty" des *Denver Clans*: John Forsythe, Linda Evans und

culine essentiellement s'efforce de retrouver le contrôle de son environnement après toutes ces années d'insécurité. Comme Richard Gere dans *American Gigolo*, l'homme, le vrai, porte un costume Armani, roule en Mercedes-Benz SL noire et rêve d'une chaîne hi-fi. L'esthétique dynamique de l'égalisateur de sons avec sa panoplie de boutons, curseurs et écrans fluorescents, marque toutes les années 80. Quartz sera d'ailleurs le nom donné à l'un des prototypes dessiné par Pininfarina pour Audi ; Giugiaro consacre son attention au tableau de bord numérique et orne de symboles high-tech les carrosseries de sa trilogie l'Aztec, l'Aspid et l'Asgard. La pluralité postmoderne est en marche. L'industrie du show-business contribue à sa manière à façonner les années 80, avec la série télévisée *Dallas* notamment. Ce feuilleton dépeint en grande théâtralité la vie de famille d'un magnat du pétrole J.R. Ewing, un macho en costume-cravate sans scrupule. Il déli-

Mercedes-Benz S, 1979

casting—one of the liberal 1980s' innovations in Europe—even the smallest products were able to leave a lasting impression: in 1982, Ferrero brought out its *Rocher*, the praline for the masses. The TV ad showed a tarted-up mistress, on her way to the 'ambassador's reception', sitting in the back of a Rolls-Royce, being served the gold-wrapped sweets by her lover/chauffeur. Demonstrating and opposing were now truly passé. The fears of the leaden years had been overcome and Ramazzotti was now advertising media mogul Silvio Berlusconi's *Milano da Bere*: fashion, design, business. The yuppie generation's social climbers were sloughing at the trough, because the business managers wanted only one thing: a decadently classy life. Therefore Lancia labelled the Delta's luxury version with the Roman digits LX. A timeless diva gets out of a golden car in front of the luxury hotel, smiles into the camera and confirms: *"Oui, je suis Catherine Deneuve."* The upper classes' hab-

Joan Collins intrigieren im Angesicht von Gold, Geld und Geschäft. Durch die Werbung im Privatfernsehen – in Europa eine Neuentwicklung der liberalen Achtziger – hinterlässt selbst das kleinste Produkt tiefe Spuren: 1982 erfindet Ferrero Rocher, die Praline für die Massen. Im Werbespot lässt sich eine aufgebrezelte Gebieterin, auf dem Weg zum „Empfang des Botschafters", auf der Rückbank ihres Rolls-Royce die goldene Süßigkeit von ihrem Charmeur-Chauffeur servieren. Demonstrieren und Opponieren ist endgültig passé. Die Ängste der bleiernen Jahren sind überwunden, und Ramazzotti wirbt für das „Milano da Bere" von Medientycoon Berlusconi: Mode, Design, Business. Die Aufsteiger der Yuppie-Bewegung greifen gerne zu, denn der Business-Manager will nur das Eine: verschwenderisch stilvoll leben. Also kennzeichnet Lancia die Luxusversion des Delta mit den römischen Ziffern LX. Dem goldenen Auto entsteigt vor dem

vre également un message implicite à la planète : au Texas, tout le monde roule en Mercedes. Sur le même schéma suit en 1981 la série *Dynastie* avec son flot d'intrigues entre les protagonistes, John Forsythe, Linda Evans et Joan Collins, avides d'or, d'argent et d'affaires juteuses. Avec l'introduction de la publicité sur les chaînes privées – une nouveauté dans cette Europe libérale des années 80 – tout produit, même des plus quelconques, peut acquérir très vite de la notoriété. En 1982, Ferrero invente Rocher, la praline pour les masses. La pub TV montre une femme très BCBG, en route pour une réception chez un ambassadeur. Assise à l'arrière d'une Rolls-Royce, son chauffeur de charme lui propose ces fameuses gourmandises à papier doré. Manifester et se révolter ne sont plus de mise. La chape sinistre des années de plomb est levée, Ramazzotti fait l'apologie du « Milano da bere » – mode, design et affaires – incarné par Berlusconi, le magnat de la presse.

Audi Quartz Pininfarina, 1981

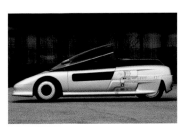

Audi Aspid Italdesign, 1988

it of melting into the background was over, the new motto: see and be seen. Hence Maserati wrapped its Biturbo in the garment of the classic coupé, combining dynamic proportions with a slight wedge shape, baroque wood, lots of chrome and an interior by Missoni. The car was its own advertising, Maserati's famous Tridente logo, scattered prominently all over the car. It is "doomed to be liked", as its inventor Alejandro de Tomaso proclaimed. After all, a guy would do anything to be liked, and a gorgeous new car might help in this respect.

CORPORATE FASHION

The eighties are unfairly seen as a decade of automotive boredom. The industry had, in fact, come of age, which also meant the end of the era of the genius engineer. Experienced, profit-oriented managers were put in charge. Radical experiments and fashionable styles, blindly adopted by everybody, are things of the past.

Luxushotel eine zeitlose Diva, lächelt in die Kamera und bestätigt: „Oui, je suis Catherine Deneuve". Das Versteckspiel des Wohlstands ist vorbei, nun kann es wieder heißen: sehen und gesehen werden. Daher verpackt Maserati 1982 den Biturbo im Gewand des klassischen Coupés, das dynamische Proportionen mit einer leichten Keilform, barockem Holz, viel Chrom und einer Innenausstattung von Missoni vereint. Der Wagen ist auch seine eigene Werbebotschaft: Überall findet man Maseratis berühmtes Dreizack-Logo prominent verstreut. Er sei „zum Gefallen verurteilt", verkündet Erfinder Alejandro de Tomaso. Und um zu gefallen, tut man schließlich alles – ein schönes neues Auto macht da vieles einfacher.

CORPORATE FASHION

Zu Unrecht werden die Achtziger nur als Jahre automobiler Langeweile betrachtet. Tatsächlich ist die Industrie erwachsen gewor-

Et la classe montante des yuppies joue le jeu. Le cadre dynamique veut la vie facile et la dépense à outrance. Lancia marque la version luxe de la Delta des chiffres romains LX. La voiture dorée s'arrête devant un grand hôtel, une femme d'une élégance et d'un charme intemporels en descend, elle sourit à la caméra et proclame : « oui, je suis Catherine Deneuve ». La richesse n'est plus une maladie honteuse. Le luxe s'affiche. Le jeu du voir et être vu revient à l'honneur. En 1982, Maserati loge son biturbo dans un coupé classique aux proportions dynamiques et à la ligne légèrement plongeante. Raffiné, il allie les chromes, les boiseries baroques et un intérieur signé Missoni. La voiture se fait sa propre publicité : le célèbre logo en forme de trident est largement utilisé en plusieurs endroits bien visibles. Selon les mots d'Alejandro de Tomaso, son créateur, elle est « condamnée à plaire ». Et pour plaire, on est prêt à tout. Une belle voiture neuve ne peut que faciliter les choses.

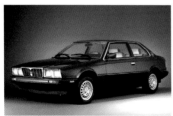
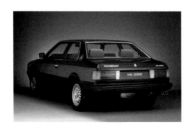

Maserati Biturbo, 1981

The manufacturers began to free themselves from common styling themes and concentrate on developing their own formal language. They were not designing products, but rather brands. The pioneer of this practice was BMW, whose product line-up had been restructured from 1972 to 1976. Defining characteristics, such as the wedge-shaped shark nose, the Hofmeister kink and the softly sloping rear were applied to all four product lines. It is the model number, not the engine specification or the serial designation, that indicates each car's rank. The 3, 5, 6, and 7 series established the idea of typological segmentation. It was the first attempt to apply marketing-oriented, rather than technocratic thinking. In 1980, Bruno Sacco, head of design at Mercedes-Benz, formulated the 'Karlsruhe Theory' as the basis of his design strategy: vertical affinity and horizontal homogeneity. On the one hand, stylistic kinship between predecessor and successor model—evolution,

den, was das Ende der Zeit der genialen Konstrukteure zur Folge hat. An die Macht kommen nun versierte, profitorientierte Manager. Radikale Experimente und modische Linien, denen alle blind folgen, gehören der Vergangenheit an. Die Hersteller beginnen, sich von allgemein geltenden Stilen zu befreien und konzentrieren sich auf die Entwicklung einer eigenen Formensprache. Sie gestalten keine Produkte, sondern Marken. Vorreiter ist dabei BMW, wo man zwischen 1972 und 1976 die Produktpalette umstrukturiert. Prägende Merkmale wie die keilförmige Pfeilfront, der Hofmeister-Knick und das sanft abfallende Heck werden auf alle vier Baureihen dekliniert. Weder die Motorisierung, noch die serielle Typenbezeichnung, sondern eine Modellnummer gibt den Rang an. Mit den 3er-, 5er-, 6er- und 7er-Reihen wird die Idee der typologischen Segmentierung etabliert. Es ist der erste Versuch, marketingorientiertes statt technokratisches Denken anzu-

MODE CORPORATISTE

Les années 80 sont considérées à tort comme insipides dans l'histoire du design automobile. L'industrie est entrée dans une phase mûre qui signe la fin de l'époque des constructeurs de génie. Les constructeurs commencent à se libérer des styles convenus, ils concentrent leurs efforts sur le développement d'un langage des formes propre à leur marque. Plus que des produits, ils construisent une marque. BMW est l'un des précurseurs de cette tendance qui se manifeste entre 1972 et 1976 par une restructuration de la palette de produits. Les caractéristiques BMW – l'avant plongeant, le pli Hofmeister et la poupe légèrement inclinée – seront déclinées sur les quatre séries. Désormais un simple numéro de modèle suffit à indiquer la classe du véhicule, reléguant la motorisation et la désignation du type à l'arrière plan. Avec les séries 3, 5, 6 et 7 s'établit l'idée de segmentation typologique qui correspond

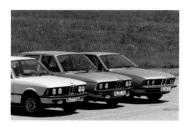

BMW, 1970s

rather than revolution—on the other hand, transfer of current stylistic elements to the whole model range—family feeling instead of individuality. The first car to follow this notion was the new S-class of 1979: the classic limousine sported discreetly contrasting Sacco planks' made of chrome and plastic, its Mercedes nose was, for the first time, slanted with the wind, but the proud radiator grille stayed resolutely put. No other car embodied the postmodern tension of these times better than the Mercedes. In 1981, Lancia introduced a uniform front grille and, in 1983, Fiat came up with its 'five bars': a new, oversized logo that defined and united each and every model. Design was identified as a weapon of strategic marketing and an increasingly important part of corporate reasoning. Engineers and stylists finally began to cooperate. This was a new kind of operating principle, on the basis of which the Germans built their leadership. Turin's independent

wenden. 1980 formuliert Bruno Sacco, Chefdesigner von Mercedes-Benz, mit der „Karlsruher Theorie" die Grundlage seiner Designstrategie: „vertikale Affinität und horizontale Homogenität". Einerseits stilistische Verwandtschaft zwischen Vorgänger- und Nachfolgemodell – also Evolution statt Revolution. Andererseits Übertragung aktueller stilistischer Elemente auf alle Baureihen – Family Feeling statt Individualität. Vorreitermodell dieses Gedankens ist die S-Klasse von 1979: Die klassische Limousine trägt funktional abgesetzte „Sacco-Bretter" aus Chrom und Kunststoff, zum ersten Mal neigt sich die Mercedes-Front mit dem Wind. Doch der stolze Kühlergrill bleibt. Kein Auto verkörpert die postmoderne Spannung dieser Zeit besser. 1981 führt Lancia schlagartig einen einheitlichen Frontgrill ein. 1983 erfindet Fiat die „fünf Stäbe": ein neues, übergroßes Markenzeichen, das alle Modelle visuell prägt und eint. Design wird als marketingstrate-

à la première tentative d'appliquer un concept marketing plutôt que technocrate. En 1980, le chef design de Mercedes-Benz, Bruno Sacco, énoncera dans la « théorie de Karlsruhe » les bases de sa stratégie de design en ces termes : « affinité verticale et homogénéité horizontale ». D'un côté, on assiste à une filiation entre modèles successifs – donc plus que de révolution il s'agit ici d'évolution – et de l'autre à une application à toutes les séries d'éléments stylistiques actuels – « family feeling » plutôt qu'individualité. Le modèle précurseur à ce concept est la nouvelle classe S de 1979 : la berline classique présente des protections de bas de caisse légèrement abaissées en chrome et en plastique, et pour la première fois, l'avant est incliné comme sous la pression du vent. La calandre, la fierté de la marque, est conservée. Aucune voiture ne représente aussi bien l'ambivalence postmoderne que cette Mercedes. Le design devenu une arme marketing efficace revient au centre de

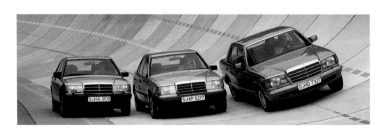

Mercedes-Benz, 1980s

carrossiers' importance was noticeably weakened by this process. A first consequence was a new pluralism of styles: every manufacturer now simply did as they pleased. The second consequence was a patchy design quality, simply because not all of them were that good at it. This resulted in a fight for survival, during which well thought-out corporate design helped strengthen brand awareness and thus defend each manufacturer's respective position. Simultaneously, this was the beginning of the period of joint ventures among competitors, at the height of which Fiat, Alfa Romeo, Lancia and Saab developed a single automobile with four faces: those of the Fiat Croma, Saab 9000, Lancia Thema and the Alfa Romeo 164. The industry was getting a move on.

DYNAMIX

Every crisis also contains positive aspects. Thanks to the oil crisis, the industry realised that design

gische Waffe erkannt und rückt verstärkt ins Zentrum unternehmerischen Kalküls. Ingenieure und Stilisten arbeiten endlich zusammen. Es ist ein neues Arbeitsprinzip, auf dessen Grundlage die Deutschen ihre Führerschaft aufbauen. Die Bedeutung der unabhängigen Turiner Karossiers wird durch diesen Prozess merklich geschwächt. Erste Konsequenz ist eine neue Pluralität der Stile: Jeder Hersteller macht nun, was er will. Zweite Konsequenz ist die schwankende Designqualität: Denn nicht jeder ist gut darin. Ein Überlebenskampf ist die Folge, bei dem ein durchdachtes Corporate Design hilft, das Markenbewusstsein zu stärken und eigene Positionen zu verteidigen. Gleichzeitig beginnt die Zeit der Joint Ventures: Fiat, Alfa Romeo, Lancia und Saab entwickeln ein Automobil mit vier Gesichtern: denen des Fiat Croma, Saab 9000, Lancia Thema und des Alfa Romeo 164. Die mächtige Maschine kommt wieder in Bewegung.

la stratégie commerciale des constructeurs. Ingénieurs et stylistes travaillent enfin ensemble. C'est sur ce nouveau principe que les allemands assoient leur *leadership*. L'importance des carrossiers indépendants de Turin s'en trouve considérablement affaiblie. De ce processus découle une nouvelle pluralité de styles – chaque constructeur faisant comme bon lui semble – et une qualité de design très inconstante, car les constructeurs ne sont pas tous aussi talentueux les uns que les autres. Une lutte acharnée s'ensuit au centre de laquelle un corporate design bien pensé contribue au positionnement de la marque et à l'accroissement de sa visibilité. Parallèlement, on entre dans l'ère des joint ventures entre concurrents, une phase qui culmine avec le développement par Fiat, Saab, Lancia et Alfa Romeo d'une voiture commune déclinée en quatre variantes différentes : la Fiat Croma, la Saab 9000, la Lancia Thema et l'Alfa Romeo 164. La machine est lancée.

efficiency could give the automobile a new quality. In keeping with this idea, in 1976, Renault introduced the R14, which looked like a dynamic box, softened by the wind. It featured innovative bumpers and drip mouldings, flush fitting with the body. In 1980, Giugiaro unveiled his Medusa, a solid-looking, slender construction shaped by aerodynamic criteria. It was a milestone, albeit one that was too extreme: the subject of aerodynamics would be better addressed with more market-oriented pragmatism. Styling a breathtaking, ideal form was not the priority: achieving measurable results was; the myth of the drag coefficient was born. From here on in it would be used objectively to measure the quality of automotive design. The main aim was no longer maximum speed, but maximum economy and efficiency. This aspect was also seized upon by the marketing departments: one example was a new gauge on the Mercedes' dashboard, which showed the

DYNAMIX

Dank der Ölkrise begreift die Industrie, dass Designeffizienz dem Automobil eine neue Qualität verleihen kann. So präsentiert Renault 1976 den R14 mit den dynamischen Zügen einer vom Wind weichgezeichneten Box. Innovativ sind dessen Stoßstangen und Regenrinnen, die in die Karosserie bündig integriert sind. 1980 präsentiert Giugiaro Medusa, eine schlanke, nach aerodynamischen Kriterien optimierte Konstruktion, die wie aus einem Guss wirkt. Das ist genauso interessant wie extrem. In der Praxis wendet man sich dem Thema Aerodynamik mit marktorientiertem Pragmatismus zu. Dabei geht es nicht darum, eine atemberaubende Idealform zu gestalten, sondern messbare Ergebnisse zu erzielen: Der Mythos Cw-Wert wird geboren. Von nun an wird er objektiv genutzt, um die Qualität von Automobildesign zu bewerten. Im Vordergrund steht aber nicht mehr die Endgeschwin-

DYNAMIX

Toutes les crises ont des bons côtés. Celle du pétrole ouvre les yeux à l'industrie automobile qui prend conscience qu'un design efficient est un atout capital. En 1976, Renault sort la R14, une voiture aux traits dynamiques, qui ressemble à une boîte aux contours modelés par le vent. Elle innove avec des pare-chocs et des gouttières qui se fondent dans la carrosserie. En 1980, Giugiaro présente la Medusa, à la structure élancée optimisée pour un aérodynamisme parfait et qui semble construite d'un bloc. Intéressante, cette expérience va néanmoins trop loin. Les constructeurs préfèrent aborder la question de l'aérodynamisme avec un pragmatisme axé sur le marché. La recherche de la forme idéale, magique, laisse place à la quête de résultats quantifiables : le mythe du Cx est né. Dès lors, le coefficient de résistance à l'air sert de critère objectif de mesure de la qualité du design automo-

Renault R14, 1976

supposed and relative 'economy' of the five litre V8. Volkswagen was asking for a premium for its Formel-E specification, including tall E ratio and, as an option, a start-stop automatic. Fiat glued aerodynamic prostheses onto its energy-saving models, which reduced fuel consumption, rather than lift. It was only becoming clear that efficiency calls for an integral approach once Audi's new 100 model was brought to market in 1982. This conceptually ordinary car achieved a sensational drag coefficient of 0.30. Head of research and development, Ferdinand Piëch, was demanding design quality in every detail: any transition, profile or component would be examined for its aerodynamic drag and then optimised. All the glass in the windshield and windows was steeply inclined and flush with the body. In this way, its form gained its unique character: it was more of a scientific synthesis than a styling exercise. A few months later, the Baby Benz arrived: a calcu-

digkeit, sondern die Ökonomie. Diese wird auch vom Marketing aufgegriffen: So zeigt auf dem Mercedes-Armaturenbrett eine Anzeige die ebenso mutmaßliche wie relative „Economy" des V8-Motors. Volkswagen verlangt Aufpreis für die Formel-E-Ausstattung, mit lang übersetztem E-Gang und, auf Wunsch, Start-Stopp-Automatik. An seine Energy-Saving-Modelle klebt Fiat aerodynamische Prothesen, die nicht den Auftrieb, sondern den Verbrauch reduzieren sollen. Dass Effizienz eine ganzheitliche Herangehensweise verlangt, wird erst klar, als 1982 der Audi 100 C3 auf den Markt kommt. Die konzeptionell gewöhnliche Limousine erreicht den sensationellen Cw-Wert von 0,30. Entwicklungsvorstand Ferdinand Piëch verlangt Designqualität in jedem Detail: Jeder Übergang, jedes Profil und jedes Bauteil wird auf Luftwiderstand hin geprüft und optimiert. Alle Glasscheiben sind stark geneigt und bündig in die Karosserie eingelassen. Die Form

bile. L'efficience d'une voiture prime désormais sur sa vitesse maximale. Ce message sera parfaitement relayé par les stratégies marketing. Volkswagen propose ses voitures avec la Formel E en supplément, avec boîte de vitesses à rapports allongés et système stop & start optionnel. Fiat appose à ses modèles Energy Saving des prothèses aérodynamiques destinées, non pas à augmenter la portance, mais à réduire la consommation. L'efficience exige une approche holistique. Le lancement sur le marché de l'Audi 100 en fera la parfaite démonstration. Le coefficient Cx de cette berline plutôt conventionnelle affiche la valeur record de 0,3. Ferdinand Piëch, membre du directoire chargé de R&D, se montre d'une exigence absolue, le design doit être parfait jusque dans les moindres détails : chaque élément, chaque ligne de transition, tout est passé au crible pour optimiser l'aérodynamique de la voiture. Les vitres toutes très inclinées se fondent avec la carrosserie.

Lancia Medusa Italdesign, 1980

lated design that stood for nothing less than perfection writ small. Bruno Sacco had conceived a multifaceted volume, whose rear window was formed three-dimensionally, so that it conforms to the tapering at the roof and rear end. Aesthetically more significant than the Audi, the 190 turned out to be the first example of sculpturally modelled design. It was no longer a geometric cube, but a body that had been integrally styled right up to and including the roof. A year later, Fiat's Uno interpreted this design change into the small car class. The humble Italian could not top the Audi's and Mercedes' constructional refinement and yet, Giugiaro's design proved to be seminal: vertical, wide, but also aerodynamically optimised, offering the space and comfort of a saloon. Gone were the cheekiness of the seventies and the Panda's ruggedness. Fiat was now taking the small car very seriously indeed. The ultimate symbol of 'dynamix' design was the Renault 25. On the in-

erhält dadurch ihr Alleinstellungsmerkmal: Es ist mehr wissenschaftliche Synthese denn stilistische Übung. Wenige Monate später kommt der „Baby-Benz": ein kalkuliertes Design, das nicht weniger als eine kleine Perfektion darstellt. Bruno Sacco konzipiert ein sehr facettenreiches Volumen, dessen Heckscheibe dreidimensional geformt ist, um sich der Verjüngung von Dach und Heck anzupassen. Der 190 ist erster Vertreter skulptural modellierten Designs: kein geometrischer Würfel mehr, sondern ein bis zum Dach integral gestalteter Körper. Ein Jahr später überträgt Fiats Uno den Designwandel auf die Kleinwagenklasse. In Sachen konstruktiver Raffinesse kann der bescheidene Italiener Audi und Mercedes-Benz zwar nicht überbieten. Dennoch ist Giugiaros Design wegweisend: Vertikal, breit, aber auch aerodynamisch stark optimiert, bietet es Raum und Komfort einer größeren Limousine. Vergessen sind der Pepp der Siebziger und die Rustikalität

C'est ce qui donne à cette forme si particulière sa caractéristique distinctive qui tient plus du condensé de technologie que de l'exercice de style. Quelques mois plus tard apparaît la « Baby-Benz » au design mûrement réfléchi, une « petite merveille de perfection ». Le volume présente plusieurs facettes avec une vitre arrière en trois dimensions, à la ligne courbée qui suit le profil effilé du toit et de l'arrière. La 190 est la première représentante du design sculptural. La voiture n'a plus rien du cube géométrique, elle est modelée des pieds à la tête. Un an plus tard, avec l'Uno, Fiat transpose ce nouveau concept de design à la catégorie des petites voitures. Le constructeur italien est certes loin d'égaler le niveau de raffinement conceptuel de Mercedes Benz et d'Audi, pourtant le design proposé par Giugiaro exercera une forte influence : vertical, large et néanmoins très aérodynamique dans la forme, ce modèle offre le confort d'une berline. Oubliés le zeste de fantaisie des années 70 et

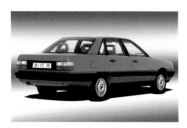

Audi 100, 1982

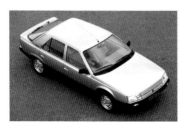

Renault R25, 1984

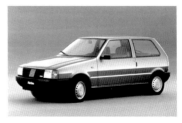

Fiat Uno, 1983

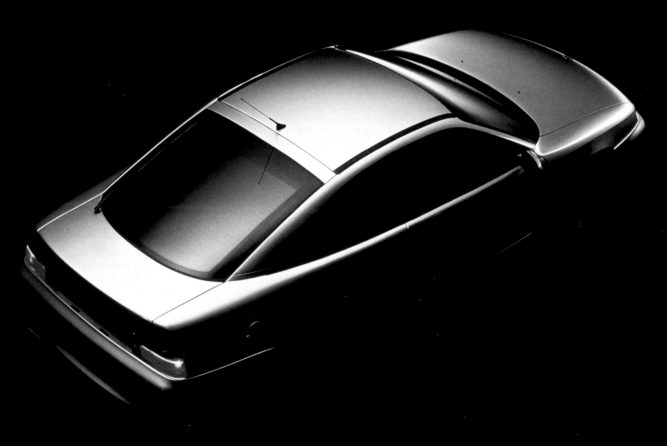

Opel Calibra, 1990

side, it offered a hi-fi console, digital instruments and a talking on-board computer. Its drag coefficient of 0.28 was the acme of aerodynamics. But its shape divided opinion: the panoramic glass dome ends abruptly. Heading towards the turn of the century, the main thinking was to optimise the automotive shape in order to reach the best balance of performance, economy and profitability. This was driving the industry even further, particularly at Opel and later at Audi and Volkswagen, where, under the direction of Hartmut Warkuß, design almost reached stylistic perfection. The Audi A8, as well as the dome-roof Passat and, later on, the Golf IV, form a synthesis of formal and constructional quality of the highest order. The process of integration of all body parts was continuing: monocolour paintwork and panel gaps reduced to a minimum gave the impression of a perfectly seamless structure. Large wheels and subtly convex surfaces created the

des Panda. Fiat nimmt den Kleinwagen sehr ernst. Das Sinnbild des Dynamix-Designs schlechthin ist der Renault 25. Innen bietet er Hifi-Konsole, Digitalanzeigen und einen sprechenden Bordcomputer. Mit einem Cw-Wert von 0,28 markiert er die aerodynamische Spitze. Doch über die Form ist man sich uneinig: Die Panoramaglaskuppel endet abrupt in einer Art Stummelheck. Der dafür verantwortliche Grundgedanke, die automobile Form zu optimieren, um den besten Kompromiss aus Leistung, Ökonomie und Profitabilität zu erlangen, treibt die Industrie bis zur Jahrtausendwende weiter an. So auch bei Opel und später Audi und Volkswagen, die sich unter Hartmut Warkuß der gestalterischen Perfektion annähern. Der Audi A8, später der Kuppeldach-Passat und dann der Golf IV bilden die höchste Synthese aus formaler und konstruktiver Qualität. Der Integrationsprozess aller Karosserieteile wird fortgeführt: Dank der Einfarbenlackierung sowie

le côté rustique de la Panda, Fiat prend la petite voiture très au sérieux. La voiture, quant à elle, qui illustre au mieux le design « dynamix » est la Renault 25. L'habitacle est équipé d'une console hi-fi, d'un affichage digital et d'un ordinateur de bord parlant. Avec un coefficient de résistance à l'air de 0,28, elle se situe en haut du palmarès mais ne fait pas l'unanimité sur le plan esthétique avec une lunette « bulle » qui s'arrête net sur une poupe tronquée. L'optimisation maximum des performances, de la profitabilité et de l'économie reste le maître-mot de l'industrie automobile jusqu'au tournant du siècle. Il en va de même chez Opel, Audi et Volkswagen où le design, sous la direction attentive d'Hartmut Warkuß, approche de la perfection. L'Audi A8, plus tard la Passat au toit arrondi et la Golf IV représentent la synthèse parfaite entre forme et impératifs de construction. Le processus d'intégration de tous les éléments de carrosserie se poursuit. Grâce aux techniques mo-

Volkswagen Passat, 1996

Audi A2, 1999

Audi A8, 1994

form, whose aerodynamic qualities were by now taken as a given: sublime substance. The result is 'smooth design', something which needs little in addition and cannot be reduced much further. But, eventually, even that was no longer enough. The Audi A2—a hitech interpretation of the compact car: tall, with extreme profiles, super lightweight, super efficient—was met with a lukewarm response by the public. The 2001 Ford Mondeo and 2003 Opel Signum, both stylistically exemplary, were considered boring. Again, at the start of the millennium, the market was demanding something new.

der auf ein Minimum reduzierten Spaltmaße wird der Eindruck eines Baukörpers wie aus einem Guss erweckt. Große Räder und die leicht konvexen Flächen verleihen der Form – deren aerodynamische Qualität mittlerweile als selbstverständlich gilt – eine erhabene Substanz. Das Ergebnis ist Smooth Design, dem man kaum etwas hinzuzufügen braucht und nichts wegnehmen möchte. Allmählich reicht das nicht mehr aus. Der Audi A2 – eine Hi-Tech-Interpretation des Kompaktwagens: hoch, extrem profiliert, superleicht, supersparsam – wird von der Kundschaft lauwarm angenommen. Den 2001er Ford Mondeo, wie auch den 2003er Opel Signum, beide gestalterisch vorbildlich, findet man langweilig. Das junge Jahrtausend verlangt schon wieder Neues.

dernes d'application des vernis et à la réduction importante des jeux entre les éléments de carrosserie, celle-ci paraît avoir été fondue en un bloc. Grandes roues et surfaces légèrement convexes confèrent aux formes, acquises au principe d'aérodynamisme, une allure majestueuse. Le résultat, c'est le smooth design où rien ne manque et rien n'est superflu. Mais on ne peut en rester là. L'Audi A2, une interprétation high-tech de la berline monocorps, haute, extrêmement légère et économe, reçoit en effet un accueil réservé. La Ford Mondeo de 2001 et l'Opel Signum de 2003, malgré l'exemplarité de leur design, sont jugées fades. Ce début de millénaire exige de la nouveauté.

Opel Signum, 2003

Ford Mondeo Turnier, 2001

Volvo 480 ES Turbo, 1988

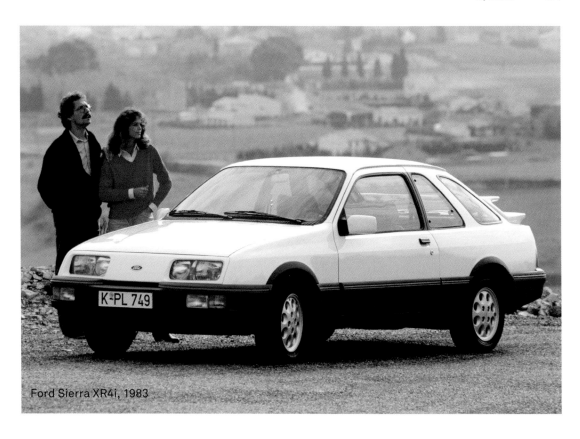

Ford Sierra XR4i, 1983

UWE BAHNSEN

No other automobile embodies the design philosophy of the 1980s better than the Ford Sierra. Uwe Bahnsen had already put down a marker in 1960 with the softened design of the 'Bath Tub'. With the Sierra, he softened not just the car's shape, but even its very concept: the domed aero tail, which gained a prominent rear wing in its sporty XR4-guise, was halfway between notch- and fastback, revolution and conformity. Despite this, the first Sierra is anything but mainstream.

Kein anderes Automobil verkörpert die Designphilosophie der 1980er Jahre besser als der Ford Sierra. Bereits 1960 hatte Uwe Bahnsen mit dem weichgespülten Design der „Badewanne" ein Zeichen gesetzt. Mit dem Sierra wird nun nicht nur die Form, sondern auch das Konzept weichgespült: Das gewölbte Aeroheck, das in der sportlichen XR4-Version einen prominenten Flügel erhält, schwebt zwischen Stufen- und Fließheck, zwischen Revolution und Konformismus. Trotzdem ist der erste Sierra alles andere als Mainstream.

Aucune voiture n'incarne mieux la philosophie du design des années 80 que la Ford Sierra. Dès 1960, Uwe Bahnsen avait donné le ton avec le design édulcoré de la « baignoire ». Avec la Sierra, ce n'est pas seulement la forme qui est édulcorée mais aussi le concept. La poupe aérodynamique courbe qui se dote sur la XR4 version sportive d'une aile imposante, hésite désormais entre la tricorps et la bicorps, entre la révolution et le conformisme. La Sierra n'en est pas moins tout sauf une voiture conventionnelle.

AUDI

The C3 series models 100/200 determinedly catapults Audi into the upper echelons occupied by Mercedes-Benz and BMW. Using a turbocharger and all-wheel drive as an admission ticket, the deliberately oversized car promised 'Vorsprung durch Technik'. Obsessed with the pursuit of perfection, engineer Ferdinand Piëch investigated each and every design detail. Chief designer Hartmut Warkuß acted within the parameters of the classic saloon shape, on which any bumps and interruptions were smoothed out. For the sake of aerodynamics, the 'greenhouse' was strongly tapered and the windows were flush with the body: everything flowed in a design that was not revolutionary, but highly evolutionary.

Entschlossen katapultiert sich Audi mit dem 100/200 der Serie C3 in die Edelliga von Mercedes-Benz und BMW. Mit Turbo und Allradantrieb als Eintrittskarte verspricht der bewusst überdimensionierte Wagen „Vorsprung durch Technik". Besessen vom Streben nach Perfektion, geht Ingenieur Ferdinand Piëch jedem Konstruktionsdetail nach. Chefdesigner Hartmut Warkuß agiert im Rahmen der klassischen Limousinenform, aus der er jede Unebenheit, jede Unterbrechung ausfeilt. Der Aerodynamik zuliebe, ist das Greenhouse stark verjüngt, die Fenster sind bündig in die Karosserie eingelassen: Alles fließt in einem Design, das nicht revolutionär, dafür aber stark evolutionär ist.

Avec les 100/200 de la série C3, Audi se propulse d'un seul coup dans le club très fermé des Mercedes-Benz et des BMW. Ce véhicule volontairement surdimensionné promet « une belle avancée technique ». Obsédé par la perfection, l'ingénieur Ferdinand Piëch est attentif au moindre détail de construction. Le designer en chef Hartmut Warkuß travaille à partir de la forme classique de la berline dont il lime toutes les aspérités, toutes les discontinuités. Pour améliorer l'aérodynamisme, la *greenhouse* est fortement rajeunie et les vitres affleurent avec la carrosserie : le tout s'inscrit dans un design qui n'a certes rien de révolutionnaire mais qui est résolument novateur.

Audi 200 20V Quattro, 1988

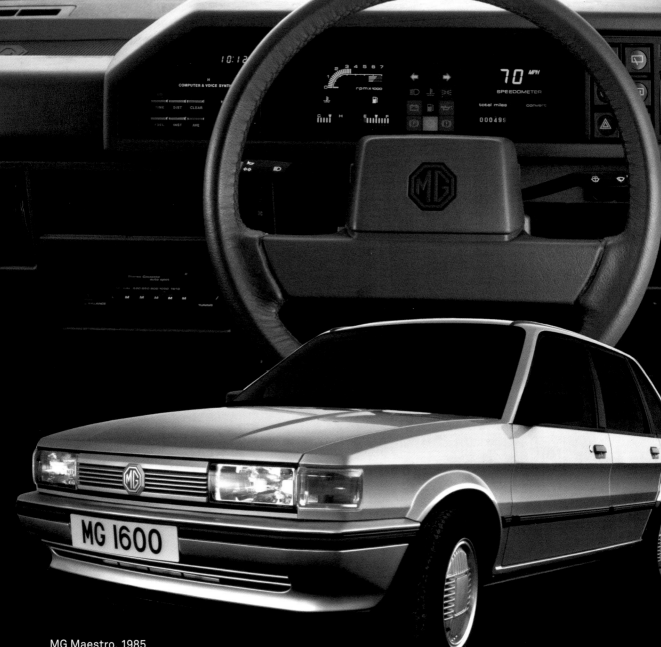

MG Maestro, 1985

Last of the idiosyncratic Leyland products, the Austin Maestro showcased pure eighties aesthetics: integrated headlamps and bumpers; the unicolour paint contrasting with the glazed area's black surrounds. Inside, you would find a triumph of quartz aesthetics and a talking computer.

Das letzte der eigensinnigen Leyland-Produkte, der Austin Maestro, zeigt pure Achtziger-Ästhetik: Individualscheinwerfer und Integralstoßstangen; die Unifarblackierung kontrastiert mit den schwarz herausgearbeiteten Glasflächen. Innen triumphieren Quarzästhetik und ein sprechender Computer.

L'Austin Maestro, la dernière des productions Leyland originales, est l'incarnation de l'esthétique des années 80 avec ses phares individualistes et son pare-chocs intégré, tandis que la peinture monocolore contraste avec le noir des parties vitrées. L'esthétique tout quartz et un ordinateur parlant sont les vedettes de l'habitacle.

Alfa Romeo 164, 1987

Saab 9000, 1985

Fiat Croma, 1985

Lancia Thema 8.32, 1986

Charlie's four angels: the first glimmerings of modern platform thinking resulted in an international quartet. These cars shared the basic body shell and the windscreen: Fiat, Lancia and Saab even use the same four doors.

Vier Engel für Charlie: Die ersten Ansätze modernen Plattformdenkens resultieren in einem internationalen Quartett. Diese Autos teilen sich den Rohbau und die Windschutzscheibe; Fiat, Lancia und Saab sogar alle vier Türen.

Un trio à quatre : les premières approches du concept de plateforme sont mises en place par quatre constructeurs internationaux. Les voitures possèdent toute la même base et le même pare-brise. Fiat, Lancia et Saab et toutes les quatre-portes sont au rendez-vous.

BRUNO SACCO

Forty years at Mercedes-Benz can undoubtedly be considered a commendable career. As chief of design since 1975, Bruno Sacco has bestowed a style of sober, modern elegance on the cars with the star. The Italian completely relies on sustainability and develops a clear stylistic concept. His flagship model, the 1979 S-Class, renounced the baroque and bends with the wind. His magnum opus is the model W124 from 1985. It is easy to miss seeing anything special about it at first glance. But this is exactly Sacco's secret: the first E-Class reveals a varied, deep personality, eschewing extravagance. Depending on colour and the viewer's

Vierzig Jahre bei Mercedes-Benz können zweifelsfrei als vorbildliche Karriere gelten. Seit 1975 Designchef, verschafft Sacco den Fahrzeugen mit dem Stern einen von nüchterner, moderner Eleganz geprägten Stil. Der Italiener setzt dabei ganz auf Nachhaltigkeit und entwickelt ein klares Stilistikkonzept. Seine Visitenkarte, die S-Klasse von 1979, schwört dem Barock ab und neigt sich mit dem Wind. Sein Meisterwerk ist die Baureihe W124 von 1985. Gut möglich, dass man auf Anhieb nichts Besonderes zu erkennen vermag. Doch genau darin liegt Saccos Geheimnis:

Avec quarante ans passés chez Mercedes-Benz, on peut considérer sa carrière comme exemplaire. Désigné chef du design à partir de 1975, Sacco donne aux véhicules à étoile un style emprunt d'une élégance sobre et moderne. L'Italien mise sur la longévité et développe un concept stylistique clair. Sa carte de visite, la classe S de 1979 abjure le baroque et se penche avec le vent. Son chef d'œuvre, c'est la série W124 de 1985. A première vue, on ne remarque rien de particulier ; c'est justement là que réside le

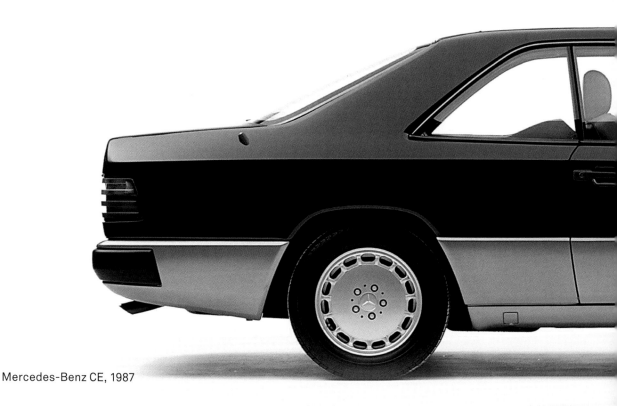

Mercedes-Benz CE, 1987

perspective, it is either humble or glamorous, robust or subtle, functional or emotional, stately or dynamic but, above all, capable, economical and constructionally almost flawless. The W124, shown here in coupé guise with the typical Sacco planks, is the ultimate automobile. More perfection—either on the inside or the outside—is simply not possible.

Ohne jegliche Extravaganz entfaltet die erste E-Klasse eine vielfältige, tiefsinnige Persönlichkeit. Je nach Farbe und Betrachtungswinkel bescheiden oder glamourös, robust oder fein, sachlich oder emotional, stattlich oder dynamisch – vor allem aber leistungsfähig, ökonomisch und konstruktiv nahezu perfekt. Der W124, hier in Coupé-Version mit typischen „Sacco-Brettern", ist das ultimative Automobil. Vollendeter – innen wie außen – geht es einfach nicht.

secret de Sacco : la première classe E est dotée d'une très forte personnalité sans toutefois donner dans l'extravagance. Selon la couleur et l'angle de vue, elle a une allure glamoureuse ou modeste, robuste ou fragile, sobre ou au contraire toute en émotion, imposante ou dynamique, mais elle est toujours performante, économique et de conception presque parfaite. La W124, ici en version coupé avec les fameuses protections de bas de caisse, est une voiture ultimative. Sans nulle doute la plus achevée tant dans les lignes extérieures qu'intérieures.

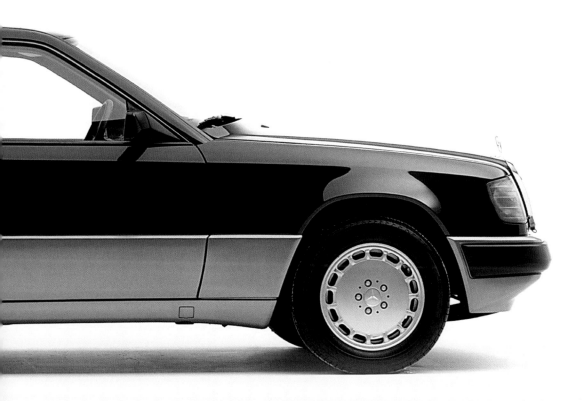

MERCEDES-BENZ

One cannot be traditional and
non-traditional at the same time.
Unless one's name is Mercedes-
Benz. Stylistically, the Stuttgart-
based company has always followed
a conservative course, with gentle
adjustments to prevailing tastes,
like during the *Wirtschaftswunder*,
when coy rear fins exuded a whiff
of Americana. Starting with the
'Baby Benz' in 1982, the engineers
in Stuttgart developed an entire
model family that followed a clear
pattern, both in terms of technol-
ogy and visuals: uncompromising
efficiency in technology and form.

Man kann nicht gleichzeitig tradi-
tionell und nichttraditionell sein.
Es sei denn, man heißt Mercedes-
Benz. Stilistisch folgen die Stutt-
garter seit jeher einer konservativen
Linie, mit sanften Anpassungen
an den jeweiligen Zeitgeschmack
— etwa als während des Wirt-
schaftswunders zarte Heckflossen
einen Hauch Amerika-Sehnsucht
verbreiten. Beginnend mit dem
„Baby-Benz" kreieren die Stutt-
garter ab 1982 eine ganze Modell-
familie, die technisch wie visuell
einem klaren Muster folgt: kompro-
misslose Effizienz in Technik und

Il est impossible d'être traditionnel
et de ne pas l'être tout à la fois. Sauf
si on s'appelle Mercedes-Benz. Sur
le plan du design, la firme de Stutt-
gart suit depuis toujours une ligne
classique qui sait s'adapter en dou-
ceur à l'air du temps. Ainsi pendant
le boom économique, elle adopte
de sobres ailerons arrière pour
servir le mythe américain. Avec la
« Baby Benz », Mercedes conçoit à
partir de 1982 toute une famille de
modèles sur un principe technique
et esthétique clair basé sur une
efficacité radicale sur le plan de la
technologie et de la forme. Tandis

While the engineers were searching for a reduction in fuel consumption without affecting safety or robustness, yet were, at the same time, also aiming for the highest levels of driving dynamics, Sacco's designers adapted the marque's timeless style, thus making it more modern and unpretentious. This results in a new way of tailoring automobiles' clothes: three-dimensional, volumetric, complex. Mercedes-Benz does not strive for brash effects yet, but one effect is obvious: a shape that appears to be both sensuous and sensible.

Form. Während die Ingenieure Verbrauchssenkungen ohne Einbußen in Sicherheit oder Solidität ermöglichen, dafür aber höchste Fahrdynamik anstreben, adaptieren Saccos Designer den zeitlosen Stil des Hauses – und machen ihn gleichzeitig moderner und schlichter. Daraus resultiert eine neue Art, Automobilkleider zu schneidern: dreidimensional, volumetrisch, komplex. Noch strebt Mercedes-Benz nicht nach dem Effekt, und doch ist ein Effekt offensichtlich: Eine Form, die gleichzeitig sinnlich und sinnvoll wirkt.

que les ingénieurs réussissent à réduire la consommation sans nuire à la sécurité et la solidité, et visent une plus grande dynamique de conduite, les designers de Sacco adaptent le style intemporel de la maison pour lui conférer modernité et sobriété. La haute couture automobile évolue, les robes sont désormais tridimensionnelles, volumétriques et complexes. Si Mercedes-Benz ne cherche pas à faire de l'effet, il en fait néanmoins avec cette forme à la fois sensuelle et efficace.

Volkswagen Golf, 1997

VOLKSWAGEN

The Golf's fourth generation reached synthetic perfection. The number of components and, therefore, visible gaps, is reduced to a minimum. The tight fit, the uni-colour paint and the softly convex surfaces convey the impression of a car like a solid piece of cast metal that has been polished smooth by the wind. But there is no place for perfection in this world: hence the critics soon begin to describe the Golf IV simply as "boring".

Mit Erreichen der vierten Genera-tion erlangt der Golf synthetische Perfektion. Die Anzahl der Bauteile, und somit der sichtbaren Fugen, ist auf ein Minimum reduziert. Die schmalen Spaltmaße, die Unifarb-lackierung und die sanft konvexen Flächen erwecken den Eindruck eines Autos wie ein vom Winde poliertes, solides Stück gegossenen Metalls. Doch Perfektion hat keinen Platz in dieser Welt: oberflächliche Kritiker finden den Golf IV daher bald nur „langweilig".

La Golf de la quatrième génération fait la synthèse et atteint la perfec-tion. Le nombre de pièces et donc de joints visibles est réduit au maxi-mum. Les interstices plus minces entre les éléments, la peinture mo-nocolore et les surfaces légèrement convexes donnent l'impression que cette voiture est une solide pièce de métal coulée d'un bloc et polie par le vent. Mais la perfection n'est pas de ce monde : on juge parfois un peu trop rapidement la Golf IV ennuyeuse.

RETROPHILIA

Perfection comes at a price. Safe, economical, fast, comfortable, rational, long lasting: the automobile of the eighties was squaring the circle. It seemed to have everything—except a soul. The UK would, therefore, mock the 'Eurobox', the European cube. After using, forgetting and scrapping them, all of a sudden the old-time classics were rediscovered. These cars contained the kind of emotions that appeared to have been lost during the digital-aerodynamic age. Their design now appeared even more distinctive than ever. You were able to nonchalantly distinguish yourself from the masses on the way to the weekend. All over Eu-

Perfektion hat ihren Preis. Sicher, ökonomisch, schnell, komfortabel, rational, langlebig – das Automobil der Achtziger ist die Quadratur des Kreises. Es hat scheinbar alles – nur keine Seele. Großbritannien verspottet die „Eurobox", den europäischen Würfelwagen. Nachdem man diese verbraucht, vergessen und verschrottet hat, sehnt man sich plötzlich nach den Klassikern. In ihnen findet man die Emotionen, die im digital-aerodynamischen Zeitalter verloren gegangen schienen, wieder. Ihr Design erscheint unverwechselbarer denn je. So kann man sich nonchalant auf dem Weg ins Wochenende von der Masse abheben. Europaweit

La perfection a son prix. Sûre, économe, rapide, confortable, rationnelle, et durable – la voiture des années 80, bien qu'excellant sur tous ces tableaux, manque cruellement d'âme : la quadrature du cercle. Les Anglais ne s'y trompent pas, qui la surnomment railleusement l'« Eurobox », le cube européen. Inévitablement, on se sent alors pris d'une nostalgie pour les voitures classiques, oubliées et mises au rebut après de longues années de bons et loyaux services. En ces temps d'aérodynamisme et de numérique à tout va, elles nous font revivre une émotion qui semblait à jamais perdue. De par leur design plus unique que jamais, elles don-

Mercedes-Benz Coupé,
2010, 1956

The shape of a sweeping wing, which might still be remembered from the past, is supposed to win customers over emotionally.

Ein Kotflügelschwung, wie man ihn vielleicht noch kennt, soll helfen, den Kunden emotional für sich zu gewinnen.

Une aile un peu courbe comme autrefois : un peu de nostalgie peut aider à séduire le client.

rope, new magazines were whetting the public's appetite for the new cult objects: *AutoCapital* in Italy (from 1981), *Classic Cars* in the UK (1982), *Motor Klassik* in Germany (1984) and the French *Retroviseur* (1987). Due to this enormous interest, the value of vintage cars went through the roof.

INSTANT CLASSICS

The manufacturers sated the consumers' hunger for the exotic with a new marketing product, the instant classic: limited edition cars, driveable collector's items. Triggering this trend was the introduction, in 1982, of the extreme Group B rally cars, of which at least 200 examples needed to be sold per model. The Lancia Delta S4, the Peugeot 205 T16 and the Audi Quattro Sport were all part of this league. The Ferrari 288 GTO, a derivative of the series 308 GTB, was also developed with Group B in mind, but the category was banned in 1986,

machen neue Magazine Lust auf die neuen Kultobjekte: *AutoCapital* in Italien (1981), *Classic Cars* in Großbritannien (1982), *Motor Klassik* in Deutschland (1984) und die französische *Retroviseur* (1987). Anhand dieses geballten Interesses steigt der Wert für Oldtimer vom Keller in den Himmel.

INSTANT CLASSIC

Die Hersteller kontern den Hunger der Kunden nach Exotischem mit einem neuen Marketingprodukt: dem Instant Classic. Automobile in limitierter Auflage, fahrbare Sammlerobjekte. Auslöser des Trends ist im Jahre 1982 die Einführung der Gruppe-B für Rallye-Extremfahrzeuge, von denen mindestens 200 Exemplare verkauft werden müssen. Der Lancia Delta S4, der Peugeot 205 T16 und der Audi Quattro Sport gehören in diese Liga. Der Ferrari 288 GTO, ein Derivat des 308 GTB-Serienmodells, ist auch für die Gruppe B gedacht – doch diese wird nach einer Reihe dra-

nent à leurs propriétaires la possibilité de se démarquer avec nonchalance de la masse sur la route des départs en week-end. Dans toute l'Europe surgissent alors des magazines, comme *Retroviseur* en France, qui donnent envie de posséder ces nouveaux objets de culte. Résultat : les prix des voitures anciennes flambent.

INSTANT CLASSIC

Les constructeurs trouvent rapidement la réponse à cette envie d'exotisme et sortent un nouveau produit marketing : « l'instant classic ». Ce sont des séries limitées, des objets de collection prêts à être conduits. La tendance est déclenchée en 1982 avec la création de la compétition du groupe B pour les voitures de rallye extrêmes, laquelle est assortie de l'obligation pour le constructeur de sortir au moins 200 exemplaires du modèle en lice. On citera dans cette catégorie, la Lancia Delta S4, la Peugeot 205 T16 et l'Audi Quattro Sport. La Ferrari

Ferrari 288 GTO, 1984

Lancia Delta S4, 1985

after a number of dramatic accidents. Maranello was blessed with unexpected luck, since the new model's acronym referred back to the 1962 250 GTO. As that car's price had since risen above the one million mark, the rare remake was considered an interesting investment. Order books were, accordingly, bursting at the seams.

The Ferrari was immediately traded far above catalogue price. A similar situation arose with the Porsche 959, a performance-bred 911 with all-wheel drive, which, in 1986, was the world's fastest production car. Ferrari's F40 had already sold at auction for more than six times its original list price, while still being in almost unlimited production. It was not just the brutal and striking aesthetics and immense engines, but mainly their absolute uniqueness that justified these instant classics' prices. This made them rare sights on the road indeed. They were thus rendered 'virtual' au-

matischer Unfälle 1986 abgeschafft. Maranello hat Glück im Unglück, knüpft doch das Kürzel des neuen Modells an den 250 GTO von 1962 an. Da dessen Preise mittlerweile die Millionen-Marke erreichen, sieht man in der seltenen Neuauflage eine interessante Geldanlage. Ein ähnliches Schicksal widerfährt dem Porsche 959, einem hochgezüchteten 911 mit Allradantrieb, der 1986 das schnellste Serienfahrzeug der Welt ist.

Der Ferrari F40 wird noch während seiner Produktionszeit bei Auktionen gar auf ein Sechsfaches des Listenpreises taxiert. Neben ihrer brutal auffälligen Ästhetik und gewaltigen Motorisierung rechtfertigen die Instant Classics ihren Preis vor allem mit absoluter Einmaligkeit. Das macht sie zu extrem seltenen Erscheinungen auf der Straße. Sie sind somit „virtuelle" Automobile, die nicht wegen ihres Nutzens, sondern einzig wegen ihrer medialen Bedeutung gekauft werden.

288 GTO, dérivée du modèle de série, la 308 GTB, est également destinée à cette catégorie. Le suffixe rappelle la 250 GTO de 1962 dont le prix atteint désormais le million. Les clients y voient donc un placement financier lucratif. Les cahiers de commande sont pleins à craquer. Il en va de même de la Porsche 959, une 911 entièrement revisitée à transmission intégrale qui sera, en 1986, le véhicule de série le plus rapide du monde.

La Ferrari F40, alors en phase de production, sera même estimée en vente aux enchères à un prix six fois supérieur au prix de départ. Ces records s'expliquent facilement. En effet, les « instant classic », ces voitures à l'esthétique extrême et dotées d'un moteur hyper puissant sont surtout des pièces uniques extrêmement rares sur les routes. Les « instant classic » se meuvent dans la virtualité : on les achète davantage pour ce qu'elles représentent que pour ce à quoi elles servent.

Porsche 959, 1986

Ferrari F40, 1987

tomobiles, which were bought not for their convenience, but simply because of their media meaning.

RETRO

In 1989, a Japanese car changed the rulebook of automotive design. The gorgeous Miata/MX-5 brought with it all you could dream of: an emotive shape and the driving experience of a classic, coupled with the reliability and usability of a new car. Its style was strongly reminiscent of the classic British roadster—above all the Lotus Elan—and yet it had a fresh, contemporary and unique personality of its own. The European manufacturers were angry at the supposed rip-off, but the public loved it: the MX-5 quickly became the bestselling roadster of all time. At first, it was described as yesterday's shape, without any measurable added value. But the customers' acceptance could not be denied. The secret behind it was that the retro con-

RETRO

Ausgerechnet ein Japaner ändert 1989 die Spielregeln des Automobildesigns. Der bildhübsche MX-5 bringt all das mit, wovon jeder träumt: eine emotionale Form und das Fahrgefühl eines Klassikers, jedoch – und das ist das Revolutionäre – gekoppelt mit Zuverlässigkeit und Alltagstauglichkeit eines Neuwagens. Sein Stil erinnert stark an den des Lotus Elan, und dennoch weist er eine frische, zeitgemäße und unverwechselbare Persönlichkeit auf. Die europäischen Hersteller ärgern sich über das mutmaßliche Plagiat, doch die Akzeptanz der Kundschaft ist unübersehbar. Das Geheimnis dahinter ist, dass sich ein mittlerweile reifer Kunde im Retro-Kontext seines Autos plötzlich wieder jung fühlen darf. Langsam aber sicher entdecken die europäischen Marken ihre eigene Tradition wieder und fahren „back to the future". Porsche präsentiert 1993 die Studie Boxster. Statt kühler Perfektion der Formen bietet

LE RÉTRO

En 1989 ce n'est autre qu'un Japonais qui réinvente les règles du jeu du design automobile. Jolie à souhait, la MX-5 a tout ce dont on puisse rêver. Des lignes toutes en émotion et la sensation d'être au volant d'un classique. Sûre et pratique au quotidien, elle présente d'autre part tous les avantages d'une voiture neuve. Même si, par son style, elle peut rappeler la Lotus Elan, fraîche, bien de son temps, elle est unique en son genre. Les constructeurs européens ont beau crier au plagiat, la clientèle la plébiscite. Le secret de la réussite du style rétro réside dans le fait que le client arrivé à un âge mûr plongé dans l'ambiance nostalgique de sa voiture se sent à nouveau jeune.

Lentement mais sûrement, les marques européennes redécouvrent elles-aussi leur propre tradition et effectuent leur « retour vers le futur ». Porsche présente en 1993 la concept car nommée

Mazda MX-5 Miata, 1989

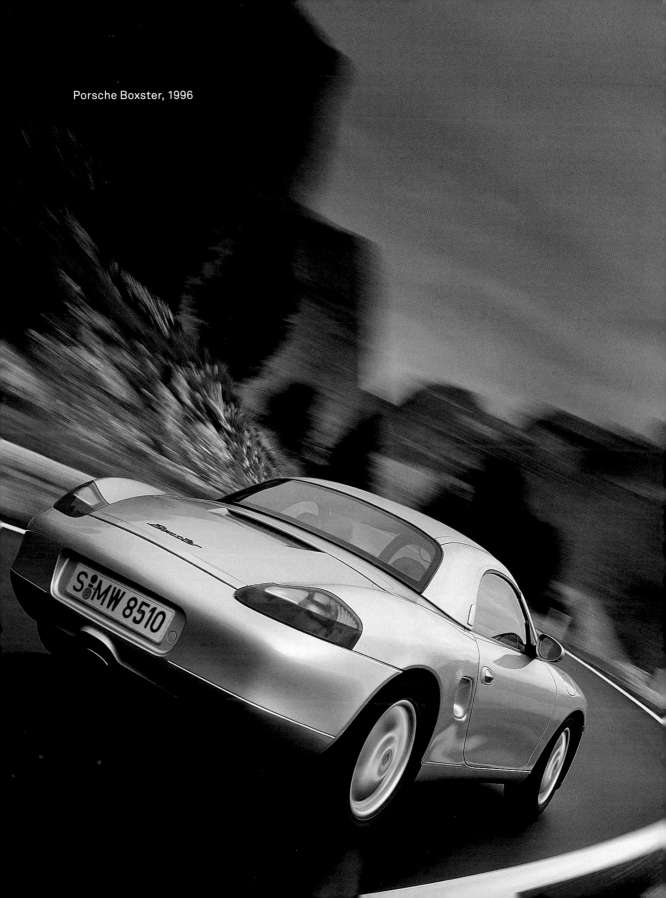

Porsche Boxster, 1996

text allowed a by-now seasoned customer to suddenly feel young again. Slowly but steadily, the European marques rediscovered their own traditions and drove 'back to the future'. In 1993, Porsche unveiled the Boxster concept car. Instead of cold Teutonic perfection, it offered smooth wings and sinuous lines. The 550 Spyder and the Speedster of the fifties were remote inspirations, combined with modern hi-tech. A spoiler, automotive sex symbol of the seventies, would only disrupt the period picture: so the aerodynamic wing is only ever electronically deployed on demand. The same year, Jaguar introduced the XK8: based on the radical XJ-S, it exhibited a body modelled in the style of the E-Type. Retro design makes the new appear old— and familiar at the same time. This kind of design does not need to be explained: its philosophy is to enable the customer to once again breathe in the "scent of the marque", as Alfa Romeo's head of styling, Walter de'Silva, ex-

diese sahnige Kotflügel und schwungvolle Linien. Die ferne Inspiration bilden der 550 Spyder und der Speedster der Fünfziger, kombiniert mit modernem Hi-Tech. Ein Spoiler, automobiles Sexsymbol der Siebziger, würde da das Gesamtbild stören, weswegen eine aerodynamische Hilfe nur bei Bedarf elektrisch ausgefahren wird. Im selben Jahr wird der Jaguar XK8 vorgestellt: auf der Basis des radikalen XJ-S fährt er mit einer im E-Type-Stil modellierten Karosserie vor. Im Retrodesign wirkt Neues alt – und gleichzeitig auch vertraut. Derartiges Design muss man nicht erklären, denn seine Philosophie ist es, den Kunden den „Duft der Marke" atmen zu lassen, wie Alfa Romeo-Chefdesigner Walter de'Silva erklärt. So ist es auch ein Besuch im Museum, der als Inspiration des 156 von 1997 dient: Auf seiner Front thront nämlich Alfas klassischer Scudetto, außerdem ist sein Körper weich und muskulös gebaut, mit nun wieder reduzierten Glasflächen und zu

Boxster. La froideur de la perfection fait place à la douceur des lignes et à la générosité des ailes. La même année Jaguar lance la XK8. Construite sur la base de la radicale XJ-S, elle est parée d'une carrosserie conçue sur le modèle de la Jaguar Type E. Avec le style rétro, le neuf prend des airs d'ancien et nous paraît familier. Le style rétro, comme le souligne Walter de'Silva, directeur du design chez Alfa Romeo, n'a pas besoin d'être expliqué, le client doit respirer l'esprit de la marque. Voilà en quoi réside toute sa philosophie. C'est d'ailleurs dans un musée que lui viendra l'inspiration pour la 156 de 1997. Elle se caractérise par la reprise de la grille de calandre propre aux Alfas, le « scudetto » qui orne l'avant de la voiture. Son corps est souple et musclé, les surfaces de verre sont limitées et les phares arrière réduits à une petite fente lumineuse horizontale. La 156, avec ses citations revisitées des Alfas d'antan, plaît immédiatement.

Jaguar XK8, 1996

BMW Z8, 2000

plained. So it seems only logical that a visit to the museum served as the inspiration behind the 1997 Alfa 156: the classical Alfa *scudetto* sat regally on its nose, its body softly, yet muscularly built, with a once-again reduced window area and rear lights shaped like small, horizontal slits. The 156 was an immediate hit, thanks to its contemporary distillation of traditional Alfa style.

REMAKE

Marketing was quick to identify the retro style as an important branding weapon: after all, nobody does Porsche better than Porsche itself, hence the decision to revive the 911 legend instead of developing a successor. The 996 model, with its front end borrowed from the Boxster, appeared almost too evolutionary in this context. Its successor, bearing the internal name 997, returned to the round headlight design. It was a pure remake of the 911. The New Beetle, Mini, Jaguar S-Type,

einem kleinen, horizontalen Schlitz geformten Rückleuchten. Als zeitgemäßes Extrakt des Alfa-Stils weiß der 156 auf Anhieb zu gefallen.

REMAKE

Das Marketing erkennt im Retro-Stil ein wichtiges Alleinstellungsmerkmal: Schließlich kann niemand besser Porsche als Porsche selbst. Daher wird entschieden, anstatt einen Nachfolger zu entwickeln, lieber den Mythos 911 wiederzubeleben. Das Modell 996, mit dem Boxster entlehnter Spiegelei-Frontpartie, wirkt da schon zu evolutionär. Der Nachfolger, intern 997 genannt, kehrt gar zum runden Scheinwerferdesign zurück. Mit New Beetle, Mini, Jaguar S-Type, Range Rover und Fiat 500 häufen sich die Remakes. Davon sind nicht alle, dem Hollywood-Prinzip entsprechend, erfolgreich. Das liegt auch an kulturellen Unterschieden: Der New Beetle kommt gut an in den USA, da er dort für Rebel-

REMAKE

Le marketing, très vite, comprend que le rétro constitue un argument de vente majeur. En effet, qui à part Porsche est le plus à même de vendre le style Porsche. Plutôt que de chercher un successeur à la 911, le constructeur décide d'en faire revivre le mythe. Le modèle 996 avec son avant aux phares « style œufs sur le plat » emprunté au Boxster est considéré comme trop novateur. Le successeur, nommé en interne la 997, retourne aux phares ronds classiques. Avec la New Beetle, la Mini, la Jaguar Type S, la Range Rover et la Fiat 500, les remakes prolifèrent. Ils ne remportent pas tous le succès escompté en raison notamment des différences culturelles entre les pays. Ainsi, si la New Beetle connaît un vif succès aux Etats-Unis à cause de son image de rebelle collant bien avec l'indéfinissable esprit « think pink » qui y règne, les Allemands, eux, ne l'apprécient guère car elle leur rappelle les mornes années d'après-guerre. La

Alfa Romeo 156, 1997

Porsche Carrera 996, 1997

Range Rover and Fiat 500 joined the ranks of the epigones. In accordance with the Hollywood principle, not all of them turned out to be successes. This was partially due to cultural differences: the New Beetle caught on in the US, for there it stood (and still stands) for rebellion and a hard-to-define 'think pink'. Yet the Germans mostly remember the (rather bleak) post-war period and hence scorn the Beetle. Fifty years after the original, The 500, once upon a time a declaration of poverty, was benefiting from the fashionable 'Italy' trend. Only the Mini was still equally welcome everywhere. Its positioning as a lifestyle car was spot-on from the very beginning. The actual design quality of these cars played hardly any role when assessing them. Often they were just a stylistic game of master and apprentice: the designers simply wanted to measure up against the classic original. But any direct comparison is absurd, since the remakes look like elephants next to the

lion, für ein kaum definierbares „think pink" steht. Die Deutschen erinnert er hingegen an die (teilweise extrem triste) Nachkriegszeit. Der 500, einst Armutszeugnis, profitiert fünfzig Jahre später vom modischen Italien-Trend. Nur die Positionierung des Mini als Lifestyle-Objekt stimmt von Beginn an. In der Bewertung dieser Fahrzeuge spielt die tatsächliche formale Qualität kaum eine Rolle. Häufig handelt es sich bei ihnen nur um ein stilistisches Spiel, wie zwischen Schüler und Meister: Die Designer wollen sich am klassischen Vorbild messen. Aber ein direkter Vergleich ist absurd, wirken die Neuauflagen doch, neben die Originale gestellt, wie Elefanten. Trotzdem erscheint eine Reise zu viert im Cinquecento, früher alltäglich, heute ebenso unvorstellbar wie unnötig. Man kauft ein Image und gibt sich mit der eigenen Reflektion im Schaufenster zufrieden. Mit ihrem absolut postmodernen Ansatz verdeutlichen die Remakes die Wachstumskrise des

Fiat 500 autrefois signe extérieur de pauvreté profite de l'engouement pour l'Italie. Quant à la Mini, partout elle fait florès. Son positionnement comme élément de lifestyle était d'emblée une excellente idée. Les qualités esthétiques et formelles réelles de ces véhicules jouent un rôle tout à fait secondaire dans leur appréciation. Les remakes se prêtent à un exercice de style, les designers voulant se mesurer à leurs maîtres, les couturiers d'antan. D'où l'absurdité de vouloir comparer les unes avec les autres, les rééditions faisant littéralement figure de mastodontes par rapport à leurs modèles. Sans compter que voyager à quatre en Cinquecento, une entreprise des plus banales autrefois, paraitrait aujourd'hui tout aussi inconcevable qu'incongru. Plus qu'un moyen de transport, on achète une image dont le reflet dans la vitrine suffit à donner entière satisfaction à son propriétaire. Par leur postulat foncièrement postmoderne, les reprises font la démonstration du

Mini Cooper, 2001

Fiat Cinquecento, 2007

Volkswagen New Beetle, 1997

originals. Today, the idea of four people going on a vacation in a Cinquecento, which was commonplace in the past, appears both hard to imagine and unnecessary. After all, you buy an image and are satisfied with just its reflection in the shop window. The remakes' postmodern approach highlights the growth crisis in automotive design at the turn of the century. The automobile now declares itself a classic: an infinite loop that started all over again in 2011, with the 'new' New Beetle.

NEW CLASSIC

The forms of the golden years of 1955 to 1965 were stylised by the media and idealised without any kind of reflection. The decisive influences for that were Tom Ford, creative director at Gucci from 1994, and Tyler Brûlé, founder of *Wallpaper* magazine. Both propagated a glamorous interpretation of the classics, ranging from architecture, to

Automobildesigns zur Jahrtausendwende. Das Automobil erklärt sich selbst zum Klassiker. Eine Endlosschleife, die mit dem neuen New Beetle im Jahre 2011 von vorne abgespielt wird.

NEW CLASSIC

Die Formen der goldenen Jahre 1955–1965 werden zur Jahrtausendwende idealisiert und stilisiert. Maßgebend ist der Einfluss von Tom Ford, seit 1994 Kreativdirektor bei Gucci, und Tyler Brûlé, Gründer der Zeitschrift *Wallpaper*. Beide propagieren eine glamouröse Interpretation der Klassiker – von der Architektur über Mode bis zum Automobil. Das ist der ultimativ coole, globale Lifestyle. 1993 repliziert Charlize Theron in einem Werbespot für Martini die Jetset-Lebensart der Sechzigerjahre. Dazu gehören ein Ferrari Superfast und ein hölzernes Riva-Boot, das fortan als Referenz bei keinem Designprojekt fehlen darf. Es ist eine positive Kombination

ralentissement de la croissance qui domine le tournant du siècle. La voiture s'autoproclame modèle classique. Avec le lancement de la nouvelle New Beetle en 2011, l'histoire repart à zéro. La boucle est sans fin. On tourne en rond.

NOUVEAU CLASSICISME

Le design des années d'or de 1955 à 1965 fait actuellement l'objet d'une mise en scène médiale et d'une idéalisation pas toujours réfléchie. Tom Ford, directeur créatif chez Gucci à partir de 1994, et Tyler Brûlé, fondateur du magazine *Wallpaper* sont largement responsables de l'apparition de ce phénomène. Tous deux propagent, dans les domaines de l'architecture, de la mode et de l'automobile, cette vision glamoureuse des classiques réinterprétés promus au rang de signes ultimes de la coolitude du lifestyle global. C'est une heureuse synthèse du style, des symboles et des valeurs qu'il faut mettre en rapport avec le design des années glorieuses.

Volkswagen Beetle, 2011

fashion to the automobile. This was the ultimate in cool, global lifestyle. In 1993, Charlize Theron replicated the sixties' jet-set way of life in a Martini TV ad. Featured were a Ferrari Superfast and a wooden Riva boat, which from then on in became the ultimate reference for any design project. The boom years' design was associated with a positive combination of style, symbols and values. A profound knowledge of the classics is a given in certain circles, but a gradually more-insecure public finally found the orientation it had been longing for. Neoclassical aesthetics have informed the design of the finest automobiles ever since. Therefore, the sports car sector rediscovered the front engine layout, which had been considered outdated for a long time. Aston Martin made the best of this approach with the DB9. Once again, luxury limousines grew to feudal sizes and regained their 'Buckingham Palace' proportions. Pininfarina, the epitome of the classical car *coutu-*

aus Stil, Symbolen und Werten, die mit dem Design der Boomjahre in Verbindung gestellt werden soll. Eine ziemlich oberflächliche, monotone Botschaft. Die profunde Kenntnis der Klassiker wird in gewissen Kreisen vorausgesetzt, dadurch erlangt ein stilistisch unsicher gewordenes Publikum die ersehnte Orientierung. Neoklassische Ästhetik prägt fortan das Design der feinsten Automobile. Im Supersportwagenbereich wird die klassische Frontmotorkonstruktion, die lange als überholt galt, wiederentdeckt. Mit und nach dem DB9 macht Aston Martin das Beste daraus. Luxuslimousinen wachsen wieder zu feudaler Größe und erlangen ihre Buckingham-Palace-Proportionen zurück. Pininfarina verleiht dem Maserati Quattroporte V eine elegante Sportlichkeit. Bemerkenswert sind dabei die skulpturale Modellierung, sowie die Beibehaltung und Hervorhebung der klassischen Karosserieaufteilung mit klar gegliederter Front, flacher,

Mais le message est relativement superficiel et peu parlant. Dans certains cercles, on suppose trop facilement que le public a une connaissance approfondie des modèles classiques, pourtant même un public qui a perdu ces références retrouve ici cette tendance nostalgique. Dès lors le design des voitures les plus raffinées est empreint d'esthétique néoclassique. Dans le domaine des supercars, suivant la même logique, on redécouvre l'architecture classique de la motorisation avant considérée comme dépassée depuis de nombreuses années. Avec la DB9, Aston Martin en tirera le meilleur parti. Les limousines de luxe elles aussi s'allongent de nouveau et retrouvent des proportions dignes de Buckingham-Palace. Pininfarina, le grand couturier de voitures au sens classique du terme, dessine une Maserati Quattroporte V d'une superbe élégance sportive. Remarquables les formes sculpturales, le retour et l'accentuation de la composition classique de la

Riva Aquarama Special, 1972

rier, gave the Maserati Quattroporte V a sporty and elegant greatness. The sculptural modelling, as well as the retention and highlighting of the classical body layout with its clearly structured front, a flat, long bonnet and defined, sweeping wings, were noteworthy in this instance. Seldom is it more than just a reference that links old with new: a sweep in the wing, a vent or a headlight. Apart from that, these neoclassical automobiles benefit from an almost excessive use of a level of technological sophistication that opens completely new opportunities for composing panels and for choosing and combining materials. Occasionally breathtakingly beautiful, occasionally trivial: these cars are stylistically completely new, yet at the same time conceptually old. Innovation comes to a halt.

langer Motorhaube und definierten, geschwungenen Massen. Häufig ist es nicht mehr als ein Zitat, das Alt und Neu verbindet: ein Schwung im Kotflügel, ein Lufteinlass oder eine Rückleuchte. Davon abgesehen, profitieren die neoklassischen Fahrzeuge von einem geradezu verschwenderischen Umgang mit technischen Raffinessen, die völlig neue Möglichkeiten, Bleche zu komponieren sowie Materialien zu bestimmen und zu kombinieren, erlauben. Mal wunderschön, mal bieder: Diese Automobile sind gestalterisch neuartig und konzeptionell alt. Innovation im Stillstand.

carrosserie marquée par une structure avant claire, un capot moteur long et bas et des ailes aux courbes bien définies. Bien souvent, l'ancien et le neuf ne partagent rien de plus que des citations éparses – ici, la ligne courbe des ailes, là, une prise d'air ou encore un phare arrière. Les néoclassiques tirent néanmoins profit d'une attitude dispendieuse vis-à-vis des raffinements techniques qui apportent de toutes nouvelles possibilités quant au modelage de la tôle, au choix et à l'assemblage des matériaux. Parfois sublimes, parfois ennuyeuses, ces voitures allient forme novatrice et conception désuète. L'innovation est au point mort.

Maserati Quattroporte, 2003

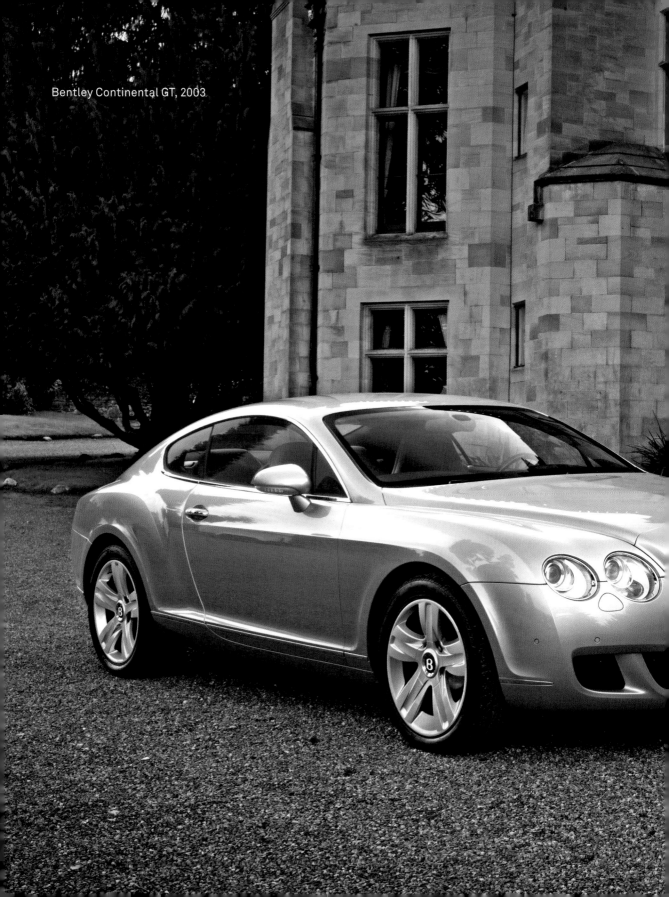

Bentley Continental GT, 2003

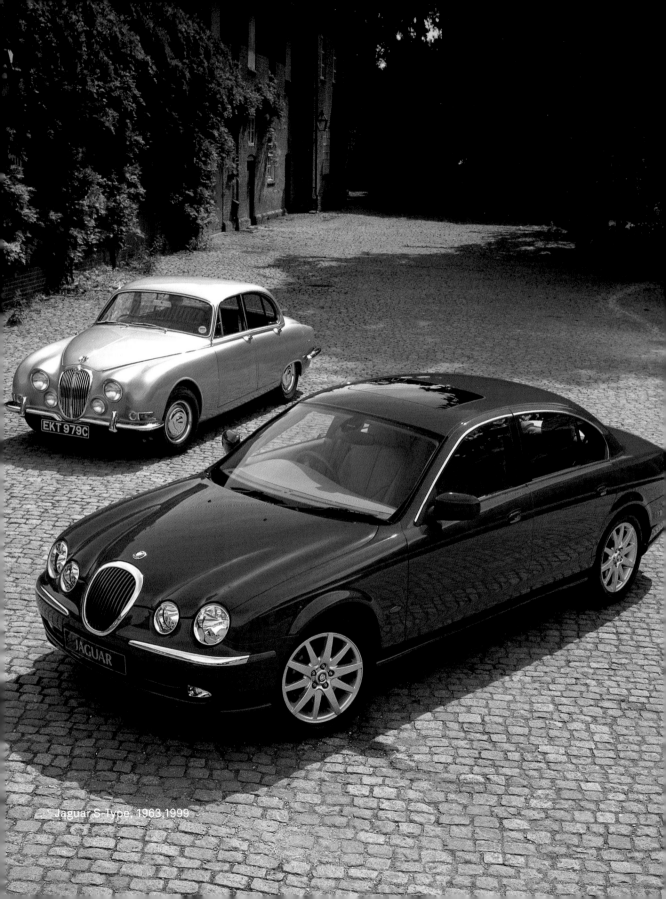

Jaguar S-Type, 1963,1999

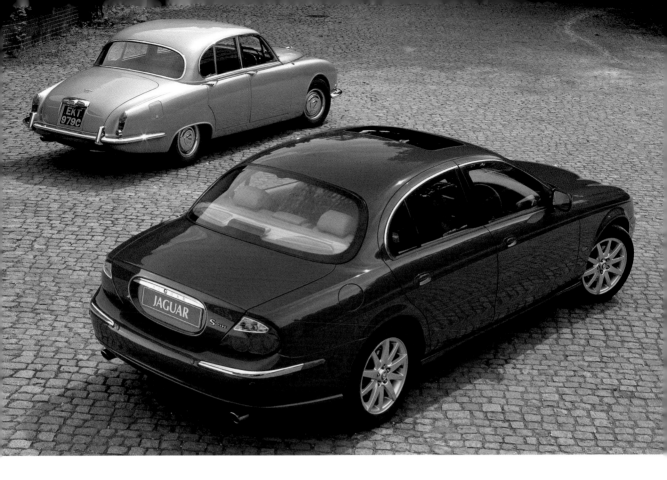

GEOFF LAWSON

For the first time in history, Jaguar wanted to return to its roots, with, of all people, a fan of American sports cars at the helm of the design department. Geoff Lawson's design strategy was based on heritage reloaded. But such a tradition never really exists, it can only be formally idealised. Like many experiments of this kind, the 1998 S-Type is nothing more than a remake. Esthetically pleasing, but never quite as right as the original. For romantics, though, that is more than enough.

Ausgerechnet mit einem Fan amerikanischer Sportwagen an der Designspitze will Jaguar zu seinem Ursprung zurückfinden. Geoff Lawsons Strategie basiert auf einem Alleinstellungsmerkmal: wiederbelebte Tradition. Doch eine solche Tradition existiert in Wahrheit nicht, sie kann nur idealisiert werden. Wie andere Experimente dieser Art, ist auch der 1998er S-Type pures Remake. Nicht annähernd so gut wie das Original, aber perfekt für Romantiker.

Avec un fan de voitures de sport américaines à la tête du Design – et ce n'est pas un hasard –, la marque veut en revenir à ses origines. La stratégie de Geoff Lawson repose sur l'idée de redonner vie à la Jaguar d'antan. Mais une telle tradition n'existe pas, c'est un mythe. Comme beaucoup d'autres expériences, la Type S de 1998 n'est qu'un remake. Malheureusement, l'idéalisation esthétique n'est jamais si bonne que l'original. Et bien, pour des Romantiques ça suffit.

Maserati Quattroporte, 2003

Lancia Ypsilon, 2003

Land Rover Range Rover, 2011

Mini Clubman, 2007

Nice details such as the split door
have returned and in addition
there is a practical lifestyle door on
the side: yet the suckling pigs have
no space in here anymore.

Schöne Details wie die geteilte
Heckklappe sind wieder da, dazu
gibt es seitlich eine praktische
Lifestyletür: trotzdem haben die
Spanferkel keinen Platz mehr.

De jolis détails comme le hayon en
deux parties resurgissent. A noter
également : la porte latérale très
pratique et très lifestyle.

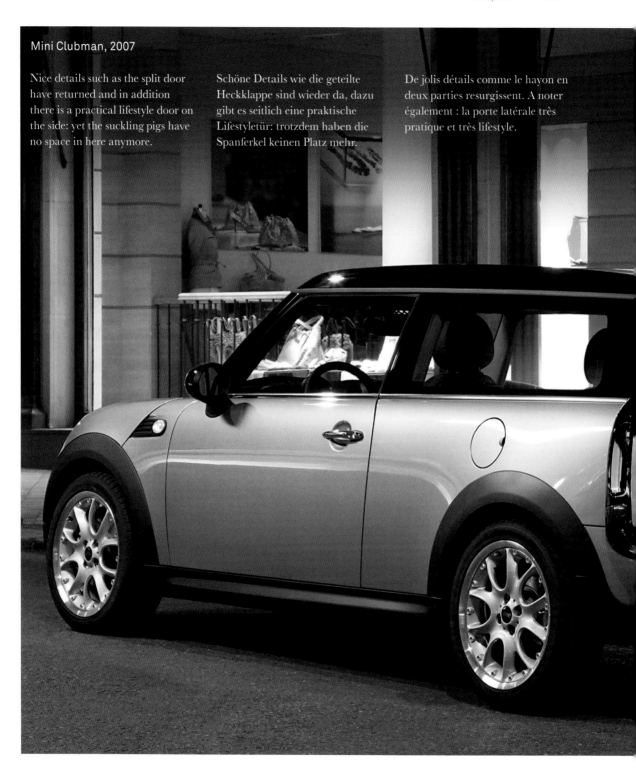

ASTON MARTIN

'New Classic' is establishing itself as the ideal for superior driving style: the long bonnet, the flowing roof and the short tail of the classic sports car of the sixties distinguish the slender outlines of the newest generation of Aston Martins. However, its imposing proportions, dynamic lines and clean modelling are equally contemporary and timeless. The New Classic automobile is becoming the timeless symbol of its own heritage.

New Classic setzt sich als Ideal des gehobenen Fahrstils durch: Die lange Haube, das fließende Dach und das kurze Heck eines klassischen Sportwagens der Sechziger charakterisieren das schlanke Outfit der Aston Martins neuester Generation. Trotzdem sind die bulligen Proportionen, die dynamische Linienführung und die saubere Modellierung genauso unverkennbar zeitgemäß wie zeitlos. Das New-Classic-Automobil wird zum zeitlosen Symbol des eigenen Erbes.

Le new classic s'impose comme l'idéal d'un style de conduite haut de gamme : le capot allongé, le toit plongeant, le hayon court d'une voiture de sport classique des années 60 caractérisent l'outfit élancé de l'Aston Martin nouvelle génération. Ses proportions imposantes et trapues, ses lignes dynamiques et son modelé clair la rendent unique, à la fois moderne et intemporelle. La voiture New Classic devient le symbole intemporel de son patrimoine.

Aston Martin V8 Vantage, 2005

Aston Martin Rapide, 2009

Mercedes-Benz SLS AMG Desert Gold, 2009

BRANDORAMA

The eighties came to an end with a number of spectacular events. In 1989, the Iron Curtain was torn down and Germany stood on the brink of re-unification. During the nineties, the establishment of the European Community, the final opening of the markets and plans to introduce the Euro were underway. Mobile phones and the internet launched a 'New Economy' that promised every citizen their own little place in the sun. A wave of happiness and enthusiasm— as well as irrationality—was sweeping the automotive sector along. The success of the Japanese car industry, which in the meantime has become the world's biggest, was particularly impressive, especially as the Japanese were able to produce better cars more cheaply. In their book *The Machine That*

Die Achtziger enden mit spektakulären Ereignissen. 1989 fällt der Eiserne Vorhang, Deutschland wird wiedervereint. In den Neunzigern schreiten dann die Gründung der Europäischen Union, die endgültige Öffnung der Märkte und die Planungen zum Euro voran. Mobiltelefonie und das Internet begründen eine New Economy, die jedem Bürger seinen kleinen Platz an der Sonne verspricht. Es ist eine Welle der Freude, des Enthusiasmus und auch der Unvernunft, die die Automobilbranche mitreißt. Dabei beeindruckt der globale Erfolg der japanischen Autoindustrie, die mittlerweile die größte der Welt ist. Im Buch *The Machine That Changed the World* lüften MIT-Forscher das Geheimnis japanischer Lean Production und zeigen, wie schlecht es im Gegensatz

Les années quatre-vingt se terminent par des évènements spectaculaires. Le rideau de fer tombe en 1989, l'Allemagne est réunifiée un an après. Les années quatre-vingt-dix sont marquées par la fondation de l'Union européenne, l'ouverture définitive des marchés et la planification de l'euro. La téléphonie mobile et Internet créent une « Nouvelle économie» qui promet à tous les citoyens une place au soleil. Il s'ensuit une vague de joie, d'enthousiasme mais aussi d'irrationalité. Elle se propage au secteur automobile. Le Japon impressionne par le succès mondial de son industrie automobile devenue la plus importante et par un mode de production meilleur et moins cher. Dans le livre *The Machine That Changed the World*, les chercheurs

Citroën C-Airlounge, 2003

In view of the lustre of old piano lacquer, brands develop a whole new world-view.

Im Glanz alten Klavierlacks entwickeln Marken eine neue Weltanschauung.

Les marques développent une nouvelle vision du monde.

Changed the World, MIT researchers uncovered the secret of Japanese 'lean' production and showed how badly the Americans and Europeans were doing in contrast. The industry set a vast process of change in motion, beginning with design. From here on in, all considerations would concern the platforms: a technological package that can serve as the basis for the production of myriad models from different marques. This somewhat resembled a return to the system of body-on-frame designs, only this time, the industry was perfectly capable of cheaply producing any complex special model itself. Development times were reduced, as were product cycles: everything now was about production speed.

As a logical consequence of the eighties' market segmentation, a vast array of new market niches was identified. The results were ideal individual vehicles, perfectly adjusted to customers' tastes. But regrettably not all customers

dazu um Amerikaner und Europäer bestellt ist. Die Industrie setzt daher einen großen Veränderungsprozess in Gang und beginnt mit dem Design. Von nun an denkt man konsequent in Plattformen. Das bedeutet, dass eine technische Grundlage entwickelt wird, auf deren Basis eine Vielzahl von Modellen für unterschiedliche Marken realisiert werden kann. Das hat etwas von einer Rückkehr zum System der separaten Rahmenkonstruktion, nur ist die Industrie inzwischen selbst in der Lage, beliebig komplexe Sondermodelle günstig zu produzieren. Die Entwicklungszeiten reduzieren sich dadurch, die Lebenszyklen der Produkte ebenfalls – alles muss schnell gehen.

Als logische Fortsetzung der Marktsegmentierung der 1980er Jahre wird eine Unmenge neuer Marktnischen ausgemacht. Im Idealfall handelt es sich dabei um Individualfahrzeuge, die genau auf den Kundengeschmack abge-

du MIT dévoilent le secret de la « lean production » des Japonais et révèlent les difficultés des branches automobiles américaines et européennes. L'industrie réagit et met en branle un formidable processus de transformation qui commence par le design. Dès lors, on pense systématiquement en termes de plateforme : les constructeurs développent une solution technique de base à partir de laquelle ils peuvent réaliser de nombreux modèles pour des marques différentes. Cela semble renouer avec la tradition du châssis séparé, sauf que l'industrie est désormais capable de produire à elle seule et à faible coût des modèles spéciaux, même des plus complexes. Les temps de développement se réduisent, les cycles de vie des produits aussi – désormais, tout doit aller vite. Comme une suite logique à la segmentation du marché des années 1980, on assiste alors à une prolifération des niches et au développement de véhicules spécifiques adaptés aux goûts des

possess good taste. Purveyors of this increasingly branching product range were, at this point, just a handful of conglomerates, dominating the European market and growing well beyond its borders: Fiat of Italy; PSA and Renault of France and BMW, Daimler-Benz and Volkswagen of Germany. None of the big players were left in the UK. And the smaller ones were looking everywhere for shelter, which Saab found at General Motors and Volvo at Ford. Everybody was fighting everybody else. Ever-new product offensives shored up the global plans for growth.

Over a period of forty years, BMW had increased its range from four models to fifteen, Volkswagen from five to eighteen, Renault from six to seventeen and Mercedes-Benz from seven to eighteen. This kept the designers busy: the industry as a whole was changing on a dramatic scale. New design centres are opened all over the globe: Mercedes-Benz

stimmt sind. Doch leider weist eben nicht jeder Kunde einen guten Geschmack auf. Anbieter dieses immer verästelteren Produktangebots sind mittlerweile gerade mal eine Handvoll Großkonzerne, die den europäischen Markt beherrschen und über dessen Grenzen hinauswachsen: Fiat in Italien, PSA und Renault in Frankreich, BMW, Daimler-Benz und Volkswagen in Deutschland. In Großbritannien hingegen ist keiner der Großen mehr übrig. Und die Kleinen suchen überall Unterschlupf bei den Großen, so wie Saab bei General Motors und Volvo bei Ford. Jeder kämpft gegen jeden. Immer neue Modelloffensiven unterstützen dabei globale Wachstumspläne.

Binnen vierzig Jahren rüstet so BMW von vier auf fünfzehn, Volkswagen von fünf auf achtzehn, Renault von sechs auf siebzehn und Mercedes-Benz von sieben auf achtzehn Baureihen auf. Das hält die Designer auf Trab: Die gesamte Branche än-

clients… mais hélas, les clients n'ont pas toujours bon goût. Les fournisseurs de cette gamme de produits de plus en plus ramifiée, ce sont les grands groupes. Réduits à une petite poignée, ils dominent le marché européen et conquièrent le monde. Fiat en Italie, PSA et Renault en France, BMW, Daimler-Benz et Volkswagen en Allemagne. En Grande-Bretagne, cependant, aucun n'a survécu. Et partout les petits constructeurs cherchent à se réfugier chez les grands : Saab chez General Motors et Volvo chez Ford. C'est le combat de tous contre tous. Les plans de croissance mondiale sont boostés par une inflation de nouveaux modèles. En quarante ans, BMW passe de quatre à quinze séries de modèles, Volkswagen de cinq à dix-huit, Renault de six à dix-sept et Mercedes-Benz de sept à dix-huit. Les designers ont fort à faire ; le secteur dans son ensemble évolue énormément. Les groupes créent de nouveaux centres de design à travers

was first, establishing its US subsidiary in 1990. The designers themselves were increasingly being treated like football players: no longer loyal servants, they changed from employer to employer, leaving their traces everywhere. This led to a culture of contamination. In 1989, a breakthrough was made on the technological front, when Silicon Graphics introduced the first NURBS-based rendering system for Computer Aided Design (CAD), which was ready for the market in the nineties. Using the computer, curves and surfaces that would be very difficult to imagine—let alone mould by hand—could be created. New formal and design languages were defined, as these shapes grew directly in the third dimension. It was to be the undoing of the classic *Linea Pininfarina*. All of a sudden, this potent technological instrument enabled any designer to play with very complex shapes. And they were finally allowed to do so, too.

dert sich gewaltig. Überall auf der Welt entstehen neue Designzentren – den Anfang macht 1990 Mercedes-Benz mit einer USA-Dependance. Die Designer selbst werden allmählich wie Fußballspieler gehandelt: Sie sind keine treuen Diener mehr, sondern wechseln gerne den Arbeitgeber und hinterlassen überall ihre Spuren. Das hat eine Kultur der Kontamination zur Folge. Auf technischer Seite erfolgt 1989 ein Durchbruch, als Silicon Graphics das erste NURBS-basierte Renderingsystem für Computer Aided Design (CAD) präsentiert, das in den Neunzigerjahren einsatzreif wird. Am Rechner entstehen nun Kurven und Oberflächen, die per Hand nur bedingt denkbar und modellierbar gewesen wären. Weil diese Formen direkt in der dritten Dimension wachsen, werden neue Form- und Designsprachen definiert. Es ist das Ende der klassischen Linea Pininfarina. Dieses potente Technikinstrument ermöglicht es plötzlich jedem Designer, mit sehr komplexen

le monde – Mercedes-Benz ouvre la voie en 1990 avec la création de sa filiale américaine. Les designers eux-mêmes commencent à être traités comme des footballeurs : ils ne sont plus attachés à une seule marque, aiment changer de maison et laissent leurs empreintes partout où ils passent. Il en résulte une culture de la contamination. Sur le plan technologique, 1989 fait date : Silicon Graphics présente le premier système de rendu d'images basé sur NURBS destiné à la conception assistée par ordinateur (CAO) et qui sera au point dans les années quatre-vingt-dix. L'ordinateur permet la création de courbes et de surfaces difficilement imaginables et la conception de modèles à peine réalisables à la main. La possibilité de créer directement en troisième dimension engendre un nouveau langage esthétique et formel. C'est la fin de la Linea Pininfarina classique. Grâce à cet outil puissant, les designers peuvent expérimenter avec des

BMW Z1, 1989

NEW EMOTION

In 1989, a dream car was turned into reality: the BMW Z1. Its body, made of plastic panels, could be screwed together within minutes. The roadster's *pièce de résistance* were the doors that could be lowered at the touch of a button. A combined sense of space and driving, where innovation meets emotion. In 1993, Mercedes-Benz unveiled a concept car featuring a new face with twin round headlamps floating on the front elevation. The negation of the corporate design principle was becoming obvious when, two years later, a new E-Class, the family's backbone, adopted this new face, as an envoy of the newfound design freedom at Mercedes-Benz. In 1994, Fiat introduced the coupé for the niche: extreme, daring, bold. The wings sported artistic cuts à la Fontana, the front lights, behind bubble-shaped glass covers, appeared animalistically brutal, while the rear lights played a rampant game

Formen zu spielen. Und endlich lässt man sie das auch tun.

NEUE EMOTION

1989 wird ein Traumwagen zur Realität: der BMW Z1. Seine Karosserie aus Kunststoffpaneelen wird in wenigen Minuten zusammengeschraubt. Sahnestück des Roadsters sind auf Knopfdruck versenkbare Türen. Raumgefühl trifft auf Fahrgefühl, Innovation auf Emotion. Mit einer Coupé-Studie zeigt Mercedes-Benz 1993 dann ein neues Gesicht mit doppelten Rundscheinwerfern, die frei auf der Front liegen. Die Negation des dogmatischen Corporate-Design-Prinzips wird deutlich, als zwei Jahre später die E-Klasse, Rückgrat der Modellfamilie, dieses neue Gesicht übernimmt – als Bote der neuen Designfreiheit von Mercedes-Benz. Doch braucht man so etwas? Es ist eine gewagt romantische Entscheidung, die viele Stammtischdebatten anregt. 1994 präsentiert Fiat das Coupé für die Nische:

formes très complexes … et enfin, on les laisse faire.

DE NOUVELLES ÉMOTIONS

En 1989, une voiture de rêve devient réalité : la BMW Z1. Constituée de panneaux en plastique, la carrosserie peut être assemblée en un tour de main. La grande originalité de ce roadster, ce sont les portes escamotables par simple pression sur un bouton. La sensation d'espace s'unit au plaisir de conduire, l'innovation à l'émotion. En 1993, Mercedes-Benz présente un concept de coupé à la proue innovante avec ses doubles phares ronds désolidarisés. La négation du principe dogmatique de *corporate design* devient évidente, lorsque deux ans plus tard, la classe E, le pilier de la famille de modèles, reprend cette innovation – comme un messager de la nouvelle « liberté de design » décrétée par Mercedes-Benz. Mais a-t-on besoin de cette liberté ?

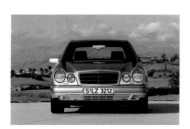

Mercedes-Benz E, 1995

with the tail's design. The year 1998 saw the first appearance of the Smart, based on an idea by the designer of the Swatch, Nicolas Hayek. The was characterised by a design in plastic that was both colourful and playful: Family Follows Fiction, just like the plastic collection by Alessi, the ultimate domestic trendsetter since 1991. A completely different direction was taken by Audi in 1998 with the TT: its shape was graphically purist, with a shade of symmetry: a volume of precise geometry, based on circles and semi-circles. As a conceptual *Ur*-Porsche, the Golf-based sports car established a new trend: the low-rider with cut-off rear and ultra low side windows. This created a new sense of intimacy with the car, which hid its driver in a most mysterious fashion. In car advertising, people were no longer to be seen at all: the car was the hero on its own, driving with tinted windows on seductively empty streets. It was Illusion vs. Real Life. The dream was turned into

extrem, mutig, gewöhnungsbedürftig. Die Kotflügel tragen künstlerische Schnitte à la Fontana, die Scheinwerfer wirken unter einer blasenartigen Glasverkleidung animalisch-brutal, während die Rückleuchten wild mit der Heckgestaltung spielen. 1998 tritt erstmals der Smart auf, basierend auf einer Idee des Swatch-Erfinders Nicolas Hayek. Das Mikromobil wird von buntspielerisch-plastischem Design charakterisiert: Family Follows Fiction – so wie die Kunststoff-Kollektion von Alessi, in den 1990ern ultimativer Trendsetter für den Haushalt. Eine ganz andere Richtung wählt Audi 1998 mit dem TT: Dessen Form ist grafisch-puristisch, mit einem Hauch Symmetrie. Ein statisches Volumen mit präziser, auf Kreisen und Halbkreisen basierender Geometrie. Der Sportwagen auf Golf-Basis begründet den Trend des Low-Riders mit abgeschnittenem Heck und ultraniedrigen Seitenfenstern. Das sorgt für eine neue Form von Intimität in einem

Cette décision, quelque peu romantique, est audacieuse. Elle suscite de nombreux débats et alimente la chronique. En 1994, Fiat, s'adressant à un segment de niche, présente son propre coupé : extrême, courageux, insolite. Les ailes portent des entailles artistiques à la Lucio Fontana, les phares cachés sous une sorte de bulle de verre évoquent la brutalité d'un animal, alors que les feux arrière flirtent gaiement avec la poupe. 1998, c'est la sortie de la Smart, sur une idée du créateur des Swatch, Nicolas Hayek. La micromobile se caractérise par son design visuel coloré et ludique, à l'instar de la « Family Follows Fiction », cette collection d'objets en plastique très tendance, créés en 1991 par Alessi pour la table et l'habitat. En 1998, Audi opte pour une toute autre direction avec la TT, dont la forme est graphiquement pure avec un soupçon de symétrie. Un volume d'une géométrie précise, basée sur des cercles et des demi-cercles. Ancêtre con-

Fiat Coupé, 1994

Audi TT, 1998

Smart City-Coupé, 1998

reality, reality into utopia. This led to the Paris Salon of 2008, where the GTbyCitroën was unveiled: originally designed for a video game, it would later be translated into physical reality.

CROSSOVER

The implementation of design freedom was noticeable not just in superficial terms. It also entailed the creation of new automotive ideas that were given the crossover tag: genetically manipulated design. One example was the 1993 Renault Twingo, a small car in the shape of a van and featuring the latter's qualities. The Twingo was an anti-automobile with anthropomorphic traits: its two frog-eye headlamps sat proudly on a bonnet that does not seem to be concealing an engine beneath it. The car swells behind the panoramic windscreen like a colourful soap bubble. Its appearance might be toy-like, but it was actually a pleasant, fun vehicle that would remain in production

Wagen, der seinen Besitzer auf geheimnisvolle Weise versteckt. In der Autowerbung sind Menschen mittlerweile überhaupt nicht mehr zu sehen: Das Auto allein ist der Held und fährt nun mit abgedunkelten Scheiben auf verführerisch leeren Straßen. Schein gegen Sein. Aus Traum wird Realität, aus Realität wird Utopie. So steht auf dem Pariser Salon 2008 der GTbyCitroën: Er wurde ursprünglich für ein Videospiel designt, bevor er später für den Menschen und die Realität gebaut wird.

CROSSOVER

Designfreiheit macht sich nicht nur oberflächlich bemerkbar. Mit ihr entstehen auch neue Automobilideen, die man Crossover tauft: genmanipuliertes Design. Renault präsentiert 1993 den Twingo, einen Kleinwagen in der Form und mit den Qualitäten eines Großraumfahrzeugs. Der Twingo ist ein Anti-Automobil mit anthropomorphischen

ceptuel de la Porsche, la voiture de sport inspirée de la Golf marque le début d'une tendance : celle des Low-Rider à la poupe tronquée et aux fenêtres latérales ultrabasses. Cela créé une nouvelle forme d'intimité dans une voiture qui cache son propriétaire de façon mystérieuse. Dans les publicités automobiles, on ne voit plus désormais ni conducteur, ni passager : la voiture est le seul héros. Et elle roule maintenant, avec des vitres teintées, sur des routes au vide séduisant. Le paraître contre l'être. Le rêve devient réalité, la réalité devient utopie. Présentée au mondial 2008 de Paris et conçue à l'origine pour un jeu vidéo, la GTbyCitroën n'échappe pas non plus à cette règle.

LES MULTI-SEGMENTS

La « liberté de design » ne se remarque pas seulement en surface. Elle s'accompagne d'un nouveau concept automobile, baptisé le crossover, un design

GTbyCitroën, 2008

for an astounding 14 years. Three years later, the van was interbred with the compact class. The resultant Mégane Scénic redefined the identity of the people carrier, based on children's spatial needs. Its round body, full of radii and curves, was exemplary of the first CAD era. Panels merge into each other, leading to a design language that was soon mocked as 'vanilla', because it is too soft, undefined and bland. In 1997, Mercedes-Benz revolutionised its own image with the first two cars not to follow the notchback dogma. The star brand's anti-Golf, the A-Class was truly design-free. It was a tall construction but, unlike Giugiaro's eighties predecessor, was detached from any rational design logic. Its body was deconstructed, with the classical components unidentifiable: its wings were non-panels located between other elements. The rear end's graphical treatment was also a surprise, since it featured zig zag-shaped panoramic rear windows meeting a curvy, wedge-

Zügen: Seine zwei Froschaugen thronen auf einer Haube, unter der man keinen Motor vermuten würde. Hinter der Panorama-windschutzscheibe bläht sich der Wagen wie eine bunte Seifenblase auf. Er wirkt wie ein Spielzeug, ist aber ein liebenswürdiges Spaß-mobil, das erstaunliche 14 Jahre in Produktion bleibt. Drei Jahre später wird das Großraumfahr-zeug mit der Kompaktklasse ge-kreuzt. Der Mégane Scénic defi-niert die Identität der Familien-kutsche mit dem Schwerpunkt Kinder(t)raum neu. Seine rund-liche Karosserie, voller Radien und Kurven, ist beispielhaft für die erste CAD-Ära. Die Bleche verschmelzen ineinander, was zu einer Designsprache führt, die bald als „90er-Vanilla" verspottet wird, da zu beliebig und zu brav. 1997 revolutioniert Mercedes das eigene Image mit den ersten bei-den Fahrzeugen, die dem Stufen-heck-Dogma bewusst nicht folgen. Wahrlich designfrei ist die A-Klasse, der Anti-Golf. Sie baut hoch, ist aber, anders als Giugia-

génétiquement modifié. En 1993, Renault présente la Twingo, un petit véhicule qui a la forme et les qualités d'un monospace. La Twingo est une anti-automobile aux traits anthropomorphes, avec ses yeux ronds malicieux posés sur un capot sous lequel on ne s'attend pas à trouver un moteur. Derrière le pare-brise panoramique, la voiture se gonfle comme une bulle de savon colorée. Elle a l'air d'un jouet, c'est une voiture ludique, amusante et sympathique, mais qui réussit l'exploit d'être produite pendant 14 ans. En 1996, on assiste au croisement du monospace et de la classe compacte. La Mégane Scénic redéfinit l'identité du carrosse familial en mettant l'accent sur l'espace enfant. Sa carrosserie ronde, toute en courbes, est typique des premières années de la CAO. Les tôles se fondent ; il en résulte un style de design, bientôt raillé sous le nom de « vanille des années 90 », car trop quelconque et trop sage. En 1997, Mercedes révolutionne sa propre image avec deux véhicules qui refusent déli-

Renault Twingo, 1992

Renault Mégane Scénic, 1996

shaped beltline. With the ML, Mercedes reinvented the SUV as a mass-market product: a cross-breed between van, off-roader and sports car. Metrosexuality meets automotive design. This giant four-by-four, made for urban driving, was the perfect fit for the kind of people who live and love ambivalently. And not just men. Ranging from retractable hard-top convertibles to coupé limousines, the crossover breed was constantly evolving in a realm somewhere between sensuality and senselessness. None of these cars offered substantial design quality, but this bad habit was in keeping with the mood of a society that believes in an extreme willingness to compromise as the recipe for a hassle-free life. Each and every crossover is a kind of grand coalition, giving the people the opportunity of not having to make commitments but, instead, of being able to have a bit of everything. These cars' extravagant utilisation profile also made them potential escape vehicles from an

ros Vorläufer aus den Achtzigern, losgelöst von rationaler Gestaltungslogik. Ihre Karosserie ist dekonstruiert, die klassischen Bauteile sind nicht mehr als solche erkennbar: Kotflügel sind Nichtbleche zwischen anderen Elementen. Die grafische Behandlung des Hecks überrascht, wo eine Panorama-Heckscheibe im Zick-Zack auf eine kurvig-keilförmige Gürtellinie trifft. Mit dem ML erfindet Mercedes das Sport-Utility-Vehicle in massentauglicher Ausführung neu: als Kreuzung zwischen Van, Gelände- und Sportwagen. Metrosexualität im Automobilbau. Dieser Riesengeländewagen für den Stadtverkehr passt zu jenem extravaganten Menschentypus, der ambivalent lebt und liebt. Darunter sind, wohlgemerkt, nicht nur Männer. Vom Stahldachcabrio bis zur Coupé-Limousine entwickeln sich die Crossover irgendwo zwischen Sinnlichkeit und Unsinn weiter. Keines dieser Fahrzeuge bietet substanzielle Designqualitäten. Doch das entspricht

bérément le dogme du tricorps. La classe A, l'anti-Golf, incarne littéralement cette « liberté de design ». Elle est construite en hauteur, mais libérée de toute logique de conception rationnelle contrairement à ses devancières des années quatre-vingt signées par Giugiaro. Sa carrosserie est déconstruite, les composantes classiques ne sont plus reconnaissables en tant que telles : les ailes sont ici des non-tôles parmi d'autres éléments. Même le traitement graphique de l'arrière surprend, où une vitre arrière panoramique part en zigzag à la rencontre d'une ceinture de caisse en pointe arrondie. Avec la ML, Mercedes réinvente le SUV, version produit de masse : un croisement entre la voiture de sport et le véhicule tout-terrain. C'est le premier cas de métrosexualité de l'industrie automobile. Cet énorme tout-terrain routier convient aux personnalités extravagantes, qui vivent et aiment de façon ambivalente. Ce n'est bien entendu pas limité aux hommes. Du ca-

Mercedes-Benz A, 1997

Mercedes-Benz ML, 1997

increasingly regulated everyday life. Because of this, limitations are willingly accepted, as the cars' compromised shapes meant that a certain amount of resilience was necessary for optimum indulgence. It is an irony of fate that the acceptance of a measurably inferior stylistic quality gave automotive designers the chance to experiment beyond any borders.

KING STYLING

The ever-increasing performance of computer software was enabling an increasingly complex ability to play with shapes that, in 1996, allowed Ford to formulate the first entry of 'New Edge' design. All of a sudden, peaks were sprouting at the meeting points of the circumferential curves, where in the past one would have expected round joints. Convex surfaces were sharpened by creases. No line was straight. The classic form was deconstructed by lines that had seemingly been drawn with the edge of a

in seiner Unart der Stimmungslage einer Gesellschaft, die in extremer Kompromissbereitschaft das Rezept für ein störungsfreies Leben zu finden meint. Sämtliche Crossover sind eine Art „große Koalition" und geben Menschen die Möglichkeit, von allem ein bisschen haben zu können. Mit ihrem extravaganten Nutzungsprofil sind sie auch potentieller Fluchtweg aus einem immer strenger regulierten Alltag. Dafür nimmt man Einschränkungen in Kauf, denn ihre kompromissbehaftete Form erfordert Nehmerqualitäten beim Genuss. Es ist eine Ironie des Schicksals, dass ausgerechnet die Akzeptanz einer messbar minderwertigen gestalterischen Qualität Automobildesignern die Chance verleiht, über alle Grenzen hinweg zu experimentieren.

KÖNIGSTYLING

Die immer leistungsfähigere Computer-Software erlaubt immer komplexere Formspiele, was

briolet à toit rigide au coupé, les multi-segments continuent à évoluer, hésitant entre sensualité et absurdité. Aucun de ces véhicules n'offre un design d'une qualité substantielle. Mais ce manque correspond à l'humeur d'une société qui croit trouver la recette d'une vie insouciante dans une disposition extrême au compromis. La plupart des crossover, comme dans une période de cohabitation, donnent la possibilité aux gens de ne pas être obligés de faire des choix et de disposer d'un peu de tout. De par leurs multiples capacités d'utilisation, ils représentent aussi une échappatoire possible à un quotidien de plus en plus strictement réglé. Le client est finalement prêt à accepter certaines limitations, d'autant que pour profiter de leurs formes tout en compromis, il faut disposer d'un sacré tempérament. L'ironie du sort veut que ce soit justement le succès d'un design de moindre qualité qui donne aux designers automobiles la chance d'expéri-

Mercedes-Benz SLK, 1997

Peugeot 206 CC, 2000

343

sword. New Edge design deliberately rejected established rules of composition: technical and functional necessities were no longer not top priority. But this New Edge was not particularly radical, since it did not challenge the concept itself. All that mattered was a charismatic appearance.

Almost too charismatic was the body of work of the *Créateur d'automobiles*, Patrick Le Quément, who was developing an overarching corporate design on behalf of Renault: this concept was intellectual, its form ornamental—and undeniably French. Leading the way was the 2001 Avantime coupé-van, followed, in 2002, by a brave implementation of a mass-market model, the Mégane II. Le Quément rejected the ordinary and presented a polarising, status-free, post-atomic automobile. Around the year 2000, 'polarising' was, in general, the automobile critic's word of choice. The question of beauty or ugliness was no longer at the core of the argu-

es Ford 1996 ermöglicht, mit dem Ka den ersten Ansatz jenes New-Edge-Designs zu formulieren. Am Treffpunkt der umlaufenden Kurven, wo man früher runde Verbindungen erwartet hätte, entstehen nun plötzlich Spitzen. Konvex gewölbte Flächen werden von Knickfalten geprägt. Keine Linie verläuft gerade. Die klassische Form wird missbraucht, wobei sämtliche Striche scheinbar per Säbelhieb gesetzt wurden. Das New-Edge-Design lehnt etablierte Gestaltungsregeln ab, technisch-funktionale Bedingungen werden zweitrangig. Doch New Edge ist kaum radikal, denn am Konzept selbst ändert sich nichts. Was zählt, ist einzig ein markanter Auftritt. Fast zu markant ist das Werk des „Créateur d'automobiles" Patrick Le Quément, der für Renault ein allumfassendes Markendesign entwickelt: vom Konzept her intellektuell, formal dekorativ – und unverkennbar französisch. Richtungsweisend ist der Coupé-Van Avantime von 2001, mutig die

menter tous azimuts et de faire reculer les frontières.

LE STYLE ROI

La montée en puissance des logiciels permettent des jeux de formes toujours plus complexes. Ford en profite et définit en 1996 avec la Ka sa première approche de ce Design New Edge, repris ultérieurement par toute l'industrie européenne. Au point de rencontre des courbes circulaires où on aurait pu s'attendre à des articulations rondes, ce sont des pointes qui apparaissent soudain. Des surfaces convexes se caractérisent par des plis. Aucune ligne n'est droite. La forme classique est déconstruite, dessinée à coups de crayons corsés. Le New Edge refuse sciemment les règles de conception établies ; les contraintes techniques et fonctionnelles passent au second plan. Mais le New Edge n'est pas radical, parce qu'il ne s'attaque pas au concept automobile en soi. Ce qui compte, c'est d'en imposer

Ford Ka, 1996

Ford Focus, 1998

ments, for design was now being judged in its own context, i.e. on the streets. 'Polarising' can even have a positive connotation: after all, it implies attracting the customer's attention.

And nothing was quite as polarising as the developments at BMW during the tenure of American design chief Chris Bangle, the most controversial car designer of modern times. His philosophy of 'flame surfacing' implied a fiery dynamisation of surfaces. Bangle's manifesto, the 2001 Concept X, mixed concave with convex, round with sharp, geometry with freedom. There were no singular lines anymore, but a firework display of lines, knots and surfaces that resulted in a particularly exciting design. The concave treatment of the 2003 BMW 5's panels was the pinnacle of this approach. Thanks to it, an overweight saloon suddenly appeared athletic again. The light units unfolded in all directions, the gaps ran freely across the body, cutting the met-

Anwendung auf ein Massenmodell, den Mégane II von 2002. Le Quément lehnt Typisches ab und präsentiert ein statusfreies Automobil, das polarisiert. „Polarisierend" ist um 2000 das neueste Lieblingswort des Automobilkritikers. Man argumentiert nicht mehr über schön oder hässlich, sondern bewertet Design im Kontext, also auf der Straße. „Polarisierend" kann sogar positiv interpretiert werden: Schließlich impliziert es die Aufmerksamkeit des Kunden.

Nichts polarisiert mehr als die Entwicklungen von BMW unter der Leitung des amerikanischen Designchefs Chris Bangle, des kontroversesten Automobildesigners der Neuzeit. Seine Philosophie des Flame Surfacing impliziert eine feurige Dynamisierung der Flächen. Bangles Manifesto, das Concept X von 2001, mischt Konkaves mit Konvexem, Rundes mit Spitzem, Geometrie mit Freiheit. Es gibt keine einzelne Linie mehr, sondern ein Feuerwerk von

par l'allure. L'œuvre du « Créateur d'automobiles » Patrick Le Quément chargé de repenser entièrement le *corporate design* de Renault est presque trop imposante: intellectuelle dans son concept, décorative dans son esthétique – et indubitablement française. Le coupé Avantime de 2001 donne le ton pour les futures voitures ; la Mégane II de 2002, courageuse, ose la série. Le Quément rejette tout ce qui est typique et présente une automobile libérée de son rôle statutaire, une voiture qui polarise. Apparu dans les années 2000, « polarisant » est le terme préféré de la critique automobile. On n'argumente plus sur la beauté ou la laideur, on évalue le design en contexte, donc dans la rue. « Polarisant » peut même être interprété de façon positive, puisqu'il implique l'attention du client.

Et rien ne polarise plus que les évolutions de BMW sous la direction du chef designer américain Chris Bangle, le designer

Renault Avantime, 2001

al in a most creative fashion. This came as a shock at first. Either too shrill or too intellectual: the fact is that the risks inherent in polarising design languages were quickly recognised. This led to a dilution of New Edge from 2004 onwards, while, in 2007, Renault imposed a rigorous design discipline on itself with the new Twingo, and BMW gradually reduced the force of its flames. In 2005, on the other hand, Volkswagen suddenly became fashionable with the all-new Passat.

BLING

Bangle's design language set a precedent. The automobile of the post-flame surfacing era was no longer a box, but a piece of meat with bones, tendons and muscles: a sometimes more tense, sometimes less, but always pulsating body. But revolution is usually followed by restoration: in the end, design must not be too original. As a consequence, every marque was now trying to be el-

Linien, Knoten und Flächen, aus dem eine besonders spannende Gestaltung resultiert. Als größter Wurf gilt dabei die konkave Behandlung der Bleche des 2003er 5er-BMWs. Durch sie wird eine übergewichtige Limousine wieder athletisch. Die Leuchteinheiten entfalten sich freiförmig in alle Richtungen, Fugen verlaufen mit ähnlicher Freiheit und durchschneiden das Blech höchst kreativ. Das schockiert zunächst. Tatsache ist, dass das Risiko polarisierender Designsprachen schnell erkannt wird. Das führt dazu, dass New Edge ab 2004 abgeschwächt wird, während Renault sich mit dem neuen Twingo 2007 eine rigorose Designdisziplin auferlegt und BMW allmählich die Kraft seiner Flammen reduziert.

BLING

Bangles Designsprache macht zwischenzeitlich Schule. Das Automobil der Post-Flame-Surfacing-Ära ist keine Box mehr,

automobile le plus controversé des temps modernes. Sa philosophie du « flame surfacing » implique une dynamisation des surfaces. Le manifeste de Bangle, le Concept X de 2001, mélange le concave au convexe, le rond aux pointes, la géométrie à la liberté. Il n'y a plus une seule ligne, mais un feu d'artifice de lignes, de nœuds et de surfaces, duquel résulte une forme particulièrement passionnante. Le traitement concave des tôles de la BMW série 5 de 2003 est considéré comme sa plus grande réussite. Grâce à lui, une berline trop lourde redevient sportive. Les unités lumineuses se déploient librement dans toutes les directions, les articulations s'étirent avec la même liberté et découpent la tôle de la façon la plus créative. Au début, ça choque. Polariser est devenu risqué. A partir de 2004, le style New Edge s'adoucit, tandis que Renault impose, avec la nouvelle Twingo 2007, une discipline rigoureuse au design et que BMW atténue progressivement le style

BMW X Coupé, 2001

BMW 5, 2003

egant, dynamic and progressive at the very same time. The overriding ideal was to be considered 'premium'. The search for a new happy medium was on, with everybody looking for it at the same time. This calibration of values was followed by the need to showcase one's own character. In 2004, Audi introduced its single frame grille, which broke the horizontal separation, did away with the bumper and created a new visual highlight. Audi's solution was even more brilliant, considering it was born out of necessity: new pedestrian crash-safety regulations made a higher front end inevitable. Together with the broad wings they created a huge area that needed to be given form. As a result, the modelling was becoming more complex: too much of a good thing, such as headlights and vents, was now just about enough. But these elements are mostly plain mock-ups, aimed at decorating the front end, evoking the fantasy of the big engine. The

sondern ein Stück Fleisch mit Knochen, Sehnen und Muskeln: ein mehr oder minder angespannter, stets pulsierender Körper. Auf Revolution folgt erfahrungsgemäß Restauration: Jede Marke will fortan elegant, dynamisch und progressiv sein. Vor allem aber eines: Hochwertigkeit ausstrahlen. Eine goldene Mitte wird gesucht, von allen zur gleichen Zeit. Diesem Werte-Abgleich folgt das Bedürfnis nach einer Hervorhebung des jeweiligen Markencharakters. Audi führt ab 2004 den Single-Frame-Grill ein, der die klassische horizontale Trennung bricht, die Stoßstange abschafft und einen neuen visuellen Höhepunkt kreiert. Neue Bestimmungen für den Fußgängerschutz erfordern schließlich eine höhere Front. Zusammen mit den breiten Kotflügeln entsteht so eine Riesenfläche, die gestaltet werden will. Daher wird die Modellierung komplexer – es darf von allem ein wenig mehr sein, angefangen mit den Scheinwerfern und Lufteinlässen. Meist sind dies

ardent du « flame surfacing ». En 2005, Volkswagen surprend avec sa nouvelle Passat qui dénote cette envie soudaine de rajouter du pep à ses créations.

LE BLING-BLING

Le style de Chris Bangle fait école. L'automobile de l'après « flame surfacing » n'est plus une boîte, mais un élément vivant, constitué de chair, d'os, de tendons et de muscles : un corps plus ou moins tendu, toujours palpitant. Mais l'expérience montre qu'une révolution est toujours suivie par une restauration : toutes les marques veulent dorénavant être élégantes, dynamiques et modernes. Mais avant tout : respirer la qualité. On cherche un nouveau juste milieu, et tous s'y affairent en même temps. Ce mouvement de rapprochement est suivi par le besoin de souligner son caractère. Audi introduit à partir de 2004 la calandre *single frame*, qui rompt la séparation classique horizontale, supprime le pare-chocs et

Audi A6, 2004

Volkswagen Passat, 2005

result is pure window dressing. The face of a Mercedes-Benz, for example, all of a sudden was exhibiting 17 separate design features, where Bracq's masterpieces made do with just five. In 2004, a Formula 1 cardboard nose was put on the SLK.

The Peugeot 407 gained an elongated Ferrari mouth, including headlights reaching well around the sides. Volkswagen stuck an ostentatious chrome panel on the front of the Passat, and, later, on every single model. It is the Euro adaptation of Buick's 'dollar grin', sixty years later. This led to an epidemic of 'bling' aesthetic (named after the title of a 1998 album by rapper B.G.), whose cultural heritage can be admired in the hip hop scene's glitter look, the garish aesthetics of football star David Beckham and his spice wife, Victoria (the posh duo of the noughties) and, last but not least, in MTV's successful *Pimp My Ride* reality TV show. Each and every model re-

jedoch nur Attrappen, die die Front, im Einklang mit der Phantasie vom großen Motor, dekorieren sollen. Das Resultat ist bloße Schminke. So weist das Gesicht eines Mercedes-Benz plötzlich 17 Designmerkmale auf, während Bracqs Meisterwerke derer nur fünf benötigten. 2004 wird dem SLK eine Formel-1-Pappnase aufgesetzt.

Der Peugeot 407 erhält ein langes Ferrari-Maul, samt weit in die Seiten ragender Frontscheinwerfer. Volkswagen setzt dem Passat – und später allen Modellen – ein plakatives Chromblech auf. Es ist die Euro-Adaption des „Dollar Grin" von Buick, sechzig Jahre später. Daraus entwickelt sich eine epidemische Bling-Ästhetik (nach dem Titel eines Albums des Rappers B.G. aus dem Jahre 1998), deren kulturelles Erbe im funkelnden Look der Hip-Hop-Szene, in der schrillen Ästhetik von Starfußballer David Beckham samt Spice-Gattin Victoria (dem Posh-Duo der Nullerjahre)

créé un nouveau sommet visuel. Brillante, la solution Audi est née de la nécessité engendrée par de nouvelles dispositions pour la protection des piétons exigeant un avant plus élevé. La proue redessinée et les ailes particulièrement larges créent de la surface qui demande à être aménagée. La modélisation se fait plus complexe, il faut un peu plus de tout, à commencer par les phares et les prises d'air. La plupart du temps, il s'agit d'éléments de décoration, de faux-semblants, censés illustrer la puissance de la voiture. Le résultat n'est que simple maquillage. Ainsi le visage d'une Mercedes-Benz présente soudain 17 caractéristiques de design alors que les chefs d'œuvre de Bracq n'en avaient que cinq. En 2004, on attribue un nez factice de Formule 1 à la SLK. La Peugeot 407 reçoit une longue proue de Ferrari qui arbore des phares avant débordant latéralement. Volkswagen applique à la Passat – plus tard sur tous les modèles – une plaque chromée

Mercedes-Benz SLK, 2004

Peugeot 407 Coupé, 2005

Mercedes-Benz R, 2005

ceived its 'bling lift'. Bling received its sublimation in the shape of the neat LED technology for rear lights and headlights, which now included an entirely new gadget: daytime running lights. At the same time, the interior glistened and glimmered like an Aladdin's cave: the metallic look (first seen inside the Audi TT) and body colour details of the Fiat coupé were adapted and misused.

Dreary silver paint was now supposed to upgrade the quality of even the nastiest plastics inside the cheapest small cars. Art deco clocks à la Maserati Biturbo were suddenly adorning ur-German hi-tech products. Bling was obviously going down well in the global market. More seductive than most can bear, these cars were positively screaming at the customer: desire me! Me…Me! Me! Me! Meanwhile, the European car manufacturing landscape, now consisting of 30 brands, 240 models and an end-

und nicht zuletzt in MTVs erfolgreicher Reality-TV-Serie *Pimp My Ride* bewundert werden kann. Jedes Massenmodell bekommt ein Bling-Lifting. Seine Sublimation findet Bling in der schmucken LED-Technik für Rückleuchten und Scheinwerfer, die nun ein neues Gadget umfasst: das Tagfahrlicht. Gleichzeitig glänzt und schimmert es im Innenraum wie in einer Kurzwarenhandlung: Der Edelmetall-Look, erstmals im Audi TT zu bewundern, und die Farblackoptik des Fiat Coupés werden adaptiert und missbraucht.

Trister Silberlack soll von nun an die Qualität des rauesten Plastiks im Billigauto aufwerten. Artdéco-Uhren à la Maserati Biturbo schmücken plötzlich urdeutsche Hi-Tech-Produkte. Auf dem globalen Marktplatz kommt Bling offensichtlich gut an. Verführerisch bis zum Umfallen, schreien diese Autos den Kunden förmlich an: Begehre mich! Die europäische Automobilhersteller-

ostensible. C'est la version européenne de la calandre à dents de Buick avec soixante ans de retard. Il en résulte une esthétique bling-bling (du nom d'une chanson du rappeur B. G. datant de 1998) contagieuse, dont on peut admirer l'héritage culturel dans le look étincelant de la scène hip hop, dans l'esthétique criarde de la star du foot anglais David Beckham et de sa Spice Girl d'épouse Victoria (le couple Posh&Becks des années 2000) et enfin surtout dans la série de télé-réalité à succès de MTV *Pimp My Ride*. Chaque modèle reçoit un lifting bling-bling – même Audi succombe à cette mode. Le bling-bling trouve sa sublimation dans l'étincelante technique LED pour les phares et les feux arrière, avec maintenant un nouveau gadget : les feux diurnes. Dans l'habitacle, même topo, ça brille et ça scintille de toutes parts : on use et on abuse du look métal précieux admiré pour la première fois dans l'Audi TT et de la finition noir laqué du coupé

Ford Ka, 2008

less number of variants, was brighter and more colourful than ever before. In the face of this, some customers might actually have to squint their eyes. Everything was meant to be mythical, yet the age of the great myth was already past.

landschaft ist währenddessen mit über 30 Marken, 240 Modellen sowie endlosen Modellvarianten so bunt wie noch nie. Da muss mancher Kunde die Augen zusammenkneifen. Mythos will alles und kann gleichzeitig nichts mehr sein.

Fiat. Sur les modèles bas de gamme, une triste peinture argent est censée rehausser la qualité de plastiques des plus simples. Les modèles haute technologie allemands se dotent de montres art déco comme sur les Maserati Biturbo. Sur le marché mondial, le bling-bling semble plaire. Séduisantes à en craquer, ces voitures lancent au client des appels, des « désire-moi » fort aguicheurs. Avec plus de 30 marques, 240 modèles et d'innombrables variantes, le paysage automobile européen est plus coloré et plus riche que jamais. De quoi en éblouir plus d'un !

Audi, 2010

Mercedes-Benz, 2010

Mercedes-Benz CLS, 2004

PATRICK LE QUÉMENT

Before he agreed to return to France as Renault's new chief of design in 1987, Le Quément set a clear precondition: he demanded maximum independence for the design department. This enabled him to push through such unique concepts as the Twingo and the Scénic. Under his reign, Renault managed, for the first time, to prescribe itself a consistent design identity. In accordance with the brand's innovative and democratic esprit, the *Créateur d'automobiles* focused on radical freedom. Mégane II, Vel Satis and Avantime are defined by unconventional lines that could only come from Paris. Emphasis is put on the roof, and hence the living space: panoramic, vertical, facetted. Neither aggressive nor bragging: yet again a Frenchman is advocating the revolutionary spirit.

Bevor er sich bereiterklärt, nach Frankreich zurückzukehren, stellt Le Quément 1987 klare Bedingungen: Er fordert eine maximal unabhängige Designabteilung. Das ermöglicht ihm, die ebenso einmaligen wie erfolgreichen Entwürfe für Twingo und Scénic durchzusetzen. Unter seiner Leitung verschreibt sich Renault erstmalig eine einheitliche Designidentität. In Einklang mit dem innovativ-demokratischen Esprit der Marke, setzt der „Créateur d'automobiles" auf radikale Freiheit. Mégane II, Vel Satis und Avantime sind geprägt von einer eigenwilligen Linie, wie sie nur aus Paris stammen konnte. Der Akzent wird auf das Dach, also auf den Lebensraum, gesetzt: panoramisch, vertikal, facettiert. Weder aggressiv noch angeberisch – der Franzose gibt sich wieder revolutionär.

Patrick Le Quément met des conditions précises à son retour en France en tant que chef designer chez Renault. Il exige que le département qu'il dirigera soit totalement indépendant. Il peut ainsi imposer des modèles uniques en leur genre et qui connaîtront un grand succès : la Twingo et la Scénic. Grâce à lui, Renault se dote pour la première fois d'une véritable identité en matière de design. En harmonie avec l'esprit de la marque qui se veut innovante et démocratique, le « Créateur d'automobiles » parie sur une liberté qu'il veut totale et inconditionnelle. La ligne des Mégane II, des Vel Satis et des Avantime relève d'un parti-pris stylistique qui ne pouvait venir que de Paris. Ni agressives ni prétentieuses, ces françaises se veulent à nouveau révolutionnaires.

Renault Mégane *II*, 2002

Ford Focus, 1998

Alfa Romeo 156 Sportwagon, 2000

Fashionable Second Life. An estate hides the rear door handle: the Sportwagon. Another car protects itself with wraparound plastic: the cross-country vehicle.

Modisches Second Life. Ein Kombi kaschiert den Griff der Hintertür: der Sportwagon. Ein anderer schützt sich rundum mit Kunststoff: der Geländewagen.

« Second Life ». Dans la famille des breaks, l'un cache la poignée de la porte arrière : le break sport. L'autre protège sa caisse avec une bande en caoutchouc : la voiture tout terrain.

Audi A6 Allroad Quattro, 2006

Ford S-MAX, 2006

The blended family standard: sporty livery, Kamm tail, variable interior, available in all sizes.

Die Norm für die Patchwork-Familie: sportliche Uniform, Kamm-Heck, variabler Innenraum, in allen Größen erhältlich.

La norme au sein de la famille recomposée : des uniformes sportifs, un hayon tronqué aérodynamique, un habitacle modulable et une disponibilité dans toutes les tailles.

Mercedes-Benz B, 2005

BMW Z4 Coupé, 2006

CHRIS BANGLE

In 2001, BMW design chief Bangle incurred the fury of the marque's traditionalists with the new 7 series. The ensuing model 5 and model Z4 were the subject of barely less-controversial public discussions. Bangle's 'Flame Surfaces' were actually progressive and up-to-date, if not in in all cases perfectly implemented. The American anticipated the bling aesthetic and employed new manufacturing technologies, in order to attain surprising solutions. Despite the malice, the entire competition was soon copying his concave surfaces, his sharp lines, his dynamics. Bangle must be delighted.

Im Jahre 2001 zieht BMW-Design-chef Bangle mit dem neuen 7er den Hass der Markentraditionalisten auf sich. Die folgenden 5er- und Z4-Modelle werden kaum weniger kontrovers diskutiert. In der Tat sind Bangles Flame Surfaces progressiv und zeitgemäß, wenn auch nicht ausnahmslos perfekt umgesetzt. Der Amerikaner antizipiert die Bling-Ästhetik und setzt auf neue Fertigungsmethoden, um zu überraschenden Lösungen zu gelangen. Trotz Häme kopiert die gesamte Konkurrenz bald seine konkaven Flächen, seine spitzen Linien, seine Dynamik. Bangle darf sich freuen.

En 2001 le chef designer de chez BMW, Bangle, s'attire l'animosité des traditionnalistes de la marque avec sa nouvelle BMW Série 7. De fait les flame surfaces de Bangle sont actuelles et novatrices, même si l'application qui en est faite n'est pas entièrement parfaite. L'américain anticipe l'esthétique bling—bling et a recours à de nouvelles méthodes de montage qui débouchent sur des résultats étonnants. L'ensemble de la concurrence copie néanmoins très vite ses surfaces concaves, ses lignes pointues, le mouvement qu'il donne à ses modèles. Bangle a de quoi se réjouir.

BMW

With the final design revolution, BMW demonstrated the power of the brand. Against the will of regular customers, and despite harsh criticisms, the Munich-based manufacturer implemented a design revolution that turned a German brand into a global brand. Not just dynamic in the development of the design, but also within the model range: depending on the model series and the intended target audience, one could find almost anything at BMW: classical elegance, brawny grandeur, bling extravagance or a mixture of everything.

Mit der endgültigen Designrevolution demonstriert BMW die Kraft der Marke. Gegen den Willen der Stammkunden und trotz starker Kritik, führen die Münchener eine Designrevolution ein, die aus einer deutschen eine globale Marke macht. Nicht nur dynamisch in der Designentwicklung, sondern auch innerhalb der Modellpalette. Je nach Baureihe und avisierter Zielgruppe findet man, trotz identischem Designprinzips, bei BMW alles mögliche: klassische Eleganz, bullige Erhabenheit, Bling-Extravaganz – oder eine Mischung aus allem.

À l'initiative de la révolution finale du design, BMW fait ainsi la démonstration de la puissance de la marque. Contre la volonté des clients habituels et malgré de fortes critiques, les Munichois font de BMW une marque mondiale. Ce n'est pas seulement le design qu'ils font évoluer mais toute la gamme de leurs modèles. Selon les séries et en fonction des clientèles-cible on trouve, malgré un design répondant à des principes identiques, tout ce qui est possible : une élégance classique, une prestance un peu lourde, une excentricité bling–bling … ou un mélange des trois.

BMW M3, 2008

BMW X6, 2008

Mercedes-Benz GLK, 2008

SUV

Sports Utility Vehicles are less automobiles and more of a cultural phenomenon. Their design concept reflects post-modern society's entire spectrum of fears. The almighty vehicle gives back a feeling of freedom to the urban prisoner, bestowing the assurance that they are well prepared for the next day after, or even for a climatic environmental disaster. Sitting safely inside, they float above the traffic. The SUV driver can see without being seen, and yet they crave admiration. Saloon, van and sports car all rolled into one: a car for the lady, as well as the (not necessarily gentle) man—SUVs are the post-nuclear family's castle. No matter if they are standing on a big or a small footprint, they are the automotive shape of the new millennium.

Das Sport Utility Vehicle ist weniger Automobil denn Kulturphänomen. Sein Designkonzept spiegelt alle Ängste der postmodernen Gesellschaft wider. Der allmächtige Wagen gibt den urbanen Gefangenen das Freiheitsgefühl zurück und verleiht ihm die Sicherheit, auf den Day-After oder die Klimakatastrophe vorbereitet zu sein. Darin geschützt, schwebt man über dem Verkehr. Man sieht, ohne gesehen zu werden. Und doch ersucht man um Bewunderung. Limousine, Van und Sportwagen in einem, genauso Frauen- wie Männerauto – SUVs sind die Burg der postatomischen Familie. Egal wie groß oder klein: Sie sind die Automobilform des neuen Jahrtausends.

Les véhicules utilitaires sportifs sont avant tout un phénomène socioculturel. Leur design reflète les peurs de la société post-moderne. Ultra-puissante, cette voiture donne aux urbains prisonniers du béton une sensation de liberté et leur permet d'être prêt à affronter les catastrophes climatiques ou autres. Bien protégé par l'habitacle surélevé, on a l'impression de dominer la circulation. On voit sans être vu. Et en même temps on cherche à provoquer l'admiration. Mélange de mini-van, de tout-terrain et de sportive, voiture dédiée à la gente masculine autant que féminine, les SUV sont des châteaux forts de la famille post-atomique. Quelle que soit leur taille, ils sont assurément le véhicule de cenouveau siècle.

Peugeot 308 SW Prologue, 2007

Ford Focus ST, 2011

Opel Insignia Sports Tourer, 2009

BLING

The automobile is less then the sum of its parts. The bling aesthetic results in details taking over control from the form. A front is just a grille and headlights. Everything is immanent, oversized, overwhelming. Nothing else. The rims grow, wheel arches are pumped up, headlights reproduce themselves, until 50 LEDs glitter inside one tail light: wings are turned into non-metal between tornado and character lines. The roof, the doors and the lids astonish with panoramic breadth. The entire car is one bumper, but nothing protects the jewel itself. The car is man's ornament—but man himself is not visible inside it anymore, as the windows now glisten black. And plastic glistens like chrome. Bling!

In der Bling-Ästhetik übernehmen die Details die Kontrolle über die Form. Eine Front ist nur Grill und Scheinwerfer: Alles immanent, übergroß, überwältigend, sonst nichts. Die Felgen wachsen, die Radkästen pumpen sich auf, die Scheinwerfer vermehren sich, bis in einer Rückleuchte 50 LEDs glänzen. Kotflügel werden zu Nichtblech zwischen Tornado- und Charakterlinien. Das Dach, die Türen und Hauben überraschen mit panoramischer Weite. Der ganze Wagen ist ein Stoßfänger, doch nichts schützt das Juwel selbst. Das Auto ist Ornament des Menschen – doch die Menschen selbst sieht man im Auto nicht mehr, denn die Scheiben glänzen nun schwarz. Und Kunststoff glänzt wie Chrom. Bling!

La voiture n'est pas toujours aussi importante qu'elle veut bien en avoir l'air. Dans l'esthétique bling-bling, les détails prennent le contrôle de la forme. La proue se résume à la calandre et aux phares. Tout est démesuré, surdimensionné, étourdissant. Mais à part ça ? Rien. Les jantes et les passages de roue prennent de l'ampleur, les phares se multiplient, le bloc optique accueillent jusqu'à 50 DEL. Les ailes deviennent des non-tôles qui hésitent entre les lignes tornado et les lignes de caractère. Le toit, les portes et le capot surprennent par leur taille. La voiture n'est que pare-chocs, mais rien ne protège le joyau. La voiture pare l'homme, alors même que celui-ci disparaît derrière des vitres teintées en noir. Le plastique brille comme du chrome … et toc : bling-bling !

Audi A8, 2010

Citroën C4 Picasso, 2006

Porsche Panamera, 2009

DRIVE OUT

During the noughties, the ideology of endless growth was omnipresent, and so it was in the automotive sector. As cars became ever cheaper to produce, they may as well just grow ever larger: a formidable selling proposition, outreaching any stylistic arguments. From now on the Mini would be as big as an old-generation Golf, the Golf as big as a Passat and the Passat as big as an S-Class. Only the S-Class was prohibited from growing far beyond its footprint of 5x2 metres, which is considered the European standard. Using the Maybach for a short trip to the supermarket would necessitate the use of two parking bays. But vertical growth was just as impressive and resulted in inhuman proportions and an inflated frontal area. The latter was, in a sense, the

Während der Nullerjahre ist die Ideologie des grenzenlosen Wachstums omnipräsent. Da sie in der Fertigung immer günstiger werden, dürfen Autos nun immer größer werden – jenseits aller Stildiskussion stets ein formidables Verkaufsargument für Jedermann. Fortan ist ein Mini daher so groß wie ehedem ein Golf, ein Golf so groß wie ein Passat und ein Passat so groß wie eine S-Klasse. Lediglich die S-Klasse kann kaum allzu weit jenseits der Standfläche von 5 x 2 Metern wachsen, die in Europa als Richtmaß gilt. Um mit dem Maybach kurz im Supermarkt vorbeizuschauen, braucht man zwei Parkplätze. Beeindruckend ist auch der Zuwachs in der Vertikalen, was unmenschliche Proportionen und eine aufgeblasene Stirnfläche zur Folge hat. Letztere ist so et-

Pendant les années 2000, l'idéologie de la croissance illimitée est partout – l'industrie automobile ne fait pas exception. La diminution des coûts de fabrication permet la construction de voitures toujours plus grandes. Cet argument d'ailleurs fonctionne très bien à la vente, et permet d'occulter tout jugement de goût. Dorénavant, la Mini est aussi grande que l'ancienne Golf, la Golf aussi grande qu'une Passat et la Passat aussi grande qu'une classe S. Au-delà de la S, il est difficile de faire plus grand car la surface au sol de 5 x 2 mètres est considérée en Europe comme niveau de référence standardisé. Pour aller faire ses courses en Maybach, il faudrait deux places de parking ! La croissance des voitures en hauteur est tout aussi impressionnante et les conséquences sont des

Škoda Vision D, 2011

New visions: after the storm,
everybody craves silence.

Neue Visionen: Nach dem Sturm
strebt jeder nach Ruhe.

Nouvelles visions : après la tempête
on recherche le calme.

footprint of the whole body. While a 1976 Ford Fiesta featured a frontal area of 1.7 sq. m., its 2008 successor's size had already grown to 2.1 sq. m., as much as an S-Class of the 1980s. This makes the compact car label seem relative indeed. This kind of over-dimensioning was partially due to safety concerns, but the all-in-one platforms also needed to be laid out for a very wide range of different engines. This resulted in the compact car easily achieving executive class performance: in the case of the Golf that meant a maximum of 235 HP or even 340 HP, like the BMW One series. Even base models' components needed to be able to cope with this amount of power. All things considered, the automobile had undoubtedly become more complex and powerful throughout. But that came at a price, one that caused unrest in Europe.

was wie das frontale Abbild der gesamten Karosserie. Während ein Ford Fiesta von 1976 es auf eine Stirnfläche von 1,7 qm bringt, sind es beim Nachfolger des Jahres 2008 bereits 2,1 qm geworden, so viel wie bei einer S-Klasse der 1980er Jahre. Die Bezeichnung „Kleinwagen" erscheint da relativ. Diese Überdimensionierung ist einerseits sicherheitsbedingt, andererseits müssen die Alleskönnerplattformen aber auch für sehr unterschiedliche Motorisierungen ausgelegt werden. So erreicht der Kompaktwagen leicht Oberklassenniveau: mit einer Leistung von bis zu 235 PS im Golf oder gar 340 PS beim BMW 1er. Auch die Bauteile der sparsamen Basismodelle müssen für diese Leistung dimensioniert werden. So ist das Automobil alles in allem durchweg komplexer und leistungsfähiger geworden. Doch das hat seinen Preis – und dieser sorgt in Europa für Unruhe.

proportions inhumaines et une proue surgonflée. Cette dernière est en quelque sorte l'image frontale de l'ensemble de la carrosserie. Alors qu'une Ford Fiesta de 1976 a une surface frontale de 1,7 m², son successeur en 2008 en est déjà à 2,1 m², autant qu'une classe S des années 80. Le terme « petite voiture » paraît ici très relatif. Ce surdimensionnement est, d'une part, lié aux exigences de sécurité, et de l'autre, au fait qu'une plateforme unique se doit d'accommoder plusieurs moteurs très différents. D'ailleurs à ce niveau, la voiture compacte s'apparente au haut de gamme : avec une puissance allant jusqu'à 235 ch pour la Golf ou même 340 ch pour la BMW Série 1. Dans ces conditions, les composants des modèles de base doivent obligatoirement avoir des dimensions en rapport. Bref, si dans l'ensemble, l'automobile est devenue plus complexe et plus puissante, cela a un prix – un

BMW 1972–2010

CORPORATE SOCIALITY

At the end of the decade, a string of events tarnished the prevailing sense of success. In 2008, oil prices skyrocketed towards the 140 dollar a barrel mark, an increase of 350% over the decade. In 2009, General Motors, the industry's paragon and, until 2007, the world's biggest car manufacturer, filed for Chapter 11 bankruptcy. That same year, the Obama administration invested billions into the development of electro-mobility. This undertaking was hotly contested, and not just after the Deepwater Horizon oil rig exploded in the Golf of Mexico in 2010, causing a gargantuan environmental catastrophe. In 2011, an earthquake almost led to nuclear disaster in Japan. At the same time, the emerging markets' boom continued without a hitch. Hundreds of millions of people were demanding an automobile, particularly in China, which had become the world's biggest producer and the

SOZIALDESIGN

Zum Ende des ersten Jahrzehnts des neuen Jahrtausends trübt eine Verkettung von Ereignissen das bisherige Erfolgsbild. 2008 schnellt der Ölpreis rasant der 140-US-Dollar-Marke entgegen, ein Plus von 350 % in zehn Jahren. 2009 mcldct General Motors, jahrelang Vorbild der Industrie und bis 2007 größter Hersteller der Welt, Insolvenz nach Chapter 11 an. Im selben Jahr investiert die US-Regierung unter Präsident Obama Milliarden in die Entwicklung der Elektromobilität. Dieses Vorhaben wird heiß diskutiert, nicht erst als 2010 im Golf von Mexiko die Plattform Deepwater Horizon explodiert, was eine Umweltkatastrophe zur Folge hat. 2011 führt ein Erdbeben in Japan fast zum nuklearen Desaster. Gleichzeitig boomen, weiterhin ungetrübt, die Emerging Markets. Hunderte Millionen von Menschen verlangen nach einem Automobil – auch und vor allem in

prix qui commence à poser problème en Europe.

DESIGN SOCIAL

En effet, à la fin des années 2000, une série d'évènements apporte une ombre au tableau, pourtant si prometteur. En 2008, le prix du pétrole s'envole vers la barre des 140 dollars US, soit une augmentation de 350 % en dix ans. En 2009, General Motors, qui jusqu'en 2007 était le plus grand constructeur au monde et faisait référence dans l'industrie automobile depuis des années, se déclare en faillite au titre du chapitre 11 de la loi américaine. La même année, le gouvernement américain sous la présidence d'Obama investit des milliards dans le développement de l'électromobilité. Survenue bien avant l'énorme catastrophe écologique entraînée par l'explosion en 2010 de la plateforme Deepwater Horizon dans le golfe de Mexico, cette décision fait l'objet d'intenses discussions. En 2011, un tremble-

most important automotive market, and on which manufacturers were now focusing a large proportion of their attention: even more so, given the increasingly crowded and consumption-weary nature of the European markets. NCAP stars and CO_2 levels, safety and environmental legislation, or, to be more precise, the fear of accidents and irreversible damage to nature were shifting—or slowing down—the economy. This meant that the big, heavy, flashy automobile was once again at the centre of social debate. Arson attacks on cars were becoming commonplace in the major cities of Germany. And if a prestige car happens to be parked outdoors, its driver may find a threatening—but professionally designed—post card with a not very subtle remark: "you park shit". Suddenly, the European manufacturers were grasping the equally fascinating and exciting complexity of the automotive society. The automobile's social acceptance was at stake. Its design

China, das zum weltgrößten Produzenten aufsteigt. Und zum wichtigsten Automobilmarkt, auf den die Hersteller nun einen Großteil ihrer Aufmerksamkeit richten. Vor allem, da sich die überfüllten europäischen Märkte gleichzeitig kaufmüde geben. NCAP-Sterne und CO_2-Werte, Sicherheits- und Umweltbestimmungen, oder besser gesagt: die Angst vor Unfällen und die Sorge um irreversible Umweltschäden, treiben – oder eben bremsen – die Kauflust. Das große, schwere, auffällige Automobil gerät wieder ins Zentrum der sozialen Debatte. In deutschen Metropolen gehören Brandanschläge auf Autos zum Alltag. Und wer eine Edelkarosse auffällig parkt, findet auf der Scheibe eine schön gestaltete Postkarte mit dem wenig schönen Hinweis „Sie parken Scheiße". Europa begreift die ebenso faszinierende wie spannende Komplexität der automobilen Gesellschaft. Es geht um die soziale Akzeptanz des Automobils, dessen Design sich anpassen

ment de terre provoque un désastre nucléaire au Japon. Dans un même temps les marchés des pays émergents continuent tranquillement leur expansion. Des centaines de millions de personnes veulent une voiture, surtout en Chine. Ce pays, le plus grand producteur du monde est en passe de devenir le plus grand marché automobile. Les constructeurs se doivent de lui accorder la plus grande attention, une attention d'autant plus grande que les marchés européens sont saturés et les clients peu enclins à consommer. Les étoiles NCAP, les valeurs de CO_2, les prescriptions sur la sécurité et l'environnement qui traduisent la peur des accidents et les préoccupations liées à l'environnement et à de potentiels dommages irréversibles, freinent considérablement le marché. La grosse voiture, lourde et voyante revient encore une fois au centre des débats sociaux. Les constructeurs européens se voient soudain confrontés à la complexité aussi fascinante que passionnante de la société automo-

Mercedes-Benz, 2010

Volvo, 2010

needed to adapt itself and render the car more likeable, useable and greener.

DOWN BY LAW

After an extremely ambivalent decade, automotive design is about to enter yet another transitional phase. Nobody wants to rule out the change to electromobility anymore, but until then the ideology of automotive design has been evolving, in keeping with the downsizing ethos. The manufacturers have identified a new niche: small engines for big cars. This variation is called Blue Motion, Blue Efficiency or Efficient Dynamics. Such enormous levels of efficiency and love for the environment naturally need to be emphatically highlighted, hence white, the colour of innocence, has become the new trend colour. This leads to advertisements designed not in the red-on-black of yore, which used to stand for speed and status, but blue-on-white, just like a bright sky with

muss. Das Auto wird unaufdringlicher, sympathischer, nützlicher.

DOWN BY LAW

Nach einem extrem wechselhaften Jahrzehnt beginnt für das Automobildesign eine Übergangsphase. Niemand möchte mehr eine Umstellung auf Elektromobilität ausschließen, doch bis es soweit ist, verändert sich die Ideologie des Automobildesigns in Richtung Intelligent Downsizing. Die Hersteller machen schon wieder eine Lücke aus: kleine Motoren für große Autos. Die Spielart nennt man Blue Motion, Blue Efficiency oder auch Efficient Dynamics. Auf soviel Effizienz und Umweltliebe darf natürlich nachdrücklich aufmerksam gemacht werden, weshalb Weiß, die Farbe der Unschuld, zur Trendfarbe erklärt wird. Statt Rotschwarz für Speed und Status gibt sich die Werbung nun Blauweiß: ganz wie ein heiterer Himmel mit hübschen Wölkchen. Plötzlich

bile. Il s'agira pour eux de comprendre que l'acceptation sociale de l'automobile passe par un design capable de s'adapter, pour rendre la voiture plus sympathique, plus utile et plus verte.

SOUS LE COUP DE LA LOI

Après une décennie extrêmement mouvementée, le design automobile entre dans une phase de transition. Le passage à l'électromobilité paraît inexorable, mais avant d'en arriver là, l'idéologie du design automobile est frappée de *downsizing*. Les constructeurs découvrent un nouveau créneau : celui des grosses voitures à petits moteurs, avec des gadgets joliment baptisés BlueMotion, Blue Efficiency ou bien Efficient Dynamics. Il faut bien attirer l'attention sur tant d'efficacité et tant d'amour pour l'environnement ! Et tout naturellement, le blanc, la couleur de l'innocence, est déclarée couleur tendance. La publicité abandonne le rouge et noir, symboles de la vitesse et du statut,

Volkswagen BlueMotion
Technologies, 2009

pretty little clouds. From one day to another, the automobile cannot become small enough, quickly enough: even SUVs begin to shrink, Q7 to Q5, then Q3 and, tomorrow, even Q1. Journalists suddenly find the Polo big enough: it is, after all, the same size as an old Golf. VW makes room to place the Up! below it, and Mini wants to return to the marque's roots, with the help of a mini-Mini. After Apple convincingly demonstrated the beauty of the simple, automotive designers are also discovering the power of straightforward simplicity. In this context it hardly seems like a co-incidence that the automotive premier league is the first to ex-periment with simple stylistic devices: a consequence of bling and botox eventually having be-come the norm with the cheapest of cars. The Rolls-Royce Ghost, the (moderately) smaller brother of the Phantom is an exemplarily sober design. Ferrari's 458 Italia wears a dress that is just as slender as Pinin Farina's Cisitalia: the

kann das Automobil kaum klein genug werden: Die SUVs schrumpfen, von Q7 auf Q5, dann Q3 – irgendwann dann Q1. Journalisten finden den Polo groß genug – schließlich ist er so groß wie früher ein Golf. Darunter will Volkswagen den Stadtwagen Up! platzieren. Mini möchte anhand eines Mini-Minis zurück zum Markenursprung. Die Superminis positioniert man als mobile Ac-cessoires für Individualisten. Nachdem Apple zehn Jahre lang die Schönheit des Schlichten be-wiesen hat, entdecken Automo-bildesigner die Kraft schnörkel-loser Sachlichkeit. Da erscheint es kaum wie ein Zufall, dass aus-gerechnet die Oberliga als erstes beginnt, mit einfachen Stilmitteln zu experimentieren – als Gegen-trend zu Bling und Botox, die selbst im Billigauto zur Norm ge-worden sind. Der Rolls-Royce Ghost, der (moderat) kleinere Bru-der des Phantom, ist puristisch schlicht gestaltet. Der Ferrari 458 Italia trägt ein Kleid, so knapp wie einst das des Cisitalia aus Pi-

et se met au bleu et blanc, comme un ciel de beau temps avec de jo-lis petits nuages. Et, tout à coup, il n'est pas de voitures trop petites. Même les SUV rétrécissent, du Q7 on passe au Q5, puis au Q3 et demain au Q1. Aux yeux des journalistes, soudain, la Polo est largement assez grande – après tout, elle a les dimensions de l'an-cienne Golf, remarquent-ils avec justesse. Alors que VW s'aperçoit qu'en bas du créneau il y a de la place pour la nouvelle Up, Mini voudrait revenir aux origines avec une Mini-Mini. Après Apple, qui depuis dix ans fait la démonstra-tion que la beauté passe par la pureté des lignes, les designers automobile, à leur tour, décou-vrent la force d'un réalisme sobre. Bling-bling, botox et liposuccion étant d'ores et déjà de mise dans la catégorie des voitures bon mar-ché, ce n'est pas un hasard si les designers expérimentent, d'abord dans le haut de gamme, un lan-gage esthétique simple. La Rolls-Royce Ghost est d'une sobriété exemplaire. La Ferrari 458 Italia

Audi Q7, 2005

Audi Q5, 2008

Audi Q3, 2011

previously mighty air vents, the brand's main symbol since the 1984 Testarossa, are tastefully hidden. A short, low fastback is supposed to aesthetically negate the Audi A7's size. Under Walter de'Silva, Volkswagen has found a new face: black, demure and functional, yet at the same time calming, clean and optimistic. Saab, Peugeot and Škoda have suddenly lost all their make-up. And the wedge shape, the peacock-on-heat of automotive design since the seventies, finds itself in limbo. The car is seeking a new balance in the horizontal plane. A new chapter begins: yet again, and certainly not for the last time.

nin Farinas Feder. Die mächtigen Lufteinlässe, die alle Ferraris seit dem Testarossa charakterisieren, werden stilvoll kaschiert. Ein kurzes, niedriges Fließheck soll die Größe des Audi A7 ästhetisch verkleinern. Unter Walter de'Silva findet Volkswagen ein neues Gesicht: schwarz, nüchtern und sachlich, gleichzeitig aber auch beruhigend, klar und optimistisch. Bei Saab, Peugeot und Škoda fehlt plötzlich jede Schminke. Und die Keilform, seit den Siebzigern balzender Pfauenhahn der automobilen Gestaltung, steht auf der Kippe. Das Auto sucht eine neue Balance. Ein neues spannendes Kapitel beginnt. Schon wieder, und gewiss nicht zum letzten Mal.

porte désormais une robe juste au corps, qui rappelle l'ancienne Cisitalia née de la plume de Pinin Farina. Les entrées d'air, si puissantes auparavant et symboles de la marque depuis la Testarossa en 1984, sont maintenant dissimulées avec style. Un poupe courte et basse est joliment dessinée pour faire oublier que la voiture n'est pas plus grande qu'une Audi 7. Walter de'Silva signe le nouveau visage de Volkswagen : noir, discret et sobre, mais en même temps apaisant, limpide et optimiste. Chez Saab, Peugeot et Škoda, on ne trouve soudain plus aucun maquillage. Et même la silhouette en coin, fier apanage de tout concept automobile depuis les années soixante-dix, est menacée. La voiture cherche un nouvel équilibre dans l'horizontalité. Un chapitre passionnant commence : la voiture, encore et toujours.

Peugeot 508, 2010

Rolls-Royce Ghost LWB, 2009

Mini Rocketman, 2011

Ferrari 458 Italia, 2009

Aston Martin Cygnet, 2011

Either sober or playful: the Play-mobil automobile is searching for a new form that radiates sympathy. Brands are prescribing themselves a new face. It may be anything but evil. Big equals small equals nice— and socially acceptable.

Ob nüchtern oder spielerisch, das Playmobil-Automobil sucht nach neuen Formen, die Sympathie ausstrahlen. Marken verschreiben sich ein neues Gesicht. Es darf alles sein, nur nicht böse. Groß ist klein ist fein – und sozialverträglich.

Qu'elle soit sobre ou ludique, la voiture « Playmobil » se cherche une forme nouvelle qui plaise. Les marques se donnent un nouveau visage. Tout est permis pourvu que ce soit gentil. Puissance rime avec petite taille, raffinement et accepta-tion sociale.

Citroën DS3, 2010

Opel Meriva, 2010

Saab 9-5, 2010

Volkswagen XL1, 2011

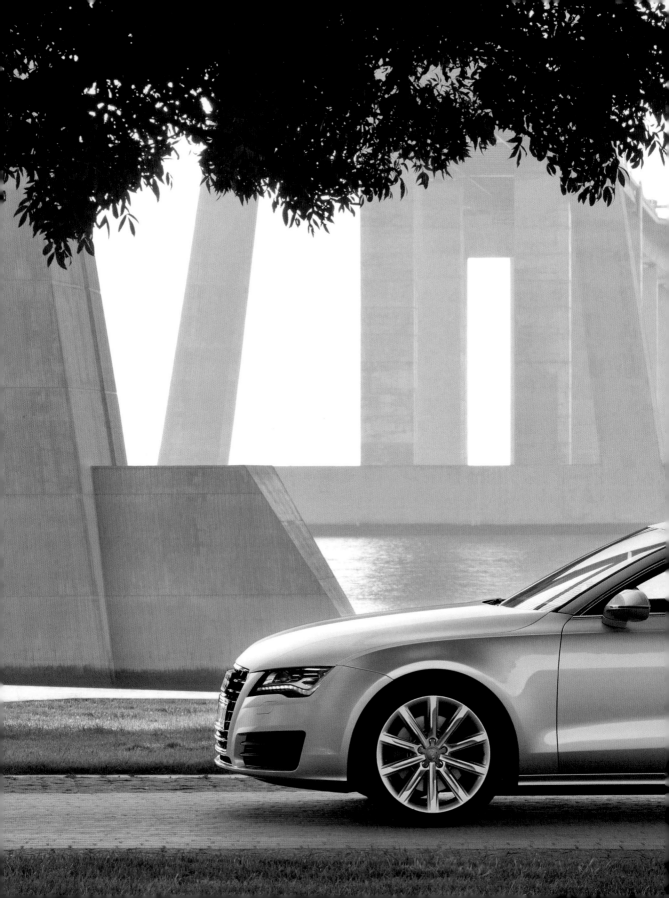

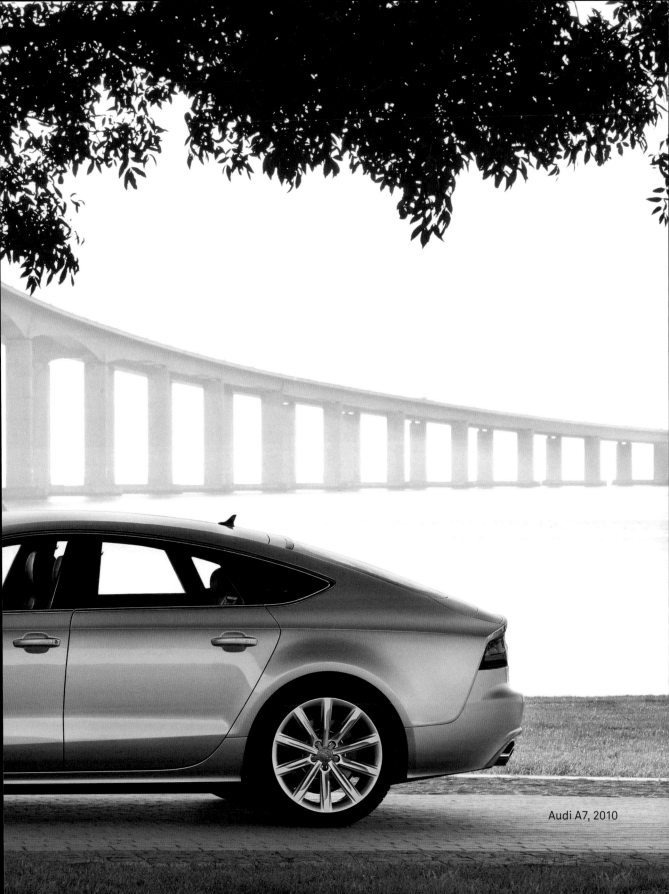

Audi A7, 2010

REGISTER

CREDITS

Adam Opel AG 46, 115(l), 117(l), 136, 137, 138, 167(l), 201(r), 235(m), 289, 291(l), 364, 383(b) — Aston Martin Lagonda Limited 157, 326, 328, 382 — Audi AG 18.1, 20, 118(m), 148, 268, 288(l), 290(m-r), 295, 338(m), 346(l), 349(l), 354(b), 366, 376, 386 — AutoBild 318, 319 — Automobiles Citroën 6, 16(l), 19(m), 26, 27, 120(m), 49(r), 140, 216, 218, 237(m), 252-3 (tm-bm), 332, 339, 367, 383(t) — Automobiles Peugeot 122(l), 146, 147, 196(l), 263(m), 342(m), 347(m), 362, 377 — Bentley Motors Limited 316 — Stile Bertone 160, 184 — British Motor Industry Heritage Trust (BMIHT) 48(m), 72, 74, 100, 101, 102, 103, 116(m), 123, 124, 135, 143, 150, 152, 200(r), 204, 219, 248(b), 251(l), 252(tl-bl), 270-1(bm), 296 — BMW Group Archiv 14, 18(m), 18(r), 25, 32, 99, 121(m), 144, 192, 199(l), 240, 262, 283, 310(m), 336, 345, 356, 357, 358, 360, 372 — Corrado Lopresto, 30, 114(r) — Daimler AG 10, 22, 24, 34, 36, 45(r), 56, 57, 98, 113, 126, 127, 128, 163(l-r), 238(m), 278, 280, 284, 298, 300, 304, 330, 337, 338(r), 341, 342(l), 347(l-r), 349(m), 350, 355(b), 361, 374(l) — Editoriale Domus SpA 44, 47, 60, 61, 62, 63, 66, 67, 69, 70, 76, 78(l), 79, 80, 84(m), 86, 87(t), 90, 91, 92, 95, 96, 97, 117(r), 119(m), 130, 141, 142, 154, 158(l), 159, 163(m), 164, 168, 170, 174, 176, 177, 182, 185, 186, 188, 189, 194, 200(l), 232, 202(m), 207, 214, 215, 224, 226, 229(r), 232(m), 236(l), 239(r), 242, 243, 244, 245, 247, 248(t), 249, 250, 251(b) — FIAT Group Automobiles SpA 19(l), 43(r), 45(m), 49, 51(r), 68, 85(m), 115(m), 119(r), 167(r), 199(m), 200(m), 201(m), 232(r), 235 (r), 238(r), 253(tr-br), 255, 256, 261(r), 263(r), 265, 266, 267(l), 270(bl), 271(tr), 275(bl-br), 288(r), 297(a,c,d), 306(m), 311(l), 312(m), 321, 338(l), 354(t) — Ferrari SpA 381

— Ford Europa GmbH 55, 122(r), 234, 291(m), 294, 343, 348, 353, 355(t), 362 — Ford Motor Company 118(l) — Fratelli Alinari - collezione Favrod, Firenze 108 — General Motors 119(l) — GNU Free Documentation License 228(r) — Goodbrands Institute 8, 9(l), 9(m), 12, 16(m), 17(l), 17(m), 31, 43(m), 45(l), 71, 73, 81(m), 82(l), 83, 84(r), 87(b), 94, 112, 116(l), 120(l), 162, 197(l), 198(l), 229(m), 230(l), 236(m), 264, 282, 391 — Istituto Policleto 33, 41, 121(l) — Italdesign Giugiaro SpA 203(m), 230(r), 281(m), 287 — Jaguar Land Rover, 171, 173, 310(l), 322 — Group Lotus PLC 246 — Maserati SpA 315, 320 — Mazda Motors 308 — Mini (BMW Group) 312(l), 324, 380 — Original Marketing Collateral 51(m), 54, 58, 59, 65, 104, 105, 117(m), 139, 172, 191, 198(m), 233(m-r), 280(l), 263(l), 274(tl-tr) — Pininfarina SpA 38, 42, 78(m-r), 81(r), 120(r), 156, 161, 178, 179, 180, 196(r), 230(m), 231, 235(l), 238(l), 281(l), 306(l), 307(l) — Dr. Ing. h.c. F. Porsche AG 28, 29, 64, 82(m), 85(l), 106, 158(l), 166(l), 202(r), 220, 221, 222, 223, 239(l), 258, 272, 307(m), 309, 311(m), 368 — Renault 48(l), 121(r), 167(m), 190, 197(m-r), 201(l), 203(r), 208, 237(l), 280(m), 270-1(tm), 271(br), 286, 288(m), 340, 344, 352 — Riva SpA 314 — Rolls-Royce Enthusiasts Club 112(m-r), 114(l-m), 115(r), 133 — Rolls-Royce Motor Cars Ltd. 134, 378 — Saab Automobile AB 166(m), 209, 210, 211, 270(tl), 274(bl-br), 297(b), 384 — Seat 239(m) — Škoda Auto 370 — TopFoto Archivi Alinari 110 — Volkswagen AG 19(r), 50, 52, 254, 261(m), 267(r), 275(tl-tr), 290(l), 302, 312(r), 313, 375(l), 385 — Volvo Car Corporation 212, 213, 237(r), 276, 292, 346(m), 374(m) — Wikimedia Commons: Ricce 228(r), Lothar Spurzem 229(l)

EDITOR

THANKS

Paolo Tumminelli's warm-up lap consisted of architectural studies at Milan before he sped into design, careened into marketing, drove through strategic brand consulting and finally handbrake-skidded to become a Professor at the Faculty of Cultural Sciences at Cologne University of Applied Sciences. In between he was—and still is— a publicist, author, curator and moderator or, to put it another way: a cultural entertainer. His design column is published weekly in the *Handelsblatt*, Germany's premier economic and financial magazine.

Paolo Tumminelli, Direktor des Goodbrands Institute, wärmte sich mit dem Architekturstudium in Mailand auf, schnellte ins Design, rutschte ins Marketing, fuhr durch die strategische Markenberatung und landete schließlich als Professor an der Fakultät für Kulturwissenschaften der Fachhochschule Köln. Dazwischen war und ist er Publizist, Autor, Kurator, Moderator – oder auch Kulturentertainer. Seine Designkritik erscheint wöchentlich im *Handelsblatt*, Deutschlands Wirtschafts- und Finanzzeitung.

Directeur du Goodbrands Institute et diplômé de l'école d'architecture de Milan, Paolo Tumminelli prend le chemin du design, bifurque ensuite vers le marketing, devient conseiller en marques et s'oriente finalement vers un poste de professeur à la faculté des sciences de la communication et de la culture de l'école supérieure de la ville de Cologne. Publiciste, auteur, présentateur, animateur et intervenant dans le domaine de la culture, il rédige également une critique sur le design qui paraît dans le *Handelsblatt*, grand journal économique allemand.

Talks & Inspiration:
Stephen Bayley, Lilli Bertone, Aldo Brovarone, Fulvio Cinti, Marcello Gandini, Giorgetto Giugiaro, Thomas Hine, Malte Jürgens, Patrick Le Quément, Paolo Martin, Giuliano Molineri, Sergio Pininfarina, Roberto Piatti, Bruno Sacco, Tom Tijarda, Roberto Tumminelli, Bernd Wieland, Tom Wolfe...

Help & Support:
Silvana Appendino, Gillian Bardsley—The British Motor Industry Heritage Trust, Lorenza Cappello, Francesco Chiolo, Maria Feifel, Carmen Figini & Massimo Calzone—Editoriale Domus, Lothar Franz, Stephanie Gehrt, Manfred Grunert, Dr.Manfred Grieger, Silvie Kiefer, Dr. Dieter Landenberger, Corrado Lopresto, Ruth Standfuss, Jens Torner, Claus Witzeck...

IMPRINT

Editorial project:
Goodbrands Institute

Goodbrands Institute
Peter-Welter-Platz 5,
50676 Cologne, Germany
Phone: +49-(0)221-348-92-681
Fax: +49-(0)221-348-92-683
e-mail: mail@goodbrands.de

Author: Paolo Tumminelli
Editor: Christopher Butt
Design: Alice Kaiser
Research: Conrad Ballschmiter
French translation: Carole Chabrel
English translation: Christopher Butt
Editing: Tim Danaher

© Paolo Tumminelli, 2011
www.goodbrands.de

Published by:
teNeues Publishing Group

teNeues Verlag GmbH + Co. KG
Am Selder 37, 47906 Kempen,
Germany
Phone: +49-(0)2152-916-0
Fax: +49-(0)2152-916-111
e-mail: books@teneues.de

Press department: Andrea Rehn
Phone: +49-(0)2152-916-202
e-mail: arehn@teneues.de

teNeues Digital Media GmbH
Kohlfurter Straße 41–43,
10999 Berlin, Germany
Phone: +49-(0)30-7007765-0

teNeues Publishing Company
7 West 18th Street, New York,
NY 10011, USA
Phone: +1-212-627-9090
Fax: +1-212-627-9511

teNeues Publishing UK Ltd.
21 Marlowe Court, Lymer Avenue,
London SE19 1LP, UK
Phone: +44-(0)20-8670-7522
Fax: +44-(0)20-8670-7523

teNeues France S.A.R.L.
39, rue des Billets,
18250 Henrichemont, France
Phone: +33-(0)2-4826-9348
Fax: +33-(0)1-7072-3482

www.teneues.com

ISBN 978-3-8327-9459-0

Printed in Italy